D0145946

THE PRINCETON RAPHAEL SYMPOSIUM

PRINCETON MONOGRAPHS IN ART AND ARCHAEOLOGY
XLVII
PUBLISHED FOR THE
DEPARTMENT OF ART AND ARCHAEOLOGY
PRINCETON UNIVERSITY

The Princeton Raphael Symposium

Science in the Service of Art History

EDITED BY
JOHN SHEARMAN AND
MARCIA B. HALL

PRINCETON UNIVERSITY PRESS
PRINCETON, NEW JERSEY

LONGWOOD COLLEGE LIBRARY
FARMVILLE, VA 23901

ND
623
.R2
P75
1983

Copyright © 1990 by Princeton University Press
Published by Princeton University Press, 41 William Street, Princeton, New Jersey 08540
In the United Kingdom: Princeton University Press, Oxford

ALL RIGHTS RESERVED

Library of Congress Cataloging-in-Publication Data

Princeton Raphael Symposium (1983)
Science in the service of art history / the Princeton Raphael Symposium ;
edited by John Shearman and Marcia B. Hall.
p. cm.—(Princeton monographs in art and archaeology ; 47)
English, French, and Italian.
Papers from a conference held in Princeton in Oct. 1983.
ISBN 0–691–04079–6
1. Raphael, 1483–1520—Criticism and interpretation—Congresses.
2. Painting, Italian—Conservation and restoration—Congresses.
3. Painting, Italian—Expertising—Congresses. I. Shearman, John
K. G. II. Hall, Marcia B. III. Title. IV. Series.
ND623.R2P75 1983
702'.8'8—dc20 89–24071

This book has been composed in Linotron Sabon

Clothbound editions of Princeton University Press books are printed on
acid-free paper, and binding materials are chosen for strength and durability.
Paperbacks, although satisfactory for personal collections,
are not usually suitable for library rebinding

Color plates and black and white illustrations printed by
Garamond Pridemark Press,
Baltimore, Maryland

Text printed in the United States of America by
Princeton University Press,
Princeton, New Jersey

LONGWOOD COLLEGE LIBRARY
FARMVILLE, 23901

Contents

List of Illustrations

Introduction

MARCIA B. HALL

THE conference at which these papers were presented took place at Princeton University in October 1983. It was the realization of planning that had begun some three years earlier. Searching around for a way to utilize and record the work that would be done to celebrate the five-hundredth anniversary of Raphael's birth, I sought out Dolf van Asperen de Boer in Amsterdam in the summer of 1980. He suggested as a model the Rembrandt year of 1969. From the start, we determined that the papers must be published together. When I took the proposal to John Shearman, he received it enthusiastically, especially because the occasion coincided with the centennial of the Princeton University Department of Art and Archaeology.

Since this is something of a pioneering effort, it may be worthwhile to chronicle in some detail the planning of the conference. In January 1981, Dolf van Asperen, John Shearman, and I met at Princeton. We determined the format for the conference and whom we should invite. We decided to seek a commitment from about five institutions with major Raphael holdings to test the feasibility of the idea and to provide a nucleus around which to build and to attract funding. When the response was unanimously enthusiastic, we decided to proceed.

John Shearman's correspondence with the participants included some specific questions that each was asked to address, but on the whole it was left to the individuals to determine the content of their papers as dictated by the facilities of their laboratories or the treatment needs of the works. It was also left to the institutions to decide whether the curator or the conservator would present the paper. Although most of the research recorded here is new, we did not preclude earlier research and in one case even requested that it be reported: the tapestry cartoons in the Victoria and Albert Museum that had been examined some years ago. Our objective has been to bring together as much scientific data on Raphael's paintings as possible, so that historians as well as scientists concerned with his work could benefit from them.

Ralphael's fifth centennial offered a unique opportunity to obtain and share new data resulting from the preparation, examination, and treatment of his works as they were readied for the innumerable exhibitions. In the past, sufficient advantage has not been taken of events such as this. Harried conservators and curators who must rush on to prepare for the next bi-, tri-, or quadricentennial rarely have the chance to share their findings, exchange views, and work toward a solution to problems in discussion with one another.

The art historian outside the museum has still less opportunity to benefit from these activities. Even today, relatively few are familiar with laboratory procedure, read the conservation literature, or seek out the scientist in the laboratory. Yet the advances

since World War II in the scientific examination of works of art have made it one of the primary sources for new data in our field. A major purpose of this undertaking, then, has been to generate interest in the possibilities of this research and to foster dialogue between the historian and the conservator.

The conference addressed an audience that was, by design, made up primarily of art historians. Our initial apprehension over how it would be received was quickly dissipated. Not only was the attendance gratifying, so also was the quality of the discussion following each paper. It was clear that both sides were eager to exchange information and points of view. It was stated at the conference, and it deserves to be reiterated here, that conservators have much to learn from historians and welcome their questions.

The papers of the conference and this volume are disparate and varied, and we have made no effort to suppress these differences. Symptomatic of this is our editorial decision on orthography. We were able to persuade our initially reluctant editor to retain the British or American spelling preferred by each author. It is, after all, part of our purpose to show the variety and range of material that can come out of the laboratory.

We regret certain lacunae: Dresden, Leningrad, and Naples were unable to participate, and at the last minute Carlo Bertelli cabled from Milan that he would be unable to attend. There is insufficient discussion of fresco, although this was partially remedied at the conference because Fabrizio Mancinelli presented his paper on the cleaning of the *Coronation of Charlemagne*, since published in the *Burlington Magazine*.

The format of some of the papers will be familiar to the art historian. We are accustomed to the classic treatment report, represented here by Wolfgang Prohaska's and Rafael Alonso's articles. Both are illustrated with valuable photographs of the works in stripped condition, documenting damage before final in-painting. Also familiar are arguments on authenticity, like those of Burton Fredericksen, based on such matters as provenance, though the reader will find these enhanced here by the study of scientific photographs. X-radiography, the oldest of the modern techniques of analysis, has produced valuable results in the past, but few more spectacular than the background discovered beneath the present surface of the *Madonna del Granduca*, reported here by Marco Chiarini. The use of this technology in an attributional problem is nicely demonstrated by Carol Christensen's discussion of the portrait of *Bindo Altoviti*. Less familiar to the art historian are reports of scientific examination by various chemical and physical procedures, such as Klein and Bauch's dendrochronological examination of some of Raphael's poplar panels, or Priscilla Grazioli Medici's study of the origin of marbles in the Chigi Chapel to determine Raphael's contribution there. Although it is frequently the case that the motive for undertaking examination may be a question relating to condition and treatment, the historian can often glean important information.

Herein lies a problem. While scientific examination may yield significant new data on a painter's technique, it is virtually never undertaken in the interest of pure research. A painting is customarily taken to the laboratory because it is deemed in need of treat-

ment, or because it is being prepared to travel. These occasions present themselves irregularly and, as Joyce Plesters points out, the scientist may miss an opportunity that will not be offered again for many years because a certain technology is not yet available. Sometimes, certain procedures are not undertaken because they are not indicated by the painting's condition. With relatively little added burden, however, an examination can be extended to address questions important to the historian. But the scientist must know what these questions are. And prior to this, the historian must know the work is due to be examined. Most fundamental of all, the historian needs to know what kind of questions to ask. The papers gathered here can help to gain this understanding.

On the whole, the historian in the laboratory tends to feel like an intruder. Surrounded by banks of elaborate instruments that mean little more to him than the shelves of delicate porcelain to the proverbial bull in the china shop, he is there on the scientist's turf by the sufferance of the scientist. He is untrained in this technology. The questions he wants to ask will take the scientist's time and will probably not contribute materially to the treatment plan for the picture; they may even cause delay in an already overcrowded schedule.

Yet there is a common endeavor that is the shared province of the scientist and the historian, the subdiscipline we might call the history of technique. Still in its infancy, this area of inquiry has seen few contributions. An important one was the conference on mural painting in Florence organized by Eve Borsook, the papers of which are now published.[1] Neither the conservator nor the historian can write in this field without the other. But like much research, it will require special nurturing and encouragements. There is the need for a new kind of art scientist and a new kind of art historian—at least as models. Both will need to be trained in the other's discipline: the scientist to interpret findings in the historical context, the historian to read the results of the analyses. The historian will need an internship in the laboratory; the scientist will need some time to engage in pure research.

One problem for the historian with the present pragmatic basis for examination, is that there is little comparative material. Frequently, works by the same painter from approximately the same date have not been examined; or, if examined, different procedures have been used, making comparison difficult at best. The advantage of the new approach taken at the Princeton Raphael Symposium is obvious; still, all the difficulties have not been eliminated. The results are maddeningly diverse because each examination followed a different agenda. Yet, it was neither feasible nor desirable for the organizers to have imposed a uniform agenda. John Shearman's call for a more systematic examination whenever a picture goes into the laboratory would, of course, do much to alleviate the problem of incommensurable results in the future.

If the historian is going to share in the benefits of the laboratory examination, if he wishes to push out the present limits of scientific examination beyond treatment-oriented questions to make contributions to the history of technique, then he has certain

[1] *Tecnica e Stile: esempi di pittura murale del Rinascimento italiano*, ed. Eve Borsook and Fiorella Superbi Gioffredi, The Harvard University Center for Italian Renaissance Studies at Villa I Tatti, 2 vols., Milan, 1986.

responsibilities toward the scientist and his discipline. He must understand the proce-
dures, together with their capabilities and limitations, and he must know how to inter-
pret the results. Shearman has emphasized the essential point that the interpretation of
scientific results is an art, not a science. The art historian must know what kinds of
questions can be illuminated by scientific examination. He must be ready to engage in
dialogue with the scientist and to respond to his questions. It is his task to provide to
the scientist the historical context as it may bear upon his research. He must respect the
ethical commitment of the curator and conservator to avoid destructive techniques of
study whenever possible.

What kinds of questions can laboratory analysis shed light on? Historians already
depend upon the laboratory to tell them about the condition of a painting: how it is
damaged; how it is changed; how what we see today differs from what the Renaissance
patron saw when his commission was delivered. Sometimes laboratory examination
can also tell us about attribution and influence. Most fundamentally, it can tell us about
how the artist prepared and executed the painting, and how this process differs from
painting to painting, from painter to painter, from place to place, from period to period.

The papers presented here do not constitute a history of Raphael's technique; that
is still to be written. They do provide some of the data needed for such a history and
point up the still-remaining gaps in our knowledge. They demonstrate the procedures
that the conservator can undertake and the kind of data they yield.

The contributions in this volume are particularly rich in two areas: infrared reflec-
tography and color technique. The recent technology of reflectography, described by its
inventor, van Asperen de Boer, in his paper, has been used extensively by these authors.
The resulting corpus of reflectograms, more comprehensive than that assembled for any
Italian artist to date, will be useful for further study. It demonstrates the surprising
range and variation that we can expect from a single painter. Superficial perusal reveals,
for example, that, at the same time, Raphael was using a pounced cartoon for one
painting and a very loose underdrawing for another. A whole new corpus of under-
drawings has been made available for study in relation to the known drawings. How
scientific findings might be used by the art historian can be illustrated by a study of
Raphael's color technique, based on the analyses here of Plesters, Béguin and the Louvre
team, Prohaska, von Sonnenburg, Rossi Manaresi, and Mancinelli and Gabrielli.

From this material, one can say that Raphael's manner of using color derives es-
sentially from Perugino and, while he later modifies it, he never abandons it. There is
no evidence presented here that Raphael imitated Leonardo's technique in the same
way that he was influenced by that master's compositional ideas and figure style. There
is no indication, for example, that he employed a Leonardesque underpainting like that
to be seen in Fra Bartolomeo's unfinished *St. Anne Altarpiece* (Florence, Museo San
Marco).

What we know of Perugino's technique is scant, to be sure, and is based largely on
the single study of the Pavia panels in the National Gallery, London.[2] Fortunately for

[2] David Bomford, Janet Brough, and Ashok Roy, 'Three Panels from Perugino's Certosa di Pavia Altar-piece,' *National Gallery Technical Bulletin*, iv (1980), pp. 3–31.

us, these panels date from the turn of the century and thus reveal Perugino's technique at the time when Raphael would have been associated with him. Perugino characteristically employed a two-part structure for painting draperies, sky, landscape: an underpainting that is then glazed in another color. Raphael uses some of Perugino's combinations; for example, azurite under ultramarine, said to be unusual in Italy, appears in the sky in the *Holy Family Canigiani* (pl. 78). As in Perugino's *Madonna*, there is no evidence in Raphael's Florentine paintings of the presence of a dark neutral pigment in the shadows. Raphael's color effects are achieved as Perugino's were by laying one brilliant color over another. The effect is rich, vibrant, and deep. It is no longer the simple, pure, one-layer structure of the Cennini system, but it is not dulled, desaturated, or muted color either.

Of course, we know that Raphael's color style evolved as he matured. The increasing *unione* of his coloring is evident at the end of the Florentine period in such works as the Borghese *Entombment* and the London *Saint Catherine* (pl. 7). Joyce Plesters has suggested that in the case of the latter, the difference can be accounted for largely by the selection of pigments. She notes a significant shift away from the highly contrasting hues used in the Mond *Crucified Christ* (1503) (pl. 5) to pigments that are intrinsically less brilliant and closer to one another in value and saturation; yellow ochre is used instead of lead-tin yellow; the russet tone she notes in Catherine's robe suggests the presence of red ochre in the place of the crimson lakes used earlier. The blue has not been analyzed, unfortunately, because it is the most interesting of the colors here. Plesters describes it as a 'dim lavender,' noting its resemblance to Jerome's robe in the *Crucified Christ*, which is composed of azurite and crimson lake mixed with lead-white. This same mixture has been found in Saint Elizabeth's robe in the *Holy Family Canigiani* (pl. 78). The appearance of this desaturated, but still highly attractive tone at the center of the composition where one might expect to find a brilliant ultramarine or azurite signals a significant shift in his color aesthetic. The choice made here would not have been made by Perugino, intuition tells us. Raphael has given a higher priority to the harmony and balance of his tones than to their individual aesthetic appeal. In order to achieve the coherence of the whole he has had to subordinate the individual parts. The principle we see him employing with such skill in designing his compositions he can now apply to his color as well.

Another significant development has taken place by the time of the *Madonna della Tenda* (1513) (pl. 84). Concern to relate the colors is apparent in the painter's use of a pink undertone to the Madonna's blue drapery, echoing the red lake of the nearby sleeve. But here the blue, azurite, is mixed not only with lead-white, but also with carbon black and brown ochre, and the shadow is created by additional black and brown. This new interest in chiaroscuro may relate to Leonardo's presence in Rome at this time, but more importantly, it is a translation in easel painting of the interest in darker and more dramatic shadows he had already employed in the Stanza d'Eliodoro.

The richness and complexity of Raphael's shadows in this period are further revealed by the analysis of the opaque brown shadow on Paul's red robe in the *Santa Cecilia* altarpiece (pl. 148). The robe itself is vermilion glazed with red lake; in the

shadow, the red pigment shifts to ochre mixed with black and a little green. Even while embracing a chiaroscuro mode, Raphael remains constant in his commitment to rich, complex color. The monochromatic obscurity of Leonardo's shadows was not for him. His technique of applying a contrasting but related glaze over the body color, learned from Perugino, survives.

This is still true of his last painting, the *Transfiguration* (pl. 164), but here the artist calls forth the full range of his skill as a colorist in order to maximize the contrast between the two simultaneous scenes. He has worked out his own variation on Leonardo's chiaroscuro underpainting. In the lower zone, the background to the struggle of the Apostles to heal the epileptic boy is dark and blackish. Each solidly painted figure, however, stands out, sharply defined against the background. Beneath the figures, the underpaint is not the dark neutralizing tone Leonardo would have used, but individually selected body colors chosen to contrast with and enrich the glaze laid on top. In the upper zone, employing a different technique, he applies the colors thinly in transparent glazes of great delicacy. Raphael's application of paint dramatizes the contrast between the failed miracle in the earthbound zone below with the ethereal vision in the upper zone. But even here in his ultimate and most virtuosic performance, the techniques are elaborations of those of his Florentine period.

The tapestry Cartoons appear to be the proverbial rule-proving exception to Raphael's technique. The characteristic method of superimposing layers is, on the whole, not used here. This is partially the result of the medium, as Plesters points out, for glue distemper is matte and not well-suited to glazing. The artist must have recognized as well that in utilitarian objects such as these, such subtleties would have been wasted, since the weavers would have to translate his colors into another material anyway. It is the same logic that led him to exclude the expensive pigments, gold and ultramarine.

We have an indication of the importance to Raphael of the harmony of the total scheme in the relationship of the Madonna's robe to the sky. He has several techniques for painting sky, and the choice he makes does not follow a neat chronological or developmental pattern. The selection seems rather to have been determined by the blue of the Madonna's robe, which in some cases would have been dictated by the commission and the patron's willingness to pay for the expense of ultramarine. Where the robe is ultramarine, so is the final, thick layer of the sky (*Holy Family Canigiani*) (pl. 78). Where the robe is azurite, so is the sky (*Tempi Madonna*) (pl. 84). And when the Madonna's robe is underpainted in pink, the sky is handled the same way (*Holy Family of Francis I*) (pl. 42). Even where, quite exceptionally, ultramarine glaze is laid over a greenish layer containing verdigris, in the *Madonna in the Meadow* (pl. 43), the same verdigris underlies the ultramarine glaze of the sky. Although no analysis has been made, one suspects that the *Madonna di Foligno*'s robe is ultramarine over pink, as we know the sky to be. In the *Santa Cecilia* (pl. 148) the problem is slightly different because the central figure wears a gold brocade robe, but the sky, made up of pink underlying first azurite then ultramarine, relates to Mary Magdalen's beautiful *cangiante* drapery. Pink highlights, carrying down the color of her collar, shimmer across her blue sleeve. Again, although it has not been analyzed, one would expect this blue to follow

the pattern and to have the same structure as the sky. It is always risky to try to guess at a complex layer structure, and we art historians should take our warning from the scientists who will not do it. But cross-sections from pictures spanning an artist's career, such as we have here, reveal patterns, and by such comparisons as these we can begin to understand how the painter composed in color.

One danger with this kind of research is that a great deal of time and money can be spent documenting the obvious. For instance, as some critic will no doubt point out, any sensitive observer will have recognized that Raphael's skies are coordinated closely with the other colors in his compositions. What the unaided eye will not have observed, however, is the presence of pink (red lake and lead-white) undertones first in the *Madonna di Foligno*, and then consistently in the later works tested: *Madonna della Tenda, Santa Cecilia, Holy Family of Francis I.* As such data are accumulated, it will be interesting to see where else this particular technique is found in Raphael's own paintings, and also in his pupils', among other painters in Italy, and elsewhere. It has been noted, for example, in Jan van Scorel.[3] We can foresee new life for the game of studying and tracing influence. The same danger is associated with the search for new documents in the archives; many finds, alas, only confirm what we already knew.

Another danger is to document elaborately some phenomenon to which the most appropriate response would seem to be: so what? Enumeration of *pentimenti* discovered by x-radiography often strikes me this way. The usefulness of *pentimenti* in establishing the priority of one version over another is beyond dispute, but the fact that the painter changed his mind and repositioned two toes does not always warrant mentioning. We must keep in mind, however, that the scientist's task differs fundamentally from the historian's. It is the former's responsibility to report; it is the latter's to interpret. Interpretation must be more selective than reporting, but in the early stages of any new methodology it is difficult to anticipate what will prove to be useful. Those paleographical pioneers of the past century, in their first sweep through the archives, passed over many documents that have since proved valuable.

The papers gathered here reflect the newness of this kind of enterprise. They examine many different questions from many different angles without the discipline that older methodologies have developed. They reflect another aspect of its newness, the excitement of working on the frontier and exploring new terrain.

WE are indebted to a number of people and institutions for their help with this project. Dolf van Asperen de Boer has served as consultant through all the stages. Kathleen Weil-Garris Brandt, Frederick Hartt, Henry Millon, and Craig Smyth made important contributions to the conference as chairmen and commentators.

The arrangements at Princeton for the complex logistics, accommodations, audiovisual and printed presentations, and all those other important things that make a conference a success, were handled by William O'Brien and his excellent staff in the Con-

[3] Molly Faries, 'Some Results of the Recent Scorel Research: Jan van Scorel's Definition of Landscape in Design and Color,' in *Color and Technique in Renaissance Painting*, ed. Marcia B. Hall, Locust Valley, 1986, note 14, citing other instances of this structure.

ference Office. Patricia Tindall and her staff in the Department of Art and Archaeology dealt with the correspondence, invitations, and editing problems throughout this undertaking. The editing of the text was accomplished by John Shearman, who was ably assisted by Meredith Gill, Luisa Judge, and Linda Klinger. In editing the illustrations and preparing this introduction, I was assisted by Lesa Mason.

For financial support we wish to thank the National Endowment for the Humanities for a generous grant. Marilyn Perry for the Kress Foundation and the Swearing Corporation kindly provided the needed matching funds. The Department of Art and Archaeology has underwritten this book as co-publisher. My travel expenses to and from Princeton during the preparation stage of the conference were met by a grant from the Mellon Fund of Tyler School of Art, Temple University.

We wish finally to express our thanks to our authors and our editors, the late Christine Ivusic, Eric Van Tassel, and Charles Ault, and to the staff of Princeton University Press.

January, 1986

THE PRINCETON RAPHAEL SYMPOSIUM

1

Current Techniques in the Scientific Examination of Paintings

J.R.J. VAN ASPEREN DE BOER

BEFORE this Raphael year, 1983, very little had been published on technical aspects of his paintings. A few publications—usually related to the exhibition of a restored picture—included technical evidence.[1] Such data were on display for a limited period.[2]

In the early stages of the planning of this symposium, it was suggested that—much as had been done in the Rembrandt year, 1969[3]—more technical studies on Raphael paintings could perhaps be generated by inviting contributions from those in a position to examine important works within the Raphael group.

In the meantime, a number of museums have to a certain extent preempted the aim of this gathering by commendably organizing exhibitions and publishing catalogues on Raphael group paintings in their custody.[4] The results of scientific and technical examination are used to varying degrees in these publications and some data are illustrated.

As the author has not yet been in a position to examine scientifically a Raphael group painting himself, various methods which have been and might usefully be applied will be reviewed, illustrated by some documents taken from these recent publications.

Selection of Scientific Methods of Examination

In order to render results of scientific examination useful in art history one should concentrate on methods of elucidating the genesis (creative process, *Entstehungsvorgang*) of, or perhaps permitting distinctions between, individual paintings.

In easel paintings, established methods of surface examination such as x-radiography and infrared reflectography, together with the study of paint cross-sections, seem

[1] L. Ferrara, S. Staccioli, and A. M. Tantillo, *Storia e Restauro della Deposizione di Raffaello*, Museo e Galleria Borghese, Rome (1972–73), esp. pp. 53–56 (three cross-sections); G. Emile-Mâle et al., *La Madone de Lorette* (*Les dossiers du département des peintures*, 19), exh. cat., Chantilly (1979), Paris (1979), pp. 55–62.

[2] (F. Mancinelli), *A Masterpiece Close-up: The Transfiguration by Raphael*, Vatican City, n.d. (1980) (one x-radiograph). Cross-sections were on display during 1980 in the room in which the *Transfiguration*

was exhibited.

[3] *Symposium on Technical Aspects of Rembrandt Paintings*, Amsterdam, September 22–24, 1969; *Abstracts*, Kunsthistorisch Instituut, University of Amsterdam (1970).

[4] G. Muratore, ed., *Raphael Vrbinas. Il mito della Fornarina*, exh. cat., Palazzo Barberini, Rome (1983); D. A. Brown, *Raphael and America*, exh. cat., National Gallery of Art, Washington (1983); H. von Sonnenburg, *Raphael in der Alten Pinakothek*, Munich (1983).

by far the most appropriate.[5] There is little point in applying rather exotic analytical or instrumental gadgets to an occasional masterpiece. A large number of paintings should be examined within a group to arrive at meaningful results that can be evaluated in art-historical terms. As it is known that Raphael had a workshop, the degree of the master's own participation must be estimated. The concept 'attribution' would then seem to require redefinition. Many paintings in the group are indeed disputed or are occasionally shifted back and forth on the autograph scale. In such cases, data of scientific examination of paintings within a particular group must be compared with those obtained from works of contemporary painters. A few paintings by Raphael's presumed teacher, Perugino, have been technically examined and the results published.[6] There is so far, however, too meager a record of comparative material.

Possibly, underdrawings detected beneath paintings in the group could be usefully compared with undisputed independent drawings by Raphael, making comparison with contemporary underdrawing less necessary. However, the problem of whether and to what extent mechanical means of transferring the design onto the support, such as cartoons, were used requires further investigation.

X-radiography

X-radiographs are produced by invisible radiation with a wavelength much shorter than blue light. Primarily depending on their energy, expressed in kilovolts (kV), x-rays are capable of penetrating matter to various degrees. In the x-radiography of paintings, the energy is usually in the range of 25–50 kV. A negative in an envelope is positioned on the surface of the painting and the x-ray source placed behind it. The negative is briefly exposed and blackened by radiation penetrating the support (panel or canvas), ground, and paint layers. A superimposed image of these various components is thus obtained, and not only what is just beneath the surface (changes in composition, for example). Lead-white, vermilion, and lead-tin yellow absorb x-rays considerably. Lead-white, having been frequently used in earlier painting for modelling light areas and highlights in flesh colors, shows white in the negative. For easier comparison with the painting, these negatives are called x-radiographs.

Von Sonnenburg has shown that in the Munich *Canigiani Holy Family* much use is still made of the white ground. Lead-white is only employed in the light-receiving zones of the flesh colors.[7] In an Italian copy of that painting of about 1550 or later, the x-radiographs show dense (lead) white in the entire area of flesh colors. Raphael seems to have used somewhat more lead-white in the flesh colors than is encountered in x-radiographs of some Perugino paintings.

[5] C. Wolters, 'Naturwissenschaftliche Methoden in der Kunstwissenschaft,' *Enzyklopädie der geisteswissenschaftlichen Arbeitsmethoden*, Munich–Vienna (1970), pp. 69–91; J.R.J. van Asperen de Boer, 'An Introduction to the Scientific Examination of Paintings,' *Nederlands Kunsthistorisch Jaarboek*, xxvi (1975), pp. 1–40.

[6] D. Bomford, J. Brough, and A. Roy, 'Three Panels from Perugino's Certosa di Pavia Altarpiece,' *National Gallery Technical Bulletin*, iv (1980), pp. 3–31.
[7] Von Sonnenburg, op. cit. in n. 4, pp. 53, 72 (Figs. 82–83).

Infrared Reflectography[8]

Invisible infrared radiation of a wavelength slightly longer than red is used to reveal underdrawings beneath paint layers. Conventional infrared photography produces images of radiation between *c.* 0.7 and 0.9 microns. Red and whitish areas in the painting can usually be penetrated, but blue and green show up as black. Infrared reflectography employs a detecting system capable of imaging radiation around 2 microns. The most versatile system used to date is a professional closed-circuit television system provided with an infrared Vidicon. The infrared radiation is translated into visible light. An underdrawing, when present, can thus be directly viewed on a monitor screen and photographed. The resulting documents are called infrared reflectograms.

With this technique, even the blue and green areas in the painting can frequently be penetrated, providing a more complete image of the underdrawing. Interpretation is sometimes complicated because of interference from overlying paint layers. The underdrawing should contain carbon (for example, black aqueous paint, black chalk, charcoal) and be made on a whitish ground. Underdrawings in brown or red chalk cannot be revealed, nor can a white chalk underdrawing on a grey ground.

Infrared reflectograms usually have to be assembled into mosaics to obtain satisfactory detail of the underdrawing to be studied. Brown has published such an infrared reflectogram assembly of the Washington *Small Cowper Madonna*[9] (pl. 321) and von Sonnenburg used detail-reflectograms in his discussion of the underdrawing in the *Canigiani Holy Family*.[10]

Paint Cross-sections and Analysis of Pigments[11]

Cross-sections can be prepared from minute paint samples. Such samples, no greater than the size of a printed dot, can be removed with a thin, sharp lancet. This operation should be carried out under a stereomicroscope at × 4 – × 20 magnification after thorough preliminary inspection of the painting. Samples are usually taken near damaged areas, or from inconspicuous spots. Part of the sample is embedded in a clear, preferably cold-setting, synthetic material such as polyester. The hardened block is reduced in size by sawing and then ground with increasingly finer grades of emery paper to reveal the paint-layer structure. All these operations are frequently checked under the stereomicroscope. The section can then be studied under higher magnifications (for example, × 200) in a dark-field reflected light. The procedure is derived from metallographic techniques. The structure, thickness, pigment concentration, and so on of various paint layers can be studied. Using ultraviolent fluorescence, intermediate var-

[8] J.R.J. van Asperen de Boer, *Infrared Reflectography. A Contribution to the Examination of Earlier European Paintings*, thesis, University of Amsterdam (1970); *idem,* 'A Note on the Use of an Improved Infrared Vidicon for Reflectography of Paintings,' *Studies in Conservation*, xix (1974), pp. 97–99.

[9] Brown, op. cit. in n. 4, p. 131.

[10] Von Sonnenburg, op. cit. in n. 4, pp. 51–52 (Figs. 68–71).

[11] R. J. Gettens and G. L. Stout, 'The Stage Microscope in the Routine Examination of Paintings,' *Technical Studies in the Field of Fine Arts*, iv (1936), pp. 207–33; J. Plesters, 'Cross-sections and Chemical Analysis of Paint Samples,' *Studies in Conservation*, i (1956), pp. 110–57.

nish layers can be easily detected. Staining tests can be carried out on the cross-section to obtain an approximate assessment of the binding media in each layer.[12] Laser-beam emission spectroscopy[13] and electron microprobe analysis[14] can be applied to determine elements in the pigments of each layer in the cross-section.

Chemical analysis of pigments is usually preceded by the study of optical characteristics. Especially, blue and green pigments can be rubbed between a microscope glass and a cover glass in some Canada balsam to produce a mount. The behaviour of these pigments in transmitted light and under crossed polarizers is valuable for identification. Very small quantities of pigment are sufficient for simple microchemical tests. In some cases, x-ray diffraction analysis is required for positive identification. More complicated instrumental analyses should always be fed back to the paint cross-section of the same sample. Otherwise, one cannot determine from which layer the identified pigments came.

Nondestructive x-ray fluorescence analysis has been applied to Raphael's paintings.[15] This method is useful for pigment identification but should be correlated with the paint-layer structure. Reliable analysis of paint media, mostly through gas chromatographic methods, still requires about 1 mm^3 of paint. A combination with more approximate staining tests is required.

Von Sonnenburg showed that the robe of the Madonna in the *Canigiani Holy Family* consists of a glaze of natural ultramarine on a thick underpainting of azurite and lead-white. The blue robe of the *Madonna della Tenda* contains azurite, lead-white, brown ochre, and vegetable black on a red underpaint.[16] The inner side of the robe of the *Tempi Madonna* contains verdigris and ochre; azurite is found in the robe and the sky.

Published cross-sections from the Perugino altarpiece, No. 288 in the National Gallery, London, would seem to show a more complex structure; in the blue of the Virgin's robe, especially, three layers containing natural ultramarine were found on top of an azurite underpaint. Simpler structures were found in No. 181, the *Madonna and Child with Saint John.*[17]

It is hoped that as such data accumulate, inventories of available material can be published. This would also apply to x-radiographs and infrared reflectograms. Such technical records should be made available to qualified researchers for future consultation. Only then can scientific examination become fully useful in art history.

[12] M. Johnson and E. Packard, 'Methods Used for the Identification of Binding Media in Italian Paintings of the Fifteenth and Sixteenth Centuries,' *Studies in Conservation*, xvi (1971), pp. 145–64; E. Martin, 'Some Improvements in Techniques of Analysis of Paint Media,' *Studies in Conservation*, xxii (1977), pp. 63–67.

[13] For a brief description, see G. Thomson, J. Mills, and J. Plesters, 'The Scientific Department of the National Gallery,' *National Gallery Technical Bulletin*, i (1977), pp. 23–24.

[14] G. Elzinga-ter Haar, 'On the Use of the Electron Microprobe in Analysis of Cross-sections of Paint Samples,' *Studies in Conservation*, xvi (1971), pp. 41–55.

[15] R. Cesareo, F. V. Frazzoli, C. Mancini, S. Sciuti, M. Marabelli, P. Mora, P. Rotondi, and G. Urbani, 'Non-destructive Analysis of Chemical Elements in Paintings and Enamels,' *Archaeometry*, xiv (1972), pp. 65–78, esp. pp. 73, 75 and plate 2; S. Sciuti and G. E. Gigante, 'Analisi non distruttiva degli elementi chimici nei pigmenti,' in Muratore, op. cit. in n. 4, pp. 38–39, 74–77.

[16] Von Sonnenburg, op. cit. in n. 4, pp. 54, 99.

[17] Bomford et al., op. cit. in n. 6, p. 26.

2

The Historian and the Conservator

JOHN SHEARMAN

THIS symposium is, in the strictest sense of the word, interdisciplinary: there is a fundamental intellectual divide between our two activities, which we would do well to ponder, I think, at the outset. Most of us assembled here are curators, scientists, conservators, or historians; some of us are several of these, and that fact in itself—the fact that one person may stand comfortably across the divide—is already encouraging. Yet it remains true that across the spectrum of activities, illuminated as it may be by a common concern for the understanding of works of art, there are between the two extremes genuine differences of philosophy, of method, and of potential. There are almost no conscious positivists left among the historians, and therefore few among them will suppose, when they practise *qua* historian, that their results resemble scientific results. Indeed, the difference, about which we are more candid than we used to be, is sometimes a source of wonder to the scientist. I believe that we shall all get more out of meetings of this kind if we are frank in the recognition of a difference, because there are frequently occasions when a fruitful meeting of minds requires a lot of patience and understanding on all sides and the admission that our goals are in some respect identical, in some respects very different.

There is one more awkward matter which I feel should be mentioned at this point: that what we call 'technical evidence' is invested too often by the historian with the finality of a scientific demonstration. It is my experience, at least, that the conclusion reached in the laboratory or on the scaffolding may yield before sceptical questioning; I have in mind, for example, the reading of x-radiographs or the apparent specificity of *giornata* diagrams. And such conclusions may turn out to be as 'soft' as those of the historian, in proportion to the measure of interpretation in their makeup. It follows, I think, that we need to understand very accurately the nature and origin of the evidence presented to us, in this case as in all others. It means neither distrust nor disrespect; on the contrary, it means that the historian, whose inclination it is to use the evidence of the conservator and the scientist, needs to engage in a dialogue; passive acceptance is not enough.

My concern here is with several aspects of that dialogue. The concern, in principle, is scarcely novel; it falls to me to suggest in the case of Raphael, as has been suggested so often in other contexts, how we might work together. It is worth trying again, however, not only because the time is ripe but also because progress is slow, often disappointing. At the recent International Congress of Art Historians in Vienna, eight out of two thousand thought it a priority to attend a special session convened for the discussion of the future of the dialogue.

Many of the questions I would raise will be, happily, addressed in other papers at this symposium. My examples were chosen to be complementary to these others, and to illustrate problems that arise in the ordinary work of an historian. In the event, there has been some unforeseen overlap; one or two questions I ask are even answered here. So much the better. It must be one of the most salutary, if disconcerting, results of such a meeting if the historian learns that an hypothesis he thought floated in perfect safety is unexpectedly put to the test.

The first example of the interconnection between historical and technical understanding might be taken from the *Belle Jardinière* in the Louvre (pl. 210). There are two texts in Vasari's *Vite* describing a *Madonna* which Raphael began for unnamed Sienese patrons and then left unfinished when he went to Rome; that painting was completed by Raphael's friend Ridolfo Ghirlandaio, said Vasari, specifying the blue robe of the Virgin.[1] It was supposed in the eighteenth century, already, that the painting in the Louvre was the one described by Vasari, partly because of the 'raw and disagreeable' appearance of its blue robe and partly because—for reasons no longer known—it was once said to have come from the collection of the Sienese Filippo Sergardi into that of Francis I.[2] Milanesi, in commenting on the identification, which he believed, corrected the usual reading of the date on the *Belle Jardinière* to 1508, which is also the date when most would say Raphael left Florence for Rome.[3]

This hypothesis about the origin of the *Belle Jardinière* has proved persuasive to many, and at times it has been elevated to a fact. Its weakness, however, on its textual merits alone, ought to have caused more concern (for instance, Vasari does not say that Ridolfo's picture had passed to Francis I, who died in 1547). But the hypothesis rests more weight on a reading, uncritical in terms of condition, of the blue robe of the *Belle Jardinière*; the painting of the robe suffers not, I think, from the intervention of another artist, but from a condition which we used to call 'ultramarine sickness' but which is now, I understand, better described as a physical degeneration of the medium.[4] This opaque, greyish, blotchy effect in the blue, resulting in a formlessness that may lead in some cases to repainting of shadows, is indeed to be found in Ridolfo's paintings, but no less in the earlier work of Raphael.[5] Hence, the appearance of the robe is not logical evidence for the identification of this picture with the one mentioned by Vasari and so for a dual attribution. It ought, rather, to lead to a different speculation: that is, about the original appearance of the blue robe; if, as is both possible and reasonable, its modelling had the same tonal range as the ochre sleeve and the red dress, the plastic consistency of the whole figure of the Virgin would have made a dramatically different picture.

[1] *Le Opere di Giorgio Vasari*, ed. G. Milanesi, Florence (1906), iv, p. 328, and vi, p. 534.

[2] J.-D. Passavant, *Rafael von Urbino und sein Vater Giovanni Santi*, Leipzig (1839), i, pp. 121–22; J. A. Crowe and G. B. Cavalcaselle, *Raphael: His Life and Works*, London (1882), i, pp. 363–64; S. Béguin, in *Raphaël dans les collections françaises*, exh. cat., Paris (1983), pp. 83–84.

[3] Op. cit. in n. 1, iv, p. 328, n. 4; the date 1508 was already preferred by J.-D. Passavant, *Raphael d'Urbin et son père Giovanni Santi*, Paris (1860), i, p. 99, but it was disputed in a footnote by his editor, Paul Lacroix, whose reading, 1507, has generally been followed; see now, however, Béguin, loc. cit. in n. 2.

[4] J. Plesters, 'Ultramarine Blue, Natural and Artificial,' *Studies in Conservation*, xi (1966), p. 68.

[5] Ridolfo's *Madonna and Two Saints* (1503), in the Accademia, Florence, is an example.

This alternative reading of the *Belle Jardinière*—of its appearance and of its history—would be more secure if it rested not on empirical observation but upon thorough scientific examination. Having raised this issue, however, I would like to take it farther, to make of it a larger historical question. I observe what looks to the naked eye like the same pseudo–ultramarine sickness affecting blues in Netherlandish painting between the Van Eycks and Rogier van der Weyden, on the one hand, and Gossaert on the other, and in Italian painting in a distinct group including Leonardo, Fra Bartolomeo, Albertinelli, and Andrea del Sarto, as well as Raphael and Ridolfo. Do we witness here a tradition in which a Netherlandish technique of oil painting with lapis lazuli, in the long term vulnerable, passed into Italian painting? In that case, it passed at about the moment of the *Benois Madonna*, that is, about 1480. If the question is not misguided, the scientist can in the long run help the historian towards a reformulation of considerable historical consequence.

We can start again with another historian's hypothesis which has had wide circulation. It was, I think, Oskar Fischel, writing before the Second World War, who first suggested that the *Donna velata* in Palazzo Pitti (pl. 100) was not originally a portrait, but a *Saint Catherine*, her attributes subsequently painted out.[6] He based his reconstruction on an etching by Wenceslaus Hollar, to be dated probably in 1636 (pl. 273); in that year Hollar made another print, a portrait of himself at Prague holding the etched plate, and from this we learn that the model for the etching was a painting in the Arundel Collection attributed to Raphael.[7] Now this hypothesis, too, has its inconsistencies, and it should have been more critically received. Hollar, for example, never crossed the Alps, and the *Donna velata* never left Italy (its provenance is complete from the 1540s), so that the etching cannot provide direct evidence about Raphael's painting, but only about Arundel's copy. Secondly, the *Donna velata* was described in the 1540s, by Vasari, as a portrait of Raphael's mistress, not as a saint, and it appears as a portrait again in an inventory entry of 1620, still before Hollar's print. There remains a very slim chance that Arundel's copy, now lost, recorded the appearance of the original before the 1540s: that it records, in other words, an extraordinarily early transformation of a *Saint Catherine* into the semblance of a portrait. I have never been able to see any disturbance of the surface of the *Donna velata* which would suggest that this was the case, and I do not believe that the picture is in any significant degree repainted. But one x-radiograph will answer our question, and this is an hypothesis which we can test.[8]

The evidence from the laboratory must on other occasions, of course, be qualified; yet, even then, it may provide a factual commentary on our opinions. I would take, as example, the case of the *Self-portrait* at Hampton Court, which was very thoroughly examined a few years ago during a cleaning which, in the usual way, revealed a purer surface and therefore a better basis for a judgement of quality.[9] The examination clar-

[6] O. Fischel, *Raphael*, ed. B. Rackham, London (1948), p. 124.

[7] G. Pathey, *Wenzel Hollar, beschreibendes Verzeichnis seiner Kupferstiche*, Berlin (1953), nos. 177, 1419.

[8] See now Marco Chiarini's contribution below, chapter 8.

[9] J. Shearman, *The Early Italian Pictures in the Collection of Her Majesty the Queen*, Cambridge (1983), pp. 208 ff.; I want to thank Herbert Lank and his col-

ified, too, the question of the picture's format, revealing that only the top edge is original; probably the portrait should be reconstructed bust-length, with arms. But the opportunity was taken to look at a question on which several historians had expressed themselves somewhat dogmatically: to look, that is, at the status of the inscription RAFFAELLO VRBINVS on the 'buttons' of the doublet, which had been dismissed as a falsification. Now, it is often hard to say that a paint layer can *not* have been added; but it nevertheless says something if we can record, as in this case, that under microscopic examination it appeared that the pigment of the inscription had suffered all the vicissitudes of the layers beneath, and gave no sign of being alien; cross-sections showed no layer of dirt or discoloured varnish under the yellow pigment of the lettering. It remains for the historian to interpret such a result—in this case to respect the scientist's qualification and perhaps to add one of his own. For if the inscription should now be understood to be, probably, intrinsic to the picture, the latter is not, even so, by the strictest standards signed; by a convention which we must reconstruct, that kind of inscription in portraits identified the sitter, not the artist. It is by another argument—about likeness—that we might be able to say that in this case the sitter and the artist are the same.

The examination of the *Self-portrait* at Hampton Court also brought new material to our notice; the then relatively new technique of infrared reflectography made visible an underdrawing of remarkable strength and decision, but one which is nevertheless different from almost all others that I have seen. The design was transferred to the panel not by *spolveri* but apparently by pressing through the outlines of a cartoon blackened on the reverse so that it acted like carbon paper (a technique described by Vasari, who probably learnt it from Andrea del Sarto).[10] In any case, the singularity of the drawing reminds us to be cautious in our interpretations of this rapidly growing corpus of underdrawings, for the record of other newly applied sources of evidence—from costume history, for example—suggests that we shall at first interpret it clumsily and simplistically.

If it were possible to satisfy our curiosity systematically in the laboratory, rather than to build on evidence piecemeal over a long period, it would be possible to open up major issues—as major, for example, as the issue of Raphael's training. Perhaps it needs to be said that there *is* a problem here; there is as yet no evidence fit for a court of law which shows that he was Perugino's pupil, or anyone else's. The new techniques of cross-section analysis and medium analysis, if applied to Raphael's very earliest works (not the *Mond Crucifixion*, therefore, but the *Trinity* standard at Città di Castello)—such techniques ought to suggest rather clearly whether he looks like an artist taught to paint in Perugino's studio just before 1500, or not. The scientist, however, might never guess from a reading of the literature that there was a question worth asking, and so the opportunity might not be taken, during a routine technical examination, to collect new information of this kind. And when the scientist interprets his material, he needs to know what alternatives there are, such as a training in the workshop of Giovanni Santi, which continued after his death.

leagues at the Hamilton-Kerr Institute, who conducted this examination, for their exemplary collaboration.

[10] Vasari-Milanesi, i, p. 177 (Chapter II of *Della Pittura*).

There are other situations in which the conservation-scientist needs to come with questions to the historian before he can interpret his evidence. We can take the example of dendrochronology, topical at this symposium. I have Dr. Klein's permission to make some sceptical remarks. These remarks might as well have arisen from common sense as from reading the sources and looking at panels, and they will surprise no one, except, perhaps, in detail.

New techniques, as I have said, sometimes seem at first to solve problems wonderfully—until we learn how difficult it is to use their evidence. In architectural history, dramatically revisionist conclusions about construction history are drawn from tree-ring dating, conclusions which do not allow for the re-use of seasoned and valuable timber. In the history of paintings, we can point to the required use, very sensibly, of old wood, as in the 1575 contract for Barocci's *Madonna del Popolo* in Arezzo, which was to be painted 'in tabulis ligneis antiquissimis, stabilibus et firmis . . .' We can use our eyes, in other cases, to see that this happened. The very large panel of Fra Bartolomeo's Gran Consiglio altarpiece of 1510–12 is made up of planks which had already split, and were then repaired with 'butterflies,' before painting was begun. The same may be seen in a large *Madonna* by Francesco Salviati; in this case, the panel is almost entirely composed of an exceptional single width of poplar, 80 cm across and of flawless quality, and this wood, too, had seasoned, and had been stabilized with 'butterflies,' before it was painted.[11] I think that we need to accumulate documents and surviving cases like these from historical research in order to collaborate in a realistic assessment of scientific evidence, and in most places I believe that this is well recognized. We already know that dendrochronology will not on its own solve all our dating problems, even in the case of a well-disciplined wood like oak; but it will be, like the identification and dating of a watermark in the study of drawings, one important factor to be made part of a more complex judgement.

Another document about an altarpiece by Barocci can serve to introduce a collaboration of a more creative kind. I want to suggest that there is a kind of history which we can write together: for want of a better name, let me call it 'technical history,' which means, more simply, what happened to works of art. I became interested in a problem concerning canvas painting when I had the privilege of working with a very old collection, the English Royal Collection, which has conservation records over an exceptionally long period. And there I was struck by the frequency with which canvasses, now lined and mounted on stretchers, had been lifted from wooden panels.

The document in question, which has apparently been of no interest to recent historians, concerns the delivery in Perugia in 1569 of Barocci's large canvas of the *Deposition from the Cross*, which had been painted across the Apennines in Urbino; on arrival it was lined with wood at considerable expense.[12] That was a provision which clearly made much sense for the preservation of such a large canvas (4.12 m); yet it seems very probable that a high proportion of canvas paintings of the fifteenth and

[11] Shearman, op. cit. in n. 9, p. 216.
[12] W. Bombe, *Federico Barocci e un suo scolaro a Perugia*, Perugia (1909), p. 18: a payment to 'Girol- lamo di Bastone per haver fodrata di tavole la pittura in tela della Tavola del deposto di croce alla nostra cappella . . .'

sixteenth centuries were to all intents and purposes panel paintings with a canvas surface.

Our colleagues in Dresden were unable to come to this symposium. I would have asked them, in case they ever reline the *Sistine Madonna* again (it has been done at least twice, the last time in the 1930s), to look very hard at the back of the original canvas. For this altarpiece, too, was delivered over the Apennines, and that is almost certainly the reason why it was painted on canvas; but when it was mounted on its altar in San Sisto in Piacenza, was it set on wood? There might be the imprint of planks or grain to prove it, but, paradoxically, the absence of any mark might make the same point. The *Baldassare Castiglione* is known to have been mounted on a panel until the eighteenth century, and probably it was so from the beginning; and when this portrait was recently relined, the back of the original canvas was found to be immaculate: not only exceptionally clean and unstained, but also innocent of all inventory numbers or other marks. An altarpiece of which the same is true is Parmigianino's *Conversion of Saint Paul* in Vienna;[13] but it must be said that in such a case a clean back is not infallibly a sign of original mounting on panel, for a large canvas was sometimes doubled, sewn round the edges like a sack.[14]

The question is complicated further by evidence of lining canvas with wood as a conservation technique of the seventeenth century. Nevertheless, it is not in doubt that the practice was common by the late Quattrocento; it is known from inventory descriptions that Botticelli's *Minerva and the Centaur* (or *Camilla*) was set on wood, as his *Saint Thomas Aquinas* in the Abegg Stiftung still is. Giorgione's *Laura* is another example. Now, it seems to me interesting to pursue this question because, if it should turn out that most early canvas paintings were also panel paintings, we might better understand the general change from wood surface to canvas surface after about 1480: the change, from the point of view of the artist, would be slight except in the matter of surface, its texture and absorbency.[15]

The *Baldassare Castiglione*, as is now well known, turned out to have a black-painted edge which was original. These black edges have been observed surprisingly commonly on paintings of the period, and we need to be sure in more cases that they are not later additions. Have they been wrongly removed? This matter has a certain interest because the black edge is almost certainly to be interpreted as a practical reaction to a (broadly speaking) new system of separating frame from painting: it copes tidily with the problems of slight movement and a visible gap between paint surface and frame. The history of framing is interesting and important, and the historian needs all the help he can get; but the conservator, for his part, needs to be asked specific questions if he is to make his contribution to a fuller understanding.

I will end with two pleas. The first is for greater variety in our research. At present,

[13] I owe this information to Wolfgang Prohaska.

[14] Shearman, op. cit. in n. 9, p. 19.

[15] J. Shearman, 'Le portrait de Baldassare Castiglione par Raphaël,' *La Revue du Louvre* (1979), pp. 261–62; G. Emile-Mâle, 'La restauration du tableau,' ibid., pp. 271–72; A. Lautraite, in *Raphaël dans les collections françaises*, exh. cat., Paris (1983), p. 431.

collaboration is proving conspicuously successful in two kinds of enquiry: punch marks, and infrared reflectography. The accumulation of data from cross-sections and medium analysis is also beginning to produce real results. There are, however, many other ways as yet unsystematically explored. And the second request would be, in fact, for more systematic examination, perhaps for a set of routine checks when a picture comes in for treatment. I have suggested that the state of the back and edges of a canvas can be important, but it is not even the case that the authenticity of the existing format will always be investigated, or that woods, pigments, and media will always be identified. I hesitate to ask that an historian always be consulted because I am conscious of a weakness in my case: the benefits mostly flow in our direction.

3

Technical Aspects of Some Paintings by Raphael in the National Gallery, London

JOYCE PLESTERS

WHEN Professor John Shearman invited me to contribute to this symposium, he suggested that in presenting data on the National Gallery's Raphaels I should attempt to show "the state of the art" of scientific and technical examination of paintings.

We have to face the fact that, despite advances in science, it is still the exception rather than the rule for a painting to have undergone more than the most cursory scientific or technical examination. This is the case in some of the world's greatest galleries. Even in those with well-equipped scientific laboratories and conservation studios, opportunities for examination are of necessity limited. There are a number of practical reasons why this is so. It is virtually impossible to make a proper technical examination of a picture hanging in the gallery. It must be moved to a place where there is adequate, preferably studio-type, lighting, and where there are facilities for magnification, x-radiography, infrared and ultraviolet examination. Any techniques involving sampling are really only feasible in association with treatment, usually that which includes removal of old varnish and repaints. Collaboration of the art historian or curator, the restorer, and scientist is desirable if the maximum amount of information is to be derived from the exercise. While all parties would agree that sampling should be kept to the minimum, and in the case of some paintings of small size or in perfect condition may not be permissible, some curators and restorers are notably less keen than others on employing sampling techniques, or indeed any scientific method of examination.

Different institutions and individuals have available to them different methods, or they may choose to specialise in a particular one. Techniques of examination and analysis change and develop rapidly or are superseded by entirely new ones, but once a picture has undergone conservation treatment, has been retouched, revarnished, reframed, and put back on exhibition in the gallery, it is very difficult to justify further sampling so as to take advantage of improved methods of analysis. With a large altarpiece, for example, there may even be reluctance to remove it from exhibition for 'nondestructive' methods of examination such as x-radiography.

The author would like to thank colleagues in the National Gallery for assistance in examination of the paintings discussed: Dr. J. S. Mills for medium analysis by gas chromatography and mass spectrography; Mr. R. White for high pressure liquid chromatography of dyestuffs of lake pigments; Dr. A. Roy for laser microspectrography and x-ray diffraction analysis; Mr. D. Bomford for infrared reflectography. Grateful thanks also to Mr. C. Gould, former Keeper of the National Gallery, for his help and encouragement over many years.

As a result, technical data available vary from one picture to another both in quantity and quality, a point well-illustrated by a brief survey of the nine paintings attributed to Raphael in the National Gallery collection. Of these, the *Procession to Calvary* (No. 2919), which is a predella panel of the *Pala Colonna* in the Metropolitan Museum of Art, New York, is in excellent condition but seems never to have undergone conservation treatment since its acquisition by the National Gallery in 1913. For this reason, no samples have been taken and not even an x-radiograph exists. Whereas it is often the pictures in worst condition which are subject to the most intensive technical examination, this has not been the case with another painting, the so-called *Madonna of the Tower* or *Mackintosh Madonna* (No. 2069). It is known to have been transferred from panel to canvas in the eighteenth century, and x-radiographs confirm early reports of the disastrous consequences. So far, its overpainted and ruined condition has discouraged any further attempt at cleaning and restoration, or even further examination beyond x-radiography, but if treatment were to be contemplated, this picture would certainly be a candidate for full-scale technical investigation.

The seven paintings on which results of examination are reported, will be dealt with in roughly chronological order, with one exception, a new (1983) acquisition which has benefited from the application of some very recently introduced analytical techniques. The provenance, history, and iconography of the pictures (apart from the last-mentioned) are discussed in detail in Cecil Gould's *Catalogue of the Sixteenth Century Italian Schools*,[1] so will be touched on only briefly here.

No. 213 *An Allegory* (*The Vision of a Knight*) (pl. 1)

Support: Wood, identified as poplar (*Populus* sp.) by microscopical examination. Single piece of wood, grain running vertically with respect to the pictorial composition.

Dimensions: 6¾ in (0.171 m) square. Painted up to the edges, but the composition seems not to have been reduced in size since a trace of a line of gold which may represent the gilding of the original framing runs along the extreme edges.

Date: Usually considered to be early, that is, *c.* 1500, but an alternative dating of *c.* 1504–5 has also been suggested.

Condition and history of conservation: No treatment since entering the collection in 1847. The picture appears from the surface and from the x-radiograph to be in excellent condition apart from a retouched loss in the skirt of the dress of the woman on the right. The surface is somewhat discoloured, but greyish rather than yellowed.

The measurements of the tiny panel correspond to those of the panel of *The Three Graces* in the Musée Condé, Chantilly (pl. 2). The back of the panel of *The Vision of a Knight* has been thinned down to a thickness of about 3 mm on the right-hand edge, tapering to about 1.5 mm on the left-hand edge. The back has been crudely planed and

[1] C. Gould, *National Gallery Catalogues: The Sixteenth-Century Italian Schools*, London (1975), pp. 207–23.

a wooden framework like the stretcher of a canvas painting has been glued on to reinforce the thinned-down panel. It has been suggested that the Chantilly *Three Graces* might have formed either the reverse of the same panel as the *Allegory* (*The Vision of a Knight*) or else a diptych with it. It should be possible, by comparing closely the backs and edges of the London and Chantilly panels, and also their x-radiographs, to tell whether they originally comprised the front and back of a single thick panel, which would seem reasonable since small wood panels by Raphael which have not been reduced in thickness are usually of the order of 1.5–2 cm. (No. 6480 *Saint John the Baptist Preaching*, the recently acquired predella panel of the Ansidei altarpiece, is an example.) There would, however, still remain the other possibility of the two paintings having been carried out on two separate thin planks cut as consecutive slices from the same tree before being put into use as painting panels. The difference in scale of the figures in the *Allegory* from those of the *Three Graces* would seem to be an argument against the diptych hypothesis.

Ground: Included in the single paint sample so far examined (see below). It is white and was identified as gesso by chemical microscopy only, x-ray diffraction powder analysis not being available at the time, so the crystalline form of the calcium sulphate was not determined.

The paint: A single fragment of paint was taken from the blue of the sky in the extreme top right-hand corner. The single blue paint layer consisted of lead-white with a few scattered particles of natural ultramarine. Solubility tests indicated that the medium was proteinaceous and little affected by water even with warming, indicating an egg-tempera medium rather than animal glue. Unlike a drying-oil medium, it was affected only slowly by aqueous solutions of caustic alkalis. The identification of egg tempera could not be confirmed, as gas chromatography was not yet available as a routine method for identification of paint media.

The x-radiograph of the painting (pl. 195) showed no notable *pentimenti*. It confirmed the excellent condition of the picture, apart from the small paint loss near the hem of the overskirt of the woman on the right, which has been crudely retouched and the edges overpainted. From the radiograph, the picture appears to have been quite thinly painted, apart from a few highlights. Fairly sparing use has been made of lead-white in the flesh tones of faces and hands.

At the same time as the National Gallery acquired the painting in 1847, it also acquired, and from the same owner, a drawing on paper, pricked for transfer, of the same subject (No. 213A) (pl. 196). The drawing is in ink, now brown in colour. Whether it was originally black and whether it is an iron-gall ink has not been established. It has always been assumed to be the pricked cartoon for the panel painting. The design itself is the same size and scale as the painting and closely similar except in one or two small details. In the painting, the dress of the woman on the left has a square neckline with a dark border, but in the drawing a round neckline with a scalloped collar. The strings of beads of the woman on the right in the painting cross over her chest passing under her breasts, then two strands drape across her right hip, disappear-

ing beneath her left hand; in the drawing on paper, a single line of beads goes across the chest and seems to continue over the right shoulder, giving more the appearance of a bead edging on the overbodice than that of a hanging string of beads. There are also a few differences in the landscape, the most notable being the substitution in the painting, just below the arm holding the book to left of centre, of three tiny horsemen for the bridge over the river seen in the drawing on paper. Very recently the panel painting was looked at by infrared reflectography. This revealed a clear and detailed black underdrawing (for example, pl. 197, 198). The first thing to be remarked is the absence of *spolveri*, the black dots resulting from pressing powdered charcoal through the pricked holes in the cartoon. The second point to be made is that the underdrawing revealed by infrared (both by reflectography and by the infrared photograph) in the panel painting appears to follow exactly the contours of the painted composition as seen by the unaided eye; in details such as the necklines of the dresses or the substitution of the horsemen for the bridge, in which the painting differs from the drawing on paper, the underdrawing revealed in the painting corresponds to the final painted image and not to the drawing on paper (for example, pl. 199). The implication is that although the drawing on paper may well be Raphael's preparatory drawing for the painted panel, its use as a *punched* cartoon seems more likely to have been for the purpose of making a copy either of the drawing itself or of the painted panel. The fact that the composition on paper (No. 213A) corresponds in size and scale with the painted image of No. 213 would be consistent with Raphael using it to transfer the design to the gessoed panel by some means other than pouncing. P. Joannides described the technique of the drawing (No. 213A) as pen 'over stylus,'[2] though the present author can see in the drawing itself no evidence for this claim. It is possible, though, that the artist might have transferred the main outlines of the drawing on paper to his gessoed panel by laying the paper on the surface of the still-resilient gesso ground and going over the drawn outlines with a stylus. If this had been the case, evidence ought to be present in the x-radiograph of incised lines (which because filled with paint would be of a density different from the surrounding general area), but it seems not to be. An alternative method which is, like the last-mentioned, described by Vasari,[3] would have been to blacken the back of the drawing, lay it on the gessoed panel, and go over the outlines with a stylus as before, the same principle as using carbon paper. In fact, Vasari also advocated the use of an early form of carbon paper, an intermediate sheet blackened on one side and placed between the cartoon and the surface to which the design is to be transferred, thereby avoiding spoiling the cartoon drawing by pricking and pouncing. Unfortunately, the drawing (No. 213A) for the *Allegory* is stuck down on board, so at present no evidence can be gained from the back of the paper. In a work of such small scale, however, it hardly seems likely that Raphael (or even one of his pupils) would require more than a few main outlines to be transferred in order to draw an accurate copy of the design on the prepared panel.

Since this account was written the picture has been cleaned with excellent results.

[2] P. Joannides, *The Drawings of Raphael*, Oxford (1983), p. 141.

[3] See *Vasari on Technique*, trans. and ed. L. S. Maclehose, London (1907), pp. 215 and 231.

No. 3943 *Altarpiece: The Crucified Christ with
the Virgin Mary, Saints and Angels* (pl. 5).
(For brevity to be referred to below as
The Crucified Christ.)

Support: Wood, identified as poplar (*Populus* sp.). Six (?) vertical members.

Dimensions: 110½ in × 65 in (2.807 m × 1.65 m), arched top.

Date: 1503, from the inscription above the Gavari altar, for which it was painted, in the church of S. Domenico, Città di Castello.

Two small panels depicting scenes from the life of Saint Jerome, one in the Museum Nacional de Arte Antiga at Lisbon, the other now in the North Carolina Museum of Art, are likely to have been part of the predella.

Preparatory drawings on paper: Some figure studies, both in ink and silver-point have been associated with the altarpiece and are discussed by Gould. No compositional drawing survives.

Condition and history of conservation: From time to time since its acquisition in 1924, the altarpiece required laying of blistering and flaking paint. In 1966–67, cleaning and restoration was carried out. It was decided not to remove the cradle which had been applied some time before the picture entered the collection, but movable members were freed and the back of the panel impregnated with a wax-resin mixture to slow down passage of moisture. Removal of discoloured varnish and old retouchings revealed the paint surface to be in generally good condition except for scattered small paint losses, the most affected area being the sky below the arms of the cross.

The large size of the work and the presence of small scattered losses made it possible to take as many as thirty samples, though a number of these were primarily for investigation of suspected repaints.

Ground: Gesso (calcium sulphate identified by chemical microscopy; no x-ray diffraction analysis).

Underdrawing: Although no infrared photographs or infrared reflectograms have so far been made, a black underdrawing is in some places clearly visible to the unaided eye, as also in the panchromatic photograph of Christ's head and shoulders (pl. 200), in which outlining and some diagonal hatching of shadows is seen (no *spolveri* apparent).

Techniques of gilding and silvering: The type of gilding most often seen in paintings by Raphael (and Perugino) takes the form of linear arabesque patterns decorating the necklines and borders of garments, and these decorations are added on top of the paint.

Gold patterning of this sort occurs in *The Crucified Christ*, but for the gold sun and silver moon to left and right of the cross respectively, Raphael has used the technique, commonly seen in gold backgrounds of trecento and quattrocento altarpieces, of laying down the metal leaf on a thin coat of red bole applied to the gesso ground. This sort of gilding is usually executed before any actual painting is begun, and in conjunction with the gilding of the frame. The gold and silver of the sun and moon are rather worn and retouched. The features of the faces appear to be painted in oil-glazes, and, to some extent, this has protected the silver of the moon from becoming completely tarnished to black silver sulphide. The mordant used to stick down the gold leaf in this type of work is an aqueous one, either animal glue (often using the glue medium of the bole layer slightly moistened) or white of egg. Raphael has also used silver leaf for the inscription, now rather blackened, at the foot of the cross (the silver, initially identified by microchemical tests, has since been confirmed by laser microspectrography on the remnants of the sample) (pl. 21). Here it looks as if a small patch of silver leaf was stuck down onto the blackish-brown paint of the cross, another coat of brown paint applied over it, and finally the letters scratched through the half-dry top layer of brown paint to reveal the silver leaf beneath. This scraping through is a technique described by Cennini. Pl. 22 shows the reverse of a fragment of the brown paint adjacent to the lettering, the back of the silver leaf still bright and shiny (tin leaf is sometimes wisely substituted as being nontarnishing).

The other type of gilding used on the picture is something of an enigma. Under low magnification the gilding of the arabesque patterns on the edges of the robes in *The Crucified Christ* can be seen to be gold leaf laid on the surface (as distinct from gold paint made by mixing powdered gold with a paint medium). Both Cennini[4] and Vasari[5] describe a method of gilding with an oil mordant which could be suitable for this purpose. The mordant consists of oil (Vasari says, boiled with some varnish in it) containing pigments, such as lead pigments, which act as driers. The feature or design intended to be gilded is painted or drawn with the brush using the mordant; the pigment which the latter contains, as well as acting as a drier, enables the artist to see the design he is drawing. When the mordant is tacky, sheets of gold leaf are laid over the whole area. On drying, the gold leaf sticks firmly only to the mordant, and the surrounding excess gold can be brushed off (perhaps to be returned to the goldbeaters for recycling), leaving the design in gold. Even very thin lines and complex patterns can be executed quite accurately in gold leaf by this method. It has been identified by us in, for example, the gold outlining of the drapery in one of the predella panels from Duccio's *Maestà*, where the oil mordant constitutes a quite thick, yellowish layer between the gold leaf and the egg-tempera paint of the drapery.[6] As mentioned above, the gold arabesque patterns on the robes in *The Crucified Christ*, for example that on the hem of the green robe of the

[4] C. Cennini, *The Craftsman's Handbook, 'Il Libro dell'Arte,'* trans. and ed. D. V. Thompson, Yale (1933), pp. 96–97.

[5] Vasari, op. cit. in n. 3, pp. 249–50.

[6] J. Plesters, A. Roy, and D. Bomford, 'Interpretation of the Magnified Image of Paint Surfaces and Samples,' in *Science and Technology in the Service of Conservation, Preprints of the Contributions to the IIC Washington Congress* (1982), ed. N. S. Brommelle and G. Thomson, pp. 169–76.

saint standing on the right (pl. 23), can be seen to be gold leaf, yet not a trace of pigmented mordant is visible, either in places where the gold leaf is lost or in the paint cross-section, between the gold leaf and the dark green 'copper resinate' glaze of the robe (pl. 24). It should be mentioned that the gold decoration in *The Crucified Christ* was rather worn and retouched, but care was taken to sample, from the edge of a damaged area, what seemed certain to be original gilding. There would be no problem in making gold leaf stick to the partly dry paint film, or indeed to an unpigmented mordant, but how would the artist be able to follow his drawing of the design which he wanted to gild unless a pigment were used?

The pigments: The usual range of pigments is present, though ultramarine blue is confined to the bluest touches of the distant landscape; elsewhere, the blue is azurite.

Verdigris would seem to be the only green pigment. All samples from green or brown-green paint give a strong positive test for copper, and where green particles are visible, as in lighter green underpaint mixed with white or yellow, they have the flake-like appearance and low refractive index associated with verdigris. In samples of old paint from pictures, positive confirmation of verdigris, whether as the basic or normal copper acetate, is, however, difficult. The obvious method would be x-ray diffraction powder analysis, which should not only confirm that copper acetate is present, but also serve to distinguish between verdigris, which is the basic copper acetate, $Cu(C_2H_3O_2)_2 \cdot CuO \cdot 6H_2O$, and normal acetate, $Cu(C_2H_3O_2)_2 \cdot H_2O$. Green or browned-green glazes of the 'copper resinate' type, in which no discrete green pigment particles are visible, would not be expected to give an x-ray diffraction pattern, since any crystalline particles of copper pigment would have dissolved, wholly or partially, in the medium. However, even samples of paint in which green pigment particles can clearly be seen under the microscope fail to give the characteristic x-ray diffraction powder pattern obtainable from verdigris as the dry powder pigment. Usefully, malachite (basic copper carbonate, $CuCO_3 \cdot Cu(OH)_2$), the only other green copper pigment much used in painting before the nineteenth century, does give a clear and characteristic x-ray diffraction pattern even when present in old paint. Hence, absence of the pattern for malachite in a sample of green paint with a high proportion of copper present can reasonably be taken to imply the presence, initially, of verdigris. When the samples from *The Crucified Christ* were first examined in 1966–67, most of the pigment identification was done by optical and chemical microscopy, but recently the residue of a sample from the deeper brown-green of the distant landscape was subjected to x-ray diffraction powder analysis. The sample could be seen under the microscope to comprise an opaque yellow underpaint containing scattered bright green particles similar in appearance to verdigris, above which was a very browned 'copper-resinate' glaze. It gave only the pattern for lead-tin yellow (Type I). No pattern for malachite was present, so it may be deduced that the opaque light green underpaint is a mixture of lead-tin yellow (Type I) and verdigris (the latter not in an appropriate crystalline state to give its characteristic x-ray diffraction pattern). It may also be deduced that the now dark brown final glaze, since it contains no known brown pigment but a high concentration

of copper, is a glaze of 'copper resinate,' initially green. Whilst the foreground hillock on which the cross stands is painted in a brown earth pigment and therefore never intended to be green, some parts of the middle and distant landscape, now brown, would originally have been of quite an intense green before the discolouration of the final green copper resinate glaze with age and exposure. It seems likely, therefore, that since the values have changed somewhat in the middle- and far-distant landscape, the recessions and perspective will have changed also (similar changes have also been found to have occurred in the middle to distant landscapes of some Early Netherlandish paintings, for example, some of those by Gerard David). By contrast with the landscape, the green draperies in *The Crucified Christ* have kept their colour well, because beneath a thick, dark green glaze, which has discoloured only slightly on the surface with time, there is an opaque, bright green paint layer, the colour of which must still tell beneath the glaze (as is also the case, as will be seen below, with the green hanging which forms the background of the *Portrait of Pope Julius II*, No. 27).

In the red areas, crimson-coloured lake pigments predominate. Unfortunately, at the time the picture was examined there was no means available of identifying specifically the organic dyestuffs from which they were derived. The crimson-coloured draperies have a deep pink underpaint of lake plus lead-white which is completely covered by the crimson glaze, especially thickly in the shadows. The characteristic scarlet hue of vermilion is obvious only in the sleeves of the angel at top right, but it was also identified, rather unexpectedly, in a mixture with charcoal black and brown ochre in the dark brown paint of the wood of the cross. This rather unusual mixture of pigments has also been noted by us in brown paint in pictures by Rogier van der Weyden (the paint of the gothic cupboard in *The Magdalen Reading*, No. 654, and that of the wooden window-shutter in *Saint Ivo*, No. 6394).

A notable feature is the use of delicate lavender and grey tones in Saint Jerome's robe which, perhaps rather incongruously for the saint depicted, give the appearance of rich silk or satin. The subdued purplish shades are composed of mixtures of lead-white, crimson-coloured lake pigment, and azurite. A paint cross-section of a sample from the lighter part of Saint Jerome's sleeve is seen in pl. 25. When ultramarine blue is combined with crimson-coloured lake pigments, a clear purple colour is produced, but if azurite, which is just slightly on the green side of pure blue, is substituted for ultramarine, the result is a more 'aubergine' shade of purple. It occurs in the dark shadows of Saint Jerome's robe. When reduced by addition of white pigment, the mixture gives rather muted mauve tones. The same shades resulting from the same pigment mixture are often encountered in Early Netherlandish School paintings, for example, in drapery in altar panels by Memling. In the case of Early Netherlandish painters, these shades are more likely to result from the need for economy in the use of ultramarine, rather than positive striving for a particular colour effect, though this could also be the case in some of Raphael's early works, in which ultramarine is often sparingly used. Saint Jerome's robe in *The Crucified Christ* is modelled and shaded with such care and subtlety that it is difficult to believe that the choice of colour was not a deliberate one, but perhaps the artist was making a virtue out of necessity. The near-black cloak of the

Virgin on the far left also has the appearance of silk or satin, and the shimmering purplish highlights contain both azurite and lake.

Lead-tin yellow provides the brightest yellows. In 1966–67, when the picture was first examined, lead-tin yellow was verified by x-ray diffraction powder analyses kindly carried out by the Department of Mineralogy, British Museum (Natural History). The National Gallery did not then have the necessary apparatus on the premises. At the time, two samples of yellow pigment were analysed, one from the pale, almost lime yellow of the lights of the striking pink and yellow changing drapery of the kneeling female saint to the right of the cross, the other from a highlight of the golden yellow drapery of the flying angel to the right of the cross (the darker shade of this drapery is yellow ochre). Both samples proved to be lead-tin yellow (Type I, Pb_2SnO_4), the most commonly occurring of the two crystalline forms described by H. Kühn.[7] The difference in colour between the highlights of the two different draperies from which the samples were removed is probably more apparent than real, dependent on contrast with adjacent colours, although lead-tin yellow does vary somewhat in depth of colour according to mode of preparation. The copy of *The Crucified Christ* which was painted to substitute for the original when the latter was removed from the church of S. Domenico at Città di Castello in 1810, was cleaned for a Raphael exhibition held in the town's museum in 1983.[8] A full-size copy on canvas, it must have been painted at a time when the original was to some extent obscured by discoloured varnish, for even after cleaning, the colours are still rather subdued. The bright pink and lemon changing drapery of the kneeling female saint which so catches the eye in the original painting, is rendered in the copy in a single tone of dullish warm yellow, which looks like yellow ochre.

The paint medium: The cleaning and restoration of the altarpiece in 1966–67 fell just within the period when gas chromatography came to be used in the National Gallery Scientific Department as a reliable routine method for analysis of binding media of paintings. This was only after some years of preliminary research by J. S. Mills on the possibility of applying it to very small samples of aged paint from pictures.[9] The ratios of the fatty acids present, as determined by gas chromatography, showed that the medium of two of the samples, from the brown foreground and from the green robe of the saint on the right, respectively, was linseed oil, while the medium of the third sample, from the blue sky, was walnut oil. Walnut oil was recommended in preference to linseed oil by Vasari because 'it is thinner and does not yellow,' and recommended by some later authors specifically for use with blue and white pigments because it yellows less than linseed oil.[10]

[7] H. Kühn, 'Lead-tin Yellow,' *Studies in Conservation*, xiii (1968), pp. 8 ff.

[8] *Raffaello giovane e Città di Castello*, exh. cat., Città di Castello (1983–84), pp. 194–95.

[9] J. S. Mills, 'The Gas Chromatographic Examination of Paint Media. Part I: Fatty Acid Composition and Identification of Dried Oil Films,' *Studies in Conservation*, xi (1960), pp. 92–107.

[10] Cennini speaks only of linseed oil, but Leonardo in his *Trattato* describes in detail the extraction and purification of nut oil from walnuts. Later Italian authors such as Borghini (*Il Riposo . . .*, Florence, 1584) and Armenini (*De' veri precetti della pittura . . .*, 1st ed., Ravenna, 1586), often mention nut oil as preferable to linseed for all colours, provided it can be obtained, but in any case preferable for whites and blues

The layer structure: The paint is applied in moderately thin, flat layers on the smooth, flat surface of the white gesso ground. Considerable use is made of glazing techniques, particularly in the draperies. Some samples from the landscape and foliage show three superimposed paint layers, a light yellow-green underpaint, the principal opaque green paint layer, and a final 'copper resinate' type glaze which may have discoloured to brown to a greater or lesser extent. A single sample was taken from one of the dark-coloured translucent wings of the flying angels, from which it could be seen that a brilliant blue-green glaze runs into a deep crimson glaze. Similar colour effects occur in the wings of the Angel Raphael in one of the three panels, now in the National Gallery (No. 288), from Perugino's altarpiece for the Certosa of Pavia. In both cases, the feathers of the dark-toned, translucent wings are delicately outlined with gold. There are other parallels to be drawn. For example, in neither altarpiece does the flesh have green undermodelling, although this does occur in some of Perugino's earlier panel paintings, such as the small *Virgin and Child with Saint John* (No. 181). Raphael's *The Crucified Christ* cannot have been painted more than a few years after Perugino's altarpiece for the Certosa of Pavia. Vasari's remark on *The Crucified Christ* comes to mind, to the effect that unless Raphael's name had been written upon it, no one would believe it to be his work, but rather the work of Pietro (Perugino).[11]

No. 168 *Saint Catherine of Alexandria* (pl. 7)

Support: Wood, probably poplar (judging from the x-radiograph), but microscopical identification not so far carried out; single plank, unusually only about half an inch thick, but does not seem to have been thinned down at a later date.

Dimensions: 28³⁄₁₆ in × 21³⁄₄ in (0.715 m × 0.557 m).

Date: On stylistic grounds, judged to be *c.* 1507 (end of Raphael's 'Florentine Period'?).

Preparatory drawings on paper: Some sketches for the figure are in the Ashmolean Museum: an actual-size cartoon in black chalk with white highlighting, pricked for transfer, is in the Louvre.

Condition and history of conservation: The picture was purchased in 1839; in 1855, Eastlake remarked in his notes in the Manuscript Catalogue that it had not been varnished since it entered the Gallery, but presumed that it must have been varnished prior

because it 'is less yellow' or 'becomes less yellow' and is 'thinner' (*più sottile*). It is likely that its greatest advantage over linseed oil was that it does tend to yellow less than linseed during the early stages of drying (that is, over a matter of some weeks or months). In the course of medium analysis of Italian paintings in the National Gallery, London, walnut oil has been identi-

fied quite frequently. A statistical analysis of results so far available, made by J. S. Mills (*National Gallery Technical Bulletin*, iv [1980], pp. 65–67) showed a predominance of walnut oil before 1520 and of linseed oil after that date.

[11] *Le Opere di Giorgio Vasari*, ed. G. Milanesi, Florence (1906), iv, p. 318.

to then with mastic. It is in good condition, apart from a small split in the panel. When it was examined before cleaning and restoration in 1967, it was found to have suffered only a few small paint losses. Removal of the varnish and old retouchings at that time proved to be a straightforward operation, and the only samples taken were a few to establish the presence and nature of retouchings and overpaint.

Ground: Gesso (calcium sulphate identified by chemical tests only) with a yellowish priming which seems to be just glue.

Preliminary underdrawing: Underdrawing is visible with the unaided eye beneath the flesh paint, and can be seen slightly better in the infrared photograph (pl. 201). No infrared reflectography has yet been done. Whereas, the drawing of the cartoon in the Louvre is executed in rather thick, black chalk lines, giving a rather soft 'painterly' look, the underdrawing visible in the painting is done in smooth, thin lines, and with no sign of *spolveri*. There is just a small amount of hatching and cross-hatching in the shadows. Gould has pointed out that the folds of drapery are more complex in the painting than in the cartoon. The cartoon also shows a knot of drapery on the Saint's right shoulder which is absent from the painting. Although there seems no doubt that the drawing on paper is the cartoon for the painting, as in the case of the *Allegory (Vision of a Knight)*, it is by no means certain that the pricking of the cartoon was done for the purpose of transferring the design to the prepared panel of Raphael's painting and not for making later copies of either the drawing itself or the painting. On the one hand, there is Cennini's instruction that, once the design has been pounced through the pricked cartoon, the dotted outline is to be reinforced with chalk, pen, or brush, and surplus charcoal from the pouncing dusted off with a feather, in which case no *spolveri* would remain, only the redrawn lines. On the other hand, *spolveri* are not infrequently seen in infrared photographs and reflectograms, proving that they can and do survive in some instances at least.

The flesh painting: The x-radiographs of *Saint Catherine* demonstrate the method of flesh painting which Raphael seems to favour in the earlier stages of his career. It is well known that, in general, white and light-coloured areas of old paintings show up white on the x-radiograph because the lead-white which they contain strongly absorbs x-rays, thereby preventing them from reaching and blackening the x-ray film. In the x-radiographs of the *Saint Catherine*, however, the face appears as an almost black silhouette against the sky (pl. 202), the pale blue paint of the sky containing a high proportion of lead-white. The appearance of the x-radiograph derives from the fact that the artist painted the flesh tones in semitransparent glazes and scumbles of yellow, brown, and red earth pigments and red lake, with almost no lead-white except in the strongest highlights, such as on the white of the eye or the tip of the nose. The white of the gesso ground showing through the flesh tones provides the middle lights, and the hatching in the underdrawing contributes largely to the shadows of the flesh. The same technique is to be found in panel paintings of the Early Netherlandish School, for example in

portraits by Memling, and seems to be carried over into the Italian school by Antonello. It is interesting to find exactly the same phenomenon in paintings by Perugino, as may be seen in an x-radiograph (pl. 203) of part of Perugino's Certosa di Pavia altarpiece, *The Angel Raphael and Tobias* (the white band across the radiograph are simply old iron struts let into the back of the panel).

Although no samples were taken at the time of cleaning in order to identify the pigments or investigate the layer structure, it is worthwhile looking at the colour gamut of the painting. When it was cleaned in 1967, no very dramatic change took place, unlike the results from cleaning *The Crucified Christ*. Details appeared more clearly and the sky became slightly more blue. The colour scheme seems deliberately slightly subdued and, at the same time, warm in tone. The cloak, of a dull, golden yellow, looks more like yellow ochre than lead-tin yellow, as identified in *The Crucified Christ*. The Saint's dress is a dim lavender shade, which is akin to Saint Jerome's robe in *The Crucified Christ*, and the sleeves are moss green (which may or may not have become warmer in tone with age). The red cloak, even though its glaze is in perfect condition, has a slightly russet tone (pl. 8). It could be, however, that the landscape, including the detailed depiction of the weeds in the foreground, has suffered from browning of copper green glazes. Gold still appears, but rather inconspicuously in the linear halo and golden rays, and with great delicacy in the fine gold threads woven into the gauze scarf. The gold, which, as in *The Crucified Christ*, appears to be leaf, is somewhat worn in places, and only traces remain of the gold decoration on the black border of the neckline of the dress. The technique of application of the gold has not yet been discovered.

No. 744 *Madonna and Child with the Infant Baptist* (*The Aldobrandini Madonna* or the *Garvagh Madonna*) (pl. 3)

Support: Wood (species unidentified).

Dimensions: 15¼ in × 12⅞ in (0.387 m × 0.327 m).

Date: Usually accepted as belonging to Raphael's early years in Rome (*c.* 1509–10?).

Preparatory drawings on paper: Gould cites a number of sketches for the Madonna and both children which are contained in the so-called Pink Sketchbook in the Musée Wicar, Lille. They appear to be in silver-point on paper with a pink ground.

Condition and history of conservation: Since the picture was acquired in 1865, there have been records of repair to cracks, blister-laying, and surface polishing, and in 1921 it was reported as having been 'retouched and varnished,' but there is no record of cleaning before 1970. The condition then proved to be much better than anticipated. There were numerous, quite small scattered damages and losses, particularly in the lower half of the picture, but the discoloured retouchings on them in most cases extended onto surrounding original paint. The retouchings were removed together with a

strip of repaint along the bottom edge of the picture. Removal of greyish yellow varnish and darkened retouchings and repaint revealed remarkable luminosity and a paint surface almost like porcelain in its fineness and delicacy of texture.

Ground: Thin, very white gesso (calcium sulphate identified by microchemical tests).

Underdrawing: An infrared photograph was taken before cleaning in 1970 (pl. 204). Even though marred by the conspicuous old retouchings and repaints, it shows extremely fine and delicate drawing, so fine that it might be silver-point, like the preparatory drawings on paper. The Virgin's face is outlined in a perfect oval and is set just to one side of a vertical line marking the centre of the composition. The Christ Child's forehead shows the band-like horizontal lines defining the proportions of the face and indicating the three-dimensional form of the head. There is some meticulous hatching in the shadows, for example, on the back of the Virgin's left hand and on the fold of her skirt, which hangs from the seat. The technique of underdrawing seems quite different from that so far seen in any of the three pictures discussed above.

The x-radiograph (pl. 205) seems at first sight to present rather a confused image. This is in part due to the fact that the most conspicuous feature comprises intensely white blobs which are, in fact, seals applied to the back of the panel at various times in its history. The red pigment of sealing wax is (or was until very recent times) either vermilion (red mercuric sulphide) or red lead, both strongly absorbent of x-rays, hence the dense white appearance of such seals on x-radiographs. Apart from this, it can be seen that the flesh—while still quite thinly executed in paint containing little lead-white, unlike the *Saint Catherine* where the lead-white is confined to the strongest highlights—has the modelling carefully graduated so as to give a markedly sculptural effect to the forms in the radiograph.

In connection with the flesh painting, it was also noted that whereas *The Crucified Christ* displays rather yellowish and brownish tones (apart from the somewhat arbitrary pink patches on the female saints' cheeks), the flesh in the *Aldobrandini Madonna* looks brighter, yet rather cooler, in tone. Two very small samples taken from edges of damage were found to contain in one case a few scattered particles of vermilion, in the other, a little red lake pigment.

The colouring of the picture as a whole is brighter and colder than that of the previous examples, and the forms harder, giving the impression of coloured sculpture in the same sort of way as does Michelangelo's *Doni Tondo*.

At the time of cleaning, the main impetus for sampling was the investigation of the nature and extent of the old repaints, but a few samples of original paint were taken. Cleaning revealed considerable subtleties of colouring. The Virgin has a bright blue cloak, which falls from her right shoulder and lies across her lap, and an underdress, also bright blue, the billowing neckline and sleeves of which contrast vividly with her crimson overdress. Both the blue of the cloak and that of the underdress are based on very high quality natural ultramarine, brightened and lightened with the addition of a little lead-white, but the blue of the underdress is slightly differentiated from that of the cloak by the addition of red lake pigment to give a slightly mauvish tone. Pl. 26 shows

a photomicrograph, at × 150 magnification, of the top surface of a fragment of the blue paint from the Virgin's sleeve, the blue particles of ultramarine mixed with pink lake pigment in a matrix of lead-white. In contrast with the draperies of *Saint Catherine*, which have a rich, sombre appearance partly due to the use of more sombre colours and partly due to the unifying effect of all-over glazing, the highlights of the Virgin's crimson and blue draperies have been left unglazed in the light body colour. The background landscape, in contrast to the yellow-brown (or browned) landscape of the *Saint Catherine*, is painted in cool blues and blue-greens, which prove to be azurite and malachite, combining well with the cool stone colour of the buildings. There is no sign of browned copper-resinate glazes. Perhaps there is a deliberate attempt to make the landscape accord with the cool, bright tonality of the figure group. The picture is painted with almost a miniaturist's attention to detail. As in the *Saint Catherine*, gold is used with great discretion, in the thin, linear haloes, outlining the edge of the Virgin's bodice, and in her beautifully painted green, gold, and blue striped turban.

Unfortunately, no medium analysis was carried out at the time, the picture being so small and the samples available only just large enough for microscopical examination.

No. 27 *Pope Julius II* (pl. 9)

Support: Wood, identified as poplar (*Populus* sp.) by microscopical examination; single plank.

Dimensions: 42½ in × 31¾ in (1.08 m × 0.87 m).

Date: Identifiable with a portrait of the Pope painted by Raphael in 1511–12.

Condition and history of conservation: Cleaned in 1970 and found to be in very good condition (see below). No record of previous major treatment since the picture entered the Gallery in 1824.

Preparatory drawings on paper: Sketch for the head, red chalk, Chatsworth Collection.

The picture was catalogued as by Raphael at the time of acquisition, but this attribution was soon abandoned. It was accepted as one of a number of versions or copies of the subject. Of these, the version in the Uffizi (pl. 10) seemed to have the strongest claim to be the original. It may be compared with the National Gallery's version before cleaning (pl. 11). The circumstances which led in 1970 to the National Gallery's picture being x-rayed over its entire surface have been described by Gould.[12] The x-radiographs

[12] C. Gould, 'The Raphael Portrait of Julius II; Problems of Versions and Variants; and a Goose That Turned into a Swan,' *Apollo* (1970), pp. 186–89.

showed that beneath the plain green background hanging, was a pattern of alternating crossed papal keys and papal tiaras (pl. 208). It can, incidentally, also be seen from the x-radiographs that the panel consists of a single large plank of poplar of wildly irregular growth, demonstrating the impossibility of applying tree-ring dating to this species of wood.

After cleaning (that is, removal of discoloured varnish and old retouchings) the *pentimenti* of crossed keys and papal tiaras became visible as slightly darker silhouettes on the green background hanging (pl. 12), but their form and location as seen either on the picture itself or in the x-radiographs gave no clue to their original colours. Hence, guided by the x-radiographs, a number of samples were taken to show the paint-layer structure of particular *pentimenti*. Pl. 18 shows a cross-section of a paint sample from a papal tiara, top right. From the paint cross-sections it could be seen that, beneath two layers of green paint of the background hanging as now visible, the crossed keys and papal tiaras were painted in yellow, presumably to simulate gold. The pigment is yellow ochre, chemically an iron oxide. Because iron is a much lighter element than lead, the papal motifs, though thickly painted, show dark on the radiograph, constituting a layer less absorbent of x-rays than the lower layer of opaque green paint of the background hanging, in which the green pigment is mixed with lead-white. It could be that the green paint of the background hanging settled in a thicker layer around the raised-up motifs than on top of them. By contrast, the lappets or ribbons of the papal tiaras appear light on the x-radiographs and were found to have been painted in lead-white, perhaps simulating silver.

The papal motifs appear from the cross-sections to be painted not directly on the gesso ground but over a layer of creamy white paint, which in some samples had a few red particles which would give a very pale pink tone. This suggests that the pattern of golden tiaras and crossed keys originally adorned an ivory-coloured curtain or hanging.

The microscopical and chemical examination of the samples gave no evidence to suggest that the green paint of the background was painted appreciably later than the rest of the picture. There is no sign of dirt or discoloured varnish between the green paint of the background and the layers beneath, such as might have been expected if a considerable interval had elapsed before the green background was added. In some of the paint sections age-cracks run vertically through all the paint layers to the gesso ground, suggesting that all layers dried, contracted, and cracked with age more or less simultaneously. The evidence seems to indicate that the green background was not applied by a later hand but represents a change of mind by the artist. Gould has suggested that the artist tried out the patterned background but found that it overcrowded the composition and then painted it out before it had reached a finished stage.[13] An interesting discovery was that in cross-sections of samples from the green background, both from near the right-hand edge of the picture (one from just above the sitter's left hand, the other at shoulder level where there is an odd semicircular shape in the x-radiograph), between the gesso ground and the green paint layers of the background hang-

[13] C. Gould, *Raphael's Portrait of Julius II, the Reemergence of the Original*, London (1970), p. 7.

ing, there was a thin, pale blue layer (pl. 19). It consisted of azurite and lead-white and looks typical of the mixtures used for painting blue sky. Gould has pointed out that the workshop version now in the Metropolitan Museum, New York, of Raphael's lost portrait of Giuliano de' Medici has in the background a green curtain looped up on the right to show just a glimpse of a view of the Castel Sant'Angelo with blue sky. It would seem that Raphael was experimenting with different backgrounds to the portrait of Julius II.

It was mentioned that the hidden papal motifs are painted in yellow ochre pigment presumably imitating gold. It may also be noted that gold as metal leaf or pigment is absent from the picture, the gold of the Pope's rings and of the acorn finials and gold fringe of the chair being realistically imitated in yellow paint. Indeed, gilding would appear anachronistic in so lifelike a representation, and of a sitter living at the time.[14]

The paint medium: At the time of cleaning, one sample only, from the green background, was analysed by gas chromatography.[15] It gave fatty acid ratios corresponding to walnut oil. Very recently, the residue of a sample of white paint from the surplice, also taken in 1970, was analysed by an improved technique and also found to be walnut oil. This result showing that the green hanging is in the same medium as an undoubtedly original area of the picture, supports the evidence for the alteration to the background having been carried out by the artist himself. Vasari describes the portrait of Julius II painted for S. Maria del Popolo as 'un quadro a olio.'[16]

A preparatory sketch on paper for the head of Julius II survives, as was mentioned above, at Chatsworth (pl. 206). It is in red chalk, and presumably drawn from life. It is boldly and freely executed, the modelling of the different planes of the head, face, and beard indicated by blocks of hastily drawn hatching. It is a preliminary study, not a cartoon. A pricked cartoon of the half-length figure is in the Corsini Gallery (pl. 207) but is now generally considered to be a copy after, rather than a cartoon for, the picture. An infrared photograph of the painting taken before cleaning did not reveal any underdrawing, so very recently the picture was scanned with the infrared reflectograph but with the same negative result. If there were a black underdrawing, it could fail to show in infrared because of the paint layers above, or the drawing on the gesso ground might be in red or brown pigment, which would not be picked up by infrared. The x-radiograph does in fact reveal that the flesh, unlike that of the *Saint Catherine*, is solidly laid in with a paint containing a high proportion of lead-white. The red mozzetta, though painted in vermilion with a crimson glaze of lake pigment, both of which would be expected to be transparent to infrared, has in fact several layers of underpaint, two

[14] Already *c.* 1435–36 Alberti disparages the use of gold, that is, the metal in leaf or pigment form: 'I should not wish gold to be used, for there is more admiration and praise for the painter who imitates the rays of gold with colours.' See: *Leon Battista Alberti on Painting*, translated with introduction and notes by J. R. Spencer, New Haven (1966), p. 85.

[15] J. S. Mills and R. White, 'The Gas Chromatographic Examination of Paint Media. Some examples of Medium Identification in Paintings by Fatty Acid Analysis,' in *Conservation and Restoration of Pictorial Art*, ed. N. Brommelle and P. Smith, London (1976), pp. 72–77.

[16] Vasari-Milanesi, iv, p. 338.

of which contain carbon-black particles, and these layers might block the penetration of infrared radiation to the gesso ground and underdrawing (pl. 20). The portrait is, however, one of Raphael's most painterly works, and once having made the preliminary sketch of the head from life, he might, in the same way as Titian, have chosen to develop his composition in the course of painting, as indeed the *pentimenti* in the background would suggest. The brushwork is very much freer than in any of the earlier works just studied (pl. 13).

Saint John the Baptist Preaching (No. 6480) (pl. 14) was a late inclusion in this paper, being the National Gallery's most recent Raphael acquisition.[17] It is the only surviving part of the predella of the *Ansidei Madonna* (No. 1171). The main panel of the altarpiece, painted in or around 1505 for the Ansidei family chapel in the church of S. Fiorenzo in Perugia, was acquired, together with No. 6480, in 1764 by Lord Robert Spencer. He gave the main panel to his brother the fourth Duke of Marlborough, and it remained at Blenheim until sold to the National Gallery in 1885. The predella he kept until 1799, when it passed to the Lansdowne Collection, from whence it was bought by the National Gallery in 1983. The two other scenes which would have completed the predella are lost, apparently abandoned on account of their poor condition when the altarpiece left Italy.

The Ansidei Madonna (No. 1171 *Altarpiece: Madonna and Child with Saint John the Baptist and Saint Nicholas of Bari*) (pl. 4), like *The Crucified Christ*, escaped the fate of being transferred to canvas and is still on its original wood panel. It was last cleaned and restored in 1956 when, unfortunately, only two samples were taken, one of gesso ground, the other of suspected repaint for identification. At the time, not only were facilities for examination and analysis in the Scientific Department still very rudimentary, but restorers and art historians regarded taking of samples primarily as a means of locating later overpainting and retouching. Any information about the original materials or technique of a painting was generally gleaned as a by-product from samples taken for this purpose. Moreover, the *Ansidei Madonna* was in reasonably good condition apart from cracks in the panel, and its cleaning and restoration did not present problems which needed scientific assistance for their solution. Six x-radiographs were taken, showing details of the heads of the Virgin and saints, one of the Child and one of Saint John the Baptist's legs. Nowadays, a work of this importance would merit x-radiography of the entire surface before conservation treatment, but in 1956, postwar economies and shortages still lingered. The x-radiographs confirm the generally good condition of the paint layers and reveal the flesh to be rather thinly and transparently painted.

[17] A. Braham and M. Wyld, 'Raphael's "S. John the Baptist Preaching," ' *National Gallery Technical Bulletin*, viii (1984), pp. 15–23. This article on the history, acquisition, condition, and treatment of the predella panel was published after the presentation of the present paper at Princeton.

No. 6480 *Saint John the Baptist Preaching*

By comparison with the main panel of the altarpiece, a quite intensive investigation was carried out on the predella panel before and during cleaning. Although the predella panel is so small, it was possible to take a number of samples of paint and pigment, mainly from the top and bottom edges of the painted composition where the original frame had been broken off, leaving an irregular edge of paint and ground. Also the thin, compact layers of paint and ground made it possible to obtain good paint cross-sections from exceptionally small samples for elucidation of the layer structure.

Support: Wood panel, identified as poplar (*Populus* sp.) by microscopical examination of a transverse section; single panel, tangentially cut, the grain of the plank running horizontally with respect to the painted composition; convex warp with respect to paint surface.

Dimensions: 11½ in × 21 in (29.2 cm × 53.8 cm) across the top and 20¾ in (52.7 cm) across the base; *c.* 1.5 cm thick; the painted area is 10¼ in (26.2 cm) in height after removal of added filling and repaint along the top edge in the course of recent cleaning and restoration.

Condition and conservation treatment: At the time of acquisition, the surface of the picture was greatly obscured by discoloured varnish (pl. 15). Once the varnish had been removed, it could be seen that whereas there was a strip of bare wood about 1.5 cm deep below the lower edge of the painted composition, along the top edge the original paint and gesso had been made up to fill a strip of approximately the same depth up to the edge of the wood panel. The addition had been made with putty composed of chalk (calcium carbonate) in imitation of the original gesso (calcium sulphate) ground. What proved to be browned copper-resinate glaze on the foliage of the original trees, had been matched on the added strip using a brownish green paint with an easily soluble resinous medium and a pigment mixture which incorporates synthetic ultramarine (invented 1828) and the green pigment viridian (hydrated chromic oxide, $Cr_2O_3 \cdot 2H_2O$), first prepared in 1838, in mixtures with brown pigment. This repaint had been extended over much of the foliage of the original trees and additionally to some of the landscape, such as the hillock on which John the Baptist stands, and even had been used to tone down the original bright and well-preserved greens of the costume so they should 'harmonize' with the browned glazes of the background trees. The filling and repaint along the top edge was removed, as was also the later repaint covering original paint. Pl. 16 shows the picture at this stage before any inpainting of losses. Pl. 14 shows it after restoration.

 After removal of infilling and repaint from along the top of the panel, there was revealed a narrow ridge of gesso ground and paint such as already existed along the bottom of the pictorial composition and which is associated with a painting being executed whilst in a frame (either temporary or permanent). Along both top and bottom

ridges were found traces of gold leaf and red bole, and microscopical examination of samples revealed that both gold and bole layers were applied to the gesso ground but continued for a little way under the paint layers of the pictorial composition. It would be in accordance with fifteenth-century practice to assemble a panel in its frame and apply gesso, bole, and gold leaf to frame and panel in a single operation before actual painting was begun. This practice continued, presumably, into the early sixteenth century, even when gold leaf backgrounds for altarpieces had become old-fashioned and were ceasing to be done. The untrimmed edges of the leaves of gold applied to the frame would have extended slightly onto the panel surface but would have been concealed in the course of painting the picture itself. On the short vertical sides of the predella panel there is no raised-up ridge of paint and gesso and no trace of gold leaf or bole. Also, whereas the two horizontal edges of the plank are planed smooth, the vertical edges have been roughly sawn, apparently after the ground and paint had become hard and brittle, since both paint and gesso are chipped. Down both vertical edges runs a narrow, painted black border with traces of orange-red paint, which might represent some sort of decoration. It was thought at first that these black borders might have been original, and, indeed, they must be quite old, for the paint of the foliage of the trees beneath the black border can be seen from paint cross-sections to be much less browned than the exposed areas, and the azurite blue of the sky has escaped varnishing. The matter was settled by the x-radiographs, in which losses and flaking of the original paint down the vertical edges of the composition are visible under the black borders. Beneath the black borders are incised vertical lines which may have been drawn to demarcate the three separate scenes of the predella. It would not be unusual for the predella of an altarpiece to be painted on a single horizontal plank, the separate scenes divided by vertical bands, either painted or as parts of the fixed frame. What seems likely to have happened is that when the altarpiece was dismembered, the original gilded and attached frame enclosing the three predella scenes was wrenched off, leaving traces of its original gilding along the horizontal edges of the painted compositions, and the three panels were divided by making rough vertical saw cuts. The order of the operations cannot be ascertained. Apparently, only the *Saint John the Baptist* panel was saved.

The ground: A single thin layer of white gesso; x-ray diffraction powder analysis identified the white inert as pure gypsum (calcium sulphate dihydrate, $CaSO_4 \cdot 2H_2O$). Of the rather limited number of analyses by this means of gesso grounds of Italian panel paintings, gypsum has occurred more frequently as the white inert of Venetian School paintings, whereas Florentine and Sienese School paintings tend to have either the pure anhydrite ($CaSO_4$) or a mixture of anhydrite with gypsum. Results are insufficient to be of statistical significance as yet, but it would clearly be of interest to have more identifications of the grounds of other paintings by Raphael and, obviously, of the main panel of the Ansidei altarpiece.

The underdrawing: Infrared, both photography and reflectography, shows some fine blackish underdrawing, mostly outlining, with a little light hatching in the shadows.

No specific sample could be obtained for identification of the black pigment used, but one or two paint cross-sections had, between the gesso ground and the paint layers, a few scattered black particles which most probably represent the drawing. These were small and rounded, unlike charcoal black, and could be either lampblack or bone black (these last two may be distinguished by x-ray diffraction from the presence of calcium phosphate in the bone black only, but this can be done only if a separate sample of the black pigment can be obtained, as is the case from a black paint layer, as distinct from drawing lines). The drawing is particularly well seen, even to some extent with the unaided eye, in the figure of Saint John (pl. 209), whose flesh and cloak are thinly painted in red lake pigment, which is transparent to infrared.

The flesh painting: As in the other pictures by Raphael considered above, green un-dermodelling is absent. In common with *The Crucified Christ* and the *Saint Catherine*, the flesh is thinly and translucently painted, mainly in ochre pigments with a little ad-mixture of lead-white, which is evident in x-radiographs. The white of the gesso ground and the hatched shadows of the underdrawing contribute to the modelling. Raphael also does quite a lot of drawing with the brush on top of the forms; this is clearly seen in the group of babies playing in the foreground (pl. 17).

The pigments: The range of pigments was the same as that found in *The Crucified Christ*. Azurite was identified as the blue in the sky and the distant landscape and the blue robe of the figure at extreme left. Ultramarine was present in one sample only, the more pink-toned, violet colour of the tights of the figure second from the left (a sample was possible from the extreme bottom edge of the painting), where it was mixed with crimson-coloured lake pigment and lead-white. In a slightly different shade of mauve of the hat of the extreme left figure, azurite was substituted for ultramarine in a similar mixture. Before the picture was cleaned, it was impossible to distinguish these nuances of colour or to appreciate that the tights of the fat man with the yellow jerkin were intended as grey (which proved to be a mixture of charcoal and lead-white that pro-duces a bluish grey). The artist's interest in mauve and mauve-grey tones was also dis-played in *The Crucified Christ* and the *Saint Catherine*. All the green areas in *Saint John the Baptist Preaching* seem to be based on verdigris, in opaque paint layers mixed with lead-tin yellow, Type I (as in similar samples of green from *The Crucified Christ*, and likewise giving an x-ray diffraction pattern only for lead-tin yellow). Glazes are in 'cop-per resinate,' very well-preserved in the deepest shadows of the greens of the costumes, where not only is there opaque bright green underpaint, but the green glaze itself is only slightly discoloured at the very top surface. Unfortunately, the glaze on the foliage of the trees in the background has discoloured badly. Pl. 27a is a photomicrograph of the top surface of a fragment of paint from the brown foliage of the tree at top centre showing the discoloured glaze on top of bright green opaque underpaint. Pl. 27b is the reverse of the same flake of paint. Pl. 28 is a cross-section of the same sample showing the intensely browned green glaze over bright green underpaint over the blue paint of the sky. The feathery sprays of foliage toward the edges of the trees are painted in the

copper-resinate glaze directly on the blue paint of the sky without any opaque green underpaint, and these have lost their green colour totally. The landscape, like that in *The Crucified Christ*, has been glazed with copper resinate in some parts and in others deliberately left in opaque yellowish greens, so that discolouration of the glazed areas may have changed slightly the tonal values and perspective of the hillocks of the landscape. The characteristic bright scarlet of vermilion (red mercuric sulphide) was identified in the tights of the man with his back turned, left of centre, and as opaque underpaint in the middle tone of the red cloak of the figure second from the left. From a small damage in the cloak, it was possible to get a sample of the deepest red shadow, which has a thick red glaze, the top surface of which is seen in the photomicrograph in pl. 29. Thanks to the improved analytical method of high pressure liquid chromatography, it was possible to identify the dyestuff of the red lake. It proved to be lac lake (whereas a sample analysed at the same time and by the same method, from Ananias's red tunic in the Raphael tapestry cartoon, *The Death of Ananias*, was identified as madder lake). Cennino Cennini particularly recommends for red drapery lac lake, the lake pigment prepared from the resin-like protective coating of the lac insect, which was imported from Asia. He advises painters on how to recognize the genuine substance.[18] A few grains of pigment from the highlight of the yellow jerkin of the fat man on the left gave the x-ray diffraction powder pattern for lead-tin yellow (Type I) mixed with a little lead-white. It is worth noting that touches of black are used very tellingly in the costumes, as for example in the square collar of the red cloak of the figure second from left and the black borders of some of the necklines, recalling the black band round the neckline of *Saint Catherine*'s dress. Originally, there seems to have been quite a lot of gold decoration on the costumes, but it is now rather worn. The gold of the Baptist's cross and his double-ringed halo has in the past been reinforced with gold paint, but wherever there are traces of original gold on the picture it does seem to be leaf, but, again, no pigmented mordant is apparent beneath.

Layer structure and colouring: As was generally the case in samples from the other pictures discussed above, the paint is applied on the smooth, white gesso ground in thin, flat layers. Samples from the landscape displayed a slightly more complex buildup, sometimes with lead-white underpaint followed by two opaque yellow to yellow-green layers and a final 'copper-resinate' glaze, the last-mentioned suffering surface discolouration to brown to a lesser or greater extent. Some small details of the figures have been painted on top of the landscape, for example, the scarlet hat of the figure third from the left goes over the trunk of the tree in front of which he stands, but, essentially, the figures must have been drawn out in detail and the landscape painted round them. In the costumes, the lights and middle tones are for the most part left unglazed as flat, bright, rather matte areas of colour, only the shadows having glazes of the same hue but higher saturation, without addition of black or brown pigment. These patches of bright, flat colour tell much better on the small scale of a predella panel than would the

[18] C. Cennini, op. cit. in n. 4, p. 26.

deeper-coloured, fully glazed draperies to be seen in many of the large-scale figures of
the big altar panels (including *The Ansidei Madonna*, No. 1171, itself). This follows in
the Florentine quattrocento tradition of brightly coloured predella and cassone panels.
It might be remarked that the man in the green cloak seated right of centre has a pink
and yellow *cangiante* turban and matching undersleeve very like the *cangiante* drapery
of the kneeling female saint on the right of the cross in *The Crucified Christ*.

The paint medium: Three samples from the edges of the picture were analysed, one
from the blue paint of the sky left of centre and another from the black edge with the
light green landscape beneath. Both gave gas chromatograms with fatty acid ratios cor-
responding to egg. The third sample was from the foliage of the tree in the middle
background, taken from the extreme top edge where the glaze (here applied directly on
the blue sky without a green underpaint) has retained some of its original green colour,
probably because of having been until recently protected by the putty of the added strip
at the top of the panel, and earlier still by the shadow of the original frame. This sample
gave fatty acid ratios corresponding to oil, and specifically walnut oil, but there was in
the gas chromatogram a small peak indicating a trace of resin components. Gas chro-
matography combined with mass spectrometry confirmed the presence of resin com-
ponents (both methyl dehydroabietate and 7 oxodehydroabietate), which indicated
that the green-glazed paint of the foliage originally contained pine resin, presumably as
'copper resinate' mixed with walnut oil. The recipe frequently quoted for making 'cop-
per-resinate' green is that from the seventeenth-century De Mayerne Manuscript, in
which verdigris is dissolved in Venice turpentine (the balsam or liquid resin of the larch
tree) and distilled turpentine.[19] In fact, Venice turpentine, which contains a proportion
of stable ester compounds, would react less vigorously with copper compounds
(thereby dissolving copper ions to produce the green colour of 'copper resinate') than
would pine resin, which consists principally of free abietic acid.[20] Moreover, the De
Mayerne recipe does not include a drying oil, so the resulting product, unless mixed
with oil, might be expected to be soluble to some extent in organic solvents such as are
used in picture cleaning for the routine removal of natural resin varnishes. Experience
gained during cleaning of pictures fails to show that 'copper-resinate' glazes are partic-
ularly vulnerable in this respect. An alternative explanation could be found in Armeni-
ni's instruction for glazing green draperies, to add a little *vernice comune* to verdigris
already ground in oil.[21] *Vernice comune* is generally understood to be a solution of *pece
greca*, that is, pine resin (colophony) in linseed oil, as explained by Merrifield.[22] Verdi-
gris would be partially soluble at least in this mixture, and in fact there are often dis-
crete green pigment particles, similar to verdigris in colour and of low refractive index,
discernible in 'copper-resinate' glazes, even when the latter are somewhat discoloured.

[19] *Het de Mayerne Manuscript als bron voor de schildertechniek von de barok*, ed. J. A. van de Graaf, Utrecht (1958), p. 174, 'Beau Verd. Rp.'

[20] J. S. Mills and R. White, 'Natural Resins of Art and Archaeology; Their Sources, Chemistry and Iden-tification,' *Studies in Conservation*, xxii (1977), pp. 16–17.

[21] G. B. Armenini, *De' veri precetti della pittura*, Ravenna (1586), pp. 126–27.

[22] M. P. Merrifield, *Original Treatises on the Arts of Painting*, London (1849), vol. I, pp. cclxiv and cclxviii, vol. II, pp. 606 and 637.

WHAT is interesting about the results of medium analyses from this quite limited number of Raphael's paintings is that they seem to demonstrate the changeover which took place in Italy around 1500 from egg tempera to oil. They also confirm that both walnut and linseed oils were in current use at the time [23] and give substance to what has hitherto been the rather hypothetical concept of 'copper-resinate' green. It would, of course, be helpful to discover the medium of the main panel of the altarpiece, No. 1171 *The Ansidei Madonna*, and also to see whether any evidence exists for the presence of 'copper-resinate' glazes on it or on *The Crucified Christ* (No. 3943).

[23] See n. 10, above.

4

Nouvelles analyses résultantes de l'étude et de la restauration des Raphaël du Louvre

SYLVIE BÉGUIN

L'EXPOSITION *Raphaël dans les collections françaises* à l'occasion du cinq-centième anniversaire de la naissance du peintre a donné lieu à un examen approfondi des tableaux du Louvre.[1] Ceux qui, à des titres divers et à des moments différents de leur histoire, portèrent le nom de Raphaël, ont été étudiés dans le catalogue mais certains, en raison de leur état, ne purent être présentés dans l'exposition.[2] Il s'agit d'oeuvres secondaires dont la présence ne s'imposait guère: le plus souvent leur association avec Raphaël, qu'il fallait cependant rappeler, fut éphémère.[3]

Nous nous attacherons seulement dans cette communication aux tableaux du Louvre qui, dans les récents catalogues du Musée, portèrent le nom de Raphaël:[4] ainsi des oeuvres remarquables, comme le "Raphaël de Morris Moore," *l'Apollon et Marsyas,* qu'il convient sans doute, comme l'a récemment montré C. del Bravo, d'appeler plutôt *Apollon et Daphni,*[5] et le *Portrait d'un jeune garçon blond,* que nous proposons d'attribuer à Corrège, seront exclus.[6]

Nous avons volontairement choisi de parler brièvement de l'*Ange* du retable de Saint Nicolas de Tolentino récemment acquis par le Louvre, car il a fait l'objet d'une communication spéciale au congrès "*Raphael before Rome*" en janvier 1983.[7] Nos remarques porteront donc sur trois catégories distinctes de problèmes.

Dans la première nous traiterons des oeuvres récemment restaurées ou dont l'état a été jugé satisfaisant pour l'exposition; ce sont le petit *Saint Michel,* le petit *Saint Georges,* la *Belle Jardinière,* le portrait de *Balthazar Castiglione,* le portrait de *Raphaël et un ami,* et la *Jeanne d'Aragon.*

[1] S. Béguin et al., *Raphaël dans les collections françaises,* Grand Palais, Paris (1983–84); désormais cité selon les différents auteurs: S. Béguin, L. Faillant-Dumas et J.-P. Rioux, et A. Lautraite, 1983.

[2] *Portrait d'un Cardinal* (cf. Béguin, op. cit en n. 1, no. 28A et 28B), *La Vierge à l'Enfant* (op. cit. no. 29), *La Vierge à l'Enfant avec le petit Saint Jean* (op. cit. no. 30), *Sainte Catherine l'Alexandrie* (op. cit. no. 33).

[3] Par exemple la *Vierge aux balances* de Cesare da Sesto qui fut gravée sous le nom de Raphaël ou le *Portrait d'homme* saisi à Rome par les Français en 1802, aujourd'hui en dépôt au château de Fontainebleau; cf. Béguin, op. cit. en n. 1, p. 65.

[4] *Catalogue sommaire illustré des Peintures du Musée du Louvre, II: Italie, Espagne, Allemagne, Grande-Bretagne et divers,* Paris (1981), coordination par A. Brejon de Lavergnée et D. Thiébaut, Paris (1981), pp. 221–24.

[5] S. Béguin, op. cit. en n. 1, pp. 133–36. La nouvelle et fort intéressante identification du tableau est due à Carlo del Bravo, 'Etica o Poesia e mecenatismo, Cosimo il Vecchio, Lorenzo e alcuni dipinti,' *Gli Uffizi, Quattro Secoli d'una Galleria,* Convegno Internazionale di Studi, Florence (1982), p. 11.

[6] Béguin, op. cit. en n. 1, no. 37.

[7] S. Béguin, 'Un nouveau Raphaël: un ange du Retable de Saint Nicolas de Tolentino,' *Revue du Louvre et des Musées de France,* xxxi (1982), pp. 99–115; et 'The *Saint Nicholas of Tolentino* Altarpiece,' *Raphael before Rome (Studies in the History of Art,* 17), Washington (1986), pp. 15 ff.

Dans la seconde figurent des tableaux, malheureusement abîmés, qui ont fait l'objet de légères "mises en ordre" destinées à améliorer, provisoirement, leur aspect pour l'exposition: la *Sainte Marguerite*, le grand *Saint Michel*.

Pour d'autres tableaux, enfin, une restauration fondamentale a été menée à bien: il s'agit de l'*Ange*, du *Saint Jean-Baptiste*, de la grande *Sainte Famille*, de la petite *Sainte Famille* et de sa coulisse, la *Cérès*, de la *Vierge au Voile*. On peut regretter que deux chefs d'oeuvre, la *Belle Jardinière*, dont l'état de conservation paraît remarquable sous un vernis un peu jauni, et le grand *Saint Michel*, malheureusement fort abîmé, n'aient pas eu le même traitement. Pour la *Belle Jardinière*, son harmonie fut jugée satisfaisante; un dévernissage pouvait, en effet, réserver des surprises et empêcher que le tableau fût prêt pour l'exposition. Dans le *Saint Michel*, il s'agissait d'une restauration fort longue et délicate, le tableau ayant subi de très graves atteintes au cours des ans. Les dates assignées à la manifestation, puisqu'il s'agissait d'un centenaire, paraissaient incompatibles avec la réalisation d'un tel travail.

Ce bref exposé, malheureusement, est entaché d'une grave lacune: les examens spectrographiques des tableaux du Louvre manquent.

Oeuvres précédemment restaurées

Nous parlerons brièvement du petit *Saint Georges* et du petit *Saint Michel*, qui ont fait l'objet d'une communication particulière au Congrès de Florence.[8]

Le *Saint Georges* et le *Saint Michel*, restaurés en 1949, sont peints sur des panneaux de format légèrement différent. La technique, l'exécution, indiquent que l'on ne peut les situer à la même date comme certains auteurs récents l'ont pensé. Comparons, par exemple, leurs visages: celui du *Saint Michel* est volumineux, la touche plus appuyée, la matière picturale plus épaisse. Ceci rappelle la technique des oeuvres peintes en 1503 et le style des dessins pour la Libreria Piccolomini. Le *Saint Georges* a une technique plus légère, une touche plus fondue, un dessin plus élégant et plus habile; il y a, au moins, une année entre les deux tableaux. *Saint Georges* paraît avoir été fait pour être mis en pendant avec *Saint Michel*; l'exécution du *Saint Georges* le rapproche des deux tableaux de Londres et de Chantilly.

Les radiographies du *Saint Georges* et du *Saint Michel* sont également très différentes. Celle du *Saint Georges* révèle une constante dans l'oeuvre de Raphaël: la qualité de la construction de la forme par des oppositions d'ombre et de lumière. L'image est forte, évidente et élégante tout à la fois. Dans le *Saint Michel*, qui comporte de nombreux repentirs, tout est plus incertain et moins habile.

L'examen technique des oeuvres renforce donc la thèse, soutenue par K. Oberhuber, de l'écart de date entre les deux oeuvres.[9] De plus leur association, certaine, a été réalisée après coup: à l'origine, ils n'étaient pas conçus comme un diptyque. Mais ils le sont, très tôt, devenus.

[8] S. Béguin, 'Nouvelles recherches sur le *Saint Michel* et le *Saint Georges* du Musée du Louvre,' *Studi su Raffaello*, Urbino (1987), pp. 455 ff.; au sujet de ces deux tableaux, cf. aussi Béguin, op. cit. en n. 1, no. 4 et 5; Faillant-Dumas et Rioux, ibid. pp. 414–16.

[9] K. Oberhuber, *Raffaello*, Milan (1982), pp. 28, 30–31.

La *Belle Jardinière* n'a jamais fait l'objet d'une restauration fondamentale.[10] Elle a été allégée en 1949 mais ce chef d'oeuvre est encore, malheureusement, dissimulé sous un vernis jaune qui altère son éclat et masque la variété délicieuse d'exécution des différentes parties.

On a pu étudier cette année sa préparation: elle est traditionnelle: mince couche de gesso blanc contenant du sulfate de calcium légèrement hydraté sous forme de gypse et de colle animale; elle a été lissée puis recouverte d'une mince pellicule. La première couche, dite couche d'impression, ne semble pas exister. Les verts sont obtenus par un mélange d'azurite bleue et de jaune de plomb et d'étain. L'infra-rouge montre que la draperie bleue est d'une exécution parfaitement homogène et cohérente. La *Belle Jardinière* ne serait donc pas le tableau signalé par Vasari comme achevé par Ridolfo Ghirlandajo.[11] Le lapis-lazuli est pur, superposé à une couche d'azurite qui, par endroits, transparaît et donne un éclat plus dense, assombri par le vernis jaune lequel accentue, hélas, son aspect verdâtre. Les coups de brosse, rapides et expressifs, sont restés imprimés dans la couche mince du lapis-lazuli (pl. 210).

Au cours de l'examen, la date, située à la hauteur du coude de la Vierge, a été de nouveau examinée (pl. 211). Passavant l'avait lue 1508, avec raison, me semble-t-il. Au microscope, grâce à plusieurs faisceaux lumineux, j'ai pu voir d'infimes fragments de l'or du dernier trait scintiller. Observons que le point final, bien conservé, lui, est très distant du dernier trait. Il laisse donc tout à fait la place pour un trait supplémentaire, presque totalement disparu, qui permet de lire: 1508. Cette date confirme les analyses les plus récentes sur l'évolution de Raphaël dans ses grandes Madones florentines.[12]

On ne peut rien ajouter à la belle étude de J. Shearman et G. Emile-Mâle, avec la contribution d'H. Rostaing, consacrée au *Balthazar Castiglione* pour sa restauration en 1975.[13] Ils ont bien observé comment le support et la finesse particulière de la toile d'origine, encore conservée, ont certainement influé sur la technique légère et moderne de cette oeuvre (pl. 212). Cependant la présence du blanc de plomb dans la préparation du *Castiglione*, a pu faire penser, un moment, qu'il s'agissait d'un tableau transposé, ce qui est inexact. S'agit-il là d'une particularité technique qui, d'une certaine manière, rapprocherait le *Balthazar Castiglione* du *Double Portrait* qui, lui, a été transposé? L'état de conservation de ce dernier tableau est médiocre, par endroits usé et parfois repiqué (pl. 213). De grandes zones de repeints sont révélées par rayonnement ultra-violet. Le tableau fut restauré en 1972.[14]

Jeanne d'Aragon a été restaurée en 1962 et transposée de bois sur toile après 1710 car l'inventaire de Bailly la signale encore sur bois.[15] Sa radiographie est d'une lecture difficile par suite de l'opacité de l'enduit au revers. Cependant, elle apporte de précieux

[10] Béguin, op. cit. en n. 1, no. 6; Faillant-Dumas et Rioux, p. 419.

[11] Béguin, op. cit. en n. 1, no. 6, p. 83 (à propos de Vasari-Milanesi, iv [*Vie de Raphaël*], p. 328, et vi [*Vie de Ridolfo Ghirlandajo*], p. 534).

[12] Cette datation est retenue par J. Shearman, 'Raphael Year: Exhibitions of Paintings and Drawings,' *The Burlington Magazine*, cxxvi (1984), p. 401, et J. P. Cuzin, 'Peintures et Dessins,' *Revue de l'Art* 64 (1984),

p. 68.

[13] J. Shearman, 'Le portrait de *Baldassare Castiglione* par Raphaël,' *La Revue du Louvre*, iv (1979), pp. 261–72; G. Emile-Mâle, 'La restauration du tableau,' ibid. pp. 271–72; cf. aussi Béguin, op. cit. en n. 1, no. 7.

[14] Béguin, op. cit. en n. 1, no. 13; Lautraite, ibid., p. 431. Le tableau était, à l'origine, sur toile.

[15] Béguin, op. cit. en n. 1, no. 12; Faillant-Dumas et

renseignements (pl. 214). On peut y voir les jointements et les fissures des supports d'origine, comme la couture de la toile de la première transposition. Dans l'ensemble du tableau, aucune variante ne paraît décelable: les architectures ont été incisées. Cependant, au niveau du visage dont les carnations sont modelées dans des tons clairs, des repentirs, une importante transformation de l'attitude du modèle, modifient le report du carton exécuté, Raphaël le dit lui-même, par un élève.[16] La pose a été changée de telle manière que l'on distingue trois yeux et deux nez. Cette particularité, jusqu'ici inaperçue, la reprise de l'oeil et du soureil sont visibles à l'infra-rouge (pl. 215), et, me semble-t'il, la haute qualité d'exécution de cette partie que Shearman a été l'un des rares à souligner, sont à rapprocher du passage bien connu de la *Vie* de Giulio Romano où Vasari affirme que Raphaël a peint lui-même la tête de *Jeanne d'Aragon*.[17] Sa technique d'une grande subtilité, les touches fines se fondant les unes dans les autres, donne au visage un aspect lisse et nacré. Raphaël, croyons nous, innova pour se rapprocher de Léonard. Il savait que son tableau serait présenté, dans les collections royales, non loin de la *Joconde*.[18]

Mises en ordre

Certains tableaux du Louvre, très abîmés, n'ont pu être restaurés mais ont fait l'objet d'un "bichonnage," comme la *Sainte Marguerite*, c'est-à-dire que leur présentation a été légèrement améliorée pour l'exposition.[19]

Un traitement analogue a été opéré sur le *Grand Saint Michel*, signalé, comme le précédent, en mauvais état au XVIIe siècle. Selon les comptes, Primatice le restaura dès 1537–40.[20] Un détail de la magnifique tête du *Saint Michel* montre l'ampleur et le nombre des petits repeints qui recouvrent la surface du tableau (pl. 216). Cependant, l'étude du laboratoire laisse penser que, à l'exception de la partie basse très abîmée surtout la jambe droite pratiquement inexistante, la restauration de la partie haute révélera d'heureuses surprises (pl. 217). A l'infra-rouge, les traces de report du carton, hélas perdu, sont très visibles.

Oeuvres restaurées

Une restauration de type "pointilliste" (stipple technique), afin de préserver le caractère de fragment de la peinture, a été adoptée pour l'*Ange* du retable de Saint Nicolas

Rioux, ibid., pp. 421–23; L. Faillant-Dumas, 'Étude de la Technique picturale et du dessin sous-jacent de quelques tableaux de Raphaël,' *Icom, Comité de Conservation*, Copenhagen (1984), Section I: Application des méthodes d'examens.

[16] V. Golzio, *Raffaello nei documenti, nelle testimonianze dei contemporanei e nella letteratura del suo secolo*, Rome, Città del Vaticano (1936), revu et corrigé par l'auteur, Londres (1971), pp. 76–77.

[17] Vasari-Milanesi, v (*Vie de Giulio Romano*), p. 525.

[18] Nous ne croyons pas que la facture de Giulio Romano soit "maigre et sèche," comme l'écrit J. P. Cuzin (op. cit. en n. 12, p. 68), dans la partie du vêtement qu'il oppose aux vêtements du *Portrait* de Strasbourg qu'il attribue à Raphaël mais, selon nous, attribuable entièrement à Giulio. Celui-ci, dans la *Jeanne d'Aragon*, s'efforce d'imiter la nouvelle manière "vincienne" de Raphaël sans y réussir tout à fait.

[19] Béguin, op. cit. en n. 1, no. 11; Lautraite, ibid., pp. 441–43.

[20] Marquis de Laborde, *Les Comptes des Bâtiments*

de Tolentino de 1501 parvenu au Louvre sous d'énormes repeints et avec un important soulèvement sur le visage, au milieu de la joue (pl. 219). Le fond fut entièrement repeint au XVIIIe siècle en bleu sombre contenant de l'outremer et cette couche recouverte, elle-même, par une couche de bleu de Prusse sur le corsage repeint, une fausse signature et une date "P.P. fecit 1502" furent ajoutées beaucoup plus tard. Comme les deux fragments de Naples (et à la différence de l'*Ange* de Brescia) il est resté sur son panneau d'origine. On a découvert, au cours du nettoyage du visage, qu'à part l'accident sur la joue, celui-ci est, dans l'ensemble, bien conservé. Il est, paradoxalement, beaucoup plus intact que l'*Ange* de Brescia, dont l'apparence est, certes, plus séduisante mais qui fut habilement refait au XVIIIe et très repris dans des interventions récentes.

Le panneau du Louvre a apporté des informations nombreuses sur le retable de Saint Nicolas de Tolentino. L'apparition de l'aile rouge du second ange est l'un des éléments les plus intéressants fournis par ce panneau; une petite zone claire supplémentaire, donne, également, la couleur de la robe du second ange disparu.[21]

Le cas de l'*Ange* du Louvre est un parfait exemple du secours que les services techniques peuvent apporter à l'historien d'art. Ils lui permettent de conforter son intuition et lui fournissent un dossier d'informations indiscutables dans le processus complexe d'une acquisition.

Parmi les oeuvres restaurées, le *Saint Jean-Baptiste*, abîmé dès le XVIIe siècle selon le témoignage de Cassiano del Pozzo, a dû subir une longue intervention. On a cherché à ne pas repeindre le tableau mais on a tempéré ses lacunes pour rendre l'image lisible. Cette restauration reste toujours décelable (reprises à la gouache, à l'aquarelle, etc.) L'analyse des pigments a révélé un grand enrichissement de la technique de Raphaël. Alors que le vert de la *Belle Jardinière*, datée de 1508, ne contient pas de pigment vert par contre, dans le *Saint Jean-Baptiste* exécuté sans doute en 1516, les pigments verts à base de cuivre sont largement représentés. Les diverses nuances de vert sont obtenues par l'addition de quantités variables de pigments jaunes, oranges et blancs et par des effets savants de superposition de couches. La complexité technique est frappante par rapport aux oeuvres précédentes.[22]

Les problèmes soulevés par ces deux derniers tableaux se posent, d'une certaine manière, à propos de la *Grande Sainte Famille*, généralement considérée comme une oeuvre exécutée en grande partie par l'atelier.[23] La restauration fondamentale entreprise à l'occasion de l'exposition en permet une approche nouvelle (pl. 218). Etant donné l'importance de cette intervention et les découvertes qu'elle a suscitées, nous avons demandé à nos collègues de la Restauration des Peintures et du Laboratoire deux contributions précises sur la technique de ce tableau que nous traiterons donc ici sommairement.

du Roi (1528–1571), Paris (1877), i, pp. 135–36. Ce texte est aussi valable pour la *Jeanne d'Aragon*. Au sujet de ce tableau, cf. Béguin, op. cit. en n. 1, no. 3; Lautraite, ibid. pp. 441–43.

[21] Béguin, op. cit. en n. 1, no. 1; Faillant-Dumas et Rioux, ibid., pp. 411–14; Lautraite, ibid., pp. 435–37.

[22] Béguin, op. cit. en n. 1, no. 8; Faillant-Dumas et Rioux, ibid., p. 427; Lautraite, ibid., p. 434.

[23] Béguin, op. cit. en n. 1, no. 10; Faillant-Dumas et Rioux, ibid., pp. 416, 426–27; Lautraite, ibid., pp. 437–40.

La radiographie ne fournit aucun renseignement intéressant, à cause de la trans-position de bois sur toile. Les examens pratiqués sur la préparation révèlent une couche d'impression claire, par suite de la présence de blanc de plomb et de cristaux oranges de minium, analogue à celle de la *Madone de Lorette* de Chantilly.

L'allègement de l'épaisse couche de vernis (pl. 42) fait apparaître la couleur rose de la robe de la Vierge dont l'effet changeant—que Raphaël a aimé dès ses débuts comme on le voit dans la *Prédication de Saint Jean-Baptiste* de la National Gallery de Londres—est obtenu par un blanc pur recouvert d'un glacis rouge plus ou moins épais. Dans la draperie bleue, la couche de laque rouge et de blanc de plomb est travaillée, puis recouverte d'une couche de lapis-lazuli dont les effets sont exaltés par la couche sous-jacente.

La tête de la Vierge a la beauté d'une tête antique par la perfection de la construction des volumes. L'élaboration de la carnation est particulièrement savante: elle contient des pigments très finement broyés de lapis-lazuli, de jaune de plomb et d'étain, de minium orangé en quantité très faible mais harmonieusement dispersés de façon homogène dans la matière. Cette complexité technique, parfaitement dominée par l'artiste, contribue à donner un modelé d'une extrême subtilité.

La qualité d'exécution ne peut revenir qu'à Raphaël; on ne peut le dire, je crois, pour la tête d'ange à sa gauche (pl. 220). Elle vient trop en avant, défaut qu'évite Raphaël, par exemple, dans le Saint Joseph. La tête est assez usée; l'ombre où elle est plongée et l'épaisse couche de vernis salis et jaunis empêchaient autrefois de voir son aile droite, dont le profil est aujourd'hui bien visible. Cette figure est donc bien un ange et non une Sainte Madeleine comme certains commentateurs l'ont pensé.[24] Les mains, très maniérées, de l'Ange qui répand des fleurs sont un morceau d'une grande finesse. Les fleurs sont évidemment l'oeuvre d'un spécialiste; on pense à Giovanni da Udine qui a peut-être, aussi, exécuté le pavage de marbre et le berceau.[25]

Vasari affirme, dans la *Vie* de Giulio Romano, que ce dernier a collaboré à la Sainte Elisabeth du tableau envoyé au Roi de France. Cette précision lui a évidemment été donnée par l'auteur lui-même lors de leur rencontre à Mantoue en 1543.[26] En effet, l'exécution plus sommaire de la draperie et du petit saint Jean confirment ce renseignement (pl. 221). Cependant, il est certain que la lumière, sur le visage ridé de Sainte Elisabeth, délicatement posée comme une caresse, revient plutôt à Raphaël. Il a pu exécuter aussi le turban, d'une facture moins lourde et moins simplifiée, en somme plus habile, que celle de la *Jeanne d'Aragon*.

Presque tous les historiens d'art ont donné sans hésitation à Raphaël la tête de Saint Joseph. Nous avons fait plus haut allusion à sa parfaite intégration dans l'ensemble (pl. 222). Cette figure était relativement très bien conservée et la restauration permet de

[24] F. Hartt, 'On Raphael and Giulio Romano,' *The Art Bulletin*, xxvi (1944), p. 85.

[25] Le motif des fleurs, qui est repris dans la partie haute du *Couronnement de la Vierge de Monteluce*, y est traité d'une manière bien différente. Sur l'attribution à Raphaël et Giulio de cette partie, cf. F. Mancinelli, *Raffaello in Vaticano*, Rome (1984), no. 108,

108a, pp. 286–94.

[26] Ce passage est inséré dans la *Vie* de Giulio Romano de 1568 (Vasari-Milanesi, v, p. 525). Il est intéressant de noter que lorsque Francesco Primaticcio restaura le tableau en 1537–40, il est appelé *Sainte Anne* dans les comptes (Laborde, op. cit en n. 20, pp. 135–36).

retrouver toute la beauté d'une technique légère, d'une extrême subtilité dans l'expression de la lumière.[27]

Les apports des services techniques sont-ils de quelque secours pour le conservateur et l'historien d'art qui doivent affronter les difficiles problèmes des oeuvres discutées? Nous le croyons. Deux tableaux du Louvre sont intéressants à envisager de ce point de vue.

La *Petite Sainte Famille* (pl. 223) a été peinte sur un panneau de peuplier très mince coupé sur les bords: aucun retrait de la matière picturale n'y est, en effet, visible sur les côtés alors qu'il existe en haut et en bas.[28] Ce fait s'explique sans doute par la manière dont le panneau fut modifié pour l'insérer dans le cadre: des trous mastiqués sur le bord, à gauche révèlent la présence d'une ancienne fixation.

La matière est épaisse; le fond, derrière les figures, a été repeint: sauf à cet endroit, la peinture a été posée par un pinceau long qui détermine une touche souple. La radiographie montre des changements, surtout au niveau des arbres derrière les figures; la composition est ouverte sur le ciel, changement intéressant mais qui n'est pas, à lui seul, significatif. Sur le dessin de Giulio Romano de Windsor, qui a justement été mis en rapport avec le tableau,[29] entre Sainte Elisabeth et la Vierge apparaît la tête de Saint Joseph. Le dessin ne peut donc pas être le carton préparatoire pour la peinture, en dépit de l'échelle comparable des figures. Ce Saint Joseph est si légèrement esquissé que sa présence jusqu'ici n'a pas été relevée. C'est une variante notable par rapport au motif original de Raphaël gravé par Marcantonio Raimondi. Le fond de verdure, sur le tableau, en constitue une autre également importante.

La qualité de la touche et les ombres denses, non modulées, les draperies trop "chiffonnées," le type des visages et la forme des mains, les pieds trop petits, révèlent un autre artiste que Raphaël (pl. 224). Nous ne retrouvons pas dans la *Petite Sainte Famille* d'analogie avec les oeuvres de la période romaine, en particulier la *Vision d'Ezéchiel* de Florence, plus sculpturale, moins "fignolée" (l'aspect "joli" du tableau du Louvre est frappant) et, en réalité, plus subtile dans l'analyse de la lumière.[30]

Sa coulisse, la *Cérès*, est peinte sur un panneau très épais de bois de noyer.[31] Les panneaux sont si différents des deux tableaux que leur association ne peut être qu'occasionnelle. La *Cérès* est en bon état, sous un vernis jaune très encrassé. L'exécution est très proche de celle de la *Petite Sainte Famille*: son attribution à Giulio paraît encore plus évidente car la transformation toute sensuelle du motif antique semble bien étrangère à l'esprit de Raphaël.

Nous abordons un problème plus difficile encore, avec la *Madone au Voile* (pl. 226), une des oeuvres les plus discutées présentées à l'exposition de Paris.[32]

[27] Le contraste avec la tête de Saint Joseph, que nous ne croyons pas attribuable à Raphaël, ajoutée en surface dans la *Madone de Lorette* (Chantilly, Musée Condé) est très frappant (S. Béguin, en *La Madone de Lorette* [*Les dossiers du département des peintures*, 19], cat. exp., Chantilly [1979], Paris [1979], pp. 17–22, et Faillant-Dumas et Rioux, op. cit. en n. 1, pp. 417–19).

[28] Béguin, op. cit. en n. 1, no. 14.

[29] J. A. Gere et N. Turner, *Drawings by Raphael from the Royal Library, the Ashmolean, the British Museum, Chatsworth and other English Collections*, Londres (1983), no. 200, ill. p. 249.

[30] Cuzin, op. cit. en n. 12, p. 68.

[31] Béguin, op. cit. en n. 1, no. 15.

[32] Béguin, op. cit. en n. 1, no. 17; Faillant-Dumas et

La restauration a montré que la patine, conservée par ailleurs, a disparu sur les visages et la draperie bleue en bas à gauche; il faut en tenir compte pour l'aspect "vidé" de cette partie. L'exécution de la draperie bleue de la Vierge, dont le lapis-lazuli est posé sur une sous-couche rose carmin (mélange de blanc de plomb et de laque rouge), diffère de la technique de la draperie de la *Jardinière*. Elle se rapproche de celle de la *Madone de Lorette* et de celle de la *Grande Sainte Famille*. Cependant la complexité technique de la *Jardinière* ou de la *Grande Sainte Famille* ne s'y retrouvent pas.

L'image radiographique du tableau paraît très décevante comparée à l'écriture si ferme de la *Jardinière* (pl. 225), aux formes puissamment construites, aux beaux contrastes d'ombre et de lumière, typiques aussi de la *Madone de Lorette*. Le tableau est exécuté d'une manière très égale sans aucune différence entre les parties. Il est donc d'une seule main. Aucun dessin n'est lisible, les repentirs sont infimes, ce qui n'est pas le cas dans les autres oeuvres de Raphaël. De plus, toutes les particularités de la composition sont déjà apparentes, surtout dans le paysage fait étrange pour Raphaël qui l'exécute après coup, en surface, de telle sorte qu'il est invisible sur la radio. La touche fondue n'est pas exécutée avec cette brosse courte que paraît affectionner Raphaël dans les autres oeuvres du Louvre, spécialement de petit format. Ce joli tableau pose donc un problème.[33] La composition s'inspire de thèmes raphaélesques connus par des originaux (*Madone de Lorette*), par des copies (la *Vierge au Voile*, Princeton) ou par des dessins (*Nativité*, Oxford, Ashmolean), mais elle est beaucoup moins bien conçue et articulée.[34]

En dépit de l'autorité de certains historiens partisans de son attribution à Raphaël, il nous paraît très difficile de l'insérer dans son parcours stylistique en 1512, date que porterait une copie perdue de la *Vierge au Voile*, selon Passavant. Cette date exclurait évidemment complètement l'attribution à Gian Francesco Penni dont le nom a été proposé le plus souvent pour le tableau du Louvre.[35] Par contre, son analogie avec des oeuvres tardives vers 1518 ou 1520 paraît évidente: il est, en particulier, fort intéressant de la comparer avec la partie basse du *Couronnement de la Vierge* de Monteluce (Rome, Vatican) pour la forme, la couleur et le paysage; ce tableau est attribué à Gian Francesco Penni.[36]

La collection du Louvre, qui possède des oeuvres très diverses depuis l'*Ange* de 1501 jusqu'au *Double Portrait* sans doute de 1519, illustre bien l'extrême variété de

Rioux, ibid., pp. 419–20; Lautraite, ibid., pp. 440–41.

[33] Il n'est peut-être pas inutile de noter l'aspect peu raffiné de la préparation du panneau de bois de peuplier: il est constitué de deux planches jointes verticalement sans qu'une bande de toile en renforce le jointement. On retrouve cette particularité dans le *Portrait d'Inghirami*, Florence, Palazzo Pitti. J. P. Cuzin fait état des repentirs dans le bras levé de la Vierge et dans le diadème (op. cit. en n. 12, p. 68) mais ces parties ne sont pas essentiellement différentes dans la version définitive pour écarter l'attribution à un élève: de toute manière nous ne croyons pas que le tableau soit exé-

cuté d'après un carton de Raphaël.

[34] La composition paraît avoir été inventée dans un esprit qui s'inspire de Raphaël.

[35] Cuzin, op. cit. en n. 12, p. 68, s'oppose à l'attribution à G. F. Penni, et K. Oberhuber dans une communication au Congrès d'Urbin et de Florence en 1984 a aussi soutenu l'attribution à Raphaël de la *Vierge au Voile* avec beaucoup de force.

[36] *Raffaello in Vaticano*, Rome (1984), no. 108b (notice de F. Mancinelli). Détail de la planche en couleur, p. 295.

Raphaël qui change selon les tableaux, adaptant de nouvelles solutions à de nouveaux problèmes.

Certaines constantes, pourtant, se dégagent. La première est la construction de la forme en trois dimensions dans l'espace, l'absence de détails inutiles, le rapport harmonieux des différentes parties du tableau entre elles. L'image est toujours forte, évidente, simple. A cet égard, la radiographie et la réflectographie fournissent des renseignements précieux.

La seconde est la présence très fréquente des repentirs et du dessin: ils sont les témoins de l'élaboration, rarement spontanée, d'un génie apparemment si facile. Dans ce domaine, les examens de laboratoire apportent encore de précieuses informations.

La troisième constante rejoint l'observation précédente: dans une oeuvre où rien n'est laissé au hasard, un soin méticuleux préside à l'exécution. Son extrême diversité, d'un tableau à l'autre, est une difficulté pour l'historien qui doit chercher à comprendre la signification de cette recherche incessante vers une perfection voulue en fonction de l'oeuvre et jamais atteinte définitivement. Cette qualité se découvre au moment de la restauration qui doit être la plus respectueuse possible de l'intégrité du tableau: c'est une question de science, mais aussi de tact, de savoir "jusqu'où l'on peut aller trop loin." C'est une affaire de vie et de mort pour la peinture car les erreurs dans ce domaine, hélas, sont presque toujours irréversibles.

Le rapport harmonieux entre le conservateur et les équipes techniques est, donc, essentiel au service du chef d'oeuvre. Le conservateur, en travaillant avec elles, doit intégrer toutes les données fournies par l'histoire, la réflexion et l'intuition mais, aussi, user de ce nouveau regard que permettent les techniques modernes. C'est seulement après avoir fait un bilan de toutes ces nouvelles données et des informations d'ordre historique qu'il peut, avec humilité, mais non sans passion, conclure ou proposer de nouvelles hypothèses.

5

La *Grande Sainte Famille* de Raphaël du Louvre: La restauration, occasion de recherche et contribution technique à l'histoire de l'art[1]

SÉGOLÈNE BERGEON

PARMI les onze tableaux du Louvre de Raphaël, seuls cinq d'entre eux ont fait l'objet d'une restauration fondamentale,[2] et parmi ceux-ci la *Grande Sainte Famille* (Inv. 604) est le plus important par son caractère monumental, par l'ampleur du changement apporté par le nettoyage et par les informations nouvelles sur la technique de Raphaël mises en évidence lors du travail de restauration (pl. 42).

Nettoyage

Ce tableau, transposé de bois sur toile en 1777 par Jean-Louis Hacquin, présentait en 1982 l'aspect typique d'un tableau sur toile dont la texture était accentuée par le rassemblement du vernis roux dans les creux de la toile; l'allégement exécuté en 1982–1983 par Jeanne Amoore a diminué cet effet de trame et fait découvrir une oeuvre à l'harmonie froide et aux couleurs vives et fraîches (pl. 30): le manteau de la Vierge est passé du vert au bleu vif lapis-lazuli,[3] sa robe d'un jaune uniforme s'est diversifiée en une robe rose avec guimpe et manches jaunes (pl. 31). L'enlèvement de lourds repeints roses opaques sur le sol a fait réapparaître les reflets bleuâtres de la robe bleue réfléchie par la surface lisse et brillante du sol de marbre.

En revanche, par souci de préservation des apports de l'histoire, l'inscription *Romae* entre deux liserés (pl. 32), repeint ocre jaune très ancien, antérieur à 1849,[4] a été conservée: remplace-t-elle une inscription perdue parce que fragile? est-elle une addition pure et simple du XVIIIème siècle ou du XIXème siècle? La robe bleu vif de la

[1] A propos du travail de restauration mené à l'occasion de l'Exposition *Raphaël dans les collections françaises*, consulter Annick Lautraite, 'Etude au Service de la restauration des peintures des musées nationaux,' Catalogue de l'Exposition, Paris (1983), pp. 437–40.

[2] Selon S. Béguin, la *Vierge au Voile* du Louvre (Inv. 603) serait peut-être de G. F. Penni; selon J. P. Cuzin, elle serait de Raphaël, ce qui constituerait le 12ème tableau de Raphaël au Louvre; voir Catalogue de l'Exposition *Raphaël dans les collections françaises*, Paris

(1983), pp. 111–14.

[3] La réponse claire du manteau bleu-vert de la Vierge sur les photos en infra-rouge permettait de pressentir la présence de lapis-lazuli.

[4] *Romae* est mentionné dans le Catalogue Villot en 1849, n'est pas mentionné par Filhol en 1815 ni dans le Catalogue Lépicié en 1752, ni enfin sur la gravure en 1727 de Frey d'après Edelinck; *Romae* aurait pu être ajouté entre 1815 et 1849.

Vierge présente côté face un double liseré original peint en pleine lumière en jaune ci-
tron intense[5] enserrant la date et la signature.[6] Ce double liseré mal interprété dans
l'ombre suivait maladroitement les plis face et revers du manteau de la Vierge de part
et d'autre de *Romae*: il a été enlevé côté revers, laissé côté face enserrant les lettres de
Romae conservées.

Technique picturale

Sûr de sa technique, Raphaël change peu de composition au cours de sa création: on
observe peu ou pas de repentirs dans son oeuvre, à peine ici quelques millimètres à
propos de l'index de la main gauche de la Vierge; cette autorité est-elle due à la maîtrise
du fresquiste qui sait qu'il ne peut se corriger?[7]

Partout où les couleurs sont peu couvrantes (près du berceau, dans la manche de
Saint Joseph, etc. . . .), apparaît un réseau de lignes, croisées en général, dues au passage
avec une large brosse d'une couche non poncée de blanc de plomb à l'huile (pl. 33).[8]
L'usage d'une couche isolante de blanc de plomb à l'huile dont le liant imperméabilise
la préparation poreuse au gypse et à la colle de peau[9] et dont le pigment très couvrant
assure une bonne réflexion de la lumière, se généralise en Italie à la fin du XVème siècle
et se retrouve tout au long du XVIème siècle.[10] Cet usage contribue à l'éclat de la pein-
ture du XVIème siècle européen.[11] Bien souvent, l'ambiguïté persiste à propos de "l'im-
primitura": pour certains il s'agit d'une mise en place des volumes et masses avec une
couleur brune; pour d'autres, conformément aux textes anciens, ce mot désigne une
mince couche jaunâtre: chez Léonard (en 1519) "l'imprimitura" est une couleur faite
de brique pilée, de blanc de plomb et de jaune de plomb et d'étain mêlés à un liant

[5] Ce jaune citron intense pourrait être le jaune de plomb et d'étain (*giallorino*) traditionnellement utilisé par les artistes dans les jaunes en pleine lumière; ce pigment opaque aux rayons X est repéré par des zones claires denses sur les films radiographiques.

[6] RAPHAEL URBINAS PINGEBAT et MDXVIII.

[7] Avis de H. von Sonnenburg, voir *Raphael in der Alten Pinakothek*, München (1983), p. 58.

[8] A la différence des couches de gesso à la colle soigneusement poncées, la couche de blanc de plomb à l'huile ne se ponce guère et le passage de la brosse est sensible par de légers reliefs souvent accentués par les très minces glacis sombres posés par-dessus. On remarque ces traces de passage de brosse dans la *Madonne de Lorette* de Chantilly (voir G. Emile-Mâle, en *La Madone de Lorette* [*Les dossiers du département des peintures*, 19], cat. exp., Chantilly [1979], Paris [1979], p. 50), dans la *Belle Jardinière* (Inv. 602), et dans le petit *Saint Michel* (Inv. 608), tous deux au Louvre (voir Lautraite, op. cit. en n. 1, p. 440), enfin dans la *Vierge à la chaise* du Palais Pitti (voir *Raffaello a Firenze*, Florence [1984], p. 264, ill. p. 156, pied de l'enfant).

[9] Voir Etude de la matière picturale du Laboratoire de Recherche des Musées de France du 5 Août 1983.

[10] Cette couche de blanc de plomb sur un gesso à la colle est rencontrée dans la majeure partie des oeuvres peintes sur bois à Florence au XVIème siècle (voir parmi les tableaux présentés à l'Exposition *Le XVIème siècle florentin au Louvre* (*Les dossiers du département des peintures* 25), Paris (1982): Franciabigio, *Portrait d'homme* (Louvre, Inv. 517), étude du L.R.M.F. du 23. 11. 1979; Bronzino, *Le Christ apparaissant à la Madeleine* (Louvre, Inv. 130), étude du L.R.M.F. du 4.11. 1980; Bronzino, *La Sainte Famille* (Louvre, Inv. 1348), étude du L.R.M.F. du 15. 5. 1981; et aussi dans une oeuvre tardive du maître de Raphaël, Pérugin, *Saint Paul* (Louvre, Inv. 721).

[11] L'usage de blanc de plomb à l'huile, couche isolante et réfléchissante, est courant aussi en Europe du Nord à la fin du XVème siècle, voir *La pittura nel XIV et XV secolo: il contributo dell'analisi tecnici alla storia dell'arte*, ed. H. W. van Os et J.R.J. van Asperen de Boer (Comité International d'Histoire de l'Art, 3), Bologna (1979), p. 14. Cet usage est habituel chez *Holbein*, voir P. Hendy et A. S. Lucas, 'Les préparations des peintures,' *Museum*, xxi (1968), p. 245; et *Cranach*, voir K. Riemann, 'Untersuchungen zur Maltechnik Lucas Cranachs an der Nothelfer-Tafel in Torgau,' *I.C.O.M.*, Madrid (1972), Groupe XX; et remarqué en France au XVIème, voir Ecole de Fontainebleau, *Gabrielle d'Estrées et sa soeur au bain*, Louvre, RF. 1937-1, analyse du L.R.M.F. du 18 Mars 1970.

aqueux (à la colle de poisson).[12] Il s'agit donc d'une couleur "chaude" mais qui peut être assez claire selon la proportion de blanc de plomb; plus tard, pour Vasari (en 1568), "l'imprimitura"[13] désigne une couleur siccative, à l'huile, étendue à la paume,[14] constituée d'argile rouge,[15] de blanc de plomb et de jaune de plomb et d'étain, sur laquelle l'artiste construira son ébauche (*abozzo*).

Il semble bien que "l'imprimitura" soit donc un film léger relativement uniforme, brun-jaunâtre, tel qu'il apparaît dans la *Grande Sainte Famille* du Louvre près du visage de sainte Elisabeth sous sa coiffure. Après avoir préparé le support par une double préparation blanche et apposé une légère "imprimitura," l'artiste a exécuté ses lignes géométriques de construction à la pierre rouge ("lapis rosso" selon Armenini) (pl. 34),[16] puis a dessiné les formes finales au trait gris assez fin et régulier, qui pourrait être un trait de pierre noire visible dans la guimpe de la Vierge (pl. 35) et le pied droit de l'Enfant Jésus.[17]

Le rôle des incisions, habituelles dans les tableaux sur bois,[18] est très limité dans la *Grande Sainte Famille*: le berceau a fait l'objet d'une mise en place avec un premier tracé circulaire au compas, en creux, puis il y eut repentir (pl. 36); il apparaît à peine perceptible que l'auréole de Jésus a vraisemblablement été mise en place avant la dorure par une très fine et peu profonde incision.[19] Raphaël utilise plutôt l'incision franche, nette et nerveuse pour une correction dans la matière fraîche à la manière d'un fresquiste comme dans la *Madone Canigiani* de Münich et la *Madone de Lorette* de Chantilly.[20]

Un des points les plus importants mis en évidence lors de la restauration de cette oeuvre insigne de Raphaël a été la structure très élaborée des couleurs bleues et vertes en deux couches, dont la sous-couche est rouge ou rosée. Cette technique s'inscrit dans les textes dans la tradition depuis C. Cennini (1437) qui conseille de moduler en laque rouge fine avant de peindre les plis en lapis,[21] jusqu'à Armenini (1587) qui conseille d'exploiter la sous-couche car il est difficile de se reprendre.

[12] *Trattato della Pittura*, (Bologne) 1786.

[13] Encore appelée "mestica" par Vasari dans l'introduction de ses *Vite*, voir E. Berger, *Quellen für Maltechnik während der Renaissance und deren Folgezeit nebst dem De Mayerne Manuskript*, München (1901), pp. 27 et 29.

[14] Lorsque le liant huileux n'est guère fluide, l'application à la paume plutôt qu'à la brosse permet d'appliquer le moins de matière possible: cette méthode se traduit souvent par des empreintes digitales, voir T. Brachert, 'Finger-Maltechnik Leonardo da Vincis,' *Maltechnik*, lxxv, Heft 2 (1969).

[15] 'Terra di campana': terre réfractaire à base d'argile rouge, utilisée dans la fonte des cloches.

[16] G. B. Armenini, *De' veri precetti della pittura*, Ravenna (1587). On trouve ces lignes géométriques de construction (mise au carreau) à la craie rouge dans le vêtement clair du personnage dextre dans le *Mariage mystique de Sainte Catherine de Sienne* de Fra Bartolomeo (Louvre, Inv. 91).

[17] Le dessin peut être exécuté soit au pinceau avec pleins et déliés à la manière traditionnelle ancienne comme dans le *Saint Georges* du Louvre (Inv. 609), ou selon Vasari (1568) au charbon de saule comme semblent l'illustrer les *Trois Grâces* et la *Madone de Lorette* de Chantilly, ou la *Vierge à la Chaise* du Palais Pitti (dans la manche rouge, voir *Raffaello a Firenze*, p. 262).

[18] Cothurne du *Grand saint Michel* (Louvre, Inv. 610), et lance de *Saint Georges* (Louvre, Inv. 609).

[19] Une incision a servi à placer l'auréole de l'enfant de la *Madone Tempi* de Münich à la manière dite ancienne 'a tempera' (H. von Sonnenburg), ainsi que l'auréole de l'Enfant Jésus de la *Madone de Lorette* de Chantilly (voir S. Bergeon, R.M.N. 1979, p. 50).

[20] Voir von Sonnenburg, op. cit. en n. 7, p. 51. La correction par incision se retrouve dans le pied droit de l'Enfant de la *Madone de Lorette* de Chantilly (voir S. Bergeon, R.M.N. 1982, pp. 50–51). D'autre part, dans ce tableau, l'incision a servi à tracer les limites latérales de la composition.

[21] Cennino Cennini (1437), *Il libro dell'arte o trattato della pittura*, Milano (1975). Les plis du vêtement bleu de lapis du Christ de Puccio di Simone dans le

La composante rouge de la couleur bleue de lapis-lazuli, responsable de la réponse claire en photo infra-rouge,[22] est exaltée par une sous-couche à base de rouge; cette sous-couche est une laque rouge vif sous le bleu intense des ombres du manteau de la Vierge (pl. 37); elle est rose (rouge mêlé de blanc) sous le bleu clair du ciel (bleu lapis mêlé de blanc) (pl. 38) comme dans le cas de la robe bleu clair rosé de la Vierge dans la *Vierge au voile* du Louvre et dans la *Vierge à la chaise* du Palais Pitti.[23] Dans le cas des vêtements aux couleurs changeantes de l'ange de la *Grande Sainte Famille* du Louvre (pl. 39) ou celui de la *Vierge au baldaquin* du Palais Pitti et vraisemblablement l'archange du *Grand Saint Michel* du Louvre, cette sous-couche est subtilement modulée: la préparation est visible dans les zones claires en réserve; la demie teinte est rosée, les ombres sont de couleur noirâtre rosé; quelquefois même, un rehaut de blanc de plomb sur la préparation claire en réserve accentue les clairs de cette sous-couche; par-dessus est posé un glacis bleu léger dans les ombres, un peu chargé de blanc dans les lumières (pl. 41).

Selon le même principe, la couleur verte de la manche de sainte Elisabeth est renforcée par un ton rouge sous-jacent (pl. 40): rouge vif sous les ombres des plis, rosé sous les demi-teintes et couleur de préparation sous les clairs; un glacis vert est posé, soit pur et fragile dans les ombres, soit mêlé de blanc et plus solide dans les lumières. De même les plis du rideau vert posés sur une sous-couche rouge-violacé présentent une couleur riche et dense.

La bonne connaissance du vieillissement des couleurs permet de faire l'hypothèse que localement dans l'ombre bleuâtre entre la jambe gauche de l'Enfant Jésus et la Vierge, Raphaël a peut-être utilisé un mélange de smalt[24] (reconnaissable à un aspect partiellement blanchi) et de lapis (dont un îlot bleu vif bien conservé trahit la présence).

Les précisions précédentes apportées au premier texte publié en 1983 lors de l'Exposition Raphaël à Paris et confrontées aux remarques de nos collègues chargés de la restauration des oeuvres célèbres conservées à l'Ancienne Pinacothèque de Münich et au Palais Pitti de Florence permettent de mieux insérer les tableaux du Louvre dans l'oeuvre de Raphaël et de mieux cerner sa technique: élève de Pérugin, il peint comme lui et ses contemporains sur une double préparation blanche réfléchissante (blanc de plomb à l'huile posé sur le gesso à la colle).

Couronnement de la Vierge (Musée du Petit Palais d'Avignon, MI. 414) ont été modulés avec de la laque rouge, voir S. Bergeon, *Comprendre, sauver, restaurer*, Avignon (1976), p. 35.

[22] Une couleur est caractérisée par sa courbe de réponse spectrale représentative des quantités de lumière réfléchie en fonction des longueurs d'ondes incidentes: l'étude de cette courbe permet de prévoir la réponse infra-rouge.

[23] Voir Lautraite, op. cit. en n. 1, p. 441, et *Raffaello a Firenze* (1984), p. 264.

[24] Le smalt est un alumino-silicate de cobalt de couleur bleue transparente qui, en mélange avec l'huile, devient blanchâtre incolore: une couche de smalt à l'huile blanchit et s'opacifie au point de ressembler ap-

paremment à un chanci; en réalité il s'agit de la décoloration d'un pigment, transformation irréversible, et non pas d'un chanci ou microfissuration régénérable (voir R. Giovanoli et B. Mühlethaler, 'Investigation of discoloured smalt,' *Studies in Conservation*, xv [1970], pp. 37–44). Le smalt est beaucoup utilisé à partir du XVIème siècle et plus tard jusqu'au XVIIème (voir H. Kuhn, 'Terminal dates for paintings derived from pigment analysis,' *Application of Science in examination of works of art*, Boston [1970], pp. 199–205). Von Sonnenburg a aussi remarqué l'utilisation par Raphaël dans le ciel de la *Madone Canigiani* d'um mélange de lapis lazuli, smalt et blanc de plomb (voir von Sonnenburg, op. cit. en n. 7, p. 58).

La matière des carnations de Raphaël, épaisse dans sa jeunesse (1500–1501, cf. *l'Ange* du Louvre, RF. 1981–55),[25] devient très vite fluide et très mince dès 1504–1505 jusqu'à la fin de sa vie; les épaisses sous-couches bleu vert d'azurite glacées de lapis-lazuli de la *Belle Jardinière*[26] du Louvre (Inv. 602), de la *Vierge de Lorette*[27] ou de la *Madone Canigiani*[28] font place aux impalpables sous-couches roses et rouges qui exaltent le lapis dans les manteaux de la *Vierge à la chaise* et de la *Grande Sainte Famille*. Cette peinture éclatante aux fines couches transparentes colorées superposées, subtils filtres de la lumière (pl. 41),[29] sera aussi celle d'hommes proches de Raphaël comme Fra Bartolomeo.

[25] Voir Lautraite, op. cit. en n. 1, p. 435.
[26] Voir Etude de la matière picturale du 4.8.1983 effectuée par le L.R.M.F.
[27] Voir S. Delbourgo, R.M.N. 1979, p. 60.
[28] Voir von Sonnenburg, op. cit. en n. 7, p. 54.
[29] Les glacis, couches transparentes colorées, sont des sélecteurs de radiation: traversés deux fois par la lumière (lumière incidente sur le tableau, lumière réfléchie sur la sous-couche), ils permettent d'éliminer les teintes intermédiaires et d'obtenir les couleurs les plus pures possibles.

Légendes

Plate 30. *Détail*: le vernis jauni cachait l'harmonie froide des carnations.

Plate 31. *Détail*: l'allégement du vernis jauni permet de retrouver la diversification des couleurs roses et jaunes du vêtement de la Vierge.

Plate 32. *Détail du manteau de la Vierge*: repeint très ancien conservé "Romae."

Plate 33. *Détail en bas à gauche*: le tracé d'un passage rapide de la brosse presque horizontalement (un peu en diagonale) témoigne d'une couche de blanc de plomb à l'huile non poncée passée sur le gesso.

Plate 34. *Détail du sol*: tracé rouge de construction.

Plate 35. *Détail de la Vierge*: tracé à la pierre noire du dessin sous-jacent.

Plate 36. *Détail du berceau*: tracé préparatoire au compas par incision en creux dans la préparation.

Plate 37. *Détail du manteau de la Vierge*: le bleu intense de lapis-lazuli est posé sur une sous-couche uniforme de laque rouge très vive.

Plate 38. *Détail du ciel*: le bleu clair de lapis mêlé de blanc de plomb est posé sur une sous-couche uniforme rose de laque rouge et blanc de plomb.

Plate 39. *Détail du vêtement de l'ange*: la couleur changeante bleu violacé est obtenue par un glacis bleu léger posé sur une sous-couche modulée dont les clairs sont la préparation en réserve, les demi-teintes rouge rosé et les sombres noir rougeâtre.

Plate 40. *Détail de la manche de Sainte Elisabeth*: la couleur verte modulée (glacis léger dans les ombres et vert mêlé de blanc dans les lumières) est posée sur une sous-couche rouge modulée progressivement depuis le rouge intense dans les ombres jusqu'à la préparation en réserve dans les lumières.

Plate 41. *Détail de la ceinture de la Vierge*: sur une sous-couche rouge intense de laque sont posés des accents clairs ocre-rosé; l'ensemble étant recouvert d'un glacis bleu très léger constitue une couleur subtile et changeante.

Appendice: La *Grande Sainte Famille* de François I^{er}: Remarques sur la technique picturale

JEAN-PAUL RIOUX

L'EXAMEN et l'analyse des couleurs principales de la composition ont été effectués sur microprélèvements. La comparaison des résultats obtenus autorise plusieurs remarques.

La transposition de bois sur toile effectuée au XVIIIème siècle, a fait disparaître en très grande partie la préparation originale. Celle-ci a été remplacée par un enduit épais à la céruse et à l'huile adhérant à la couche picturale par de la colle de peaux.

Sous toutes les couleurs repose une couche d'impression claire d'épaisseur variable contenant, pour l'essentiel, du blanc de plomb mêlé d'un peu de charbon noir et de rares grains orangés. Le liant est à base d'huile de lin.

Le rouge de la robe de la Vierge et le vert de la tenture sont faits d'un simple glacis transparent posé sur cette couche d'impression au rôle réfléchissant. Exploitant au maximum la transparence du glacis, la technique ainsi employée donne aux couleurs tout leur éclat. Le rouge est une laque organique, le vert un résinate de cuivre.

Dans les écoles italiennes du XVIème siècle, les drapés bleus sont généralement réalisés à l'aide d'un bleu au cuivre recouvert de lapis-lazuli. Raphaël respecte cette technique dans de nombreux tableaux.[1]

La *Grande Sainte Famille de François I^{er}* offre bien, dans les bleus du ciel et du manteau de la Vierge, du lapis-lazuli broyé mais la sous-couche de bleu au cuivre est absente. Une matière rose, mélange de blanc de plomb et de laque organique, la remplace. Cette stratigraphie inattendue est celle de tous les bleus, même dans la robe de Sainte Elisabeth où le bleu de surface n'est pas du lapis-lazuli mais un bleu au cuivre. Le rose sous-jacent donne au bleu superficiel beaucoup plus d'éclat que le bleu au cuivre habituel. Cette superposition de bleu sur rose ne se retrouve dans aucun des tableaux italiens plus anciens étudiés au laboratoire. Raphaël semble donc innover. La *Vierge au diadème bleu*[2] révèle l'usage de la même technique dans la réalisation des drapés bleus.

L'orangé du manteau de Sainte Elisabeth ne contient pas de pigment de cette couleur. Plutôt que d'utiliser une ocre ordinaire ou du minium, Raphaël a soigneusement superposé deux couleurs chacune réalisée avec une matière de grande qualité: un jaune clair au plomb et à l'étain recouvert d'une mince couche vermillon.

Les carnations sont diversement rendues. Tantôt par un beige rosé contenant du vermillon, mais relativement pauvre en blanc de plomb et recouvert, dans les parties en

[1] La *Belle Jardinière* (Musée du Louvre, Inv. 602); [2] Musée du Louvre, Inv. 603.
La *Madone de Lorette* (Musée Condé, Chantilly).

lumière, d'un rose clair à pigment blanc plus abondant. Dans d'autres cas, les chairs ne sont représentées que par une seule couche de couleur claire. Outre le blanc de plomb et le vermillon, de très faibles quantités de pigments bleus, jaune clair et ocre, dispersés de façon homogène au sein de la matière, introduisent des nuances subtiles.

Les marbrures bleues du pavement sont faites d'une mince couche de lapis-lazuli posée sur un fond beige. Les vertes contiennent un pigment vert au cuivre sur fond vert clair sans pigment vert, obtenu par mélange de bleu au cuivre et de jaune au plomb et à l'étain. Cette technique, de règle chez les italiens du XIVème siècle, fait progressivement place pendant la deuxième moitié du XVème siècle à l'utilisation de pigments verts au cuivre. L'observation montre que, dans certains cas, Raphaël demeure fidèle à des traditions techniques presque abandonnées à l'époque où il est actif.

6

The Restoration and Scientific Examination of Raphael's *Madonna in the Meadow*

WOLFGANG PROHASKA

THE subject of this paper is the cleaning of Raphael's *Madonna in the Meadow* under-taken by Professor Hubert Dietrich in the restoration department of the Kunsthisto-risches Museum in Vienna during the year 1982–83 (pl. 43). I will not go into questions of preparatory drawings (the sequence of which, by the way, is not at all well estab-lished), nor will I discuss our *Madonna's* position among Raphael's other full-length and half-length *Madonnas* painted in his Florentine period, and the problem of relative dating. Cleaning and scientific research did not solve any of these issues.[1]

To a certain degree it is a matter of guesswork whether one reads the Roman nu-merals on the hem of the Madonna's red garment as 1505 or, by adding the last Roman digit after the round ornament, as 1506, though the latter date is more probable than the former (pl. 73). But perhaps precise dating during such a short period as Raphael's stay in Florence might be useless or even inappropriate anyway—in the first place be-cause, as many drawings show, Raphael put down "early" and "late" compositional ideas for the Florentine *Madonnas* on one and the same sheet, and secondly because we should bear in mind that, given Raphael's prolific production in these years and there-fore his need for timesaving working methods, he might have had several *Madonnas* in his workshop at the same time, signing and dating them according to the time he used the blue or red colour on which dates, signatures, or ornaments were applied in gold. Hubert von Sonnenburg has shown in his admirable investigation of the *Canigiani Holy Family* in Munich that we must take into account that Raphael's signatures and dates are only of relative reliability with regard to the completion of a work.[2]

I am extremely grateful for help and technical advice during the preparation of this paper both to Mr. Hu-bert Dietrich, who did the real work, and to Mr. Ger-ald Kaspar, who took all the photographs and infrared reflectograms during the cleaning and in-painting pro-cess.

[1] Kunsthistorisches Museum, Vienna. Inv. No. 175; poplar wood; 113 × 88.5 cm. For recent literature concerning the *Madonna of the Meadow* see L. Duss-ler, *Raphael: A Critical Catalogue of his Pictures . . .*, London and New York (1971), p. 20; P. L. De Vecchi, *Raffaello: La pittura*, Milan (1981), p. 242, no. 30; K. Oberhuber, *Raffaello*, Milan (1982), pp. 39 ff.; A. Rosenauer, *Raffael, Die Madonna im Grünen, Das Meisterwerk, Einführungen und Betrachtungen zu ausgewählten Werken des Kunsthistorisches Museums*, ii (1983); exh. cat., E. Mitsch, *Raphael in der Alber-tina*, Vienna (1983), nos. 2 and 3; exh. cat., J. A. Gere and N. Turner, *Drawings by Raphael from the Royal Library, the Ashmolean, the British Museum, Chats-worth and Other English Collections*, London (1983), nos. 54 and 55. See also D. A. Brown, 'Raphael's *Small Cowper Madonna* and *Madonna of the Meadow: Their Technique and Leonardo Sources,*' *Artibus et historiae*, viii (1983), p. 9 ff.

[2] H. von Sonnenburg, *Raphael in der Alten Pinako-thek*, Munich (1983), p. 56.

Due to the short time at my disposal, I shall not talk about other Raphaelesque paintings in the Kunsthistorisches Museum such as *The Holy Family* from the collection of San Carlo Borromeo, on which scientific research is not yet finished. The art-historical problems of attribution and dating are extremely difficult and are far from being solved. The Raphael-gurus (so to speak—I am not one) have the same contradictory views of this work as they used to have of another Raphaelesque painting in Vienna, the *Saint Margaret with the Dragon*, which is also at this moment in our restoration department.

The attribution of the *Madonna in the Meadow* to Raphael has never been in doubt. Vasari and Baldinucci establish its pedigree from Raphael's Florentine workshop to his friend and patron, Taddeo Taddei, with whose family it remained until 1662 when Archduke Ferdinand Karl of Tyrol, who married one of Granduke Cosimo II's daughters, bought the work for his collections in Innsbruck and Schloss Ambras. It remained there until 1773 when it became part of the Imperial collection in Vienna.[3]

There is no specific mention of a previous cleaning or restoration in the period since 1874, when conservation records started in the then Imperial private collections. Passavant wrote in the French edition of his book on Raphael in 1860: "La conservation de ce tableau est bonne, à l'exception de quelques endroits qui ont été un peu trop nettoyés et tachés."[4] I will return later to a somewhat unfortunate cleaning which was probably undertaken around 1830. Otherwise there is only a record of routine blister laying and superficial repairs in 1929.

Technically speaking, it was not absolutely necessary to take the *Madonna in the Meadow* down to the restoration department, apart from the fact that layers of discoloured varnish, unevenly applied, and discoloured retouchings had altered the appearance of the painting's surface. The treatment was intended to bring greater visibility, or even an aesthetic gain, worthwhile especially in the year of Raphael's five-hundredth anniversary.

In this case, x-radiographs were not very revealing because the priming consists of a rather consistent layer of lead-white (pl. 227–228). Later I will discuss some of the cross-sections of paint samples. It was well known from previous x-radiograph examination that the lower left and the upper right corners, especially, showed substantial paint losses of unknown but probably mechanical origin. There are also losses on the three upper margins of the panel, on the upper left-hand side in the sky and on the meadow—all hitherto covered by in-painting. On Saint John's shoulder and to the right in the meadow there were two knotholes; the knots had been extracted at an unknown date and had been replaced with putty. On his shoulder, especially, the putty had sunk, creating a perceptible difference of level; adjusting this level was the only work to be done on the panel itself. Pl. 74 shows the beginning of the process of in-painting in this area.

[3] *Le Opere di Giorgio Vasari*, ed. G. Milanesi, Florence (1906), iv, p. 321; F. Baldinucci, *Notizie de' professori*, Milan (1811), vi, p. 230; L. Dussler, op. cit. in n. 1.

[4] J.-D. Passavant, *Raphaël d'Urbin et son père Giovanni Santi*, ii, Paris (1860), p. 36.

Scattered on the Madonna's red garment there were small but concentrated paint losses, probably caused by the use of dark red pigments in a rather fatty medium; the pigments, when drying out, became very hard and brittle and tended to flake off (pl. 45–46). As was customary in the past, the retouchings were much broader than the loss they were meant to hide, and they usually encroached onto well-preserved original paint. An example from the upper right-hand corner appears in pl. 63–65. By taking off these repaintings, it was possible to regain well-preserved original surface. It was well known that the surface of the bottom left corner had suffered damage similar to that in the top right corner, and showed an inventive in-painting (pl. 59). The putty and in-painted colour covered parts of the original surface. It was decided initially to remove only those parts of the in-painting and the related putty reaching into the well-preserved meadow area. This procedure became unsatisfactory, however, because of a considerable difference of level (1 mm) between the made-up corner and the original painting. We agreed to remove the remaining triangle, substituting a *tratteggio*-like retouching for the invented in-painting (pl. 61).

There was another kind of damage and probably a more serious one, as its origin evidently lies in an imprudent and extremely unsuitable attempt at cleaning. It is tempting to attribute this to the ill-famed cleaning and restoration campaign around 1830 when "leider einige [Bilder] von der furchtbaren Wäsche des Directors Rebell besonders hart getroffen worden sind," as Waagen stated as late as 1866 in his fundamental book on the Viennese Collection (based on notes made in the late thirties).[5] Following Imperial orders, Rebell and other painters (amongst them Waldmüller) had to clean and restore all of the paintings exhibited in the Belvedere in Vienna, then housing the Imperial collection, a campaign which took place between 1825 and 1836. Since we know from other sources that *The Holy Family* by one of Raphael's close followers was cleaned by Rebell in 1827–28, with its wooden support reduced and cradled in exactly the same manner as that of the *Madonna in the Meadow*, we may assume that our *Madonna* also underwent treatment.[6] It has a specific type of very heavy and dense cradle to be found behind quite a lot of panel paintings in the Viennese Collection and this type can be distinguished from those used in the later nineteenth century.

It is impossible to reconstruct exactly what happened on that occasion. When he began cleaning the painting, which probably stood upright on the easel, the restorer started with the flesh colours of the Christ Child. He evidently applied a very strong liquid solvent—perhaps a kind of alkaline solution like liquid ammonium—and he probably applied too much (pl. 47). It seems that the solvent ran down over the Christ Child's loin and thigh, starting close to the Madonna's right hand where the *pentimenti* are strongly visible now. It might be that the damage under the Madonna's finger, in pl. 49, already filled with putty, is the result of a concentration of dripping solvent remaining for a certain time on one spot.

[5] G. F. Waagen, *Die vornehmsten Kunstdenkmäler in Wien*, i, Vienna (1866), p. 30. See also T. von Frimmel, *Geschichte der Wiener Gemäldesammlungen*, Leipzig (1899), p. 315.

[6] See Rebell's letter to Count Czernin in E. von Engerth, *Kunsthistorische Sammlungen des Allerhöchsten Kaiserhauses, Gemälde, Beschreibendes Verzeichnis*, iii, Vienna (1886), p. 325, no. 472.

Pl. 51 shows the difference between harmed and unharmed parts on the Christ Child's ankle. The ultraviolet fluorescence photograph (pl. 236) is less clear than it might be, but, nevertheless, one might assume that the difference it shows between flesh colour and adjoining meadow is due to a different medium of the topmost glaze or layer. It was decided to soften the contrast between harmed and unharmed paint so as to achieve a more consistent surface.

Pl. 54 shows the head of the Madonna after the removal of the varnish, revealing the damage once done by overcleaning, which affected mainly the top glazes. A closer view indicates that the restorer had now turned the picture horizontally (pl. 76). By accident, probably, the solvent spread and ran over the Madonna's neck, leaving behind the clear traces of dripping liquid. Similar marks, although not as spectacular and obvious, are traceable in various other parts of the painting, mainly on the right-hand side.

Perhaps I may make a small digression at this point. As we shall see more clearly in the infrared reflectographs, Raphael decided to lower the crown of the Madonna's head. It is worth noting how the painter reserved the space to be filled up by the head. He had to conceal the already-prepared top contours by overpainting them horizontally with the colour-loaded brush (pl. 75). He seems to have drawn the brush away from the Madonna's head, disregarding its already established outlines. Later, when he was working out the flesh colours and the coiffure, he had to go over the already "reserved" head. The radiographs also suggest that Raphael painted the sky first, leaving the space for the Madonna's head (pl. 227). On the shoulder to the right, for example, the hem of the Madonna's red garment clearly lies above the thick layer of lead-white with blue; and on the left, as was to be expected in view of the preparatory drawings in Chatsworth and New York, the plait of her hair was added in the last minute as a thin glaze.[7] Similar observations were made for the *Canigiani Holy Family* in Munich and the *Terranuova Madonna* in Berlin.

One final word about the way our conservator handled the in-painting: he aimed at a softening of non-original contrast, without completely concealing the damage wrought by history.

The *Madonna in the Meadow* is painted on a poplar panel made up of three separate boards. The joints, often covered with a strip of linen, seem in this case to be left open. The panel must have been thinned down considerably, since it is now only about 10 mm in thickness; in comparison, the *Canigiani Holy Family's* unaltered panel is 3.5 cm thick.[8] The boards left and right show a considerable number of wormholes and knotholes, while the central board is well preserved. At this point we might notice the area to the right where, probably during a rather late stage, Raphael painted the poppy flower; this thicker white area, contrasting with the consistent if unevenly applied ground layer of lead-white, indicates where Raphael wanted to cover something which he had already painted.

[7] See J. Bean, 'A Rediscovered Drawing by Raphael,' *The Metropolitan Museum of Art Bulletin*, xxiii (1964), pp. 1 ff.; more recently, E. Knab et al., *Ra-phael: Die Zeichnungen*, Stuttgart (1983), nos. 118 and 124; exh. cat., Gere-Turner, op. cit. in n. 1, no. 54.
[8] H. von Sonnenburg, op. cit. in n. 2, p. 49.

To investigate the structure of paint layers and the consistency of ground, it was decided to take six samples, mainly from the edges of the damaged areas. Cross-sections were made at the Institute for Technical Chemistry in the Hochschule für angewandte Kunst under the direction of Dr. Vendl. Unfortunately, there is still no scientific department at the Kunsthistorisches Museum. For information on the paint medium used by Raphael, four samples were sent to Dr. Mills of the National Gallery in London who kindly analysed the material. Not being a chemist, I am only reporting the results.[9] The first sample was taken from the sky (pl. 67). As one expects in an Italian painting of Raphael's period, there is a white gesso ground. Above that, one finds a yellow-white priming of lead-white, while the next greenish layer contains verdigris with lead-white. The topmost layer is composed of a thin final glaze of genuine ultramarine. There is no azurite at all in this sample, nor in the following ones. This might turn out to be interesting; azurite is found to have been indeed rarely employed at that time as a blue pigment in its own right, but it frequently appeared as an underlayer for ultramarine, or mixed with green pigments. I was told that the two top layers contain a certain amount of cobalt. It might be, therefore, that a bright smalt was added as a finely ground component to create the bluish green sky.

Two samples from areas of green were found to have been composed in a variety of ways, involving several superimposed layers in order to achieve the final "mixed" colour. I am not competent to go into the much-discussed and intricate problem of the appearance of copper resinate.[10] The second sample (pl. 68) comes from the yellowish green meadow in the background to the left. The gesso ground is almost missing; above it, there is again the thin layer of lead-white priming. The adjacent layer is obviously a mixture of green, brown, yellow, and black pigments containing bright green earth, ochre, lead-tin yellow, charcoal black, and quartz—the slivers of white. The third sample comes from the dark greenish brown landscape behind Saint John's shoulder (pl. 69). The thick gesso ground is probably discoloured by excess glue; the surface of the ground appears to have been sized with glue, revealed as a stained thin band. Then there is clearly visible the well-defined layer of lead-white. In this photograph, the layer containing colour pigments is much too dark; the original one showed the predominant green pigment, that is verdigris, along with green earth, ochre, lead-tin yellow, and charcoal black. In quality, *grosso modo*, this sample's composition is the same as the second sample.

The fourth sample is taken from the Madonna's red garment above the head of the Christ Child (pl. 70). The gesso ground is missing from the sample. The first visible layer shows the lead-white priming infiltrated with the superimposed single layer of red lake pigment, the components of which are explicable by the production process of red lake—alum, sulphur, aluminium, and so forth. I was informed that the bright red infil-

[9] These results will be published separately in A. Vendl, B. Pichler, M. Grasserbauer, A. Nikiforov, W. Prohaska, 'Zu Raphaels Madonna im Grünen,' *Wiener Berichte über Naturwissenschaft in der Kunst*, i (1984), pp. 76ff. I am grateful to Dr. Vendl for briefing me in chemical matters and explaining to me the results of the cross-sections.

[10] See G. Thomson, 'Penetration of Radiation into Old Paint Films,' *National Gallery Technical Bulletin*, iii (1979), pp. 25 ff.; A. Roy, 'Three Panels from Perugino's Certosa di Pavia Altarpiece,' *National Gallery Technical Bulletin*, iv (1980), p. 29.

tration does not contain any inorganic red pigments, which is why it is here recorded as originating from the superimposed red lake layer. There is no vermilion at all: no trace of mercury is present.

The fifth sample comes from the Madonna's deep blue robe (pl. 71). The gesso ground is again missing from this sample. Adjacent to the lead-white stratum there is a green layer containing lead-white and verdigris as a colour pigment, followed by a layer of ultramarine mixed with lead-white. The top layer consists of finely ground, genuine ultramarine. I have to repeat that here again no trace of azurite was found. "Ultramarine when used alone in oil, without the addition of lead-white, dries slowly, frequently with the formation of shrinkage or drying cracks."[11] I do not know whether this statement holds good when the medium is not oil but egg tempera, as it was found to be here by Dr. Mills. In case it does, it would account for the hundreds of drying cracks in the Madonna's coat. "Azurite," on the contrary, "in common with other copper pigments produces a relatively fast-drying film with oil media."[12]

The last sample (pl. 72), from Saint John's shoulder, does not contain any of the common red pigments typical for the flesh colours because, unfortunately, it was taken from a spot where the painter indicated dark shadow. As usual, there is the gesso ground, yellow-brown probably from excess glue, followed by the line of brown glue priming on the gesso, then the lead-white underpainting. The colour pigment layer in this sample is once again verdigris, along with lead-white.

The medium analysis carried out by Dr. Mills on four samples (red sleeve of the Madonna, her blue robe, and two plants close to the lower edge) showed only traces of fatty acids.[13] It is to be emphasised that these samples did not contain drying oils. I quote from Dr. Mills's letter: "The fatty acid levels were barely above the level of a blank run, nevertheless as sample four (bottom plant) was not so very small I think the result must be significant. The paint must be in tempera medium, presumably a very lean egg tempera." However, another sample (also a plant near the bottom) "showed much larger fatty acid peaks and also the usual dicarboxylic acids characteristic for drying oils. It is, or it contains, a drying oil then. The palmitate/stearate ratio was 2.4, which is rather ambiguous as it lies on the borderline where the values for linseed and walnut oils overlap." And he continues: "I think that this oil is much more likely to come from an original copper-resinate glaze (which has perhaps now turned brown) than from an old varnish." He explained that from two samples taken from the National Gallery's newly acquired Raphael predella, *Saint John the Baptist Preaching*, it appeared that they were also in a very lean egg tempera medium. On the other hand, another sample of green paint from the same painting was found to contain drying oil, unlike the first two samples.

However that may be, we have to face the possibility that during this fairly early period, Raphael used both media. It was previously ascertained by Miss Plesters for Giovanni Bellini's *Madonna in the Meadow* in the National Gallery that the medium

[11] A. Roy, op. cit. in n. 10, p. 31.
[12] Ibid.

[13] Dr. Mills's letters to Dr. Vendl of July 4, 1983, and August 4, 1983.

identified in a blue underpaint was egg "but with a suspicion of added drying oil."[14] We still very often remain in the area of uncertainty. Miss Plesters continues: "It must be emphasised that particularly with pictures painted in the 15th century when oil and egg media were both current and the picture was built up . . . in thin flat layers, whichever medium was used, it is often impossible to guess from casual inspection of the picture itself, or even from samples or sections under the microscope, what type of medium was employed."

The most revealing technical examination proved to be by infrared reflectography with the aid of an infrared Vidicon television system (pl. 229). We all know the various and varying ways painters transferred their compositions from drawings or cartoons to walls, panels, or canvases—squaring and incising the contours of the cartoon on the new ground and so on. We know of several punched drawings by Raphael, especially for the very small paintings like the so-called *Dream of the Knight*, in London, the *Eszterházy Madonna* in Budapest, or the *Saint George* in Washington.[15] It is rare that traces of *spolveri* are found in his large easel paintings, as here (pl. 231, 235), indicating that Raphael or his assistant put the cartoon directly on the panel's priming, pricked most of its significant outlines and inner contours and transferred the design by pouncing it onto the panel. It is interesting to note that Raphael does not seem to have applied another means for transfer in this case; that is, by incising or tracing the contours of the cartoon to the panel, as he did during the preparation of the *Canigiani Holy Family* in Munich.[16] It is not easy to say whether all the *spolveri* are still preserved or whether, for reasons arising from the working process, the *spolveri* disappeared in some parts. We find them preserved primarily in those areas which were supposed to establish the proportions of the figures, like feet, hands, and particularly the Madonna's head. We were not able to detect *spolveri* in the landscape, a fact which corresponds with the findings in the *Canigiani Holy Family* where there are no incised lines in the background landscape. Evidently, Raphael sketched the underdrawing directly on the ground in these areas. In the head of the Madonna not only the outlines of the chin, the edges of her coiffure, and her parting down the middle are marked by *spolveri*, but even the eyebrow, the nose, and the inner contours of the eyelid. We have already seen that Raphael lowered the topmost outlines of the head; he also altered the position of the undulating hem of her veil.

The *spolveri* were either connected with rather awkward, heavy strokes without much care for their form, or by spirited, looping, sketchy lines, giving a shorthand impression of what Raphael wanted. It is interesting to note that the outstretched foot of the Madonna was supposed to be still longer, since the originally intended nails indicated by the *spolveri* are still visible (pl. 231). Both means are seen combined in the infrared reflectograms of Saint John's feet (pl. 233–234): first the clumsy, angular way of connecting the *spolveri* and then the reworking of the outlines with quick-spirited,

[14] J. Plesters, 'A Note on the Materials, Technique and Condition of Bellini's *The Blood of the Redeemer*,' *National Gallery Technical Bulletin*, ii (1978), p. 24.

[15] See, for example, E. Knab et al., op. cit. in n. 7, nos. 8, 93, 130, and 241.

[16] H. von Sonnenburg, op. cit. in n. 2, pp. 51 ff.

linear but soft strokes. The outline of Saint John's thigh was originally intended to be much higher.

The infrared reflectogram revealed furthermore that Saint John's left foot underwent several changes (pl. 233). As far as one can see, Raphael first planned it to be rather short, then he tried elongating it, only to return later to the initially intended solution. Another interesting detail is provided by the infrared reflectogram of the Madonna's left hand (pl. 232). The scarcely visible *spolveri* and the connecting strokes indicate a position for the hand guiding her son which is closer to the last drawings for our *Madonna*, especially the one now in the Metropolitan Museum. Raphael tried out an even more elongated form of the hand, revealed by the now visible *pentimenti*.

Summarizing the findings of the infrared reflectograms, it may be said that in many of the figural parts of the painting the underdrawing turned out to be originally intended as a mechanical means of connecting the *spolveri*. However, Raphael did not always follow the contours of his cartoon, but continued to make experiments directly on the picture using a shorthand, fluid, and even casual type of underdrawing. This manner does not seem really to be connected with the style he used in his contemporary drawings on paper. Stylistically speaking, it must be said that these underdrawings are completely different from those, for example, which David Brown published from the *Small Cowper Madonna* in Washington (pl. 321), a painting which is otherwise very similar to our *Madonna*.[17] In that case, they bear much more resemblance to Raphael's usual drawing style of the period. It seems to me that the underdrawings in the *Madonna in the Meadow* look much more like those in the *Canigiani Holy Family* in Munich, although in part their purpose was technically different. In this field, too, we still need more comparative material. So far, however, John Shearman's recent remark that with Raphael "it is a mistake to assume a consistency in preparatory technique" holds good.[18]

[17] D. A. Brown, *Raphael and America*, National Gallery of Art, Washington (1983), p. 130; D. A. Brown, op. cit. in n. 1.

[18] J. Shearman, 'A Drawing for Raphael's *Saint George*,' *The Burlington Magazine*, cxxv (1983), p. 25.

7

The Examination of Raphael's Paintings in Munich

HUBERTUS VON SONNENBURG

Introduction

Two works of Raphael's so-called Florentine Period (1504–8) are preserved in the Alte Pinakothek in Munich. The *Tempi Madonna* (WAF 796) (pl. 84a), generally dated at the end of this period, is a devotional picture of fairly modest size (75 × 51 cm), whereas the *Canigiani Holy Family* (Inv. 476) (pl. 78), with its ambitious group of five figures, comes closer to the dimensions of an altarpiece (131 × 107 cm). Before the recent restoration of the latter, the familiar pyramidal composition resembled those similarly composed Madonnas in a landscape with an open sky painted at about the same time (pl. 77). Now, with the clusters of eight cherubim again visible in the sky, top left and right, the composition has regained its original balance and festive character. For those whose conception of Raphael is still more or less rooted in the past century, this changed image might possibly be a disappointment.[1] It is now clear for the first time that Raphael never quite finished the putti. The incomplete areas, however, give a most instructive insight into Raphael's oil-painting technique and are closely related to comparable passages in the very small, unfinished *Eszterházy Madonna* (Budapest, 28.5 × 21.5 cm) (pl. 79). The generally accepted date around 1507 for the *Canigiani Holy Family* is favourably supported by the related technique of the Borghese *Entombment* of that year. The *Tempi Madonna*, with its refined and unified colour scheme, clearly belongs to a more advanced state in the artist's development. According to the most recent examination, *La Belle Jardinière* apparently also dates from the year 1508.[2] Even though Raphael eventually settles for a heavier impasto in the flesh areas in about 1512—the *Madonna della Tenda* in the Alte Pinakothek (WAF 797) (pl. 84b) is a characteristic example of this new development—no gradual or systematic approach to this can be observed in his works prior to that time. Thin paint application as apparent in the *Small Cowper Madonna* (about 1505) contrasts with much heavier flesh paint in the *Madonna in the Meadow* (1506), and a stylistically more advanced work such as the *Saint Catherine of Alexandria* is again extremely thin in the flesh. There are even subtle variations within one and the same work (for instance the Borghese *Entombment* and the *Canigiani Holy Family*). Eastlake was the first to describe these differences in

[1] One of the Critics (P. L. De Vecchi, *Raffael*, Munich [1983], pp. 22ff.) would even go so far as to describe Raphael's original composition as a fascinating case of failure.

[2] See Sylvie Béguin, in this volume, p. 41.

paint application and how Raphael fluctuated between the contrary influences of Leonardo and Fra Bartolommeo during his Florentine period.[3] These observations are hardly encouraging, and it does not seem reasonable to attempt to reconstruct Raphael's artistic development as it progresses within half a decade from work to work on grounds of his painting technique alone. It has also to be taken into account that in some instances time elapsed between the preparatory studies and the execution of the works, and furthermore that the actual painting process was interrupted at times or never altogether completed for that reason.

A comparison of Raphael's two earlier works in Munich with the *Madonna della Tenda* of about 1513 not only demonstrates the astounding change in the development that has taken place within such a relatively short time, but it also shows how little Raphael was actually influenced by Leonardo's chiaroscuro during his Florentine period—an observation that might help to reevaluate and define his rôle as a colourist more clearly. Raphael's preference for a full display of saturated colours covering larger areas of the picture plane prevails even in his later works, sometimes at the expense of a systematic transition from light into dark.

Reference will also be made later in this paper to the *Portrait of a Young Man* (Inv. 1059) (pl. 85), formerly believed to be a self-portrait by Raphael from his Umbrian period. It belongs to a group of several portraits with background landscape motifs reminiscent of, or directly copied from, a Memling diptych, part of which is also in the Alte Pinakothek. These works by different artists are either compilations inspired by more than one painting of the Florentine period or else reflections of a lost work by Raphael.

Through modern methods of examination, we gain an unprecedented insight into the physical construction of paintings. Much of this steadily increasing information, however, has yet to be brought into proper perspective. In recent debates, for example, the fairly ordinary workshop procedure of transferring the pricked outlines of a cartoon to the gesso ground has perhaps been given undue attention. In view of the underdrawings so far discovered, this traditional method, originating in fresco painting, was only occasionally and not systematically made use of in Raphael's paintings, and can therefore at best shed some light on the diversified methods practiced at the time by studio assistants.

The *Canigiani Holy Family*

This work of Raphael's Florentine period, first mentioned by Vasari, remained in Florence until the end of the seventeenth century.[4] At the marriage of the Elector Johann Wilhelm of the Palatinate with Anna Maria de' Medici, the daughter of Grand Duke

[3] Charles Lock Eastlake, *Materials for a History of Oil Painting*, 2 vols., London (1847). Reprinted as *Methods and Materials of Painting of the Great Schools and Masters*, 2 vols., London (1960), ii, pp. 161 ff.

[4] For a detailed description of the history of the *Canigiani Holy Family*, see Hubertus von Sonnenburg, *Raphael in der Alten Pinakothek* (history and restoration of the first Raphael painting in Germany and of the *Madonnas* acquired by King Ludwig I, catalogue of a documentary exhibition held in Munich at the Alte Pinakothek), Munich (1983), pp. 12–14.

Cosimo III, in 1691, it was sent as a wedding gift to Düsseldorf. Later, in the eighteenth century, reportedly during a cleaning procedure, the top part of the painting was deliberately damaged. The restorer responsible for this apparently took offence at the glory of child angels and tried to remove them altogether. Its seems reasonable to assume that the unfinished state of the figures might have encouraged him to do this, because he first started to scrape away the putto on the extreme right, where Raphael had hardly begun the underpainting (pl. 93). Fortunately, this destruction was stopped in time so that at least five figures on the left side were hardly touched (pl. 82, 83); the entire top part of the composition was subsequently overpainted. This condition is first recorded in an engraving dated 1776. A copy on a porcelain plaque of 1840 clearly shows the subtle differentiation in flesh colour of the two children which was completely obscured in our time by the increasing discolouration of the varnish (pl. 96). Frequent comments on the condition of the painting by authors of the nineteenth century are for the most part pessimistic.

Condition and restoration. An ultraviolet photograph of 1938 shows the extent of the old overpainting (pl. 237). Until 1950 the actual condition of the original corners was left to speculation only. According to x-radiographs taken at that time, however, the paint losses proved to be far from discouraging (pl. 238). Nevertheless, there was concern as to surface blemishes not revealed by radiography. It was not until recently that the issue was taken up again in view of the Raphael year and, not least, thanks to the stimulating enquiries of Marcia B. Hall and John Shearman. As it turned out, the thick layer of eighteenth-century oil paint covering the upper part proved fairly readily soluble. An occasionally voiced argument in favour of leaving the old restorations—with the passage of time they have become an inseparable part of the historically evolved reality of the original—can now be countered. After removal of the overpainting, the original paint layer was found to be covered by the remains of discoloured varnish, as is recorded in colour slides. With the exception of the obvious mechanical damages, the original remains in close to perfect condition. Even the most delicate touches are preserved. The largest paint loss involves the putto to the extreme right but fortunately does not include his head. Many of the parallel scratches are not actually losses, because the original paint has been partly pushed down to a lower level. It was therefore decided only to fill a few of the most disturbing grooves with putty in order to preserve as much original paint as possible (pl. 93). In the areas of paint loss, the luminous original gesso ground, with its slightly yellowish tinge, provided an almost ideal underlayer for in-painting.[5] Even though the damaged areas were blended with the surrounding colours, they can still be distinguished, in slightly raking light, on account of their lower levels.

Beyond the damages described above in the newly recovered top corners, only minute scattered paint losses were found in the main group. They are restricted to the shadow areas of the blue and yellow draperies, where the paint layer is quite thick, and also to some of the deep shadows among the contours of the children. The brittleness

[5] Retouchings were carried out mainly with opaque water colours; a few adjustments were made with pigments and vinylite (AYAB A–70).

of the paint film in the areas afflicted by tiny flaked losses is probably due to the greater proportion of medium employed. These clusters of pinhole-type paint losses, for example, those found in the shaded foot of the little Saint John, are very characteristic of Italian sixteenth-century panels with gypsum grounds. It is difficult to judge whether or not the hair of the two children has suffered from slight abrasion, in view of the fact that the flesh areas have been left here and there in a state only approximating completion. Some areas of the original paint layer were found to be covered by a thin, transparent film of grey tonality not soluble in any of the common organic solvents used by restorers. Presumably, it is glair (not analyzed), and possibly an original application which could have protected the paint layer from solvent action in the past.[6] In any event, it is possible that a forced removal of this film might hurt the original paint layer. The Virgin's blue robe was found to be in a very good state of preservation, except for part of the shadow zone to the right, where greenish discolouration and blanching obscured the design of the folds. It appears that the ultramarine present in the topmost layer, over thick azurite underpaint, has undergone partial discolouration.[7]

The wood panel. The poplar panel, 3.5 cm in thickness, consists of four vertical members (three of more or less the same width with an additional one on the left side, as seen from the front) with plain butt joints, additionally secured by bevelled slide-in crossbars (the present ones are later replacements made of oak wood).[8] The slightly tapered bars are in this case arranged with their tapering in opposed directions rather than parallel.[9] The spacing between the crossbars and the panel's top and bottom edges is equal, an argument against the old hypothesis that the painting has been cut at the top. The joints of this carefully made panel were secured on the front with canvas strips about 4 cm wide (as can be seen in the x-radiograph, pl. 238) in order to prevent the joints from being transmitted eventually to the surface.[10] A small round punch mark

[6] A similar coating was found on the sky of the *Madonna della Tenda*. Furthermore, on a large part of the *Borghese Entombment* and on the *Madonna di Loreto* (Chantilly): see L. Ferrara, S. Staccioli and A. M. Tantillo, *Storia e Restauro della Deposizione di Raffaello*, exh. cat., Museo e Galleria Borghese, Rome (1972–73), p. 54, and G. Emile-Mâle in *La Madone de Lorette* (*Les dossiers du département des peintures*, 19), exh. cat., Chantilly (1979), Paris (1979), p. 50. The use of glair functioning as a varnish (or rather making the painting look as if it were varnished) is already mentioned by Cennino Cennini, *The Craftsman's Handbook*, ed. D. Thompson, New York (1933), pp. 100 ff. For the use of glair in later periods see M. Koller and F. Mairinger, *Problems of Varnishes: Use, appearance and possibilities of examination*, ICOM meeting, Venice (1975), preprints 22 / 9. The application of glair on freshly painted pictures as a protection against future cleanings was not uncommon in the nineteenth century. See J. Fernbach, *Oelmalerei*, Munich (1843), pp. 164 ff.

[7] This phenomenon is described in great detail by Ashok Roy in the examination of panels from Perugi-no's Certosa di Pavia Altarpiece, and by Joyce Plesters and J. Mills in reference to seventeenth-century paintings, especially those by Claude Lorraine, in *National Gallery Technical Bulletin*, iv (1980), pp. 26–27, 60–63.

[8] The three Raphaels in the Alte Pinakothek, and the *Portrait of a Young Man* by an unknown follower, are all painted on poplar wood, according to a recent wood-biological analysis by Peter Klein (Hamburg University). The specifications in the most recently published descriptions of the paintings in the Alte Pinakothek are therefore incorrect.

[9] The panel of Raphael's *Madonna di Loreto* is fitted with parallel running crossbars; see B. Fredericksen, 'New Information on Raphael's *Madonna di Loreto*,' *The J. Paul Getty Museum Journal*, iii (1976), fig. 6. For further references regarding panel paintings by Raphael and his circle, see J. Marette, *Connaissance des Primitifs par L'Étude du Bois*, Paris (1961), nos. 537–46.

[10] The panel of the *Madonna di Loreto* is treated in the same way; Emile-Mâle, op. cit. in n. 6, p. 48.

(2 cm in diameter) (pl. 248) was discovered on the back of the panel depicting what appears to be two adzes tied in the centre, presumably representing a carpenter's trademark.

The ground. The white glue-bound gesso ground (0.8 mm thick) is mainly composed of anhydrate.[11] Traces of surplus ground found on both vertical edges of the panel are sufficient proof that the original width of the panel has been preserved. This also applies to the bottom edge, where a narrow strip of unpainted white ground marks the border-line of the painted surface. The use of chalk instead of gypsum or anhydrate in a white ground could be important evidence against an Italian origin for a painting.[12]

So far, the gypsum ground in several paintings by Raphael has been found to be covered by a thin insulating priming layer containing lead-white bound with glue or oil.[13] There is no evidence of such a layer in the *Canigiani Holy Family*. A distinction should be made between on the one hand a priming layer covering the entire surface of the white gypsum ground and on the other only locally applied thin coatings of varying colour functioning as ad hoc underpainting.[14] It would appear logical to assume that the application of coatings of this kind would be based upon a compositional design provided by the underdrawing. Further reference to this point will be made below.

Underdrawing. Compared with the generally simpler and often rather schematic underdrawings of Perugino (pl. 243) and Fra Bartolommeo, Raphael's preparatory designs on the white ground are generally more varied and also more thinly drawn (pl. 242). More often than not, helping hands were responsible for the transfer of the essential outlines of the cartoon to the painting's ground, and it seems that only certain details have been given special attention by the master himself; sometimes, however, as

[11] According to statistics established so far, it appears that a predominant use of anhydrate in the grounds is typical for Umbrian, Sienese, and Florentine paintings; see D. Bomford, J. Brough and A. Roy, *National Gallery Technical Bulletin*, iv (1980), p. 28. Radiographs of Italian paintings around 1500 and later frequently show clusters of tiny white dots, probably resulting from air bubbles. These bubbles originated during the preparation of the ground when the mixture of glue and gypsum was agitated while filler was being added; see P. Hendy and A. S. Lucas, 'The Ground in Pictures,' *Museum* (UNESCO), xxi, 4 (1968), pp. 269–70. K. Wehlte (in an unpublished examination report on the so-called *Madonna di Gaeta*, actually a copy after the *Alba Madonna* by Raphael, at the Doerner Institute, Munich, No. 27, 1940, in cooperation with T. Roth and Jacobi) has noticed the frequent occurrence of such white spots in x-radiographs of paintings by Perugino and Raphael. They do, however, occur in painting-grounds of other masters as well.

[12] This, however, is the case with a version of Raphael's *Holy Family with the Lamb* accepted by L. Dussler and credited with a lengthy entry in his *Raffael: Kritisches Verzeichnis der Gemälde, Wandbilder*

und Bildteppiche, Munich (1966), p. 44; English ed. (1971), p. 11. According to A. P. Laurie, "the panel is coated with a gesso of chalk and glue, thus differing from the earlier Italian practice of using gypsum"; see Viscount Lee of Fareham, 'A New Version of Raphael's *Holy Family with the Lamb*,' *The Burlington Magazine*, lxiv (1934), p. 8. This important evidence is omitted from Dussler's otherwise quite thorough entry.

[13] The earliest example is the fragment with an angel (now in the Louvre) from the altarpiece of Saint Nicolas of Tolentino; see S. Delbourgo and J.-P. Rioux in *La Revue du Louvre*, ii (1982), p. 112. The following paintings have been cited as further examples during this symposium: the *Madonna in the Meadow*, *La Belle Jardinière*, the *Monteluce Coronation*, and the *Transfiguration*.

[14] A pink priming layer containing lead-white and realgar was found on the gesso ground of the *Madonna di Loreto*, except, however, for the figure of the Virgin (see S. Delbourgo, in *La Madone de Lorette*, cit. in n. 6, p. 60). A thin brownish layer is visible in a cross-section of the sky in the *Tempi Madonna*. Further sampling would be necessary to determine how far this layer extends.

is the case in the *Small Cowper Madonna*, a fairly complete underdrawing aided the painter's brush (pl. 321). Such disparities might be due in part to the varying thicknesses of the superimposed paint layers, or to the different dimensions of the paintings.

The design of the *Holy Family*[15] has been traced onto the white ground from a cartoon (now lost), apparently by pressing a stylus along the lines instead of using the traditional process of pouncing. The most important function of this transfer was the definition of the exact position of the outlines. These often abbreviated lines would in some instances (Elizabeth's hand, for example) give sufficient information to the painter, whereas in others some strengthening or reworking proved to be necessary (as in Joseph's foot, pl. 245). The more elaborate drawing of the Christ Child's ear was subsequently highlighted with flesh paint, leaving, however, the contours of the drawing still visible (pl. 95). The finishing touch consisted in a further accentuation of the shadow and was achieved with hatching strokes of dark paint. In this way the underdrawing was perfectly integrated into the paint layer. It should be pointed out that the hatched strokes, presumably carried out with oil paint, are also recorded in the infrared reflectogram (pl. 247) (most likely they contain carbon black), and they are not clearly distinguishable from the underdrawing.

The putti are drawn in such a very summary manner and with such great sureness that they may have been drawn directly on the ground without the help of a cartoon (pl. 244). The sparse lines masterfully illustrate how the fingers of a small hand function (as in the putto in the center of the left-hand group), and in some other cases contain elements of spherical drawing (as in the head at the very top left).

Architectural details in the landscape (pl. 246) most closely resemble Raphael's drawings, and probably these were also sketched directly on the white ground. Significantly, all notable revisions are restricted to the background, an observation that can be made in other works by the master. For example, at an earlier stage of the execution, Raphael planned two mountains at the very right of the horizon, with rock formations below (visible in the reflectogram), similar to those frequently found in paintings by Memling.

The underdrawing would also provide the necessary border lines for priming layers which only extend under certain areas of the composition, and of course for all localized underpainting to follow. As can be expected, the underdrawing sometimes shows deviations from the cartoon, or from the finished painting, or from both.[16] In part, this might be explained by the fact that more superficial details, such as a transparent veil, are usually not included in the preparatory cartoon.

The painting procedure. The radiograph (pl. 238) conveys precision and clarity and shows that the different compositional elements are tightly interlocked. Accordingly, the actual painting process had to be carried out within the predetermined border lines transferred from the cartoon. To some extent, it was left to the painter's choice which

[15] For the preliminary studies, see von Sonnenburg, op. cit. in n. 4, pp. 48–49 and figs. 51–58.

[16] In the *Tempi Madonna* the reflectogram reveals a fold (apparently of the veil).

parts of the compositional pattern he would complete first; but much depended on choice of the pigments, on their different modes of preparation, and not least on the more or less elaborate underpainting required for certain colours. In that sense, the production of a painting was also a matter of economy, especially in view of Raphael's growing production and the need for speedy execution.

The outlines of the compositional elements are further emphasized by the different levels of the paint layer. As a result, the more thinly painted flesh areas in particular are embedded in the raised layers surrounding them. X-radiographs show these differences only to a limited degree because the raised areas, for example of Joseph's green and yellow draperies, do not offer much resistance to radiation on account of their pigmentation and therefore appear very dark. Additional viewing of the painting's surface in raking light is therefore required to note these differences. The effect somewhat resembles a low relief and enhances the volume of the (nearly) enclosed form. How deliberately Raphael used this artistic effect is revealed by the radiograph of the *Tempi Madonna* (pl. 239), where the space between the two heads, actually an area of deep shadow, was also underpainted with sky blue in order to achieve a slightly more raised paint relief in the shadow zone, thus accentuating and offsetting even the inner contours of the heads. With the aid of the x-radiographs of the *Canigiani Holy Family* it can furthermore be determined that the two top corners are in fact an integral part of the composition. Following the drawn outlines of the putti (including their wings), Raphael first painted the clouds. The angels' wings were completed next in one operation—a good example of his economical working procedure. At this point, the main group, including the landscape with the skyline of the distant city, must have been essentially finished, and then the thick, top layer of the sky was brushed on with sweeping strokes. In order to achieve an even application of this rather heavy paint, considerable speed was required. Manipulating the pasty paint close to and around the contours of the distant buildings apparently proved to be too time-consuming. Raphael therefore painted several details out and replaced them afterward. Minor readjustments of the outlines here and there are noticeable. The same raised layer of sky blue encloses the whole group of putti and clouds.

It was only at this stage that Raphael began the underpainting of the putti. Some of the initial shading with thin reddish paint of the second head from the left was brushed beyond the contour of the head onto the raised layer of blue, which therefore must have been applied previously.[17] All nuances of the successive stages of execution of flesh painting can be studied in these unfinished passages which are closely related to parts of the small unfinished *Eszterházy Madonna* (pl. 80, 81). Raphael almost instantly achieves modelling by indicating shadows, either with hatching strokes or in a less systematic manner by applying paint with a fuzzy but stiff brush; the latter produces irregular hairlines and occasionally deposits globules, as well as conglomerates, of pigments, as is noticeable in the central putto to the left. In the profile head to the

[17] Overlaps of this kind allow conclusions as to the sequence of paint applications. The preservation of such a delicate layer confirms the excellent state of preservation of this area.

extreme left, with its loosely brushed-on hair, the preparatory modelling with ruddy-coloured shadows seems to have been carried a bit further than in the other heads, probably because it was to receive relatively little highlighting.

The application of opaque pinks, the next and conclusive step in the technical buildup, was carried furthest in the damaged head in the top right corner, in contrast to the putto next to it, hardly begun (pl. 93). The heads on the left received only a few touches each of this pale pink as a first indication of more intense lighting to be applied subsequently. For unknown reasons, however, Raphael was interrupted in his work and obviously never returned to it. Certainly this is not an isolated instance.[18]

Undoubtedly, Raphael left the completion of the flesh painting in the *Holy Family* to the final stage, and a comparative study of the Budapest *Eszterházy Madonna* supports the hypothesis that he usually did so. The underpainting visible in both instances is responsible for the yellow tone in the flesh that is typical for the Florentine paintings of Raphael.

A comparison between the unfinished putti and the two children of the main group (pl. 93, 90) makes it quite clear that the finishing touches would have required further highlighting by spreading a mixture of lead-white and vermilion, with varying covering power over different parts of the warm tones of the undermodelling. Only this topmost layer is recorded in radiographs. It is therefore frequently, but nevertheless wrongly, referred to as underpainting. The relatively transparent underpainting, consisting essentially of mineral pigments, ensures that enough of the reflecting quality of the white ground is retained to preserve the extraordinary luminosity of the more opaque pinks on top.

Compared with the extremely thin flesh painting sometimes found in paintings by Fra Bartolommeo, Raphael's thinly painted carnations show more density, firmer modelling, and sufficient covering power to conceal the underdrawing. Perugino's heads, on the contrary, are generally modelled with more contrast of light and shadow. More often than not, hatching strokes for shading are employed in the topmost layers and they extend into the light flesh areas, particularly of male heads. An example of Raphael still to some degree adhering to this technique can be seen in the *Colonna Altarpiece*; even in this picture, however, there is a noticeable tendency to give more substance to the light areas of the flesh and, above all, to intensify chromatic qualities, thereby achieving a greater variety and individuality in the heads.

A comparison between Perugino's Saint Augustine in the Munich Altarpiece (Inv. 525) (pl. 94) and the head of Saint Joseph of the *Canigiani Holy Family* (pl. 89) strikingly illustrates Raphael's development toward intensified and diversified flesh colours

[18] According to G. Vasari (*Vite*, ed. Milanesi [1878–85], iv, pp. 328 ff.) *La Belle Jardinière*, or *the Madonna Colonna* (Berlin-Dahlem), and the *Madonna del Baldacchino* (Galleria Pitti) were also left unfinished by Raphael. Vasari also seems to say that one of the two works mentioned first was completed by Ridolfo Ghirlandaio; no evidence for or against this hypothesis has been furnished as yet (but see Sylvie Béguin in this volume, p. 41, and John Shearman, p. 8. It is worth mentioning that early copies of the unfinished *Eszterházy Madonna* exist, one of which, now attributed to Fra Bartolommeo (Uffizi, Catalogo Generale, 1979, P 144), excludes the little Saint John. Dussler, op. cit. in n. 12, p. 22, mentions another 'unfinished' copy in the Ambrosiana. A catalogue of unfinished paintings of the sixteenth century is in preparation by Joy Allen Thornton.

and the exclusion of hatched shading.[19] And in Raphael's head of the Virgin, compared with Perugino's, a higher-pitched pink, expanding over larger surfaces, emerges more forcefully from the warm coloured underpainting, thus rendering the flesh more life-like—a quality especially praised by Vasari. The subtle differentiation between the complexion of the two children is not only evident in the radiant fairness of the Christ Child but also in the slightly heavier modelling of the body of the little Saint John, which required more admixture of lead-white (recorded in the radiograph). In these highly fused paint layers, no cracks are visible to the naked eye, in contrast to the slightly more thickly painted *Tempi Madonna* and to other works of the Florentine period as referred to in the introduction.[20]

The brilliant luminosity of the flesh areas keeps them in balance with the rather vivid local colours surrounding them, and a restrained chiaroscuro leaves unimpaired their radiant expansion in the picture plane. In this way the two children and the Virgin are given prime importance in this deliberately symmetrical composition, held in balance by the angel groups in the top corners.

As the *Holy Family* is a representative example of Raphael's more thinly treated flesh painting, the change in the handling of these areas within less than a decade seems even more astounding. In the *Madonna della Tenda* (about 1513) (pl. 92) the warm, yellowish tone in the luminous flesh, so characteristic of the Florentine period, has been replaced by a subtle violet tinge. The impasto now has considerable body and as a result of this shows noticeable cracks. The colour quality is distinctly heavier, and it is integrated into a rather pronounced chiaroscuro, greatly enhancing the plasticity of this complicated group of figures. Even though of relatively modest dimensions (65.8 × 51.2 cm), this monumental composition is clearly related to his fresco painting of the same period. Despite these new tendencies, Raphael retains much of his traditional practice. The flesh painting is still applied directly on the white ground, whereas the surrounding turquoise blue of the Virgin's robe,[21] including the whole shadow zone to the left, is painted on a fairly light red preparation (visible in a cross-section) which borders the outlines of the legs and body of the Christ Child.[22] Despite the stronger chiaroscuro, the contour of the Virgin's head is still accentuated in his Florentine manner.

The incomplete state of the "Canigiani Holy Family." This painting, as we have seen,

[19] The highly finished, light flesh areas of the *Holy Family* are free from hatching. There is, however, subtle hatching in some of the shadows of the hands and feet, partly complementing the already-existing hatched lines of the underdrawing still visible through the thin layer of flesh paint. Details such as nails are very precisely and thinly drawn with the brush as a finishing touch. There is quite a bit of hatching (brown, dark brown, and red as well) in the shadows of the hands of the *Tempi Madonna*. See von Sonnenburg, op. cit. in n. 4, figs. 77, 78.

[20] It is quite instructive to compare, for example, the Virgin's left foot in the *Canigiani Holy Family* with its counterpart in *La Belle Jardinière* or the *Madonna in the Meadow*, to realize the considerable difference in thickness of the paint layers, which also explains the dissimilar handling of the oil paint.

[21] The layer of blue was applied over the dark red lake of the Virgin's dress. As to the more important compositional change involving the head of the little Saint John, see von Sonnenburg, op. cit. in n. 4, pp. 98 ff.

[22] This red layer also extends under the arm of the little Saint John but not beyond; for further details see von Sonnenburg, op. cit. in n. 4, pp. 98–101.

has not been brought to the desired final state in the top corners, and even a few details of the flesh painting of the main group, such as Saint Joseph's left hand and his foot, are lacking the finishing touches. Except for one putto in the top right corner, however, these omissions are hardly noticeable from a normal viewing distance.

An answer to the frequently posed question, why Raphael added his name to an unfinished work, is provided by the technique of painting itself: ornamental design and the inscription RAPHAEL VRBINAS are intrinsic parts of the Virgin's robe (pl. 91), which was completed down to the last detail at an early stage, independently of other areas of the composition. The idea that such an inscription with an artist's signature is added to the finished painting as a last touch, as if to confirm its completion, is clearly a more modern conception.

Pigments used and layer structure.[23] In the red draperies of the three paintings examined, only madder lake was used as a red pigment. This point deserves attention because the three reds are each of a different hue. In the *Holy Family* the madder lake is mixed with lead-white, which accounts for the cool tonality, whereas in the *Tempi Madonna* an admixture of azurite relates the crimson-coloured sleeve to the surrounding blues, which all have a greenish cast. The slightly warmer red of the *Madonna della Tenda* consists of a mixture of madder lake with lead-white and a small addition of carbon black.

Vermilion was used for the ribbon in the Virgin's hair in the *Holy Family* and introduces the delicate touch of a warm red in the proximity of the cool pink of the complexion.

There is a great variation in the use of blue. Azurite is the only blue pigment found in any quantity in the two Madonnas, to which is attributable the predominance of greenish blues in these paintings. The evanescent colour of the sky (azurite, lead-white) in the *Tempi Madonna* not only relates to the greenish blue of the Virgin's robe (azurite, lead-white, traces of ultramarine) but just as closely to the tonality of the distant landscape (azurite, ochre, lead-white). This contributes to the harmonious unity of the painting. The greenish hue in the sky, furthermore, stimulates the flesh colour and almost makes it appear as if it were illuminated by sunlight. In the *Holy Family*, by contrast, the blues are cooler and more saturated, due to the extensive use of ultramarine and also of smalt (in the sky only). While the sky of the *Tempi Madonna* is composed of a single layer of blue, there is a two-layer buildup in the *Holy Family*:

1. a fairly thick underpainting of a greenish blue (lead-white, azurite, and very little ultramarine) which extends under the middle section of the sky, serving as a preparatory colour for the transition from the deep blue to the horizon. The colour of this layer matches exactly the colour of the sky of the *Tempi Madonna*, as demonstrated in a photograph taken when the two panels were moved close together (pl. 88).[24]

[23] For the analysis of the pigments and the preparation of the cross-section, I am indebted to Karin Junghans and Frank Preusser.

[24] See von Sonnenburg, op. cit. in n. 4, fig. 89.

2. a thick layer of cooler and more saturated blue (mainly consisting of ultra-marine, light smalt, and lead-white).

The blue zone of the landscape immediately above the green middle ground is thinly underpainted with a semitransparent layer of a vivid blue (azurite, verdigris, lead-tin yellow, lead-white, and very little carbon black) and covered by a layer of cooler blue with considerably more covering power (not analyzed).

The mauve-grey-coloured mantle of Saint Elizabeth is composed of a thin bluish green underpainting (not analyzed) and a solid top layer (azurite, madder lake, lead-white).

The *Madonna della Tenda*'s blue robe consists of two layers: a light red under-painting (not analyzed) and a thick layer of turquoise blue (azurite, lead-white, carbon black, a little brown ochre). The more thinly painted shadows contain azurite, brown ochre, and carbon black.

The landscape. The right margin of the *Holy Family* is not painted up to the very edge and therefore gives a rare insight into the layer structure of the landscape (pl. 97). For that reason, sampling of some of the separate layers was facilitated.

First, the white ground under the whole landscape was tinted with a thin yellowish brown wash. Horizontal movements of the terrain were marked out with brushstrokes of dark red-brown.

The shadow area reaching up to the elbow of the Virgin is underpainted with a sombre olive green and covered with a thick glaze (not analyzed). The half-shadow zone above shows alternating dark red-brown strokes (referred to above) and light green underpaint (verdigris, lead-tin yellow, lead-white), both covered with a brown layer (verdigris, lead-tin yellow, brown ochre, lead-white, a little carbon black). The topmost layer (probably a modified version of the former layer) consists of a glaze showing marked trails or drips here and there (mostly brown ochre, verdigris, admixtures of lead-tin yellow, lead-white, and plant black). The high percentage of brown ochre suggests that this glaze was meant to have a warm tonality in the first place, and it somewhat differs from discoloured 'copper-resinate' glazes.[25]

Layer structure of the predominantly green section of the landscape.

A. 1. brown wash on the gypsum ground
 2. green layer; this is a first application which looks olive green mainly on account of the brown wash underneath[26]
 3. light green layer (verdigris, lead-tin yellow, lead-white); a second application to accentuate certain passages

The bushes on the right side (and similarly the bushes and trees on the left side, which

[25] Saint Joseph's green drapery is a good case in point. It consists of a solid underpainting (lead-white, verdigris, lead-tin yellow) covered by a 'copper-resin-ate' glaze which is relatively little discoloured.

[26] The same buildup is found in the *Eszterházy Madonna*.

do not appear in x-radiographs) were added subsequently. They are constructed as follows:

 B. 1. very dark transparent green. This layer was broadly brushed on the first general application of green (layer A-2) and partly serves as the shadow of the big bush. The opaque cool green surrounding the bushes and the warm grey used for painting the paths were subsequently applied over this dark layer
 2. green half-shadows of the foliage
 3. dotted bright yellow highlights
 4. thin overall 'copper resinate' type glaze

The more distant trees to the right of the Virgin's head show the following layer structure:

 C. 1. blue-green underpainting
 2. reddish brown leaves summarily applied (scumbled)
 3. dotted warm yellow highlights

This foliage is of a distinctly brownish tonality because no green pigmentation is present in layer C-2 as compared to the more elaborately treated foliage closer to the spectator (B). For that reason, this foliage is not covered by a unifying final overall glaze. In this case, the cool green underpainting is seen through the loosely sketched-on brown leaves.

The main group of figures must have been completed before the landscape received its final adjustments, because, for example, one of the brown scumbles slightly overlaps the white headdress of Saint Elizabeth.

X-radiographs reveal that the plants in the foreground are underpainted with great precision (pigmentation: lead-white, verdigris, lead-tin yellow). Presumably, this area has darkened considerably as a result of the heavy glazing.

Not only the frequently quoted small panel with *Saint George and the Dragon* (Washington) reflects Raphael's study of paintings by Memling but also this elaborately treated landscape of the *Holy Family*. Comparative analytical study would be required in order clearly to define the difference in terms of technique.

Raphael's choice of pigments for the different layers of the landscape turns out to be quite consistent throughout and conspicuously excludes the use of blue pigment, at least in this case. The unknown painter of the *Portrait of a Young Man* (Inv. 1059), by comparison, used an admixture of azurite for both cool and warm (brownish) greens (pigments used in different proportions: azurite, lead-tin yellow, ochre).

Gilding. The haloes and most of the ornamental design of the *Holy Family* were painted with great sureness directly on the paint layer. Raphael's name was painted on a preparatory dark brown glaze and subsequently glazed again in order to offset the individual letters more clearly.

The haloes of the *Tempi Madonna* were done with gold powder on the basis of

incised lines. The delicate ornamentation of the hem of the Virgin's blue robe is carried out with gold powder in tiny parallel strokes and dots of different intensity. By comparison with the rather stark gilding of the *Holy Family*—which, however, seems in keeping with its vivid colours—this type of ornamentation, following more the movement of the underlying material, might be interpreted in terms of a more advanced stylistic development.

A considerable step beyond this stage at the end of the Florentine period is reached in the *Madonna della Tenda* of about 1513, where the gold ornament of the hem is imitated with impressionistic accents of yellow paint (lead-tin yellow). The haloes are painted with gold powder. For the incision of the circular halo of the Christ Child, a pair of compasses was used and clearly left its mark in the paint layer.

General comments on Raphael's colour. The extraordinary luminosity of Perugino's colours, unusual for his own time, undoubtedly impressed the young Raphael. However, already at the beginning of his Florentine period, he gradually softened the intensity, particularly of the reds, which in Perugino's paintings sometimes seem to rival the effect of stained-glass windows. A touch of this is still to be found in the *Colonna Altarpiece* and, at the same time, a preference for the combination of bright pink and yellow so frequently used in draperies of fifteenth-century paintings.

As compared with the often rather hard colouring of many contemporary Florentine works, subject to the primacy of modelled form, there is in Raphael's work an obvious tendency towards greater harmony of the general colour scheme, which ensures them a somewhat independent position. This is evident in comparison with works of other artists, such as Michelangelo's *Doni Tondo*, which in other respects had a considerable influence on Raphael's *Holy Family*. The Umbrian master's rather static group contrasts with Michelangelo's relatively agitated figures, but he introduces movement into his composition in quite a different way by using the full impact of saturated colours surrounding the luminous areas of flesh.

Even at a more advanced stage in Raphael's development, the primary rôle of the colour in relation to the increasing contrasts of light and shade still prevails. This is evident in a passage such as the foreshortened shoulder of the *Madonna della Tenda*, where Raphael changed his composition by introducing blue into the shadow zone, quite obviously at the expense of considerations of chiaroscuro.

The Portrait of a Young Man (Inv. 1059) (pl. 85), presently exhibited in the Alte Pinakothek as 'Umbrian about 1505.'

Condition. The general state of preservation is good. Very old repaints in the hair apparently cover up early cracks. There are some discoloured retouchings in the face and neck. The varnish is slightly discoloured.

The portrait is painted on a poplar panel (of one piece) 53.5 × 41.2 cm, 1.4 cm thick.

The back of the panel is covered with a white ground of gypsum and anhydrate

(showing tiny white spots in the x-ray[27]) and an additional grey priming (original). At the top and bottom of the panel there is a margin not covered with the ground, indicating that the panel was fitted into the groove of a temporary frame of sorts before the ground was applied, a practice not uncommon around 1500.

The face is extremely thinly painted and shows a predominantly yellowish undertone, whereas the hand is of a cooler tonality, the result of a somewhat more substantial layer of flesh paint. The eyebrows are noticeably accentuated with loosely sketched brushstrokes, contrasting with the extremely fine hatching under the man's left eye. Several corrective changes are noticeable in the contour of the shoulder and of the hair. X-radiographs (pl. 241) reveal that the contour on the left side was altered more than once. First, it was considerably narrowed and subsequently changed back approximately to its first position. It is evident that the trees copied from Memling's *Saint John the Baptist* (Alte Pinakothek, Inv. 652) were only introduced into the composition at this stage, because they meet the final contour of the mass of hair.

Apparently, the painter planned a compositional scheme comparable to the *Lady with the Unicorn* (Galleria Borghese), with an open landscape and two framing columns. The unrevised incorporation of a section of Memling's landscape, which has a much higher horizon, results in a somewhat odd distortion of the perspective. A direct comparison of the two paintings in the original shows a considerable difference in the colour of the foliage. Memling's green is noticeably cooler and of greater intensity and transparency compared with the distinctly brownish tonality of the portion copied in the Italian painting. The technical buildup of the earlier Flemish work, with its more complicated layer structure and choice of different pigments, is probably more responsible for the difference than the passage of time.

Since the first mention of the portrait in 1759, the inscriptions on the two buttons, RAFFAELLO VRBIN(A)S P, have given rise to speculation regarding the identity of the sitter as well as the authorship of the painting. The lettering consists of a thick layer of dark brown transparent paint which was directly applied on the yellow highlights of the buttons (lead-tin yellow, yellow ochre). The letter V is faintly perceptible in the radiograph, which would support an argument in favour of its being contemporary with the buttons. It could, however, just as well have been incised at a later date into the yellow highlight and strengthened with dark paint. A terminal date for this inscription is provided by an undated engraving of the eighteenth century by Antonio Pazzi (1706–66). The obviously laboured and clumsily spaced lettering strongly suggests a later addition. In any event, it should be of little consequence in view of the rather derivative quality of the painting itself.[28]

[27] See above, note 11.

[28] For further detail, see von Sonnenburg, op. cit. in n. 4, pp. 106–13 and J. Shearman, *The Pictures in the* *Collection of Her Majesty the Queen: The Early Italian Pictures*, Cambridge (1983), pp. 208 ff.

8

Paintings by Raphael in the
Palazzo Pitti, Florence

MARCO CHIARINI

OF THE eleven paintings by Raphael in the Pitti Gallery, three have always puzzled critics and scholars on account of their present appearance: they are the *Madonna del Granduca* (pl. 98), the *Madonna del Baldacchino* (pl. 99) and the *Portrait of a Lady* called *La Velata* (pl. 100).

The *Madonna del Granduca* was acquired for the Florentine Grand-Ducal Collections in 1799 to replace the paintings by Raphael which Napoleon had taken from the Pitti Palace for the Grande Galerie in the Louvre. It was the idea of Tommaso Puccini, then director of the Uffizi, to compensate in this way for the losses suffered by the Habsburg Grand Duke, Ferdinand III of Lorraine, who was exiled at Würzburg. The necessary permission to buy the painting for the exiled Grand Duke had to be given by Napoleon before the *Madonna*, whose provenance still remains a mystery, could be secured for the banished ruler;[1] afterwards, it was to remain linked to his name because of his fondness for it.[2]

This *Madonna* is one of the most popular and celebrated of Raphael's Florentine period; it has been suspected that the dark background might not be authentic ever since Fischel connected with it a drawing in the Uffizi printroom—a drawing which shows that Raphael originally intended to have a landscape background behind the figures of the Mother and Child.[3] A further confirmation of this possibility was Berenson's identification of a copy after the *Madonna del Granduca*, a photograph of which exists in the Berenson Archive;[4] the background consists of a landscape with trees and hills in the manner of some of Raphael's portraits of the Florentine period. But exactly what the black background conceals from our eyes has now been revealed by recent x-radiography of the painting (pl. 249); the Virgin and Child are not set in a landscape, but in a room with a window, or rather a loggia, on the right, through which one has a

I with to thank my colleagues Umberto Baldini and Ing. Maurizio Seracini of Editech, who was responsible for the radiography of Raphael's paintings in Florence, for having kindly allowed me to anticipate the results in the three paintings in Palazzo Pitti.

[1] It has sometimes been said that the painting came from the collection of Carlo Dolci, but this is the result of a misreading of a remark by Passavant (see the exhibition catalogue, *Raffaello a Firenze*, Palazzo Pitti, Florence [1984], p. 88).

[2] The painting was seen by Von Rumohr in Würz-burg in 1802 (J. Pope-Hennessy, *Raphael*, London and New York [1970], p. 285, n. 18; thereafter it returned to Palazzo Pitti but remained in the private rooms until some time after the opening of the Palatine Gallery in 1834, since it is not listed in the catalogue by F. Inghirami of that year.

[3] O. Fischel, *Raffaels Zeichnungen*, iii (1922), no. 105.

[4] Pope-Hennessy, op. cit. in n. 2, pp. 185 and 285, n. 19; reproduced in *Raffaello a Firenze*, cit. in n. 1, p. 97.

view of a landscape, rapidly sketched in. The revelation was unexpected, as everyone was convinced, on the basis of the Uffizi drawing and the photograph of the old copy, that there would only have been a landscape. Furthermore, the reflectogram of the painting has revealed a very careful underdrawing, transferred from the cartoon onto the primed surface by the traditional method of pricking the outlines of the composition and dusting with charcoal powder (pl. 250, 251). But the *spolveri* thus produced are limited to the two figures, which are meticulously drawn in every detail; there are no traces of such underdrawing for the background, which seems to have been painted straight on the panel without using a preparatory cartoon. This could imply that Raphael changed his mind, abandoning his first idea reflected in the Uffizi drawing (the copy mentioned above evidently cannot be taken into account any more in this context as a document of the actual state of the painting before the black background was applied). The question remains as to the date when the background was painted over. From the scientific analysis of the painted surface it has become increasingly clear that the black paint was added much later, after the background had already suffered some losses in the paint.[5] That Raphael himself decided to alter the appearance of the background can now be excluded, but we are still not able to establish when and why it was repainted: whether on account of a change of taste, or because the original background was damaged. A decision to go ahead and uncover the background completely might answer the question.[6]

Chronologically, the second painting to be examined here is the *Madonna Enthroned between Saints Peter, Bernard, James the Great and Augustine*, known as the *Madonna del Baldacchino*. This painting was begun by Raphael for the Dei family in Florence and commissioned for the altar of their chapel in Santo Spirito, an Augustinian church (hence the presence in the painting of the titular saint). As is well known, Raphael never finished the painting because he left Florence on being summoned to Rome by Donato Bramante. The altarpiece remained in its unfinished state, and after some time it was sold by the Dei family to Messer Baldassarre Turini, a dignitary at the Papal Court in Rome and a friend of Raphael, who placed it in his family chapel in the Cathedral of Pescia, his native town. The painting remained there until Ferdinando de' Medici, son of Grand Duke Cosimo III, acquired it in 1697 for his collection in the Pitti Palace, where it is still preserved. On that occasion we know that the panel was added to at the top (to match the size of Fra Bartolommeo's *Risen Christ*, also in Ferdinando's collection) by Niccolò Cassana, restorer to the Prince, who was also responsible for some restoration and retouches.

The present state of the painting, as has been observed several times, is virtually limited to the preparation and underdrawing; only some of the draperies have been given a more finished form. The problems posed by this unfinished work by Raphael have been admirably summed up by P. A. Riedl in an article devoted to the *Madonna del Baldacchino* in which he discusses all the evidence concerning its provenance and

[5] These observations were kindly passed on to me by Signora Paola Bracco, who has made tests on the painting and cleaned the figures of the Virgin and Child.

[6] The painting will continue to be exhibited with its dark background for the forseeable future.

critical history.[7] His conclusions need nevertheless to be revised in the light of the evi-
dence now available from the x-radiographs and the reflectograms of the surface, and
from a close-up examination of the painting under a strong light. First of all, it appears
that the painting was evolved in several phases, a fact that is confirmed by the evidence
of the preparatory drawing at Chatsworth.[8] From the comparison between the drawing
and the painting and the results of the various investigations of the surface, it may be
possible to draw some conclusions. Raphael began by transferring onto the primed
surface, cartoons for the figures of the Madonna and Child and the two singing angels
at the foot of the throne; this can be seen very clearly from the reflectogram, which
shows *spolveri* in certain areas, especially in the angels (pl. 262–266). The outlines of
the base and steps of the throne, however, were not transferred from a cartoon but
incised directly on the priming, as may be seen if one examines the surface of this area
in raking light. The figures correspond exactly to the Chatsworth drawing with only
minimal differences between the two compositions.

On the other hand, Raphael made many changes when he began work on the two
flying angels holding up the curtain of the canopy and on the four saints; these are the
parts of the painting, in addition to the architectural background, that have given rise
to discussion. It is not necessary here to refer to all the various opinions, which have
been summarized by Riedl; but it is interesting to report his final conclusions. In his
opinion, Raphael was responsible for the four central figures (the Madonna and Child
and the two singing angels) and perhaps also for the two saints on the left, whereas the
rest of the painting was the work of one of Raphael's pupils or of an artist in Florence.
The argument for rejecting Raphael's authorship for these parts is that the two flying
angels are derived from those in his fresco in S. Maria della Pace, while the two right-
hand saints are considered untypical of Raphael's style.[9]

But recent examination of the work would appear to confirm Raphael's author-
ship, even for the controversial parts, because of the extremely high quality of the pre-
paratory drawing throughout. This drawing was executed by the painter directly with
the brush, perhaps over an initial pencil outline which is not visible; the technical mas-
tery of the drawing and its perfect homogeneity in all parts of the work are, to my mind,
proof of their being by Raphael's own hand. Furthermore, the x-radiographs of some
parts (pl. 267, 268)—for instance, the heads of the angels above—have all of Raphael's
stylistic characteristics and the relationship of these two figures to the architectural
background makes it improbable that they should have been added by a different hand
at a later date. The same can be said of the two saints to the right of the throne (pl. 271,
272); Raphael changed his mind completely here and altered the poses and attitudes of
those in the Chatsworth drawing. The details of the heads, hair, hands, and feet reveal
Raphael's personal style and the ease and accomplishment with which he outlined the

[7] P. A. Riedl, 'Raffaels "Madonna del Baldac-
chino," ' *Mitteilungen des kunsthistorischen Institutes
in Florenz*, viii (1959), pp. 223–46.

[8] The Chatsworth drawing is reproduced, from an
old photograph, in *Drawings by Raphael from the
Royal Library, The Ashmolean, the British Museum,*
Chatsworth and other English Collections, exh. cat. by
J. A. Gere and N. Turner, British Museum, London
(1983), p. 82.

[9] An objection to this point of view is also expressed
by Gere and Turner, op. cit. in n. 8, pp. 83–84.

forms with the brush straight on the priming. What still remains doubtful is whether the colouring of the draperies of these two saints was added later, since they appear to be more coarsely painted compared with those of the other figures.

Riedl based his conclusions about the architectural background of the painting on two factors: the first, that it does not appear in the Chatsworth drawing, which shows an empty background behind the throne; the second, that the type of architecture demonstrates an acquaintance with Roman Imperial architecture (the Pantheon). Against the first point it can be argued that, having changed his mind on several parts of the composition, Raphael could easily have added the architectural background on second thought; the second is contradicted by the fact that the capitals of the columns and pilasters in the painting correspond exactly to those of Santo Spirito, the church for which the altarpiece was intended. If one bears in mind that the chapels of Santo Spirito are semicircular in shape, one can appreciate Raphael's sensitivity in creating a similarly hemispherical space for his group—as Fischel seems to imply in his comment that the architecture is "a niche in the best style of Brunelleschi." But again, x-radiographs (pl. 270) have brought to light the powerful drawing of the architecture, which cannot have been executed by a hand other than that of Raphael himself: the feeling of unity binding the whole composition is too strong to allow for the theory advanced by Riedl, whereby Raphael could have sent a drawing from Rome, before 1516, for the completion of the painting by another artist.[10] The recent technical examination therefore confirms that Raphael was personally responsible for the whole work, which marks the passage from the artist's Florentine style to the one he was to develop in Rome.

The third painting under discussion here is the *Portrait of a Lady*, called *La Velata*, also in Palazzo Pitti. The painting was known to Vasari, who mentions it in the collection of a Florentine, Matteo Botti, whose son bequeathed it to Grand Duke Cosimo II de' Medici in 1619. It was admirably commented on by Fischel,[11] who drew attention to an etching by Wenzel Hollar after a painting then in Lord Arundel's collection but now lost, which showed the *Velata* with the attributes of Saint Catherine (pl. 273). Consequently, the German scholar suspected that the Pitti painting might originally have represented Saint Catherine and that this could have been the sitter's name. A very interesting x-radiograph of the painting (pl. 274) has now solved the problem: not only did the figure never have the Saint's attributes, but Raphael first painted her almost completely wrapped in her veil, hence the name *La Velata*. Evidently Raphael, or the sitter, had second thoughts, and the artist decided to add the sleeve, an astonishing piece of 'bravura' painting, which was painted, concealing the first idea, over a red preparation.[12] The reflectogram has revealed only a few traces of underdrawing executed very freely (pl. 275–282). The cleaning has now brought out all the nuances and tonal subtleties of this painting: the effect is cooler than before, after the removal of the yellow varnishes, but all its preciosity, so aptly described in Fischel's words, is still more ap-

[10] The date 1516 is provided by a copy of the *Madonna del Baldacchino* by Leonardo da Pistoia, dated to that year, cited by Riedl (reproduced in E. Carli, *La Pinacoteca di Volterra*, Pisa (1980), fig. 17).

[11] O. Fischel, *Raphael*, London (1948), pp. 123–24.

[12] I am grateful to Prof. Alfio Del Serra, who has restored this painting, for having brought this fact to my notice.

parent, and the 'idealisation' of the figure stronger than ever, even if we can now say for certain that the *Velata* was never a saint.

SINCE delivering the above paper at the Raphael Symposium of 1983 held in Princeton, I have been obliged to revise my opinion on two points regarding Raphael's paintings in the Pitti Gallery. I no longer think that the dark background of the *Madonna del Granduca* was a later addition: I am now convinced that it was the result of a change of mind on the part of the artist. However, my arguments for this would be too lengthy for inclusion here. The *Madonna del Baldacchino* is currently being restored: the cleaning confirms that it is entirely by Raphael himself and that there are no traces of another hand, except for the documented addition of the strip at the top dating from the late seventeenth century.

9

Analyses of Wood from Italian Paintings with Special Reference to Raphael

PETER KLEIN AND JOSEF BAUCH

FOR many years, wood-biological investigations and dendrochronological analyses have been carried out on panels.[1] Up to the present, these studies have mainly concentrated on ring-porous wood, which was generally used for panels in England, the Netherlands, Belgium, France, and also Germany.[2]

Making use of the experience gathered with oak panels, dendrochronological dating is now being successfully applied to diffuse-porous beech wood, which was used, for example, by Lucas Cranach the Elder.[3] After the first successful datings, we attempted to obtain similar information from other diffuse-porous wood species. Analyses of linden wood showed promising results, making dendrochronological statements a future possibility.[4] But for a long time, the art historians had been making a special request for corresponding studies of poplar, which was the most important wood species for Italian artists. The problem is of special interest in the case of the paintings of Raphael, because they are mostly neither signed nor dated.

The object of this paper is to provide an introduction to the biological characteristics of poplar wood, and to give some consideration to the construction of panels and the possibilities and limitations of a tree-ring analysis of poplar panels.

Wood Species Used for Italian Paintings

The panels that form the supports for paintings were almost invariably made from species available locally. Fundamental information on works of art and artifacts can be

[1] J. Bauch, 'Die Problematik der geographischen Reichweite von Jahrringdatierungen dargestellt an Beispielen aus der norddeutschen Tiefebene,' *Kunstchronik*, xxi (1968), p. 144.

[2] J. Bauch and D. Eckstein, 'Woodbiological Investigations on Panels of Rembrandt Paintings,' *Wood Science Technology*, xv (1981), p. 251; J. Bauch, D. Eckstein, and G. Brauner, 'Dendrochronologische Untersuchungen an Eichenholztafeln von Rubensgemälden,' *Jahrbuch der Berliner Museen*, xx (1978), p. 209; D. Eckstein and J. Bauch, 'Dendrochronologische Altersbestimmung von Bildtafeln,' *Die Kölner Maler von 1300–1400*, exh. cat., Cologne, Wallraf-Richartz-Museum (1974); J. M. Fletcher, 'A Group of English Royal Portraits Painted Soon after 1513: A Dendrochronological Study,' *Studies in Conservation*, xxi (1976), p. 171; *idem*, 'Tree-ring Dating of Tudor Portraits,' *Proceedings of the Royal Institute of Great Britain*, lii (1980), p. 81; P. Klein, 'Dendrochronologische Untersuchungen an Eichenholztafeln von Rogier van der Weyden,' *Jahrbuch der Berliner Museen*, xxiii (1981), p. 113.

[3] P. Klein and J. Bauch, 'Aufbau einer Jahrringchronologie für Buchenholz und ihre Anwendung für die Datierung von Gemälden,' *Holzforschung*, xxxvii (1983), p. 35.

[4] P. Klein, 'Dating of Art-Historical Objects,' D. Eckstein et al., eds., *Dendrochronology in Europe* (Hamburg, Bundesforschungsanstalt für Forst-und Holzwirtschaft, 1983), p. 201.

derived from knowledge of the wood species.[5] Table 1 shows the identification of species of fifty Italian panels exhibited in Berlin and Munich. It is obvious that poplar was principally used as support for the paintings, and these results correspond to the investigations by Marette.[6] Because the species have often been determined in museums with the naked eye, it is necessary to identify microscopically the wood species for every panel to be analysed (pl. 102–105). There exist considerable possibilities of confusion between linden and poplar wood, and also between chestnut and poplar.

The Raphael panels investigated were manufactured from poplar. The identification of the support of the *Canigiani Holy Family* as linden wood, and of those of the *Tempi Madonna* and *Madonna della Tenda* as a chestnut wood, can no longer be upheld.[7] Very few Italian panels, in fact, can have been made of chestnut; so far, all panels identified as "chestnut" have been found actually to belong to other species.

In contrast to this survey of Italian paintings, a statistical analysis of several hundreds of Dutch paintings shows a different choice of wood species: fifty percent were painted on oak panels, the remainder on a variety of supports, including canvas, copper, and even to a limited extent, tropical wood species.[8] Besides the identification of the wood, it has been possible to extract from our investigations further information about the manufacture of poplar panels. The manner of fabrication of a panel can be quite informative about its quality, or even about the century to which it may be attributed.

The Saw-cut of Boards from Poplar Trees

In contrast to panels of oak and beech wood, where the thickness varies from 5 to 12 mm on average, the poplar panels of Raphael show a range of thicknesses from 15 to 35 mm. In most cases (pl. 106) the boards were oriented tangentially within the trunk. The planks were often cut in strictly tangential directions (Case 1), but sometimes a mixture of radial and tangential cuts was evident (Case 2). The boards often extend across the entire tree, but they were not sawn through the pith; therefore a saw-cut in a strictly radial direction could not be found. Due to the removal of all the bark, and the uniform colour of the wood, it could not be decided whether the entire tree had been utilized and how many growth rings toward the bark had been cut off.

In contrast to poplar wood, the cut of high-quality panels from oak (pl. 107) was made parallel to the rays, which guaranteed optimum dimensional stability. Care was taken in removing the less durable sapwood as well as the young wood near the pith (Cases 1 and 2). But the carpenters also took smaller-size boards from the inner heartwood (Case 3), and in some cases large-size boards extending across the pith (Case 4). Occasionally, the boards were oriented tangentially within the trunk (Case 5), which entailed the risk of warping.[9]

[5] D. Grosser, 'Holzanatomische Untersuchungsverfahren an kunstgeschichtlichen, kulturgeschichtlichen und archäologischen Objekten,' *Maltechnik-Restauro*, lxxx (1974), p. 68.

[6] J. Marette, *Connaissance des primitifs par l'étude du bois du XII^e au XVI^e siècle*, Paris (1961).

[7] H. von Sonnenburg, *Raphael in der Alten Pinakothek*, Munich (1983), p. 49, n. 10.

[8] Bauch and Eckstein, op. cit. in n. 2.

[9] Ibid.

Table 1. Examples of the Nature of the Wood of Fourteenth- to
Sixteenth-century Italian Support Panels.

Wood species	Klein/Bauch (1983)		Marette (1961)	
	number	percent	number	percent
Beech	4	8.0	1	0.3
Chestnut	—	—	—	—
Cypress	1	2.0	—	—
Fir	1	2.0	9	2.6
Linden	2	4.0	5	1.4
Oak	—	—	5	1.4
·Poplar	36	72.0	310	90.0
Spruce	5	10.0	3	0.9
Walnut	1	2.0	10	2.9
Other species	—	—	2	0.5
Total	50		345	

A similar investigation was made into the use of beech wood. Because this species does not have a "true" heartwood, however, it was found that the entire tree radius was utilized and that in the making of the panels only the bark was removed.[10]

The Manufacture of Poplar Panels

The saw-cut of the boards from the trunk determines the construction and the composition of the panels. The Italian poplar panels that were analysed from Vivarini and his workshop, Raphael, and other unknown schools of the fifteenth and sixteenth centuries, had often been cut as a single board with dimensions from 17 × 14.5 cm to 105 × 46 cm.

All boards of the seven panels painted by Raphael at Berlin and Munich (Table 2) were found to have been oriented tangentially within the trunk. Two panels consist of one board (pl. 284), three panels of two boards (pl. 283, 285), and the other two panels of three and four boards respectively. In contrast to the tests of the wood of linden trees, of which panels painted by Dürer, Cranach, Altdorfer, or Baldung-Grien are composed, which were glued from several small boards, the survey of the Raphael panels showed that they were composed of wider boards. The tangential saw-cut of boards often entails the risk of warping. For example, the panel of the *Solly Madonna* warps to the extent of 0.8 cm over the span of 40 cm (fig. 9–1), and the panel of the *Diotalevi Madonna*, consisting of two boards, warps to the extent of 0.5 cm over a span of 69 cm (fig. 9–2). It is evident that the tangentially sawn boards may be painted on the side adjacent to the bark or on that toward the pith; the warping of the board is always

[10] Klein and Bauch, op. cit. in n. 3.

Table 2. List of the Analysed Paintings by Raphael

Museum	Painting	Chronology	Wood species	Dimensions: height × width × thickness, in cm	Number of boards
Berlin, Gemäldegalerie, Cat. No. 141	Solly Madonna	1500–1	Poplar	54.5 × 40.0 × 1.3	1
Berlin, Gemäldegalerie, Cat. No. 145	The Virgin and Child with Saints Jerome and Francis	1501–2	Poplar	34.5 × 29.5 × 1.2	1
Berlin, Gemäldegalerie, Cat. No. 147	Diotalevi Madonna	c. 1502	Poplar	69.0 × 50.0 × 2.0	2
Berlin, Gemäldegalerie, Cat. No. 248	Colonna Madonna	c. 1508	Poplar	78.5 × 57.5 × 3.0	2
Munich, Alte Pinakothek, Inv. no. 476	The Canigiani Holy Family	c. 1507	Poplar	131.0 × 107.0 × 3.5	4
Munich, Alte Pinakothek, WAF 797	Madonna della Tenda	c. 1513	Poplar	66.0 × 51.0 × 1.3	3
Munich, Alte Pinakothek, WAF 796	Tempi Madonna	c. 1507–8	Poplar	75.0 × 51.0 × 2.8	2

front of the panel

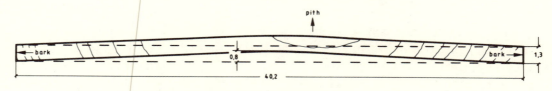

back of the panel

Figure 9–1. Cross-section of the edge of the Solly Madonna (Gemäldegalerie Berlin-Dahlem), one board.

front of the panel

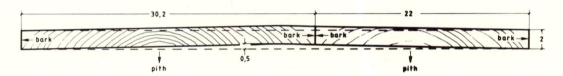

back of the panel

Figure 9–2. Cross-section of the edge of the *Diotalevi Madonna* (Gemäldegalerie Berlin-Dahlem), two boards.

determined by the paint layer, which marks the convex side. From this behaviour of the wood, it can be concluded that the paint layer prevents the diffusion of moisture. Consequently the shrinkage will always start on the unsealed area. Normally, however, the boards shrink more on the bark side than on the pith side. It is also obvious that the boards of the panels of the *Canigiani Holy Family* are not visibly warping (fig. 9–3). Their good condition is largely dependent on their thickness and not on the anatomical structure of the wood.

Dendrochronological Analyses of Poplar Panels

In contrast to oak and beech trees, poplars grow very fast. Every year the growth ring may amount to a width of 1 cm or even more. Hence a poplar tree with a diameter of 20 to 30 cm may contain only about twenty growth rings, while in an oak tree of similar size about a hundred growth rings can be counted (pl. 108, 109). Furthermore, in diffuse-porous species such as poplar, several growth rings always contribute to the passage of water, with the consequence that under adverse climatic conditions, for example in very dry years, the tree is not bound to form a new growth ring. Such trees may sometimes show totally or partially missing rings. On the other hand, two growth in-

front of the panel

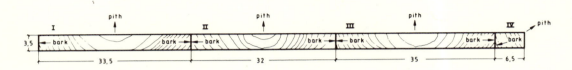

back of the panel

Figure 9–3. Cross-section of the edge of the *Canigiani Holy Family* (Alte Pinakothek, Munich), four boards.

crements may be detected in one year, resulting in a so-called "false ring."[11] Such mis-leading, double-ring formation is caused by late frost, or influenced by fungi or insects.

Nevertheless, we obtained growth-ring curves of thirty to forty years, and the chronological compatibility of recent poplars within similar and between different sites was examined. Because of the insufficient number of tree rings, it was not possible to establish a chronology. Transferring this experience to an examination of Italian paintings, it could be shown for paintings of Antonio Vivarini (1418/20–1476/84), that up to seventy growth rings were present. Normally, the boards would show at most about forty growth rings. Furthermore, it would be possible to attribute to the same tree, by means of the growth-ring pattern, boards of different panels (fig. 9–4).

Such observations could not be made about the paintings by Raphael. In the panel of the *Solly Madonna*, only sixteen growth rings can be detected. In the first board of the panel of the *Diotalevi Madonna*, thirty-five growth rings can be counted. The patterns of the two sides of the tree correspond, but this dendrochronological synchronization is an exception. A comparison of the seven Raphael panels with a total of fifteen boards does not allow any statement about chronology.

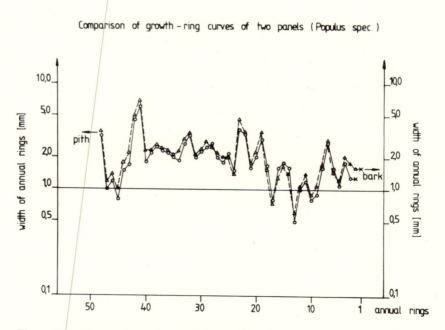

Figure 9–4. Comparison of annual ring widths of two poplar panels painted by Antonio Vivarini: *The Coronation of the Virgin* and *The Adoration of the Magi*, from *Six Scenes from the Life of the Virgin* (Gemäldegalerie Berlin-Dahlem, cat. no. 1058).

[11] W. Elling, 'Schwierigkeiten bei der Jahrringanalyse zerstreutporiger Holzarten,' *Kunstchronik*, xxi (1968), p. 146.

Conclusion

For many years wood-biological and dendrochronological analyses have been helpful for dating works of art. An attribution can often be checked by a tree-ring analysis. From the different master charts which exist for oak, beech, spruce, or fir wood, it is possible to give the felling date of a tree used for panels or woodcarvings.

For poplar wood, a dendrochronological dating is not possible, because of the insufficient number of growth rings. Consequently, a master chart designed to cover the historical period of the Italian artists cannot be established for this species. For panels of Italian artists such as Antonio Vivarini, a correlation between different boards originating from the oeuvre of one artist can be established. However, the individual pattern of growth rings of the Raphael paintings analysed does not allow a similar statement.

Technological studies of the composition and construction of Italian panels can give some assistance to the conservator in judging the stability of the panels. Therefore, in the case of poplar panels, further research might contribute more knowledge useful to the conservation of Italian paintings.

10

Sixteenth- and Seventeenth-Century Marble Incrustations in Rome: The Chigi Chapel

PRISCILLA GRAZIOLI MEDICI

DURING the restoration work carried out last year on the marble incrustation, that is, the interior decorative marble facing, of the Chigi Chapel in the Church of S. Maria del Popolo in Rome, I had the opportunity to study these marbles and to compare them with other recently restored sixteenth- and seventeenth-century floor and wall incrustations, such as those in two halls in the Vatican, the Sala Regia by Antonio da Sangallo and the Sala Clementina, and in two chapels by Gian Lorenzo Bernini, the Fonseca Chapel in the Church of S. Lorenzo in Lucina and the Chapel of S. Barbara in the Cathedral of Rieti.

To arrive at a comparison between the sixteenth and seventeenth centuries, I believe it would be useful to recall briefly that the history of polychromatic marble floor and wall decorations began in Rome in the classical period around the first century B.C., but reached a level of splendour and opulence only two hundred years later with the luxurious floors of the Domus Tiberiana and the Domus Transitoria and with the Domus Aurea of Nero, lavishly decorated with marbles as well as gold, gems, and every other sort of precious material. The ancient history of these marbles, which came, for the most part, from distant provinces of the Empire, continued with the splendours of Hadrian's Villa, of the Pantheon, of the Curia Senatus, of the Basilica of Junius Bassus, and of many other buildings, and lasted until the sixth century. They attained a richness of effect and of polychromy as well as a perfection of working techniques believed, until now, to have seen their revival only with Bernini and Baroque art.

When the ancient quarries were closed, the sixth century gave rise to a new art—the reuse of old materials, of ancient traditions, and of Byzantine tastes—in which later on several families or dynasties, such as the Vassalletto and the Cosmati, distinguished themselves. This style remained relatively unaltered through the centuries until the threshold of the sixteenth century with the floors of the Sistine Chapel and of the Stanze of Raphael (pl. 110). We then find the floor of Raphael's Stufetta for Cardinal Bibbiena (pl. 111), which can still be considered Cosmatesque in style because of its large circular pattern, but where one already notices a modern symmetry and fullness of form and colour, different from the designs and polychromy of the style of the Roman marble craftsmen, which was so precious and detailed, so colourful and asymmetrical.

With the exception of the white Carrara (the ancient marble of Luni), all the mar-

bles used in Rome from the sixth century until the beginning of the sixteenth were exclusively reused ancient marbles. It was the Medici of Florence who first sought out and quarried the new marbles, such as *Breccia Medicea* which was used in Rome, to my knowledge, for the first time in Palazzo Madama. However, it was Bernini who introduced really new marbles, almost as fine as the ancient ones, to Rome. In fact, as far as I know, there does not exist a single example of his marble decorations which does not contain at least one of these new marbles.

For centuries, however, the working techniques (as opposed to the materials themselves) remained unchanged, varying only according to the period, the skills of craftsmen, and their tastes, until the First World War, when the use of cement and of electrical machinery for cutting and polishing began. The value of polychrome marbles remained intact and their preciousness even increased due to the difficulties in finding and working them. The methods of excavation, of transport, and of cutting, first of blocks and later of columns removed from the ruins of ancient Rome, never changed (although, between the sixth and the fifteenth centuries we do find some thick and irregular slabs and pieces sheared off rather than cut). The coloured marble panels were backed or 'lined' with a local volcanic stone called *Peperino*, using a very strong resin known as *misturina*. Whilst the bronze clamps, used to attach the marble linings to the masonry walls, were replaced with iron ones during the sixteenth and seventeenth centuries, the polishing continued to be done using the old techniques.

For the reasons outlined above, it remains difficult to date a marble incrustation with confidence, without studying also the architectural style, the marbles used, and the section in profile. It is particularly important to distinguish the quality of the working of the joints and the regularity of the thickness of the slabs of marble. In my analysis of the individual marble elements in the Chigi Chapel, I will follow the order of the process of construction as it would have been if things had proceeded normally.

The Floor

The paved surfaces, a documented 'restoration' of the seventeenth century, are in the very personal style of Bernini, expressed in the design of the panels and of the borders in grey and white Carrara marbles (a mirror image of the vaulted ceiling) as well as in the inlaid tomb lid (pl. 112). In addition, I find that the work was executed with the mastery and the knowledge of materials and methods typical of Bernini's atelier. The pieces are thin and regular—the floor slabs vary between 10 and 12 mm, the retaining frame around the tomb lid is not less than 50 mm thick, and the lid itself, in antique marbles inlaid in black Carrara, reaches seventeenth-century dimensions of around 3 to 4 mm.

The Corinthian Order

The pilasters—in a splendid white Carrara marble and all cut from a single block— were placed on top of the floor, and were erected around the circumference of the

Chapel, course by course (rather than individually, one pilaster after another), beginning with the Attic bases (fig. 10–1) until reaching the exceptionally rich decoration between the capitals (pl. 113), which seems to come from the same marble atelier as the panels of the Stufetta of Cardinal Bibbiena (pl. 114). The Corinthian capitals, on the other hand, are incised on their sides with diagonal notches (pl. 115), indicating that the subsequent marble facing of the walls to either side of the pyramids was, in fact, anticipated.

The frieze is composed of a simple band of pink *Portasanta* marble from Chios (pl. 116), ancient like all the other marbles in this wall incrustation, which changes to *Rosso Antico* marble from Tenaro where the trabeation recedes and is broken by the pyramids. This reminds me of the visual play which Bernini creates in S. Andrea with pink and red marbles (the new *Cottanello* and *Diaspro* from Sicily), perhaps in order to put the mouldings into greater relief against the recessed plane surfaces.

The Niches

I believe that the niches were faced with marble at the same time as their shell decoration (pl. 117), in *Portasanta* of sixteenth-century workmanship. The plane surfaces are, in fact, in *Africano* (Lucullean or Teos marble), perfectly aligned to the white trabeation beneath the cornice, trimmed by a sort of moulding of *Portasanta*. The vertical splines, of the same pink marble and built to the same thickness as that of the facing band within the niches, correspond precisely to the external spline of the same thickness as the shell.

Under the coping of the niches, the four large panels of *Portasanta*, coming again from a single block or column, are surprising at first sight for their exceptionally 'modern' symmetry. But, upon closer scrutiny, and in comparison with other sixteenth-century marble panels and, above all, because of the cornice with cincture and cyma in white Carrara marble placed over the panels, one quickly realizes their contemporaneity with the earliest decorative phase of the Chapel.

The Tombs and the Altar

The two pyramids are faced with pink *Portasanta* of a thickness which is probably maintained constant at about 1 cm (pl. 118 and 119). On both pyramids, the marbles of the lowest part are identical in origin and method of working (they are probably slabs from a single column, 73 cm in diameter, cut vertically). They, too, are surprising for the modernity of their extensive and very symmetrical marble surfaces. The working and placement of the two would appear to be contemporary for two reasons: (1) the physical impossibility of conserving intact for more than a hundred years the fragile slabs of *Portasanta* which had been cut to a thickness of 1 cm, and (2) the working technique using straight joints, in contrast to the clearly restored patch at the centre of each pyramid which was worked with *giocati* joints (pl. 120), a sophisticated type of working used in ancient times and re-introduced during the Baroque period to make

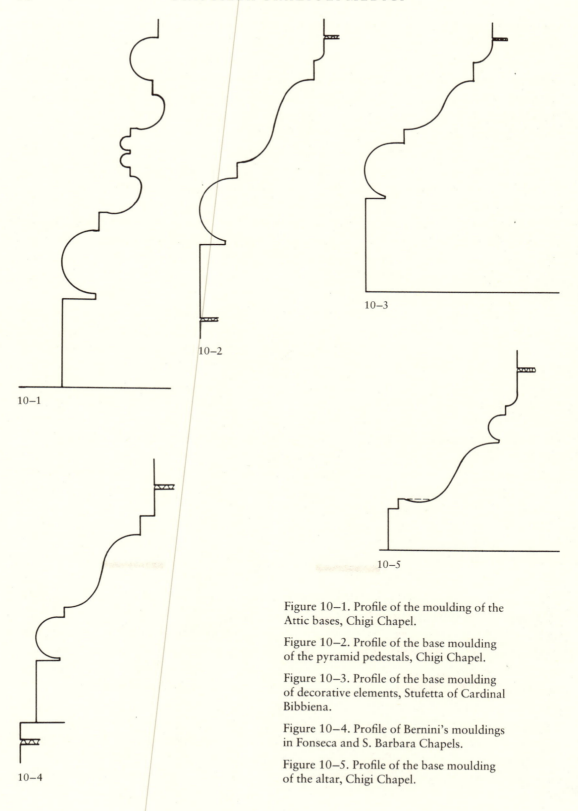

10–1

10–2

10–3

10–4

10–5

Figure 10–1. Profile of the moulding of the Attic bases, Chigi Chapel.

Figure 10–2. Profile of the base moulding of the pyramid pedestals, Chigi Chapel.

Figure 10–3. Profile of the base moulding of decorative elements, Stufetta of Cardinal Bibbiena.

Figure 10–4. Profile of Bernini's mouldings in Fonseca and S. Barbara Chapels.

Figure 10–5. Profile of the base moulding of the altar, Chigi Chapel.

one believe that a surface is constructed of a single piece when, in reality, it is composed of many small pieces (pl. 121, 122).

The pedestals of the pyramids have panels faced in *Verde Antico* marble from Thessaly, quite thin (from 3 to 5 mm), in use in seventeenth-century marble incrustations and similar to the inlaid tomb lid in the Chapel. The mouldings of splendid *Giallo Antico* marble from Numidia present a more complicated problem. On the one hand, I found that, while the profile of the moulding is basically very sixteenth-century in style (fig. 10–2)—similar to that of the bases of the decorative elements of the Stufetta of Cardinal Bibbiena (fig. 10–3)—it is rather dissimilar to the much more voluptuous outlines of Bernini's mouldings, for example in the Fonseca and S. Barbara Chapels (fig. 10–4) and also in the Chigi Chapel itself on the base of the altar (fig. 10–5). On the other hand, the Numidian marble itself is not only identical in the mouldings of both pedestals (it seems, that is to say, to have come from a single block or column, pl. 123, 124), but it also seems to be the same material as that used for the mouldings of the altar and for the balustrade at the entrance of the Chapel (pl. 125). In addition, the balusters themselves have the same profile as those of Bernini, for example in S. Andrea al Quirinale, and are quite unlike the Raphaelesque balusters of the recently restored Loggia of Leo X.

The Wall Panels

Finally, the facing of the walls behind the altar and behind the pyramids is decorated with raised panelling, almost resembling *bugne*, in pink *Portasanta*, with the background in the elegant and valuable black marble known as *Africano*, mottled with pink and grey, used, as we have already seen, outside the niches as well. This work in relief recalls to mind the very simple monochromatic panel below the window in the Stufetta of Cardinal Bibbiena.

Conclusion

My own opinion is that prior restorations which the Chapel may have undergone since the seventeenth century were of no consequence. As to the state of conservation of the marbles, I found it to be very good, essentially due to the fortuitous lack of capillary humidity in the Chapel.

I understand that about ten years ago the walls underwent a restoration consisting solely of puttying the joints of the pyramids and of the niches with a synthetic mastic of a rather obvious pink colour.

Our 1982 intervention was carried out at the request of the Soprintendenza ai Beni Artistici e Storici di Roma, which is responsible above all for the conservation of paintings and which, with this gesture, demonstrated a desire to bestow on these antique marbles a value on a par with that given to mural paintings. Our efforts were primarily given over to the restoration of the floor and of the extremely deteriorated Berninian tomb lid; interventions on the walls were carried out only to affix some detached mar-

bles using small pieces of steel (on the green panels of the pedestals and at the sides of the pyramids) and to remove the unsightly and very dangerous layer of white salts formed by a type of hygroscopic humidity existing in the Chapel. The walls and floor were finally polished with wax as in antiquity. All phases of the restoration were carried out manually.

References

A. Bartoli, *Curia Senatus: lo scavo e il restauro*, Rome (1963).

G. Becatti, *Scavi di Ostia: edificio con Opus Sectile fuori Porta Marina*, vi, Rome (1969).

R. Bianchi Bandinelli, *Roma: la fine dell'arte antica*, Milan (1976).

F. Borsi, *Bernini architetto*, Rome (1980).

C. Cecchelli, *La vita di Roma nel Medioevo*, I, xiv (*Tarsie*), Rome (1951–52).

F. Corsi, *Trattato delle pietre antiche*, 3rd. ed., Rome (1845).

A. Costamagna, 'Affreschi sculture e stucchi sec. XVII–XVIII, Rieti, Duomo, Cappella S. Barbara,' in *Un Antologia di restauri* (Soprintendenza per i Beni Artistici e Storici di Roma), Rome (1982), p. 132.

B. F. Davidson, 'The Decoration of the Sala Regia under Pope Paul III,' *The Art Bulletin*, lviii (1976), pp. 395 ff.

D. Redig de Campos, 'La Stufetta del Cardinal Bibbiena in Vaticano e il suo restauro,' *Römisches Jahrbuch für Kunstgeschichte*, xx (1983), pp. 221 ff.

M. and M. Fagiolo, *Bernini, una introduzione al gran teatro del barocco*, Rome (1967).

R. Gnoli, *Marmora Romana*, Rome (1971).

P. Grazioli Medici, *Conservazione delle crustae mar-moree policrome*, Rome (1986, in press).

F. Guidobaldi and A. Guiglia Guidobaldi, *Pavimenti Marmorei di Roma dal IV al IX secolo* (Pontificio Istituto di Archeologia Cristiana), Vatican City (1983).

A. Hoffmann, *Das Gartenstadion in der Villa Hadriana*, Mainz-am-Rhein (1980).

R. Lanciani, *Storia degli scavi di Roma*, Rome (1902–12).

I. Lavin, *Bernini and the Unity of the Visual Arts*, New York (1980), Italian translation, Rome (1980).

G. Lugli, *La basilica di Junio Basso sull'Esquilino*, Rome (1932).

G. Lugli, *Il Pantheon*, Rome (n.d.).

A. W. Pullen, *Handbook of Ancient Roman Marbles*, London (1894).

J. Shearman, 'The Chigi Chapel in S. Maria del Popolo,' *Journal of the Warburg and Courtauld Institutes*, xxiv (1961), pp. 129 ff.

J. Shearman, 'Raphael as Architect,' *Journal of the Royal Society of Arts*, cxvi (1968), pp. 388 ff.

A. Terenzio, 'La Restauration du Panthéon de Rome,' *La Conservation des Monuments d'art et d'histoire*, Paris (1933).

J. B. Ward-Perkins, *Architettura Romana*, Milan (1974).

11

Raphael and Raphaelesque Paintings in California: Technical Considerations and the Use of Underdrawing in His Pre-Roman Phase

BURTON B. FREDERICKSEN

IN THE recent and very enlightening exhibition in Washington titled *Raphael and America*,[1] David Alan Brown showed in fascinating detail how a relatively small but significant group of roughly thirteen works by the artist, along with some others that are now no longer accepted as Raphael's, came to the United States. This migration had virtually come to a close shortly after the last World War, and by the 1960s the possibility of acquiring a painting by Raphael had almost disappeared. The western United States, whose collecting tradition did not come into its own until recently, has, as a result, very little that can be seriously connected with his oeuvre.

There are now just three paintings in California that have at one time or another been plausibly connected with Raphael himself. First, the ravishing *Madonna* in the Norton Simon Museum in Pasadena, which was bought in 1972 and which is undeniably a work by his own hand (pl. 292). It is well documented by drawings and clearly a primary example of Raphael's work from the formative years during the first half decade of his activity. Secondly, there is the version of the so-called *Madonna di Loreto* (or more appropriately, the *Madonna del Velo*) purchased by J. Paul Getty as a copy for his private collection in 1938 and moved to the Getty Museum in Malibu in 1974 after an extended period on loan in the National Gallery in London (pl. 286). Finally, there is the *Portrait of a Young Man* (pl. 295), bought by the Getty Museum in 1978, which has been tentatively attributed to Raphael by a number of specialists and only slightly less often denied by a number of others. The present paper will look primarily at these three paintings, especially the two in the Getty Museum, and utilize the opportunity to speculate about their significance for Raphael's corpus of early works as a whole.

For reasons of convenience, it might be appropriate to begin with the one of the three paintings that has already been subjected to the most scrutiny, probably seen by

When this paper was read at the Princeton conference in October, 1983, contributions to the Celebrazioni Raffaellesche in Italia in 1984 had not yet appeared, in particular, the catalogue of the exhibition *Raffaello Architetto*, Rome, 1984, edited by C. L. Frommel, S. Ray, M. Tafuri. The reader is referred to the relevant texts in this catalogue and in other publications since 1983.

[1] D. A. Brown, *Raphael and America*, exh. cat., Washington (1983).

the most people, and is now accepted by the fewest authorities. That is the severely damaged—by overcleaning at some undetermined time in the past—*Madonna del Velo* which now rests in the storage room of the Getty Museum in Malibu. This panel enjoyed a brief but mildly spectacular fame from 1963—when it was cleaned by John Brealey and then published by Alfred Sharf—until approximately 1977 when the present writer unfortuitously discovered and published the significance of the Borghese inventory number on another version of the composition, the one in the Musée Condé in Chantilly[2] (pl. 287). Although critical opinion at the time, and for the past century and one half, had been unanimous in calling the Chantilly painting a studio replica—indeed, even the museum catalogues from Chantilly never claimed it as an original by Raphael—the recognition of the Borghese number in its lower left corner was enough to cause an immediate reappraisal of the painting by scholars. One year later Cecil Gould became the first to claim in print that it was the lost original.[3] Like Mr. Gould, who had once been among those who supported the priority of the Getty version, a number of other scholars came to agree that the Chantilly painting, newly cleaned and x-radiographed, was in fact the one by Raphael's own hand. This opinion has now found general acceptance.

I do not know of a more explicit example of the power of provenance—if I may be allowed to coin a phrase—than this transposition of rôles between two versions of the same composition. If anyone ever needed proof of the value of looking closely at miscellaneous marks and inventory numbers on both the front and back of a painting in order completely to understand it and its history, this episode should provide it. The number 133, visible for centuries on the Chantilly panel, even clearly legible on postcards presumably sent all over the world, was not recognized for what it was until less than a decade ago. Its significance could admittedly not have been understood prior to Paola della Pergola's publication of the 1793 Borghese inventory in 1965,[4] and, although the painting did benefit from cleaning—and an x-radiograph—that allowed us to see the painting in a new light, it was primarily the little black number that brought about the reversal of the two paintings' fortunes.

I believe this story demonstrates the fallibility of critical opinion in respect to Raphael studies and reminds us how replete the history of Raphael attributions is with wrong guesses and misfired assertions, in particular the history of the *Madonna del Velo*. For the past hundred years, scholars have periodically recommended various versions of the painting as the lost original, only to have them superseded by another more highly recommended one. However, it *does* appear as though the Chantilly version will prove to be the correct one, if only because its provenance is so nearly flawless and the fact that it has the largest *pentimento* of all, Joseph instead of a window.

In the belief that we can in fact learn from our mistakes, it should be worthwhile to recall briefly what it was that led the present writer, and some other much more

[2] B. B. Fredericksen, 'New Information on Raphael's *Madonna di Loreto,' The J. Paul Getty Museum Journal*, iii (1976), pp. 5 ff.

[3] *La Madone de Lorette (Les dossiers du département des peintures*, 19), exh. cat., Chantilly (1979), Paris (1979), pp. 6 ff.

[4] P. della Pergola, 'L'inventario Borghese del 1693, III,' *Arte antica e moderna*, xxx (1965), p. 203.

distinguished scholars in this field, to accept the Getty version over the one at Chantilly. Besides the fact that it was thought to be of particularly high quality, the one more readily demonstrable detail of the Getty version that caused it to be preferred was the presence of extensive, and fairly bold, underdrawing, partly visible to the naked eye but most clearly seen with the aid of infrared photography. In my article of 1976, I reproduced detailed infrared photographs of both the Malibu and Chantilly paintings (pl. 288–290), stating that the details of the Chantilly panel "reveal that the preparatory drawing is very linear and does not attempt to indicate modeling or gradations. This is in striking contrast to the drawing revealed by infrared photographs of the Getty Madonna where such indications are very extensive." What seemed at the time like the optimal use of modern technology in the pursuit of the truth has, in the meantime—with the advent of still better technology and a more extended use of it—proved to have led to an erroneous conclusion.[5]

In the past few years, a series of conservators and restorers, many of them present at this symposium, have demonstrated that most of Raphael's pre-Roman paintings, at least those so far subjected to infrared photography, do not have extensive underdrawing. The Chantilly painting corresponds more closely to this norm than does the Getty panel. It appears as though the overwhelming majority of them were prepared from cartoons, and that whether transferred by pricking or by darkening the back of the cartoon, the resulting underdrawing usually consists of simple contours with no modeling whatsoever. It is not difficult to anticipate a catalogue raisonné of Raphael's underdrawings some day, and though many key paintings in Italy have yet to be examined in this manner, the lacunae are rapidly closing. Perhaps by the end of the Raphael centennial, the picture of his career as an "underdrawer" will be nearly complete.

A quick survey of the pre-Roman panel paintings, roughly forty-two in number if we count commissions rather than surviving individual panels, shows that they are represented by about ten or eleven extant cartoons, or about one quarter of the total. They are, briefly: the cartoons for *Saint George* (Louvre), the *Vision of a Knight* (London), the predella of the Colonna altarpiece (New York), predella of the Mond *Crucifixion* (London), *Saints Mary Magdalen* and *Catherine* (private collections), *Saint George* (Washington), *Eszterházy Madonna* (Budapest), *Tempi Madonna* (Munich), *La Belle Jardinière* (Louvre), *Holy Family with a Lamb* (Prado), and *Saint Catherine* (London). This is a significant number, considering how few cartoons exist from this period outside the oeuvre of Raphael. And one can assume that many more by Raphael have been lost or destroyed. Moreover, because those still extant seem to be spread over the entire span from shortly after the turn of the century to at least about 1507, there appears to be every reason to think that this was Raphael's standard workshop practice for the first decade of his career.

However, at least one major exception has already been found to this axiom with the inclusion and publication of the excellent reflectogram of the *Small Cowper Madonna* (pl. 321) in the recent exhibition in Washington.[6] Although there are indications

[5] H. von Sonnenburg, *Raphael in der Alten Pinakothek*, Munich (1983), p. 52, n. 21, has recently drawn attention to this same matter.

[6] Brown, op. cit. in n. 1, p. 131.

that a cartoon was used, there is a large amount of drawing that clearly has nothing to do with a cartoon. The basic composition is scarcely altered by this drawing—all of it presumably added after the composition had been transferred—and it seems for the most part to elaborate the details of the drapery and to model large blocks of the figure and indicate its volume. This is more clearly seen at the waist of the Virgin, but it is also obvious on her neck and left shoulder, as well as the right side of the Christ Child's head. And in David Alan Brown's own words, "In its succinct definition the image revealed by the reflectogram resembles Raphael's independent sketches." This statement comes fairly close to my earlier description of the underdrawing on the Getty panel. Although the drawings on the two panels do not quite look identical in character, they are nevertheless approximately the same in function. I do not intend by this to say that the underdrawing on the two panels is by the same artist, but only that as a working preparation for the final painting they are not radically different in nature.

I suspect that other Raphael panels will be identified that have extensive underdrawing on them like the *Small Cowper Madonna*. (Since this writing, Joyce Plesters has shown that the *Saint Catherine* in London also has comparable underdrawing (pl. 201); see her paper, chapter 3 in this volume.) However, the *Small Cowper Madonna* by itself is enough to show that one must not overgeneralize about Raphael's workshop techniques and that at least one of the master's own paintings does have extensive drawing much beyond what was indicated by the cartoon and which is not directly connected with *pentimenti*. In other words, extensive underdrawing—or the lack of it—on panels from Raphael's workshop cannot be taken in and of itself as a conclusive indication of authenticity. Raphael did not always follow the same formula. Indeed, the actual process of transferring a composition with the use of a cartoon would most likely not have been done by the master himself but rather by an assistant, suggesting that the contour drawings retrievable through infrared photography are very possibly not by Raphael at all, and that only in those instances where the underdrawing has been enlarged upon, such as in the *Small Cowper Madonna*, can one expect to see his hand.

One is led also to consider how a replica, or copy, such as the Getty panel is now supposed to be, would itself have been made. Assuming it was done sometime after the Chantilly version, perhaps within a few years or at most a decade or so, how was it prepared? The infrared photographs indicate that very probably it too was prepared with the use of a cartoon. The contours seem to be equally exact and careful, and the mere fact that they correspond so closely to the original composition would indicate that the artist had some sort of cartoon or template to work from. It may well have been the same cartoon used for the Chantilly panel.

Against this must be weighed the fact that the two paintings disagree in some details, such as the forms of the background drapery and, especially, the head of the Madonna which, in the Getty version, is much more geometric and linear—not unlike the heads of the four figures of Theology, Philosophy, Justice, and Poetry found on the ceiling of the Stanza della Segnatura. The Chantilly head has a completely different character, much softer in contour and modeling. The greatest discrepancy is in the figure of Joseph, which has certainly been added to the Chantilly painting by a different

hand to cover a window—as seen in x-radiography—and was therefore not part of the original cartoon. But no matter how one imagines the process, the author of the Getty version, as with any other contemporary version, must have had access either to the original cartoon, or to the original painting from which he made a new cartoon, or at the very least to yet another copy of the original from which he would have made a cartoon. Simply put, both the Chantilly and Getty versions must have had cartoons, and perhaps the same one.

While discussing the matter of the *Madonna del Velo*, one other "technical" detail should be referred to, and that is the incised mark on the reverse of the Chantilly panel (pl. 291). This mark, a double circle made with a compass and enclosing a delicate rosette made with the same compass, was pointed out by the present author in his article seven years ago, along with an inscription that he took to be a date.[7] The full inscription, scratched fairly crudely into the panel and written to either side of the rosette, reads "S.T. 1544," followed by a word that I took to be "ago S 10." The proximity of the inscription and the rosette led me to think that they were done by the same person, and possibly the panel maker, meaning that the panel was not produced until long after Raphael's death. This theory was understandably rejected when the Chantilly painting was recognized as the original, and it was suggested by Cecil Gould that the inscription was not a date at all but more probably an inventory mark, and that the "S.T." might stand for, perhaps, Sala Terrena.[8] Indeed, I learned later that many paintings at Capodimonte are marked "S.T." on the reverse for "Sotto Tetto," and so it was left.

Not long ago, however, it was pointed out to me by someone—I no longer remember who; I don't think I noticed it myself—that the last word, that neither I nor the Louvre officials had succeeded in reading, in fact is "Agosto." This is, to my mind, an acutely embarrassing revelation, because having written "ago S 10" it should have been obvious long ago that it was in fact "Agosto." In any case, this leaves no doubt that the inscription does refer to a date and a month, and that it was August 1544.

One must now ask what this inscription means if it does not refer to the creation of the panel. Assuming that the Chantilly painting was in the church of Santa Maria del Popolo in 1544, why would it have had a rosette added to it with such an inscription? If an inventory was made in that year, would not the *Portrait of Julius II* in London have a similar inscription on the back, since both paintings came from the same church and apparently had the same provenance until their dispersal from the Borghese collections at the end of the eighteenth century? We know from Vasari that the two paintings were not on permanent view in the public portion of the church but were rather brought out only on religious holidays. Therefore, they were transported about, and it would not have been inappropriate to inventory such things. Still, it would not seem likely that a rosette made with a compass, followed by an inscription, would be the normal way to mark a painting that had been inventoried, and to my mind some other explanation must be found.

[7] Fredericksen, op. cit. in n. 2, pp. 14–15. [8] *La Madone de Lorette*, op. cit. in n. 3, p. 66, n. 4.

This mystery was enhanced by the mention in the dossier published on the occasion of the Chantilly painting's re-baptism to the effect that another painting at Chantilly had the same rosette but without an inscription.[9] That painting, given in all of the Chantilly catalogues to Andrea del Sarto, is a portrait of a young man; and it does not, so far as one can discover, have much to do with the *Madonna del Velo*. Very recently its provenance, or at least a significant part of it, was found and published by Giuseppe Bertini in the Chantilly bulletin.[10] Bertini has shown that the number 106 on the reverse of the Chantilly portrait refers to the inventory of paintings sent from the Palazzo Farnese in Rome to Parma in 1662.[11]

Although the Florentine portrait and the *Madonna del Velo* could conceivably have both belonged to either the collections of Cardinal Sfondrati or Scipione Borghese, it is highly unlikely that an incised rosette was utilized to identify paintings in either collection, since no other instances of it have been found on other Borghese paintings—and Sfrondrati's were all absorbed by Borghese. Nor is it likely—for the same reasons—that the rosettes were added during the nineteenth century when both paintings belonged first to the King of the Two Sicilies, and then to the Prince de Salerne. To my mind, to explain them as inventory marks at all is a futile endeavor.

The present speaker does not want to utilize a bit of circumstantial evidence of this kind to propound any radical theories. But the most obvious explanation for this coincidence—all other considerations aside—is that this device was simply the mark of a panel maker. This is perhaps complicated by the fact that the portrait is more likely to have been painted in Florence than Rome, but there is no reason why the artist could not have been active in Rome. If one ignores the inscription, one might conclude that both panels were simply the products of a single panel maker during the first decades of the century, and perhaps this is the safest assumption. We are required to conclude, however, no matter what solution we choose, that the rosette and the inscription are not contemporaneous.

At the very least, this part of the story serves to emphasize how valuable a survey of the backs of paintings would be if it could turn up more information on panel-makers' marks. Recently Hubert von Sonnenburg[12] has identified one on the reverse of the *Canigiani Holy Family*, a very small—2 cm—stamp that he describes as depicting two woodworking tools bound together in the middle (pl. 248). This is, so far as I know, the first instance of such a stamp on Raphael's panels, and there are altogether very few recorded stamps on panels of Italian make. A careful search of panels in museum collections, especially in Italy, would undoubtedly turn up more.

The only unquestioned painting by Raphael in California, and the last work by the artist to have been discovered and added to his oeuvre, is the *Madonna* in the Simon collection in Pasadena (pl. 292), dated by some as late as 1504, but to my mind some-

[9] Ibid.

[10] G. Bertini in *Le Musée Condé*, xxiv (1983), pp. 4 ff.

[11] The inventory was published by A. Filangieri di

Candida in *Le Gallerie Nazionali Italiane*, v (1902), pp. 311 ff.

[12] Von Sonnenburg, op. cit. in n. 5, p. 50, illus. p. 65.

what earlier, shortly after the *Solly Madonna* (pl. 284), and therefore *c.* 1502–3. This writer has very little to add to the understanding of this painting, which is in extremely good condition and as colorful and vibrant as the day it was painted. I would only point out that the landscape in this picture, with its lakes, turreted castles, and lightly forested hills, is very similar in character to that in the Liechtenstein *Portrait of a Young Man* which is sometimes attributed to Raphael. I have not seen this latter painting since its recent cleaning and restoration, but I am told that the appearance has been changed. As a result, I do not want to comment on its authorship. However, its use of landscape motives at least parallels that in the Simon painting.

The only other aspect of this painting that we will touch upon here is the under-drawing, which until now had not been photographed (pl. 293–294). Although the equipment used for this proved to be less than perfect, and the photographs will probably in time be improved upon, it was nevertheless possible to obtain infrared photographs that show that the underdrawing of the Simon *Madonna* is limited to contour lines of the sort that we have already seen in the Chantilly *Madonna* and most of Raphael's early paintings. Very little can be detected under the face, and the delineation of the eyes, nose, and mouth is not readily perceptible. But contour lines can be seen in the hands, particularly where the hand of the Christ Child has been moved slightly, and around the fingernails. Otherwise, the painting follows the drawing so closely that the latter cannot be visually separated from it.

Although a few sketches for the Simon *Madonna* are known, no cartoon has survived; but it is safe to assume that one must have existed. From the evidence it is fairly clear that the composition was transferred to the panel in the normal way and was not elaborated upon during execution, except to move slightly the Christ Child's hand. It is not possible to see if any changes occurred in the execution of the landscape.

The third painting to be treated here is the least well known of the group and potentially the most difficult to interpret. It has not been published in any detail, and whether seen as remote from or in close proximity to Raphael, it is worthy of careful consideration. The present writer has had the opportunity to discuss the painting with a variety of specialists, and a surprising number, indeed a majority, have given the opinion that the painting is most likely to be an original work by the master, or at least has a good chance of being such. Only two or three opinions have wanted to put it completely outside of Raphael's workshop.

The *Portrait of a Young Man*[13] (pl. 295) was bought by the Getty Museum in 1978 on the London art market. It should be immediately emphasized that the painting was sold as the work of Francesco Francia, not Raphael, and that the price paid was appropriate for a work by an artist on the level of Francia. There is, therefore, no overwhelming compulsion forcing us to catalogue the painting as the work of Raphael. At the time of purchase the present writer, who had known the painting since 1972, felt that it was probably by Raphael, and this opinion was shared by Federico Zeri, a long-time adviser

[13] Accession number 78.PB.364.

to Mr. Getty. It was recommended for purchase with the belief that it could perhaps be shown to be the work of Raphael himself, but it has been consistently exhibited and published in the museum's guidebooks as "attributed to Raphael."

The history of the painting is annoyingly incomplete. It first appeared in the sale in London of pictures from the collection of Princess Labia in November 1963[14] and was described as having come from the collection of her father, Sir Joseph Robinson, whose acquisitions dated mostly from the 1890s. But none of the earlier Robinson catalogues or sales—such as that of 1923—includes it.[15] The painting was put up for sale once more in 1972, at which time it was bought by Agnew's. The Getty Museum bought it from Agnew's six years later.[16]

The painting is not in exceptionally good condition. It has been transferred to a new panel sometime in the past, and it has undergone at least two or three cleanings and restorations in this century. The right cheek of the sitter is damaged, as is the neck just below the line of the jaw. There are curious losses, like heat blisters, on the face, the cause of which is unclear. The surface throughout, moreover, is moderately abraded. Recent photographs show it in its stripped condition (pl. 296).

Infrared photographs of the portrait have recently been made that show very little underdrawing. A careful examination of the photographs themselves reveals what are probably contour lines around the face (pl. 297) and perhaps some details, such as the eyes, but these are hardly perceptible in reproductions or slides. The same is true of the hands, where *pentimenti* can be seen, and perhaps very faint contours, but definitely no modeling (pl. 298).

The sitter is a youngish man perhaps in his early twenties, with a smile that reminds one of that of a Greek *kouros*. He is dressed in a kind of red cape that is tied at the neck and covers black robes. He wears a black cap and is seated with one arm on a parapet or, more probably, a table with his left hand resting in front of him. In his right hand he holds a pair of gloves. The table is covered with an Oriental carpet, and the sitter is shown framed between two variegated marble columns, rendered in deep red, green, and black, that stand upon a ledge behind him. In the background is a landscape with trees on either side and some prominent buildings, one with a distinctive palazzo with a kind of *loggetta* poised on top, and on the right another with fortifications. In the sky there are some clouds.

There are a number of motives in this painting that immediately relate it to other pictures normally connected with Raphael or his followers. The first is the so-called *Self-Portrait* in Munich, now generally rejected as a work of Raphael himself and called by the museum an anonymous Umbrian painting of the early sixteenth century (pl. 85). It shows the sitter posed between two marble columns very similar to those in the Getty panel, with a cluster of trees in the background that obviously resembles those in the

[14] Sotheby's, 27 November 1963, lot 29.

[15] The Robinson Collection was put up for sale in 1923 and largely bought in by the owner.

[16] A photograph published in N. Cooper, *The Opu-*

lent Eye, New York (1976), p. 33, indicates that the painting belonged to an architect, H. A. Peto, in London, in 1891.

Getty landscape. The way in which the head is joined to the neck and torso is resolved in a similar manner, with the forward, or left, contour leading straight up and the nape shown with a very sloping line. (This is more exaggerated in the Munich picture.) The eyes are rather similarly rendered, and the hat is exceedingly close. There are no clouds in the sky.

Hubert von Sonnenburg informs me that infrared photography likewise revealed no significant underdrawing on this painting, excepting perhaps simple contours that cannot be readily distinguished from the painted ones. The Munich portrait is better preserved than the Getty panel, and there is more detail in the flesh areas, such as in the hand where one sees some veins indicated. Neither the hand nor the face is very well rendered, however, and overall the technique includes more drawing, especially in the hair and the eyebrows.

To the present writer, the Getty portrait is a more advanced, more successful work, and if by the same artist—which I doubt—then must date slightly later. One technician, Frank Preusser, presently the senior scientist in the conservation laboratories of the Getty Museum but until recently with the Doerner Institute in Munich, knows both paintings quite well and believes they are by different hands. The Munich picture is so much more remote from Raphael's mature Florentine portraits such as those of the Doni that I find it difficult to imagine that it could be his.

The second painting to which the Getty portrait can be readily compared is the so-called *Francesco Maria della Rovere* in the Uffizi (pl. 86). The poses of the two sitters are very similar, and they share the rather cramped left arm and very poorly drawn left hand. The hand of the Florentine sitter that rests on the apple, however, is very strong and fits very successfully around the fruit. The comparable hand in the Getty painting, though not as well preserved, is not as well rendered.

The man in the Uffizi portrait wears a jacket with a large fur collar and sleeves which are red, but a less intense, yellower red than in the Getty painting. He also wears a red cap. The landscape in the background is simpler and less developed than in the Getty painting. It has no prominent buildings and recedes further. There are no clouds in the sky, a detail that this picture has in common with all of Raphael's pre-Florentine paintings except those in which clouds were required for iconographical reasons. The Uffizi portrait is more "Umbrian" in character and has been dated anywhere from 1496 to 1507, though it is now generally accepted as being by Raphael and therefore from toward the later of these two dates.

The manner in which the features of the face are depicted, in rather simplified terms with relatively little modulation and with what I would describe as almond-shaped eyes, is seen in both works. Such eyes, with a very simple dark elipse to form the upper lid, are a trademark of these and of most of the following pictures that we will discuss. The left eye of the Uffizi sitter illustrates the style at its best.

But it is the left hand, combined with the similarity of the way the faces and hair are depicted, that presents the most compelling reason to associate the Getty and Uffizi portraits. I do not think that they prove that the two paintings have a common author,

but they are a strong incentive to link the two stylistically. Indeed, the hand in the Getty portrait, seen with infrared (pl. 298), shows that it was once a bit closer to the other than it now is.

The infrared photograph of the hands in the Uffizi picture, recently made for Dr. Baldini (pl. 299), displays once more a surprisingly free and untypical approach, leaving us with the outlines of fingers in a variety of positions. The various attempts to get the outlines correct do not vary much one from the other, but they do not give the impression of having worked from a cartoon upon which the predetermined contours were to be found. This is, in fact, the first painting that we have seen where the preparatory underdrawing seems to have been done directly on the panel. It not only distinguishes it from the Getty panel, but all of the others we have seen.

A third painting that is worth comparing to the Getty portrait is the *Self Portrait* in the Uffizi (pl. 87) whose painted surface is very thin, making any discussion of its authorship very difficult. However, the form of the hair, the hat, the neck, and the general nature of the face can all be plausibly connected with those in the California picture. The Uffizi self-portrait is a controversial one, and Wagner,[17] writing fourteen years ago, came to the conclusion that this painting was a copy, done sometime later, after the head of Raphael seen the other way round in the *School of Athens*. This interpretation might in fact be correct, as the resemblance is strong.

Once more, we are fortunate to have seen the infrared photographs made in Florence under the direction of Dr. Baldini (pl. 300, 301). They reveal a very different kind of underdrawing from any seen so far, a surprisingly careful and patient rendering that hardly differs from a finished drawing. It almost certainly was not made from a cartoon, and yet does not compare well with the Della Rovere portrait either. It is modeled and shaded in a manner that shows considerable skill, and conceivably was necessitated by the nature of the self-portrait itself. But in the corpus of Raphael underdrawings, it stands completely alone.

Although it is still too early to make general statements about the character of underdrawings in Raphael's works and what they might signify for the connoisseur of Raphael's paintings, at first glance the very different nature of the underdrawing in the *Self-Portrait* would seem to isolate it in the oeuvre of the artist and perhaps substantiate the opinion of Wagner. But such conclusions are, I fear, still premature.

In a more general way—and I must emphasize the word "general"—the Getty painting also corresponds stylistically with a small group of portraits that are often, but not invariably, given to Raphael. This group must include the portraits of *Emilia Pia da Montefeltro* in Baltimore, *Elisabetta Gonzaga* in the Uffizi, and *Guidobaldo da Montefeltro*, likewise in the Uffizi. The latter is very much damaged and ultimately difficult to judge. (I do not include the *Portrait of a Young Man* in Budapest which has the sitter posed in a similar manner, with hair that vaguely resembles that of the Getty sitter, but which—in my opinion—is so heavily restored and overpainted in the face that I am reluctant even to treat it as genuine until it can be cleaned and freed from later

[17] H. Wagner, *Raffael im Bildnis*, Bern (1969), pp. 62ff.

additions.) I am not insisting that all of these paintings are necessarily by the same hand—indeed I am inclined to think they are not—but any study of the Getty portrait should also look closely at these. Unfortunately, no infrared reflectograms yet exist for them, and consequently one must wait a while before one can make comparisons of the underdrawings.

The purpose of this symposium is to consider the works of Raphael in the light of recent technological investigations, and thus it is not the appropriate forum to propose new attributions based on extended stylistic comparisons. Such proposals might more profitably be made after the close of the Raphael centennial. Suffice to say at this moment that there is strong indication that during his pre-Roman period at least, Raphael normally used cartoons to prepare his panels, and that the typical underdrawing for his paintings from this time consists of fairly direct and unelaborated contours. In some cases he worked these up more extensively after the transfer, as in the *Small Cowper Madonna*, and the *Saint Catherine* in London. The Getty portrait and its underdrawing does not contradict this norm in any way, but it remains to be seen whether other technical information would also substantiate the attribution.

12

Raphael's Cartoons for the Vatican Tapestries: A Brief Report on the Materials, Technique, and Condition

JOYCE PLESTERS

THE seven surviving Cartoons for Raphael's Vatican Tapestries were acquired in 1623 by Prince Charles, later Charles I, for use at the recently founded Mortlake tapestry factory. They have been in the Royal Collection ever since that time, but in 1865 Queen Victoria, undoubtedly influenced by the Prince Consort's enthusiasm for Raphael, loaned them to the newly built South Kensington Museum, now the Victoria and Albert Museum.[1] Successive sovereigns, including Her Majesty Queen Elizabeth II, have graciously renewed the loan.

For a substantial part of their existence the Cartoons were regarded primarily—one might even say, merely—as an accessory for tapestry weaving and were cut into strips for the convenience of the weavers. They were not reassembled and stuck onto stretched canvases until the end of the seventeenth century, and only after that did they come to be regarded as works of art in their own right. By that time, inevitably, they had suffered wear, tear, damage, and soiling, and by the nineteenth century a good deal of repair, retouching, and repainting also.[2] Their condition and treatment can be only briefly touched on in this paper, which is concerned mainly with the technique and materials of the original works.

In 1965–66 the Cartoons were cleaned and restored in the Conservation Department of the Victoria and Albert Museum under the direction of the then Keeper of Conservation, N. S. Brommelle. It was at this time that the present writer was invited to examine the Cartoons before and during treatment and permitted to take a limited

Thanks are due to Sir Oliver Millar, Surveyor of the Queen's Pictures, and Sir Roy Strong, Director of the Victoria and Albert Museum, for permission to publish an account of examination and treatment of the Cartoons; Sir Trenchard Cox, former Director of the Victoria and Albert Museum, and Mr. Norman Brommelle, former Keeper of Conservation at the Victoria and Albert Museum and the then members of the Conservation Department of the Museum, for their encouragement and help; Dr. J. S. Mills and Mr. R. White of the Scientific Department of the National Gallery for analysis of paint media and dyestuffs of lake pigments respectively, and Dr. Ashok Roy of the same department for laser microspectral analysis and x-ray diffraction powder analysis of pigments.

[1] The Victoria and Albert Museum has published three accounts of the Cartoons: G. Reynolds, *The Raphael Cartoons*, London (1974); J. Pope-Hennessy, *The Raphael Cartoons*, London (1950, reprinted 1958), 10 pp., 30 black-and-white illustrations; J. White, *Raphael's Cartoons in the Collection of Her Majesty the Queen*, London (1972), illustrated in colour.

[2] The fullest account of the Cartoons, including their relationship to the tapestries and their history of conservation, appears in J. Shearman, *Raphael's Cartoons in the Collection of Her Majesty the Queen*, London (1972), that is, after the most recent cleaning and restoration.

number of samples for microscopical examination and chemical analysis from edges of existing damages and losses. The initial purpose was to identify later retouching and repaints, assess the nature and condition of the originals, and attempt to discover whether the latter might have changed with age and with exposure to light and atmosphere. From the examination there also accrued a certain amount of information about the artist's techniques and materials. The most detailed examination was made of the first two Cartoons to be treated, *Christ's Charge to Peter* and *The Miraculous Draught of Fishes*, respectively, and from these the greatest number of samples were taken. The problems of conservation and the materials and techniques proved to be closely similar in the other five Cartoons, so fewer samples were necessary from those. When the cleaned and restored Cartoons were put on show again in 1966 they were accompanied by a small technical exhibit.

One of the first tasks of the restorers was to repair tears in the paper and lay loose and flaking paper and paint. Many old repaints and in-fillings which did not match the surrounding original were removed, and those which could not be safely removed were disguised. The surface of the Cartoons was dry-cleaned to remove dust and surface grime by gently rubbing with powdered synthetic gum rubber. A cleaning test on the background architecture of *The Blinding of Elymas* can be seen in pl. 131. Cleaning effectively removed the overall greyish tone which the Cartoons had acquired in the course of time. Retouching of losses was done in pastel so as to be easily removable if required. A selected range of colours was used, specially prepared for durability by the firm of George Rowney and Company, Ltd., as compressed sticks of dry pigment without added binding medium.

The Cartoons were put back in their existing frames, but their appearance was greatly improved by the substitution in each of the frames of a single large sheet of nearly colourless glass, made by the modern float process, for what had been three vertically joined sheets of thick greenish plate glass.

The Materials and Technique of the Cartoons

The support: The Cartoons are executed on a fairly heavy linen-rag paper. They are made up of sheets each approximately 42 × 28.5 cm, with 170 to 180 sheets per Cartoon, the edges glued together with overlaps of 1 to 4 cm in width. The joining was done before painting began; the paint goes over the joins. The joined sheets of original paper are stuck down on a similar composite sheet, the paper of which seems to be old, if not contemporary, and in places where glimpses of the underlayer of paper were seen during repairs to damages in the upper layer, it seemed that some of the sheets had previously been used for drawing and writing. The double layer of paper was glued onto stretched canvases near the end of the seventeenth century, when presumably the separate strips cut for the convenience of the weavers were rejoined; a further series of joins in the paper derives from this operation.

In the original paper the fibres are rather loosely packed, as is often the case with hand-made paper of the period; but the individual flax fibres appear to be strong and

in good condition for the age of the paper, as can be seen from the photomicrograph, magnification × 65 by reflected light, in pl. 135. The pH of the paper was measured (rather approximately, using Universal Indicator solution) and found to be between 4.0 and 4.5. This is not, however, an exceptional degree of acidity for old paper kept long in an urban atmosphere. Deacidification by the accepted chemical methods used for unmounted or demountable works of art on paper was not feasible and (as was also the case with the National Gallery's Leonardo Cartoon) it was decided to try to stabilise the condition of the paper by control of the environment. This was done by filtration of air going into the space between glass and backboard, the latter coated with magnesium carbonate, combined with a controlled level of illumination and the elimination of ultraviolet radiation. The paper is now a pale buff colour, but whether this was its original colour or the colour it has acquired with age is difficult to assess. In any case, the colour of the paper contributes little to the appearance of the Cartoons as a whole, since its entire surface, apart from losses and abrasions, is covered with comparatively opaque paint.

There is no all-over preparation or priming on the paper, either white or tinted, such as is often found on paper of drawings of the period. The drawing and painting is done directly on the surface of the paper, which may have been lightly sized.

The preliminary drawing: The matter of preparatory studies and *modelli* for the Cartoons has been treated in detail by John Shearman and other authors.[3] On the Cartoons themselves much underdrawing can be seen even with the naked eye, and more in the infrared photographs (now lodged with the Courtauld Institute of Art). Much of the modelling of the faces and limbs consists of hatched shadows beneath a comparatively uniform layer of flesh-coloured paint. There is some initial drawing in charcoal, reinforced in part with the brush and black paint, but there is also a good deal of further outlining and hatching on top of the paint layer which, like the underdrawing, would be seen intensified in the infrared photograph. In a detail (pl. 132) from *The Blinding of Elymas* (pl. 130) both underdrawing and drawing on top of the paint are visible. A black and white photograph of Ananias's legs (pl. 302) in *The Death of Ananias* shows how strongly outlined are the limbs on top of the flesh paint. Many of the outlines of the forms are pricked, some more than once. The pricking has no connection with the use of the Cartoons in tapestry weaving and seems more likely to derive from the making of numerous copies of the Cartoons themselves, as for example the two in the National Gallery of Ireland which are to the same scale as the originals. In order not to spoil the painted surface of the original by pouncing pigment through the prick marks, the Cartoon would have been pricked through to pierce a sheet of paper beneath on which the copy would be made following the pricked outline, as described by Armenini, who is probably referring to a practice going back at least to the beginning of the sixteenth century.[4]

[3] Shearman, op. cit., in n. 2, pp. 94 ff; P. Joannides, *The Drawings of Raphael*, Oxford (1983), pp. 222–25; E. Knab et al., *Raphael: Die Zeichnungen*, Stuttgart (1983), pp. 606–8.

[4] G. B. Armenini, *De' veri precetti della pittura*, Ravenna (1587), p. 104.

The paint medium: At the time of examination all samples assumed to be of original paint were found by relatively simple chemical tests of solubility, combustion, and staining, to have the characteristics of animal glue. Some years later this identification was confirmed on remaining sample portions by gas chromatography of the amino acids present. As distinct from water colour, in which the medium (usually gum acacia) is present in very low proportion to pigment and the paint is applied in thin washes, the pigment in the Raphael Cartoons is very well bound with a comparatively high proportion of glue medium to pigment, and applied in layers of thickness comparable to that found in easel paintings (that is, 20 to 35 μ). In a few thickly painted areas, a craquelure can be seen similar to that of egg tempera paint, but samples from such areas were also found to have a glue medium.

The pigments: The range of pigments identified is comparatively small. The first of the Cartoons to be examined and treated was *Christ's Charge to Peter* (pl. 126), and in that Cartoon comparatively stable inorganic pigments were used. Those identified were:

Lead-white (basic lead carbonate, $2PbCO_3 \cdot Pb(OH)_2$).

Azurite (blue basic copper carbonate, $2CuCO_3 \cdot Cu(OH)_2$), the natural mineral form.

Malachite (green basic copper carbonate, $CuCO_3 \cdot Cu(OH)_2$), the natural mineral form.

Vermilion (the red form of mercuric sulphide, HgS), as either the natural mineral form or the artificial dry-distilled form.

Red lead (lead tetroxide, Pb_3O_4), used only as an underpaint for vermilion

Lead-tin yellow, Type I (Pb_2SnO_4); this was tentatively identified at the time as litharge or massicot, that is, the pale yellow lead monoxide, PbO, but more recent x-ray diffraction powder analysis has ascertained its true identity. Type I is the most commonly occurring form of the pigment[5] and has been identified in easel paintings by Raphael.[6]

Yellow, red, and brown earth colours (hydrated and anhydrous forms of ferric oxide, $Fe_2O_3 \cdot H_2O$ and Fe_2O_3).

Carbon black, in both underdrawing and as a paint pigment. The splinter-like form of many of the particles indicates a wood charcoal.

In the next Cartoon to be examined, *The Miraculous Draught of Fishes*, there was evidence of the use of red lake pigments (that is, vegetable or insect dyestuffs absorbed onto a substrate such as aluminium hydroxide or chalk), with some evidence also of their having faded to a greater or lesser extent. The above range of pigments, including red lakes, was found to have been repeated in the other Cartoons. Lead-white is the white pigment used throughout, both alone and in mixtures with other pigments. In recent laser microspectral analysis of a sample of the white pigment, traces of calcium were found, but these could derive from chalk or calcium sulphate retouchings which

[5] H. Kühn, 'Lead-tin Yellow,' *Studies in Conservation*, xiii (1968), p. 8.

[6] J. Plesters, Chapter 3 in the present volume, pp. 23 ff.

were frequently encountered during examination. The blue pigment throughout is azurite, seen in sky, sea, landscape, and draperies. Judging by the large size and irregularity of the particles and the occasional occurrence of both green particles of malachite and red-brown particles of cuprite (copper oxide), it is the natural mineral form. The green pigment used throughout is malachite—again, from its particle characteristics, certainly the mineral form. It is interesting to note that these two pigments (and particularly mineral malachite which is comparatively rare in easel paintings) are the standard bright blue and green pigments of fresco painters. Raphael's assistants would currently have been working on the Vatican frescoes. Vermilion is the predominant red pigment, of high quality and a pure, intense red. A photomicrograph (pl. 136) at × 150 magnification by transmitted light shows particles of vermilion from Saint John's red sandal strap in *Christ's Charge to Peter* (pl. 126). A paint cross-section from the same sandal strap, photographed at × 125 magnification is seen in pl. 137. Both red layers are of vermilion, but in the underlayer the pigment is finely ground, which results in a more orange-red tone, while the top layer contains very coarse particles which have an almost crimson hue.[7] In some of the red drapery in the Cartoons the vermilion, which is a rather costly pigment to use on large areas, is underpainted with the cheaper orange-red pigment, red lead. Vermilion mixed with lead-white provides the bright rose pink of the lights in the striking pink and (azurite) blue *cangiante* drapery of the scallop-edged cloak of the fifth apostle from the right in *Christ's Charge to Peter* (detail, pl. 129), though judging solely from the colour on the painting one might have mistaken it for a pink colour based on a red lake pigment. Most of the yellow and orange tones in the Cartoons, and some of the more subdued reds, are earth (iron oxide) pigments. A particularly brightly coloured yellow ochre has been used in many of the yellow draperies. The more lemon-toned lead-tin yellow (Type I) has been reserved for highlights and to imitate gold, as in the ornate gold belt of the man wielding the axe in *The Sacrifice at Lystra*. A little lead-tin yellow has also been used in combination with malachite and azurite in the brightest grass and leaf green colours of landscape and certain draperies (identified for example in the lime green sleeve of the apostle with upraised arm in *The Death of Ananias*). Lacking from the palette of the Cartoons are the most expensive of all pigments, ultramarine and gold. Both clearly would have been wasted on large-scale Cartoons intended solely as working designs for tapestry weavers, though lavish use is made of gold (and silver) thread on the Tapestries which are the end product. On the Cartoons themselves even the haloes are painted in yellow ochre and not gilded, Christ's halo being distinguished by having a vermilion pattern.

The painting technique of the Cartoons: The technique of the Cartoons, employing a medium of animal glue, incorporating white and other opaque pigments applied for the most part in comparatively thick layers, might correctly be described in Italian as *guazzo* (a term equivalent to *gouache* in French, and in English *glue distemper*). Much

[7] Coarsely ground vermilion was found to have been used on top of a layer of finely ground vermilion in the deeper red shadows of Ariadne's scarlet cloak in Titian's *Bacchus and Ariadne*. See J. Plesters, 'Titian's *Bacchus and Ariadne*. The materials and technique,' *National Gallery Technical Bulletin*, ii (1978), p. 41.

of the painting of the Cartoons, particularly of the sky, architecture, and draperies, is executed in a single layer of paint applied directly to the paper. A double layer does, of course, occur when details or outlines are applied on top of an already-painted area. For example, features of the background architecture in both *The Sacrifice at Lystra* and *The Blinding of Elymas* are columns of an exotic marble of brownish grey colour having occasional vivid blue diagonal streaks. Such streaks can be very clearly seen in a black-and-white photograph detail from *The Sacrifice at Lystra* (pl. 303). A paint cross-section from one of these blue streaks, photographed at × 125 magnification, is shown in pl. 138. The blue streak is very thickly painted in azurite mixed with just enough lead-white slightly to increase the opacity and at the same time to add a certain brightness to the blue. It is applied on top of a single layer of grey-brown paint representing the background colour of the marble, a mixture of lead-white, brown ochre, and charcoal black, with one or two flecks of crimson-coloured lake pigment. Attached to the lower side of this layer are a few flax fibres from the rag paper. In the draperies the individual pigments are generally used pure, at full strength in mid-tones and some shadows, mixed with different proportions of lead-white to make the lights. In certain of the red draperies shadows have been added in red lake over vermilion, a technique analogous to glazing in oil painting, though less successful in a matt medium like glue distemper. The use of superimposed layers to produce a particular hue which is difficult to obtain with a single coat of paint, has not been much used in the Cartoons. One minor example encountered was the dark steely blue of the mooring chain of one of the boats in *The Miraculous Draught of Fishes*. The surface colour, suggestive of the organic pigment indigo, resulted in fact from the application of a thin coat of azurite over a thicker one of charcoal black. Physical mixtures of pigments of different colours ground together are largely confined to the landscape and the architecture (as for example the grey-brown background colour of the blue-flecked marble column described above and shown in pl. 138). It was interesting to find, however, that the 'white' paint of Christ's drapery in *Christ's Charge to Peter* (pl. 127) contains an occasional particle of yellow ochre, a deliberate addition it would seem, since white paint occurs elsewhere in the Cartoons without any included coloured pigment particles. It was perhaps intended to give the drapery a softer, creamier tone. The shadows of the folds of the drapery are grey. The greens and blues of the land- and seascape consist of malachite and azurite mixed with varying proportions of lead-white, yellow, and brown earth pigments and charcoal black, with, as mentioned above, lead-tin yellow incorporated in the brightest and purest greens. The trees are, not unexpectedly, painted on top of the blue of the sky and distant hills. Pl. 128 shows the landscape behind Christ's head in *Christ's Charge to Peter*. Pl. 139 is a photomicrograph at × 150 magnification of the top surface of a fragment of paint from the deep green tree just behind and to the left of Christ's head. The green paint of the tree, a coarse mixture of malachite, yellow ochre, and lead-tin yellow, has cracked to reveal the blue paint of the sky beneath consisting of azurite with lead-white. Pl. 140 is a cross-section through the same fragment of green paint at × 130 magnification. Beneath the blue layer of the sky are some flax

fibres from the paper, rendered brownish and translucent by glue which is probably associated with some later restoration process.

The flesh of the limbs is for the most part painted in a single layer based on lead-white with the addition of red, brown, or yellow pigments. The modelling of the forms comes partly from hatched underdrawing in black, showing through the more thinly painted parts, and partly from outlining and hatching in black or brown with the brush on top of the main paint layer. As might be anticipated, quattrocento-type green under-modelling, such as that still found in Perugino's earlier works, is absent. The faces seem to be painted in a rather more complex manner, though only one or two samples from edges of losses were possible. X-radiographs (like the infrared photographs now housed at the Courtauld Institute) show strong undermodelling of the heads in lead-white. A number of x-radiographs of the heads have been reproduced in John Shearman's book on the Cartoons and he has discussed their stylistic significance.[8] One cannot perhaps make a wholly fair comparison between the x-radiographs of paintings on panel and paintings on paper, but such a comparison is nevertheless interesting and relevant. In chapter 3 of this volume (pp. 25, 30) the present writer contrasted Raphael's technique for painting flesh in his earlier and later (that is, Roman period) works. In his earlier panel paintings Raphael, in common with Perugino, tends to paint the flesh in thin, warm-coloured glazes and scumbles of earth colours and lakes, using the gesso ground showing through as the white component for the middle tones and reserving lead-white for the strongest highlights such as on the contour of a cheekbone, the tip of a nose, or the white of an eye. Consequently in the radiographs a head, for instance, is seen almost as a black silhouette since there is very little lead-white present to absorb x-rays (a good example is the *Saint Catherine* in the National Gallery, London, pl. 202). By comparison, in some of his later panel paintings the flesh is rather solidly blocked in with lead-white, as may be seen from the radiographs (an example is the *Pope Julius II* in the National Gallery, London, pl. 208). The technique used in the Cartoons for flesh painting seems to fall between the two, but perhaps closer to that of the later works. As may be seen from the x-radiographs, the heads have for the most part been solidly blocked in with a light underpaint consisting largely of lead-white, leaving in reserve the shadows (already in situ in the underdrawing) of the eye sockets, around the nose and mouth and on the shadowed side of faces in half profile. This produces in the x-radiograph a very strong, contrasting, almost mask-like image, more forceful often than that seen in the finished painting where the light underpaint will have been toned down by the application of darker flesh tones and of fine detail both in light and shadow. The x-radiographs give an indication of the vigour of the initial conception of the heads, particularly useful in the case of those which have since suffered from some wearing and damage of the top surface of the paint. One further observation might be made about the flesh paint. Whilst there is quite a variety in the flesh tones, there runs through the series, particularly in the naked limbs, a frequent repetition of a rather brightish pink

[8] Shearman, op. cit. in n. 2, pp. 112–16.

colour to which black is added in the shadows, giving the latter a somewhat purplish grey tone. It can be seen for example in the flesh of the two naked children in the left foreground of *The Healing of the Lame Man* (pl. 134) and of the figure holding the sacrificial ram on the extreme left of *The Sacrifice at Lystra*. Examination of one or two paint samples from this type of flesh paint showed the pink colour to be based on lead-white plus vermilion, with charcoal black in the shadows producing the purplish tone. The flesh tones of the faces are much more diversified. Christ's face and torso in *Christ's Charge to Peter* is pallid, even slightly greyish, though his extended left (that is, in the Cartoon) arm is of the pinkish colour described above. In the *Death of Ananias*, Ananias's flesh is a pale biscuit colour with no hint of pink (though this could be interpreted as a deathly pallor) (pl. 133). By contrast, the flesh of the man in the foreground who starts back from Ananias is of the pink with purplish grey shadows type described above. Moreover, the loose and wrinkled hose which cover his legs seem to be painted somewhat crudely in a flat coat of pink paint which looks identical to that used for the flesh of his bare arm. It is dangerous to speculate on how much significance can be read into this, but a closer study of the technique and pigment mixtures used in the painting of the flesh of both heads and limbs might give some clue to the extent of involvement of studio assistance in the Cartoons.

It is interesting to compare the Cartoons with the Vatican Tapestries, the end to which they were a means. Pl. 127 shows a detail from the Cartoon for *Christ's Charge to Peter* (pl. 304), the Vatican Tapestry of the same subject. It can be seen at once that the Tapestry is the mirror image of the Cartoon. The reason for this is the low-warp method employed in the weaving in which the Cartoons were placed beneath the warp, the weaver working on the back of the Tapestry while following the design on the Cartoon. Hence gestures normally carried out with the right hand, such as Christ pointing to Peter in *Christ's Charge to Peter*, or Saint Peter blessing in *The Healing of the Lame Man*, are usually, though not invariably, performed with the left hand in the Cartoons. John Shearman has pointed out that even in his preliminary drawings for the Cartoons, Raphael was already thinking in terms of the designs being reversed in the final tapestries.[9]

Another notable difference between the Cartoons and the Tapestries is the amount of embellishment and surface pattern added by the weavers to Raphael's original designs. The most obvious occurs in *Christ's Charge to Peter* where the plain white (post-Resurrection) drapery worn by Christ in the Cartoon has been replaced in the Tapestry by a robe patterned and bordered with large star- or flower-shaped motifs in gold and silver thread. A close examination of the white robe on the Cartoon revealed no trace of its ever having been patterned (though, as mentioned above, the occasional yellow ochre particle is mixed into the white paint, presumably with the intention of giving a slightly creamy tint). The weavers, unused to the comparatively large areas of unbroken colour of draperies, sky, and architecture in the Cartoons, added in the Tapestries not just the occasional detail, but broke up the surfaces with small variations of colour and

9 Shearman, op. cit., pp. 109–11.

the textural contrast of wool, silk, and metal threads. Also, while remaining remarkably faithful to the contours of Raphael's designs, they have subtly changed, for example, the values of light and shade in folds of draperies, though part of this effect may be due to selective fading of dyestuffs used in the Tapestries.

Changes in the Colours of the Cartoons with Age and Exposure

Considering their age and hard use, followed by periods of neglect, which they have suffered in the past, comparatively little change appears to have taken place in the colours of the Cartoons. Mercifully, they escaped being varnished in imitation of easel paintings. Also, since most of the pigments used are opaque, or mixed with white to make them so, any slight discolouration of the animal glue medium with age will have had little effect on the surface appearance. Now that superficial dirt has been removed, many of the colours must look much as they did originally. The red, brown, and yellow earth pigments and carbon black are not, of course, subject to change in ordinary conditions of light and atmosphere. What is surprising is that the lead-white does not seem to have blackened perceptibly to lead sulphide after nearly a century in the urban atmosphere of central London, and much of that during the most intensive period of coal burning, when the concentration of sulphur gases in the atmosphere would have been very high. Drawings on paper are sometimes encountered in which, instead of chalk or gypsum, lead-white has been used for the highlights and has turned quite black by transformation to lead sulphide. Lead-tin yellow is a rather more stable pigment chemically and in the bright touches on the Cartoons where it has been used unmixed with other pigments it seems unchanged. The good state of preservation of these pigments is probably partly accounted for by their being well-protected from the atmosphere by the glue medium. Vermilion (red mercuric sulphide) is prone to surface blackening not from polluted air, but from exposure to light. It is not a chemical but a physical change from one crystalline form of mercuric sulphide which is red to another which is black. Again, in the case of the Cartoons the darkening of this pigment is quite slight. It is perhaps most noticeable where in drapery painted in fairly finely ground vermilion a further thin layer of the deeper-coloured coarsely ground pigment is applied to the shadows in the same way as a glaze (though in this case the term 'glaze' would be a misnomer since vermilion is one of the most opaque pigments known). It could be that the large particles protruding above the surface of the paint film are particularly vulnerable to light. The defect is perceptible as dark patches on the deep red shadows of Saint Paul's cloak in the Cartoon of *Saint Paul Preaching in Athens*.

The two basic copper carbonate pigments, azurite and malachite, are reasonably stable to light and atmosphere in ordinary conditions, and provided they are protected from excessive moisture and attack by chemical reagents such as acids and alkalis. There was no evidence that they had changed colour on the Cartoons. Verdigris, and in particular its derivative, 'copper resinate,' the use of which has resulted in so much brown discolouration of green areas, particularly landscape and foliage in easel paintings of the same period (including some of Raphael's own works), is mercifully absent

from the Cartoons so that the green colours are probably very little changed. By contrast, the green colours originally present in the Tapestries are likely to have become bluer in tone, or even changed completely from green to blue because the green dyes used for tapestry yarns were regularly a mixture of blue and yellow. The yellow component was generally a rather fugitive plant dyestuff which faded, leaving the blue component, indigo, which is reasonably light-fast when applied to protein fibres like wool and silk.

Organic and lake pigments used in painting, at this period by-products of the cloth-dyeing industry, are probably those most liable to change from exposure to light and atmosphere. Neither was found in the initial investigation of the Cartoon *Christ's Charge to Peter*, though, of course, only a limited number of areas could be sampled. They do occur, however, in some of the other Cartoons examined and in varying states of preservation. In this connection it is useful to make a comparison between another Cartoon and a corresponding tapestry, *The Miraculous Draught of Fishes* (pl. 144 and 145, respectively). A detail of this Cartoon shows Christ sitting in the boat wearing a creamy white cloak not dissimilar to that which He wears in *Christ's Charge to Peter*, though in the *Miraculous Draught*, which is a pre-Resurrection episode, it is not His only garment but is worn over a blue robe. It can be seen, though, that the reflection of the cloak in the water is red. In the tapestries of the same subject, both Christ's cloak and its reflection in the water are the same crimson red. The enigma of Christ's whitish cloak with its red reflection in the water was noted as early as 1831 by Passavant when he saw the Cartoons while making a tour of England principally to collect material for his book on Raphael. He writes: '. . . Our Saviour has a blue robe, with a white mantle, which latter, strange to say, casts a red reflection in the water. This has been accounted for by the supposition of the mantle's having been once red, and being now completely faded; an hypothesis, which on nearer examination, will not be found to hold good, not a trace of the red being perceptible and the white colour being handled with the greatest skill.'[10] In fact Passavant, though a keen observer, proves to be wrong in this respect. Under the stereo-binocular microscope traces of pink colour were still visible beneath the surface near the bottom of cracks and losses in the now-brownish shadows. Samples, even of the whitish paint from the lighter parts of the robe proved on analysis to contain not just lead from the lead-white present, but to give quite a strong positive test for aluminium, indicative of the presence of the aluminium hydroxide substrate of a lake pigment. A sample of paint removed from the mid-tone of the cloak, though whitish on the surface, was a rose pink colour beneath. Red lake pigments of organic dyestuffs vary in their degree of permanency when exposed to light and atmosphere, not just between one dyestuff and another, but depending also on the mode of preparation and of use; however, accelerated fading tests in the laboratory have shown that

[10] J. D. Passavant, *Tour of a German Artist in England*, London (1836), i, p. 83. Although Passavant is correct in saying that the mantle in the Cartoon of *The Miraculous Draught of Fishes* is "completely faded," in the sense of "not a trace of the red being perceptible," in the lights it is of an appreciably warmer cream colour than Christ's (intentionally) white mantle in the Cartoon of *Christ's Charge to Peter*, and the shadows, where traces of pink colour were found beneath the surface, are a warm mid-brown. The brown colour results from the photochemical degradation of the dyestuff of the red lake pigment.

it is perfectly possible for a red lake pigment painted out in a conventional way to fade to the point of total disappearance of the colour. The non-fading of the red reflection was easily explained by analysis of a sample, for the pigment used was not a lake pigment at all, but vermilion, which, as already discussed, does not fade with exposure to light, and indeed has a slight tendency to darken. The reflection does have the scarlet hue characteristic of vermilion rather than the crimson hue which both the cloak and its reflection have in the corresponding Vatican Tapestry.[11] The employment in the Cartoon of different red pigments for Christ's cloak and its reflection in the water perhaps lends support to the view that the landscape (or rather, seascape) was painted by a different hand from that which painted the figures.

In 1965–66 the National Gallery Scientific Department had no means of identifying the dyestuffs of lake pigments, but a number of years later research was instituted to find a method which could be applied to very small paint samples (that is, of the order of 0.5 mm diameter of paint surface). The first stumbling block was that standard pigments for comparison were required, but lake pigments of natural dyestuffs are no longer manufactured or available commercially, with the exception of pink madder lake. The first step, therefore, was to extract the dyestuffs from materials of known origin (obtained from a variety of sources including the British Museum of Natural History and the Royal Botanic Gardens, Kew). The range of dyestuff raw materials used in the past for red lake pigments includes both plant dyestuffs like madder and brazilwood and insect dyestuffs such as kermes and cochineal. From the dyestuffs extracted, a variety of lake pigments were prepared using a range of traditional recipes dating from the fourteenth to the nineteenth centuries. The lake pigments were ground in drying oil in the traditional way and painted out thickly on gessoed panels. Using these as standards, three separate methods of identification have been developed for identification of unknown red lake pigments in pictures. The first was a microspectrophotometric method,[12] the second, thin-layer chromatography; the third and very recently introduced method, high pressure liquid chromatography (HPLC), has the merit that not only is it more sensitive than the previously used methods, but it does not require the destruction of a sample of the rather precious prepared standards each time an analysis of any unknown pigment is done. By chance there remained from 1966 one very small paint sample from the Cartoons in which red lake pigment appeared to have been used, and this sample (together with one from the National Gallery's predella panel, *Saint John the Baptist Preaching*) was one of the first from any painting to be subjected to routine analysis by HPLC just the week before this symposium began.[13] It should be pointed out that lake and organic pigments are less liable to fade when they

[11] A Mortlake tapestry of *The Miraculous Draught of Fishes*, woven in the second quarter of the seventeenth century, is on loan to the Victoria and Albert Museum and hangs with the Cartoons. In this tapestry Christ's actual cloak is crimson, but its reflection in the water is of a distinctly different light scarlet hue. This would suggest that at the time of weaving (a) Christ's cloak was still crimson red and (b) that the weavers had followed the Cartoons sufficiently faithfully to re-

produce the difference in colour between the crimson lake pigment and scarlet vermilion as seen in the Cartoon.

[12] J. Kirby, 'A spectrophotometric method for the identification of lake pigment dyestuffs,' *National Gallery Technical Bulletin*, i (1977), pp. 35–45.

[13] Mr. R. White plans to publish shortly an account of recently developed methods for identification of dyestuffs of lake pigments in paintings.

are used at full strength and rather thickly, so that not much light can either enter or be reflected back through the paint layer. They are most vulnerable when used in thin translucent layers, as in water colours, or when mixed with a high proportion of white pigment, when the tendency is to fade at the surface (as in Christ's cloak in *The Miraculous Draught of Fishes*). The shadows of Ananias's tunic in the Cartoon of *The Death of Ananias* (pl. 133) constitute an example of a well-preserved crimson-coloured lake pigment, used at full strength (that is, undiluted with white pigment) and thickly applied. In the highlights of the folds the red colour may have faded somewhat. A cross-section of a sample of paint from the well-preserved shadow is shown in pl. 141, photographed at × 150 magnification. Even in this sample taken from where the red colour on the Cartoon is very strong, it can be seen that the top surface of the paint has become slightly greyish brown. It was the residue of this sample which was recently analysed by HPLC, which proved the dyestuff to be natural madder (*Rubia tinctorum L.*). In the course of identification of lake pigments in a number of paintings in the National Gallery, contrary to what was previously assumed, madder lake has so far been found less frequently than the insect-derived red lakes (kermes, lac, and cochineal); in Italian School paintings it is found quite rarely, less so in Flemish and Dutch.

It has already been mentioned that lake and organic pigments were by-products of the cloth-dyeing industry. So far as is known, no analyses have been made of the dyestuffs of the yarn used for the Vatican Tapestries, though this is in fact a simpler task than that of identifying the dyestuffs of lake pigments in paint samples. However, in a series of analyses made in Holland on samples of textile fibres taken from a large number of tapestries of different countries of manufacture, and from collections held in different countries, madder proved to be the most common red dyestuff in tapestries of Netherlandish manufacture but was not identified at all in samples from tapestries of Italian manufacture.[14] The only red lake pigment so far identified by us in one of Raphael's easel paintings, the predella panel of *Saint John the Baptist Preaching*, turned out to be lac lake. It is a rather curious coincidence that there was identified in the Cartoons a red lake pigment from a dyestuff rarely found in Italian Renaissance paintings, but commonly used in tapestries woven in the Netherlands. It would be of some interest to know what red dyestuffs occur in the Vatican Tapestries. Elsewhere on the Cartoons are some areas of paint where there may have been lake pigments used which have faded or changed colour beyond recognition. Pl. 142 is a photomicrograph of the top surface of a fragment of paint from the apparently light brown shadows of the pale blue cloak of a woman holding a baby, on the right of the Cartoon of *The Healing of the Lame Man* (pl. 134). On the brownish surface can be seen a few blue azurite particles, some grains of lead-white, and just one or two faint flecks of reddish material of low refractive index and ill-defined particle characteristics, which could be remains of a red lake pigment. The suspicion is further confirmed by the detection by means of laser microspectral analysis of aluminium in the sample. A cross-section of the same sample photographed at ×250 magnification is shown in pl. 143 where occasional

[14] J. H. Hofenk-De Graaff and W.G.Th. Roelofs, 'On the occurrence of red dyestuffs in textile materials from the period 1450–1600.' ICOM Plenary Meeting, Madrid, October, 1972.

particles of red survive below the surface. It seems likely that, given the scattering of blue pigment and traces of red, the now worn and faded shadows of the woman's pale blue cloak were originally intended to be a mauve colour.

Concluding Remarks

Inevitably, among an audience composed largely of art historians, the question will be asked whether results of technical examination can throw any light on the extent of participation of Raphael's assistants. It has to be said at once that since the main purpose of the work was to aid restoration and conservation of the Cartoons, that aspect was not at the time given very high priority. It would require much more extensive and intensive research before any conclusions could be drawn. It has been suggested above, for example, that a more detailed study of the different techniques of flesh painting might be rewarding. Scanning by infrared reflectography to reveal underdrawing is another possibility; at the time the Cartoons were examined this technique was not available and only a small fraction of the area has been investigated with infrared photography. What does emerge most strikingly is the consistency of both materials and techniques throughout the series (the single anomaly of red lake not being identified in the first Cartoon to be examined, *Christ's Charge to Peter*, is not necessarily significant, considering the limitations on sampling). The obvious interpretation, and perhaps a naive one, is that the Cartoons were executed throughout by a single hand, presumably that of Raphael. An alternative interpretation would be that Raphael, having prepared preliminary studies and carried out some underdrawing on the Cartoons and painted the most important heads and figures, could with impunity have handed over much of the painting, which in many parts consists of 'colouring' the design, to his assistants. He would presumably have established the colour scheme and system of drapery painting. It seems from the results of analysis that anyone working on the Cartoons must have been issued with the same simplified palette of pigments (as described above), to be mixed with a single simple medium, animal glue, and that fairly strict control was exercised to ensure conformity in technique. A clue to the presence of more than one hand at work is the use in the Cartoon of *The Miraculous Draught of Fishes* of different red pigments for Christ's cloak (now faded) and its reflection in the water, an instance of lack of 'continuity,' in the filmmaker's sense. If another artist (such as Giovanni da Udine, well-known for his still-life and nature painting) had painted the seascape, with the cranes and the still life of fish in the boat, he might have added the reflection of Christ's cloak in the water, using the first red pigment which came to hand. On the matter of the extent of studio assistance, Cecil Gould has remarked that there was a necessity for Raphael to evolve a simplified technique for the Cartoons which depended on broad effects and not on subtle variation of tone,[15] and, as we have seen, the technique is simple compared with that of Raphael's easel paintings. It also had to be a rapid technique, given that ten enormous Cartoons were finished in about eighteen

[15] C. Gould, letter: 'The Raphael Cartoons,' *The Burlington Magazine*, xciii (1951), pp. 93–94.

months at a time when Raphael and his assistants were engaged in other important commissions. It has also always to be borne in mind that the Cartoons were not intended as works of art in their own right, but as a means to an end, the Vatican Tapestries, so no more elaboration or 'finish' was required beyond that which would supply adequate guidance for the tapestry weavers. From this limited technical study of the Cartoons the impression gained is that the degree of consistency of technique and materials throughout serves to emphasize a unity of conception and a conformity of execution which rather lessens the importance of the contribution of individual hands in relation to the series as a whole.

13

A Technical Examination of Raphael's *Santa Cecilia* with Reference to the *Transfiguration* and the *Madonna di Foligno*

RAFFAELLA ROSSI MANARESI

THE restoration of Raphael's *Santa Cecilia* (pl. 148), supervised by the Soprintendenza per i Beni Artistici e Storici of Bologna and carried out in 1976–79 by Ottorino Nonfarmale, was preceded by a technical examination using a variety of methods.[1]

The principal aim was to obtain information useful for a correct cleaning, but the opportunity to examine the picture and to take samples of paint also provided an insight into the artist's methods. A full survey of the materials employed by Raphael was not possible as only a few areas of particular concern were sampled. However, the main features of his technique were revealed.

Reference to documents and comparison with cross-sections from other works of Raphael—the *Transfiguration* and the *Madonna di Foligno*—kindly supplied by the Vatican Gallery for examination, were useful for interpreting the paint structure. This comparison has also indicated that the more technical aspects of Raphael's painting did not change essentially in the course of the years in which these panels were painted.

The attempt made in this paper to interpret the results of technical examination in terms of execution concerns both Raphael's technique and the methods of the restorers who treated the painting in the past.

History and Past Restorations

The *Santa Cecilia* was painted by Raphael for the chapel dedicated to the saint and founded by Elena Duglioli dall'Olio in the church of S. Giovanni in Monte in Bologna.[2] The picture was commissioned in 1513 by Cardinal Lorenzo Pucci (on behalf of Elena dall'Olio) and was set up as an altarpiece, with its splendid frame carved by Formigine, by 1517. It remained in position up to 1786 when, after the capture of Bologna by Napoleon's army, it was commandeered by the French and taken to France.[3]

[1] O. Nonfarmale, 'Il restauro della Santa Cecilia di Raffaello,' *Indagini per un dipinto: La Santa Cecilia di Raffaello; Rapporti della Soprintendenza Beni Artistici e Storici di Bologna*, no. 44, Bologna (1983), pp. 239–50. R. Rossi Manaresi, 'Contributi analitici allo studio della Santa Cecilia di Raffaello,' ibid., pp. 253–78.

[2] J.-D. Passavant, *Rafael von Urbino und sein Vater Giovanni Santi*, Leipzig (1839), i, pp. 254–56; ii, pp. 180–82; ed. Le Monnier, Florence (1889), ii, pp. 171–73.

[3] A. Emiliani, *La Pinacoteca Nazionale di Bologna*, Bologna (1967), p. 43.

Napoleon's commandeering extended throughout the entire country and involved various other paintings by Raphael, among which was the *Madonna di Foligno*, now in the Vatican Gallery. The pictures were taken to Paris, to the Musée Central des Arts (the Louvre), where the *Santa Cecilia*, like the *Madonna di Foligno*, underwent restoration and was transferred from panel to canvas.[4]

The restoration workshop of the Musée Central des Arts can be considered one of the first organised institutions where the restoration of paintings was carried out in a programmed and controlled way.[5] Thanks to strict regulations for restoration treatments we have access to a detailed description of the procedure adopted by the restorer F. T. Hacquin in order to transfer the *Madonna di Foligno*.[6] The procedure provided for the removal of the wood support and of the gesso ground, application of a new lead-white preparation in oil medium, and, finally, transfer onto a new canvas support.

A similarly meticulous description of the transfer of the *Santa Cecilia* is not known, but such an operation was also carried out in this case by Hacquin in 1803, only two years after the restoration of the *Madonna di Foligno*. It may be presumed that he followed the same procedure, which was, in any case, approved by the technical evaluation committee. This hypothesis appears to be largely confirmed by the results of the present investigation.

In 1815, after the fall of Napoleon's empire, many works of art were returned; thus the *Santa Cecilia* was sent back to Bologna and was placed in the Pinacoteca, which had been founded in the meantime.[7] Dissatisfaction with the aesthetic consequences caused by the Paris restoration of the *Santa Cecilia* can be noticed in the words of Bolognini-Amorini who, when the painting returned to Bologna, observed: "Although in France every manual operation on works of art is carried out very well, and great care has been used in taking this painting off the panel and transferring it onto canvas, we would nevertheless have preferred it to have come back as it was, on the panel, because it has suffered quite a lot, both in the sky and in the brightness of the half-tones."[8]

In fact, the painting underwent a second treatment immediately after its return to Bologna when, as Passavant reports, "the retouchings done in France were removed."[9] There is no record of other restorations between that of 1815 and the treatment carried out by Mauro Pelliccioli soon after the Second World War, apparently the third on the painting.

[4] For detailed information on the vicissitudes of the *Santa Cecilia* in this period see G. Emile-Mâle, 'Le transport, le séjour et la restauration à Paris de la Sainte Cécile de Raphaël 1796–1815,' *Indagini per un dipinto: La Santa Cecilia di Raffaello*, cit. in n. 1, pp. 217–36.

[5] A. Conti, *Storia del restauro*, Milan (1973).

[6] 'Rapport à l'Institut National sur la restoration du tableau de Raphaël connu sous le nom de la Vierge de Foligno, par les citoyens Guyton, Vincent, Taunay et Berthollet,' in P. Lacroix, 'Restauration des tableaux de Raphaël,' *Revue universelle des arts*, ix (1859), pp. 220–28.

[7] A. Emiliani, 'L'opera dell'Accademia Clementina per il patrimonio artistico e la formazione della Pinacoteca Nazionale di Bologna,' *Atti e Memorie dell' Accademia Clementina*, x (1971), pp. xi–xxiv. The painting was enclosed in a frame which is a copy of the original one; the latter is still in S. Giovanni in Monte.

[8] A. Bolognini-Amorini, *Descrizione de' quadri restituiti a Bologna i quali da' Francesi che occuparano l'Italia nel 1796 erano stati trasportati in Francia*, Bologna, n. d.

[9] Passavant, loc. cit. in n. 2.

After all these treatments, as Cesare Brandi observed, "a terrible unbalance of colours was evident . . . and it seemed impossible that all of a sudden, Raphael, in his very own painting, had completely lost one of his classic gifts *par excellence*; precisely the chromatic, as well as the plastic balance"[10] (pl. 147). As will be seen, the technical examination showed that this effect was merely a consequence of the state of the top layers due to restorers in the past. The careful cleaning has returned to Raphael's work "a chromatic balance that was absolutely unhoped for," as Brandi testifies.

Investigation Using Infrared and Ultraviolet Light

The first part of the examination was carried out by using global-analysis techniques that allow the exploration of the hidden structure of the entire painting underneath the surface. X-radiography could not give any significant information since the thick lead-white ground (laid during the transfer as a new preparation) absorbed x-rays so much as to hide the overlying pictorial image, but mosaic photographs of the entire painting were taken by infrared light, reflected ultraviolet and fluorescence excited by ultraviolet. Examination by infrared reflectography was also performed after treatment.

Infrared light that passes through varnishes, surface glazes (even paint layers, if sufficiently thin), and is reflected by the inner structural layers, permitted the identification of various inner retouchings (pl. 307) that appeared as dark spots in the infrared photographs. The infrared photographs also displayed some underdrawing which was then revealed by infrared reflectography. The technical features of the underdrawing will be discussed later.

Both the reflected ultraviolet and fluorescence photographs brought out other retouchings, presumably the ones closer to the surface, which showed as white or black spots in the photographs (pl. 305, 306). Moreover, in those photographs the areas where cleaning tests had been carried out, particularly in the sky, looked extremely different from the uncleaned parts: they looked very bright in the fluorescence photographs (pl. 308) and black in reflected ultraviolet (pl. 309); this suggested that the entire sky was not only revarnished but also overpainted, perhaps with a very thin paint layer which hid the ultraviolet fluorescence of older varnish underneath and partly reflected the ultraviolet light which, on the contrary, was completely absorbed by original paint.

Analytical Study

Of prime interest, before extensive cleaning could be undertaken, was the paint structure of a number of areas which appeared from technical photography to present potential problems for the restorer. However, in order to avoid taking many samples from such an important picture, only two areas of particular interest were sampled.

Three tiny fragments were taken from the sky, in the hope that they would give

[10] C. Brandi, 'Intorno a due restauri eccezionali: la facciata di San Petronio e la *Santa Cecilia* di Raffaello,' speech given in the closing session of the XXIV International Congress of the History of Art, Bologna, quoted from the transcription in *Bologna Incontri*, x (1979), no. 10, pp. 24–25.

information on the suspected total repainting of this area of the picture. Two other samples were taken from Saint Paul's mantle: one of them from a zone that was perhaps still in the original state (or, at least, without the repainting shown by photographic investigation), the other one from a zone shown by infrared photography as a retouched area. It was supposed that the comparison between the two samples would yield information that could be extended also to the other zones shown by infrared photography as repainted areas.

Fragments of the samples taken were used to prepare cross-sections to be examined under the microscope. Staining tests were carried out for medium analyses.[11] Pigments were identified by means of optical and chemical microscopy.[12] This was supplemented by x-ray microanalysis using a scanning electron microscope equipped with an energy dispersive x-ray spectrometer (EDAX). Five of the paint samples from other works of Raphael which were examined for comparison came from the *Transfiguration* and one from the *Madonna di Foligno*.

The Original Preparation and the Modification Due to the Transfer

All sample cross-sections from the *Santa Cecilia* showed a lower part, underlying the paint layers, with the same structure and composition (pl. 149, 151, 152); that is to say, they showed the following succession of layers, from the bottom upwards:

1. thick, white layer of lead-white in oil medium, presumed new preparation laid in Paris
2. very thin, brownish and translucent band which gave particularly intense staining reactions both with Sudan black and with acid fuchsin: a staining pattern consistent with the presence of both oil and animal glue
3. very thin white layer, about 10 μ thick, which seemed to consist of lead-white and very little oil medium

Traces of gypsum were present in this lower part of the samples (they were identified by microchemical tests), but they seemed submicroscopic and not sufficient to form a layer with a thickness that could be observed even minimally under the microscope.

The sample cross-section from the *Madonna di Foligno* showed a rather similar layer structure underneath the paint proper, but the layers 2 and 3 indicated above looked in this case respectively thinner and thicker (pl. 159). A correct distinction between original and later layers in this intriguing structure represented a puzzling problem. A clue to the way the sequence of these layers may have originated was given by the examination of the paint samples from the *Transfiguration* and by reference to sixteenth-century painting methods described by Vasari, as well as to the detailed account of the methods used by the French restorer.

[11] M. C. Gay, 'Essai d'identification et de localisation des liantes picturaux par des colorations spécifiques sur coupes minces,' *Annales du Laboratoire de Recherche des Musées de France* (1970), pp. 8–24; E. Martin, 'Some Improvements in Techniques of Analysis of Paint Media,' *Studies in Conservation*, xxii (1977), pp. 63–67.

[12] J. Plesters, 'Cross-section and Chemical Analysis in the Study of Paint Samples,' *Studies in Conservation*, ii (1956), pp. 110–57.

The *Transfiguration* was not transferred from panel onto canvas, and its still-preserved original preparation was found to consist of a rather compact gesso ground covered by a film of animal glue and then by a priming layer (about 10 μ thick) containing lead-white and very little oil medium (pl. 156, 157, 158). The features noted in this preparation are described by Vasari's instructions: "the gesso laid on the panel is smoothed and four or five coats of the smoothest size are spread over it with a sponge . . . when the size is dry a priming is applied and then beaten with the palm of the hand so that it becomes evenly united and spread all over . . . when the priming is dry the underdrawing is outlined."[13] It seems that Raphael prepared the panel in precisely this way. In particular, he certainly applied glue to the well-smoothed gesso ground in great excess, so that it was not absorbed by the gesso but formed a thin film on its surface. Moreover, he certainly worked up the white priming on top with great care, as it looks perfectly even and thin.

These observations support the hypothesis that the original preparation of the *Santa Cecilia* must have been very similar to that of the *Transfiguration*.[14] The present layer structure of the *Santa Cecilia*'s preparation may be interpreted as follows:

· The thin lead-white layer on top (layer 3) is the original priming.
· Hacquin had accurately eliminated the whole gesso ground until, as stated in the documents: "l'ébauche de Raphaël a été découverte entièrement."[15] More precisely, he left the thin glue film that still exists.
· This film also contains oil, because once the gesso was eliminated, the back of the paint film was treated with oil; more precisely, it was "frottée partout avec de la carde de coton imbibée d'huil et essuyée avec de la vieille mousselin."[16]

The Underdrawing

Infrared photography and reflectography of the *Santa Cecilia* have revealed the design delineated by Raphael before any painting was carried out. The preservation of the underdrawing, in spite of the fact that the gesso ground had been completely eliminated, seems to indicate that the lead-white priming (observed in a few sample cross-sections) is really present all over, and that the underdrawing is outlined on the priming layer, as Vasari recommends.

This is confirmed by documentary information. In fact, Boucher-Desnoyers, who saw both the *Santa Cecilia* and the *Madonna di Foligno* in the Paris laboratory during the transfer and when the whole original gesso ground had been removed, affirms that

[13] G. Vasari, *Le Vite* (1568), ed. De Agostini, Novara (1967), i, p. 113.

[14] A rather similar preparation was also observed in another of Raphael's paintings, the *Madonna di Loreto*, which belongs to the Roman period, as do the works here taken into consideration; see S. Delbourgo, 'La matière picturale,' *La Madonne de Lorette* (*Les Dossiers du département des peintures*, 19), Paris (1979), pp. 60–62. A thin, perfectly white, lead-white priming on a gesso ground can also be observed in pictures by other Italian painters from this period, for instance, Francesco Francia; see R. Rossi Manaresi and J. Bentini, 'The Felicini altarpiece by Francesco Francia: contribution of technical analyses to the solution of a chronological problem,' *Atti del XXIV Congresso Internazionale di Storia dell' Arte* (Bologna, 1979), Bologna (1983), iii, pp. 395–426.

[15] Quoted from the 'Rapport,' cit. in n. 6.

[16] Ibid.

from the back of the paint films of both pictures the underdrawing showed through the thin priming and seemed to have been sketched by brush with raw umber.[17] A similar observation is also reported by Lavallée.[18]

The underdrawing revealed by infrared investigation shows fine, precise lines in some areas, rather suggesting the use of pencil or charcoal (pl. 310, 312). Elsewhere, relatively broad and thick lines, such as those modelling the folds of the clothes (pl. 311), may indicate brush strokes; but the latter might have been used, of course, to reinforce a pencil contour. Changes in the position of Saint Cecilia's left eyebrow (pl. 314) and in the profile of her left anklebone (pl. 313) seem to have been made during the drawing stage, whereas the lengthening of three pipes of the portative organ in her hands probably represents a change made in the painting stage (pl. 315).

However, only these few *pentimenti* are observed. In general the underdrawing, carefully built up, does not show any modifications, and the ultimate painted forms and volumes are closely based on the underdrawing.

The Layer Structure of the Paint

The paint layers above the lead-white priming show that the *Santa Cecilia*'s sky consists of a pink underpaint (containing lead-white and a red lake pigment) and a blue top layer formed by two imperfectly divided sublayers, the lower one containing azurite and the upper one ultramarine (lapis lazuli); both azurite and ultramarine are mixed with lead-white (pl. 149, 150). The interpenetration of the azurite sublayer by the ultramarine one suggests a wet-in-wet method of working. The sky was probably painted all over in this way, with the exception of the relatively thin boundary around the upper area with the angels: this looks blue-green, and is presumably obtained by a layer of azurite only, mixed with lead-white.

A similar structure with ultramarine over azurite is also found in a sample from the sky of the *Transfiguration* (pl. 156).[19] But azurite under ultramarine is not noticed in the other blue paint samples examined. In fact, a relatively thick layer of ultramarine alone, mixed with lead-white, appears to produce the blue of the castle in the background of the *Transfiguration* (pl. 157), and the sample cross-section from the sky of the *Madonna di Foligno* shows a thinner ultramarine / lead-white layer on top of a pink underpaint (pl. 159).

The cross-sections prepared from samples taken from Saint Paul's mantle in the *Santa Cecilia* show that the original red colour was applied in two layers: a relatively thick layer of vermilion (mixed with a little lead-white) covered by a thin glaze of red lake pigment (pl. 151, 152). EDX analysis detected aluminium in the substrate of the lake pigment. A similar structure with a transparent glaze over a body-colour layer is also observed in two sample cross-sections from the shadow area of a reddish mantle in the *Transfiguration* (pl. 158). An unusual mixture of pigments was found in these

[17] G. Emile-Mâle, op. cit. in n. 4, p. 234.
[18] J. Lavallée, *Galerie du Musée Napoléon*, Paris (1840), iii, p. 4.

[19] Ultramarine over azurite was also noticed in the Virgin's robe in the *Madonna di Loreto*; see S. Delbourgo, op. cit. in n. 14, p. 60.

opaque layers, consisting of red ochre, black (possibly charcoal) and a little green; EDAX analysis shows that the green pigment is a copper green, but owing to the small quantity of pigment present a more precise identification was not possible.

General Observations on the Painting Technique

Even though the results reported above are limited to only a few colour areas and cover an incomplete range of the pigments used, they nevertheless furnish some information on Raphael's technique.

Many of the features noted in the *Santa Cecilia* and the *Transfiguration* indicate a similar method of construction and a very refined technique. Above the white priming layer, the paint is built up in a sequence of thin, even layers. The pigments are of the best quality, carefully mixed with a very little oil medium, thus avoiding darkening due to oil discolouration. The whole paint film, in general rather thin, laid on the absolutely white and perfectly reflecting priming layer, was designed to produce great brightness and transparency.

The various paint layers were intentionally laid one over another in order to obtain very precise effects: thus the pink underpaint was certainly intended to give a warmer tone to the sky and, in fact, when observing the *Santa Cecilia*, it can be perceived through the superimposed blue layer; likewise, glazes, used rather freely, were certainly intended to give depth and richness to the dark colours of the clothes without losing transparency.

The method of obtaining a blue paint by laying ultramarine over azurite also seems a deliberate choice rather than a means of economising on the use of the costly ultramarine.[20] This appears to be indicated by the fact that a thick ultramarine layer was used for a minor detail such as the little castle in the *Transfiguration*'s background, and that ultramarine only was used, probably intentionally, for the sky of the *Madonna di Foligno*, much deeper in tone than the bright skies of the *Santa Cecilia* and the *Transfiguration*.

Modification of the Santa Cecilia's Surface by Treatments Following the French Restoration

The original brightness and transparency of the *Santa Cecilia* were completely dimmed by all that had been laid over the surface by the restorers of the past.

[20] Ultramarine over azurite is considered a structure peculiar to Flemish painters; see J. Plesters, 'Ultramarine Blue, Natural and Artificial,' *Studies in Conservation*, xi, (1966), pp. 43–50. However, it was also widely adopted by Italian painters. The present author has noticed it in pictures by Francesco Francia (see n. 14 and R. Rossi Manaresi, 'Notizie sulla tecnica pittorica di Francesco Francia, Alessandro Tiarini e Guercino,' *Il Carrobbio*, iii, Bologna [1977], pp. 339–52), Cima (see *Restauri a cura della Soprintendenza per i Beni artistici e storici di Parma e Piacenza*, Parma [1979]), and Garofalo. The same structure was also observed in pictures by Perugino (see D. Bomford et al., 'Three panels from Perugino's Certosa di Pavia altarpiece,' *National Gallery Technical Bulletin*, iv [1980], pp. 3–31), Mantegna (see S. Delbourgo et al., 'L'analyse de peinture du "Studiolo d'Isabella d'Este",' *Annales du Laboratoire des Recherches des Musées de France* [1975], pp. 21–28) and other Venetian painters (see H. W. van Os and J.R.J. van Asperen de Boer, *The Early Venetian paintings in Holland*, Maarssen [1978], pp. 40, 113).

The cross-sections of all samples—those from the sky and, unexpectedly, also those from Saint Paul's mantle—show the same upper structure with three (or two) layers of discoloured varnish; these are very dark, and not noticeable if observed by reflected light (pl. 149–152). However, if illuminated by ultraviolet light, they are rendered clearly visible by their yellow fluorescence and by the dark, nonfluorescent and extremely thin bands that divide them (pl. 153–155). These thin, dark bands are not natural deposits of dirt, but are purposely applied brown-tinted glazes, as demonstrated by the fact that they include a protein medium. In the two samples showing only two varnish layers, both brown-tinted layers are present, the first of them being in contact with the upper paint layer (pl. 153).

The suspected total overpainting of the sky, therefore, appeared to be extended to other areas, and showed features of two patina layers applied on two subsequent occasions, probably to the whole painting (an hypothesis confirmed during cleaning). Secco-Suardo and Forni, in two well-known nineteenth-century Italian treatises, testify that the application of a patina before revarnishing was an operation generally carried out to reduce the bright tone of the retouchings, to unify the colours, and, above all, to give the entire picture that uniform yellowish tint much appreciated at that time as typical of old paintings.[21] Various substances were used for giving a patina, such as beer, asphalt, ivory black mixed with yellow and red lake, coffee, soot, saffron, extract of walnut shells, or liquorice juice. Both Forni and Secco-Suardo include size in all their recipes and, as we have seen above, a protein medium, probably glue, was found present in the two patina layers subsequently applied to the *Santa Cecilia*.

Taking the documentary information into account, an attempt to date the various layers of varnish and patina can now be made. The original varnish, if not already previously removed, was certainly eliminated by the Paris restorers, as was clearly stated by the documentary sources.[22] When the pictures returned to Bologna, "the French retouchings were removed"; this suggests local treatments, without removal of all the varnish laid in France: the first layer of varnish, therefore, would be Hacquin's.[23] The retouchings were probably only partially removed, as suggested by the sample cross-section from Saint Paul's mantle showing a repaint layer, deep red in colour, with the surface corrugated as if it had been scraped (pl. 152). The spots of perhaps only partially removed retouchings were then hidden under a brown-tinted glaze and a new varnish layer (these could be the first patina layer and the second layer of varnish).

Finally, in the present century, Pelliccioli in his restoration did not remove the discoloured varnishes, nor the previous patina layer; instead, he laid something else over them. Perhaps he carried out the local retouchings that, being relatively close to the surface, appeared as dark spots in the ultraviolet fluorescence photographs. Moreover, he seems to have been responsible for the second patina layer and for the third layer of varnish.

[21] G. Secco-Suardo, *Il restauratore dei dipinti* (1873), ed. Hoepli, Milan (1927), pp. 539–40; U. Forni, *Manuale del pittore restauratore*, Florence (1866), pp. 101–2.

[22] G. Emile-Mâle, 'Appendice di documenti' in

D. Redig de Campos, 'La Madonna di Foligno di Raffaello. Note sulla sua storia e i suoi restauri,' *Römische Forschungen der Bibliotheca Hertziana*, xvi (1961), pp. 184–97.

[23] Passavant, loc. cit. in n. 2.

Even if the above hypotheses are not completely correct, there is no doubt that the three layers of discoloured varnish with two layers of brown patina in between were responsible for the dull tones and for the unbalance of colours, as their effect was relatively more noticeable in the light areas such as the sky.

One should underline, therefore, the poor aesthetic consequence of the policy of past restorations when the restorers believed in masking damaged areas and improving the appearance of a painting by covering the original surface under layers, though thin, of dark glaze and varnish.

Cross-sections Described

Photomicrographs of paint cross-sections from *Santa Cecilia* photographed by reflected light.

The layers are described from the bottom upwards in the relative captions.

Plate 149. Blue of the sky, area to the left of Saint Cecilia's head

1. Lead-white: new preparation applied when transferring from panel to canvas.
2. Thin brown line: original size plus oil applied during the transfer.
3. Extremely thin lead-white layer: original priming.
4. Thin pink underpaint: lead-white plus a red lake pigment.
5. Blue layer containing, besides lead-white, azurite in the lower part and ultramarine in the upper part.
6. Later dark accretions (see pl. 153).

Plate 150. Blue of the sky, area to the right of Magdalen's head

1. Traces of pink underpaint. The layers underneath not present in this cross-section.
2. Blue layer formed, as layer 5 in pl. 149, by ultramarine over azurite.
3. Later dark accretions (see pl. 154).

Plate 151. Red from Saint Paul's mantle, area with no retouching shown by infrared and ultraviolet photographs

1. Lead-white: new preparation for transfer.
2. Thin brown line: original size plus oil applied when transferring.
3. Very thin original priming: lead-white.
4. Thick red layer: vermilion plus a trace of lead-white.
5. Probable red glaze, but not clearly distinguishable.
6. Later dark accretions (see pl. 155).

Plate 152. Red from Saint Paul's mantle, area showing retouchings in infrared photograph

1. Lead-white: new preparation for transfer.
2. Thin brown line: original size plus oil applied when transferring.
3. Very thin original priming: lead-white.
4. Red layer: vermilion plus a trace of lead-white.
5. Glaze: a red lake pigment on aluminium hydroxide substrate.
6. Red retouching; the aspect of the layer surface suggests that this was scraped.
7. Dark accretions.

Photomicrographs of sample cross-sections from *Santa Cecilia*, photographed by fluorescent light excited by ultraviolet.

The various layers of the later dark accretions (see pl. 149-152) made evident, due to the yellow fluorescence of the varnish layers, are described from the bottom upwards in the relative captions.

Plate 153. Blue of the sky, same cross-section as in pl. 149

1. Dark band: first patina.
2. Varnish.

3. Thin dark band plus a few black particles: second patina.
4. Varnish.

Plate 154. Blue of the sky, same cross-section as in pl. 150

1. Varnish.
2. Dark band plus a few dark particles: first patina.
3. Varnish.

4. Dark band: second patina.
5. Varnish.

Plate 155. Red of Saint Paul's mantle, same cross-section as in pl. 151

1. Traces of varnish.
2. Dark band plus a few dark particles: first patina.
3. Varnish.

4. Dark band: second patina.
5. Varnish.

Photomicrographs of sample cross-sections from the *Transfiguration* and the *Madonna di Foligno*, photographed by reflected light.
The layers are described from the bottom upwards in the relative captions.

Plate 156. Blue of the sky, from the *Transfiguration*

1. Gesso ground.
2. Thin brownish band: animal glue.
3. Very thin lead-white layer: priming.

4. Blue layer: azurite plus lead-white covered by a thin top layer of ultramarine plus lead-white.
5. Thick blue layer (on the right): later retouching.

Plate 157. Blue of the castle, in the background, of the *Transfiguration*

1. Gesso ground.
2. Very thin layer of glue.
3. Lead-white priming, not distinct from the layer above showing a few particles of azurite in a lead-white matrix.

4. Thick blue layer: ultramarine plus lead-white.
5. Discoloured varnish.

Plate 158. Red-brown of the shadow area of a mantle, from the *Transfiguration*

1. Gesso ground.
2. Very thin yellowish band: animal glue.
3. Lead-white priming.
4. Thin reddish layer: red ochre plus black plus a little copper green.

5. Original glaze: a dark red lake pigment on a substrate containing aluminium.
6. Dark brown overpaint.

Plate 159. Blue of the sky, from the *Madonna di Foligno*

1. Thick lead-white layer: new preparation applied for the transfer.
2. Very thin, light brown band: glue plus oil.
3. Lead-white: priming layer.

4. Pink layer (a red lake pigment plus lead-white) interpenetrating layers 3 and 5.
5. Ultramarine plus lead-white.

14

Raphael's Portrait of Bindo Altoviti

CAROL CHRISTENSEN

RAPHAEL'S late portrait of the Florentine banker, Bindo Altoviti (pl. 146), is something of an art-historical puzzle. Because it is so unlike Raphael's earlier, more classical paintings, the portrait's attribution has often been debated. In addition, ambiguous references in the literature have raised questions about the identity of the sitter. Even the painting's date and condition have been a matter of some discussion. It was hoped that an examination by the conservation department, undertaken in conjunction with the National Gallery's 1983 exhibition, *Raphael and America*, might contribute information of a technical nature which could help answer some of these questions.

The earliest reference to the portrait, whose history David Brown discusses in detail in his exhibition catalogue, *Raphael and America*,[1] appears in Vasari's first edition of the *Vite* (1550): "E a Bindo Altoviti fece il ritratto suo, quando era giovane, che è tenuto stupendissimo (And for Bindo Altoviti he made his portrait when he was young)." The portrait remained in the collection of the Altoviti family until 1808, when it was sold to agents of Ludwig of Bavaria and was shortly afterward installed in the newly created Alte Pinakothek in Munich. At this time the painting was popularly considered to be a Raphael self-portrait, according to a hypothesis which had been advanced by Bottari in 1759.[2] Bottari suggested that Vasari's words *il ritratto suo* were properly interpreted to mean that Raphael painted a self-portrait which he gave to Bindo Altoviti rather than that Bindo Altoviti was the subject of the portrait. Because of this theory, now generally discredited, the painting was quite famous throughout the nineteenth century.[3]

Morelli was among the first to express reservations about the Raphael attribution.[4] In 1880 he wrote that it was based on eighteenth-century restoration which gave the

I would like to thank Gretchen Hirschauer and David Brown of the Department of Italian Paintings at the National Gallery for providing me with historical information on the *Bindo Altoviti* portrait. Burton Fredericksen of the Getty Museum was kind enough to make available Suhr's conservation report from the Suhr archive at the Getty. The nineteenth-century accounts of the painting's condition are part of the ongoing research of Jane van Nimmen regarding the nineteenth-century perception of Raphael.

[1] D. A. Brown, *Raphael and America*, Washington (1983), pp. 178–87. The catalogue presents stylistic arguments for a Raphael attribution outside the scope of this article. For a review of scholarly attributions see also F. R. Shapley, *Catalogue of the Italian Paintings in the National Gallery of Art, Washington*, Washington (1979), pp. 394–96.

[2] G. Vasari, *Vite de' più eccellenti pittori, scultori e architetti*, ed. G. Bottari, 3 vols., Rome (1759–1760), ii, p. 88.

[3] The self-portrait theory, never universally accepted by scholars, is now out of favor due to the painting's dissimilarity to other more generally accepted self-portraits such as that in the *School of Athens* fresco in the Stanza della Segnatura.

[4] The very first was Anton Springer in an 1873 review of Grimm's *Leben des Raphaels* in *Zeitschrift für bildende Kunst* viii (1873), pp. 65–80.

flesh tones a violet-red hue and obscured a clear view of the picture.[5] The painting must indeed have been heavily overpainted at this time, since between 1873 and 1885 there are five written reports of bad restoration, from Springer in 1873,[6] Lübke in 1879,[7] Morelli in 1880, Springer again in 1883,[8] and Crowe and Cavalcaselle in 1885.[9] Writing twelve years later in 1892, Morelli mentioned that the painting had been cleaned during the previous year.[10] The removal of overpaint convinced him more strongly than ever that the painting was not even of the Raphael school, based on the form and treatment of the ear, hair, and eyebrows. It was Berenson's opinion in 1907 that the picture was painted by Baldassare Peruzzi.[11]

The decline of the painting's reputation can be followed by noting its attribution in successive Alte Pinakothek catalogues. Dollmayr was the first to attribute the painting to Raphael's student Giulio Romano, in the late nineteenth century.[12] In the 1911 Alte Pinakothek catalogue, the portrait was given to Giulio. In the 1925 catalogue, however, the painting was demoted to School of Raphael. By 1932, Berenson had changed his attribution from Peruzzi to Raphael.[13] Nevertheless, persistent questions led to the picture's sale six years later by the Alte Pinakothek, which already owned three more conventional Raphael *Madonnas*, which were firmly attributed. The portrait was acquired in 1938 by Duveen, who two years afterward sold it to Samuel Kress. Since its entry into the National Gallery collection, opinion has varied as to authorship. Although in earlier publications many writers gave the picture to Giulio,[14] more recently there has been a swing back toward a Raphael attribution.[15] One of the chief arguments against a Giulio attribution, apart from stylistic considerations, is that Giulio, born in 1499, would have been too young to paint the portrait if it were executed between 1512[16] and 1516,[17] the dates put forward by most scholars.[18]

[5] G. Morelli, *Die Werke italienische Meister in den Galerien von München, Dresden und Berlin*, Leipzig (1880). English translation as *Italian Masters in German Galleries*, by L. M. Richter, London (1883), p. 85.

[6] In his 1873 review, he says, 'the Munich portrait has been (similarly) altered, almost past all recognition, by a thoroughgoing overpainting, so that not only the hair and neck, but also the forehead, eyebrows, the cheeks down to the corners of the mouth, possess nothing of their original condition.'

[7] W. Lübke, *Rafael-Werk: Sämtliche Tafelbilder und Fresken des Meisters*, Dresden (1875), pp. 120–21. The painting is described as 'lovely but overpainted.'

[8] A. Springer, *Raffael und Michelangelo*, 3rd ed., Leipzig (1883), p. 357: 'The heavy overpainting complicates the investigation.'

[9] J. A. Crowe and G. B. Cavalcaselle, *Raphael: His Life and Works*, London, (1885), pp. 174–76. Noted as 'repainted.'

[10] Morelli, *Italian Painters: Critical Studies of Their Works. The Galleries of Munich and Dresden*, trans. Jocelyn Ffoulkes, London, (1893), pp. 112–14.

[11] Bernard Berenson, *Gazette des Beaux-Arts*, 3ème Pér., xxxvii, 1907, p. 209.

[12] H. Dollmayer, *Jahrbuch der kunsthistorischen Sammlungen des allerhöchsten Kaiserhauses*, xvi (1895), p. 357.

[13] Bernard Berenson, *Pitture italiane del rinascimento* (1936), p. 413.

[14] These include O. Fischel, *Raphael*, London (1948), i. p. 365; F. Hartt, *Giulio Romano*, New Haven (1958), i, pp. 51 ff.; S. Freedberg, *Painting of the High Renaissance in Rome and Florence*, Cambridge, Mass. (1961), i, pp. 338 ff.; and L. Dussler, *Raphael: A Critical Catalogue*, London (1971), p. 66.

[15] Those who have accepted the Raphael attribution include J. Pope-Hennessy, *Raphael*, London (1970), pp. 219, 289 n. 80; E. Camesasca, *Tutta la pittura di Raffaello*, Milan (1962), i, pp. 89 ff.; S. Freedberg, *Painting in Italy, 1500–1600*, Harmondsworth (1971), p. 471 n. 49; and B. B. Fredericksen and F. Zeri, *Census of Pre-Nineteenth-Century Italian Paintings in North American Public Collections*, Cambridge, Mass. (1972), p. 646. Hartt, however, in the second edition of *Giulio Romano* (1981) still favors a Giulio attribution.

[16] Date suggested by David Brown, op. cit. in n. 1.

[17] Date suggested by S. Freedberg, op. cit. in n. 14, p. 338.

[18] Hartt suggests a date of 1520, when Giulio was 21.

Our technical examination of the painting included x-radiography, infrared reflectography, ultraviolet examination, and a limited amount of pigment identification using energy-dispersive x-ray fluorescence analysis. Infrared reflectography did not prove to be a useful analytical tool. If underdrawing were at one time present, it did not survive the 1939 transfer, during which the original ground was removed.

For information about the painting's original support we were able to study the 1939 conservation report of William Suhr, to whom Duveen sent the portrait for restoration. This report and the accompanying photographs constitute the only existing written record of conservation treatment prior to the painting's entry into the National Gallery collection in 1943.

The original support (pl. 318) was a 2.5 cm-thick poplar panel composed of two radially sawn members with vertical grain joined to the left of center. On the front of the painting, the join ran vertically through the ear of the sitter. The panel was rough-planed and reinforced on the reverse with two horizontal wooden battens. A butterfly spline had been inset at the top along the join, but was no longer in place at the time of the painting's transfer.

The design did not extend to the edges of the panel but instead ended 3 cm from each edge. The paint layers are very smoothly blended, wet into wet, using opaque underpaint overlaid with thin glazes. For example, the green background consists of an underlayer of pale green, a mixture of lead-white and a copper-green pigment. This was overlaid with a transparent darker copper-green glaze.[19] The smoothly blended quality of the paint application suggests oil-bound paint was used; however, no medium analysis was done to confirm this assumption. No design changes were noted during examination of the radiograph.

In comparing our portrait with other paintings by Raphael we found that the artist's technique differed significantly from what we noted in other paintings by him in the structure of the blue cloth and the flesh tones. The blue robes in most paintings by Raphael consist of an extremely thick underpainting which makes the area stand up in relief against the rest of the painting. In contrast, there is no relief effect in the robe which Bindo Altoviti wears. We did find, however, a fairly intense layer of pinkish red underpaint (visible during microscopic examination) beneath the blue upper layer which, when overlaid with blue, creates a purplish effect. A similar construction was noted in the grey-blue armor of Saint George in the National Gallery's *Saint George and the Dragon*.

The underpaint application in the flesh tones was closely studied during examination of the x-radiograph (pl. 316) of the portrait. When compared to the radiograph of the *Niccolini-Cowper Madonna* (1508) (pl. 320), the difference in construction is pronounced. In the earlier painting, Raphael created his flesh tones by applying thin translucent glazes over a white partially revealed ground, which makes the flesh tones in the radiograph appear black, that is, lacking in density. A similar structure was noted in the three other Raphael paintings in the collection of the National Gallery. The flesh tones of the *Bindo Altoviti* are by contrast quite opaquely rendered, with a very dense,

[19] Analysis based on microscopy and x-ray fluorescence.

smoothly blended lead-white paint. This increasing use of lead-white in the flesh tones appears to be characteristic of later works by Raphael, although there are occasional departures from this rule.[20]

In comparing the National Gallery's portrait with other Raphael paintings closer in date than those in the Washington collection, it was noted that the Bindo Altoviti radiograph did not closely resemble available radiographs of other paintings of the same period. The flesh tones of the *Madonna della Tenda*[21] (c. 1513, Alte Pinakothek, Munich) and of the portrait of *Julius II*[22] (c. 1513, National Gallery, London) are both thickly painted but with much greater contrast between light and shadow and with a looser, less blended brushstroke in the underpaint. Radiographs of the *Baldassare Castiglione* (c. 1514) and *Raphael and His Fencing Master*[23] (c. 1516) also appeared quite unlike the *Bindo Altoviti* radiograph. The two Louvre paintings are quite thinly painted, with very little lead-white.

It should be pointed out that the radiograph of the *Portrait of Bindo Altoviti* is unusual among the nineteen Raphael radiographs examined during the project in the extreme enamel-like smoothness of the underpainting in the flesh tones. The radiograph which it most closely resembles is the Louvre's *Portrait of Joanna of Aragon* which has been attributed to both Giulio and Raphael. The Louvre suggests the density of the flesh tones in their painting is caused by an augmentation of the ground during the transfer and a layer applied to the back of the new support.[24] This seems especially unlikely in the case of the Washington portrait, since according to Suhr's conservation report, no lead-white was added to the new ground which he applied. Furthermore, this unusual density is apparent only in the light colors, which would not be the case if a ground containing lead-white augmentation had been applied over the entire area of the painting.

Other paintings whose radiographs are somewhat similar to the National Gallery portrait include the *Portrait of Tommaso Inghirami* in the Pitti Palace and the *Donna Velata*.[25] This is hardly surprising since the intent in these paintings, to create a sort of idealized portrait, is nearest to the artist's intent in the *Bindo Altoviti*, and to which the painting technique may consequently be more closely related.

Not surprisingly, the technical examination done to date has not been able to support or disprove the hypothesis that Raphael painted the *Bindo Altoviti*. First, the transfer of the painting made examination procedures such as infrared reflectography unusable. Secondly, other analytical techniques such as pigment identification cannot be used to distinguish between the two artists, since Raphael and Giulio, working together

[20] As in the early *Granduca Madonna* (x-radiograph published in A. Gilardoni, R. A. Orsini and S. Taccani, *X-Rays in Art*, Como [1977], p. 149) in which the flesh tones are opaquely underpainted.

[21] Reproduced in H. von Sonnenburg, *Raphael in der Alten Pinakothek*, Munich (1983), p. 102.

[22] Reproduced in C. Gould, *Raphael's Portrait of Pope Julius II*, London (1970), p. 6.

[23] The Louvre radiographs were examined at the Louvre in 1982, with the kind assistance of Mme. Lola Faillant-Dumas, Documentaliste, Laboratoire des Musées de France.

[24] L. Faillant-Dumas and J.-P. Rioux in *Raphaël dans les collections françaises*, exh. cat., Paris (1983), p. 421.

[25] Radiographs of *Tommaso Inghirami* and *Donna Velata* are reproduced in *Raffaello a Firenze*, Milan (1984), pp. 257 and 268.

in the same shop, are likely to have used the same pigments, perhaps even the same layering of paint. Pigment and cross-sectional analysis would become more meaningful if a large group of samples from paintings close in date, by both artists, could be studied for similarities and differences. Unfortunately, while cross-sectional analysis of Raphael's paintings may soon be available, comparable analysis of the paintings of Giulio has not been done. Therefore, pigment identification cannot be used as a basis for attribution at present.

Technical investigation was somewhat more useful in determining the painting's present condition and restoration history. According to the 1939 report of William Suhr, who transferred the painting, it was covered with blisters when he received it. Judging the blisters to be caused by a recurring separation between the paint layer and the ground, he decided to replace the ground with a more strongly adhering one. Accordingly, after the blisters were set down, the wood was mechanically removed from the reverse and then the old gesso was scraped and washed away. In pl. 319 the painting is seen from the reverse at this stage of the treatment; the paint layer is visible through a thin layer of ground which was eventually completely washed away. According to Suhr's report, a new ground made from chalk, glue, zinc, and linseed oil was applied to the back of the paint layer to replace the one removed. The painting was then attached to three layers of laminated pressed wood whose pattern is faintly evident in the radiograph. After the new support was attached to the paint, strips of wood were added to all sides and to the back. Suhr left a thin veneer of the original poplar along all edges. Finally, the panel was cradled, presumably for cosmetic reasons.

According to Suhr's treatment report, after the painting had been transferred, the varnish was removed. The 1982 ultraviolet light photograph (pl. 317) shows that at present there is still a heavy layer of natural resin varnish covering most of the painting. The unclouded sections of the photograph (head, hands, and throat) are those places from which it has been selectively removed. The dark areas along the join line, in the mantle, and along several small splits in the original panel are retouches done one year after the transfer. Since the restoration and retouching of the picture in 1939 and 1940, the picture has not been treated except for periodic setting down of the blisters, which have recurred despite the transfer.

As to its present condition, we know from the nineteenth-century reports that the picture had been heavily restored. The twentieth-century transfer resulted in a few more losses, especially in areas where the blisters were quite pronounced. Technical examination shows, however, that many parts of the picture appear to be very well preserved, particularly the proper right side of the sitter's hair and face, which is strongly illuminated. There are no large losses or fills, although the proper left eye and the hand are abraded and may be retouched. The losses revealed in the radiograph are confined to small isolated pinpoints throughout the face, along minor splits in the original panel and in a few spots in the background. The only clearly evident fill lies beneath the ear.

Examination using a stereomicroscope was useful in locating thinly applied repaint not visible in the radiograph. It was noted in several strands of hair on the shadowed side of the face, in the proper left eye, in the background at the far right, in small

feathered strokes in the blue mantle, and in the hand. Many of these retouches are clearly apparent to the naked eye, due to whitening in the case of the blues, and darkening in the case of the flesh tones. The flat, limp appearance of the hair on the shadowed side of the face may be due to restoration. Comparison of the 1939 before-treatment photograph with photographs taken in 1982 revealed subtle differences in the shape of the hair strands. It is possible that there is thinly applied old retouching here which has now assumed the crackle pattern of the rest of the paint surface, making it difficult to distinguish from original paint.

The technical investigation of the *Portrait of Bindo Altoviti* is at present incomplete, with further pigment studies still anticipated. While the work done to date has answered questions about the restoration history of the picture and its present condition, it has been of limited use in solving the attribution problems. It was noted that in two particulars, the construction of the blue robe and the dense enamel-like undermodelling of the flesh tones, this painting is unlike other works by Raphael which were studied. However, technical information is only one tool in the determination of attribution. It may be less likely that an adolescent Giulio Romano could have painted this extraordinary portrait than that Raphael, never a rigid artist in his use of materials and in his technique, deviated from his normal technical practices in one late portrait. Moreover, since there is no information available on the technique of Giulio, we have no comparative material for study. It seems that in the case of the *Portrait of Bindo Altoviti*, stylistic rather than technical considerations must be, for the present, the primary factor in deciding the question of attribution.

15

Restoration of the *Madonna of the Oak* and Conservation of Raphael's Paintings in the Prado

RAFAEL ALONSO

TRANSLATED BY TOBY TALBOT

IN inventories of the Spanish Royal Collections and those of the aristocracy, from the beginning of the seventeenth century there is listed a considerable number of works attributed to Raphael, or copies of his compositions. Placed in prominent positions in the Alcázar in Madrid, or the Escorial Monastery, in Buen Retiro, Palacio Nuevo, or Sitios Reales, they are invariably regarded as among the treasures in the collection.

Some of these works are now identified with the eight currently in the possession of the Prado Museum, while others are currently held in museums and collections outside Spain, for example, the *Madonna della Tenda* and the *Madonna Alba*, and others were lost in the Alcázar fire of 1734 and in Napoleonic lootings. There are eight Raphael paintings, or works attributed to him, in the Prado's possession, all deriving from the Royal Collection: *Holy Family with the Lamb, Madonna of the Fish, Spasimo di Sicilia, The Cardinal, The Visitation, The Holy Family (La Perla), Madonna of the Rose,* and *Madonna of the Oak.*

Of these, four were transferred from their original wooden supports to canvas during the years when they were in Paris, from 1813 to 1818, having been taken out of Spain during the retreat of the Napoleonic army. The necessity for changing the supports, deemed absolutely imperative at the time, and described in detail by Villa-Urrutia, was highly praised by Spanish witnesses who claimed that the paintings suffered scarcely any damage or loss of color. The panels, particularly of the *Spasimo di Sicilia* and the *Madonna of the Fish*, were wormeaten, and the paintings, in transit to France, had been exposed to hazardous conditions and then to outdoor storage in Tours. It seems certain therefore that had these paintings not been transferred to canvas, they would have been unable to withstand the arduous return voyage to Spain, which lasted almost two months and was made in mule-drawn wagons along poor roads.

The four paintings that were transferred to canvas are: *Spasimo di Sicilia* (3.06 × 2.30 m), *The Visitation* (2.00 × 1.45 m), *Madonna of the Fish* (2.12 × 1.58 m), and *Madonna of the Rose* (1.03 × 0.84 m). The radical treatment of these works not only resulted in the loss of their original supports, an integral and essential part of any work, but also altered their appearance completely, for the transfer to canvas gave them a

different quality and texture, in which the weave of the cloth on which they were glued was plainly revealed, instead of the smooth, even, refined surface of the panel.

Looking at these works in the Prado produces an odd sensation, as if one were gazing at something that does not quite harmonize with Raphael's aesthetic, or paintings which might even be old copies of the painter's work done on canvas. That perhaps is what prompted the conservators of the studio to intervene.

The Prado has four other Raphael paintings which are perfectly conserved on their original panels.

Holy Family with the Lamb (29 × 21 cm). On the fringe of the Virgin's garment there appears the inscription: "Raphael Urbinas MDVII." The painting, which is in a good state of conservation, is executed on a black poplar board, approximately 0.5 cm thick, covered on the reverse side by a coat of burnt sienna in tempera. The panel on which this Holy Family is painted is joined to a pine stretcher which dates possibly to the end of the seventeenth century, judging by the grisaille architectural adornment typical of that period in Madrid. Though the painting belonged to the Roman family Falconieri in 1696, it entered the Spanish Royal Collection and was deposited in the Escorial around 1700, and the cradling with its Baroque decoration dates perhaps to these latter years. The frame of the cradling is not glued and can be opened and taken apart like a modern stretcher for paintings on canvas, so that the painted panel, held in grooves only at the upper and lower edges, remains free to allow horizontal expansion and contraction, yet cannot bend. The conservation of this painting and of its support is perfect, partially owing perhaps to the place where it was stored on its arrival in Spain, the sacristy in the church of El Escorial Monastery, and also to its small size.

The Cardinal. Painted on a support of black poplar wood, on a single plank measuring 79 cm high, and 60.5 cm wide, and 3 cm thick. It is Raphael's last painting to reach the Royal Collection, and was apparently acquired by Charles IV while he was still a prince. It bears on the back a Castillian inscription: "Cardenal Grambeli . . . empo Carlos V. Olio de Antonio Moro."

The support is absorbent, well-seasoned poplar. On the upper left-hand portion is a bow-shaped dovetail insertion which reinforces a fragile grain in the wood (pl. 330). The panel is reinforced with two horizontal pine crossbars, which are not original.

La Perla. Painted on a support of two pieces of light poplar, 147 cm high and 116 cm wide and 3 cm thick, it is branded on the back with the seal of King Charles I of England, to whose collection it belonged. This painting, held always in high esteem, was acquired by King Philip IV of Spain, along with other masterpieces now held in the Prado Museum, at the sale of King Charles I's goods.

The original cradling of this panel painting was like that described in the *Holy Family with the Lamb*. This is evident from the two grooves on the upper and lower edges, 2 cm wide. The panel is presently reinforced by two sliding horizontal crossbars in pine, which fit into the two channels cut into the support. The date when the cradling was converted to wooden reinforcements is not known.

In view of the fact that *The Cardinal, La Perla* and the *Madonna of the Oak* display the same reinforcement (pl. 328), we may assume that all three were modified when the paintings arrived in Spain. The reinforcements are not of the same hand, of course, nor perhaps of the same period. That of the *Madonna of the Oak* appears older, the crossbars carefully carved in oak, while the most modern, the *Cardinal*, has very slender pine crossbars. The ones on the *Cardinal* seem not to predate the middle of the eighteenth century, while those of the *Madonna of the Oak*, carved in a style similar to that employed in Spanish furniture of the first half of the seventeenth century, may belong to that period. The pine crossbars of *La Perla*, judging from their style, were undoubtedly placed on the painting when it was brought to Spain.

Conservation of the paint layer of *La Perla* and of the support is perfect: we hope soon to undertake its cleaning and are confident that the results will be excellent.

Madonna of the Oak. The origins of this painting, which must have entered the Spanish Royal Collection at an early date, are unknown. The first description of it appears in the 1666 Alcázar inventory, where it is mentioned among the works that adorn the Galería del Mediodía or the Salas del Rey. In the inventory of 1686, it occupies the same location, which in all likelihood was the warmest section in the Alcázar, and most subject to changes during the day and from season to season. In the 1701–3 inventory, following the death of Carlos II, this work was appraised at 100 doubloons, a very high sum when compared with other fine paintings in the Royal Collection. Saved from the 1734 fire in the old Alcázar, it is mentioned again in the 1772 inventory of works held in the Nuevo Palacio. The most perilous moment in its history probably occurred in the trip from Madrid to Paris after the Napoleonic invasion, owing to the already mentioned rigors of transport and to the neglect the paintings suffered on their arrival in Tours, where they were stored outdoors for several months. Despite this, the painting was deemed to be in a good state of conservation in Paris since it did not have to be transferred from wood to canvas. On its return to Spain, the *Madonna of the Oak* entered the Prado Museum along with the *Spasimo di Sicilia*, and from 1819 onward hung in the Central Gallery, where it is listed in the first museum catalogues.

The work must always have been treated with the greatest of care, judging from the high appraisals it received in subsequent inventories. In the final one, done in 1833 at the death of Ferdinand VII, by which time the work belonged to the Prado Museum, it was appraised at 1,500,000 reales, which is the second highest appraisal of a Prado painting, the first being the *Spasimo di Sicilia*, appraised at 4,000,000 reales. These figures are significant only when compared with the appraisals of other paintings in the collection. Raphael's *The Cardinal* was appraised at 50,000 reales; the costliest Murillo at 100,000 reales, the most highly appraised Velazquez at 260,000 reales, and Titian's famous *Bacchanals* were jointly appraised at 60,000 reales.

Restoration of the *Madonna of the Oak*

Support. Poplar wood, 144 cm × 109 cm; thickness: 3 cm.

The support of this painting is especially interesting for its documentary value,

since it has not undergone subsequent changes and thus demonstrates the importance, when conserving a work, of not altering the original balance of its parts through additions and tactics that may at times be capricious.

The support of the *Madonna of the Oak* (pl. 328) is formed by three glued planks of dark poplar wood, 3 cm thick, vertically placed and reinforced with three mobile crossbars of oak which slip into horizontal channels cut into the boards of the support, running perpendicular to the grain of the wood. The crossbars are trapezoidal in section, 10 cm at the widest point and 9 cm at the narrowest. These mobile crossbars, which are not glued or nailed to the support, have allowed the wood its natural contraction and expansion movements, arising from changes in atmospheric humidity. The panel by not being constricted or obstructed in its movement, has not opened up at any of its wooden joins, nor been deformed, for the crossbars keep it perfectly flat.

This mobility of the sliding crossbars has functioned perfectly to date and has been vital in conserving the painting for the more than three hundred fifty years that it has been in Madrid, where the dry, extreme climate poses considerable problems in conserving paintings on wooden supports. The oak crossbars are not the original ones, but in all likelihood were put on in the seventeenth century, when the painting arrived in Spain, for the support system is similar to that of *La Perla* and the *Cardinal*.

We have done as little as possible to the support so as not to interrupt the functioning of the mobile bars. The center crossbar however had become too narrow—about 3 mm smaller than the other two—and easily slipped out of its channel. To avoid this slack, the crossbar had been connected to the support at some earlier date by means of three linen strips, about 15 cm wide, placed perpendicular to the crossbar. The same tactic had been used on the other two crossbars and also on *La Perla*. These strips of cloth, glued to the original support, not only created stress in the places where they were attached, but also disrupted the balance of the support and prevented free movement of the crossbars.

Placement of these cloth strips seemed relatively modern and may have been done to protect the crossbars when the paintings from the Prado Museum were transferred in 1937 to Valencia and then to Geneva during the Spanish Civil War.

The edges of the support also revealed shreds of the same cloth and of paper that had been pasted on to cover the holes where it had been attacked by woodworms, largely on the left side of the painting.

We decided to remove these shreds since they were useless and harmful, thus allowing the panel to regain its original balance. The center crossbar, which was not too narrow, was supplemented by a strip of well-seasoned old oak, 3 mm wide, which restored its former tension.

At the bottom edge of the painting there are three visible cracks, two on the left side and one on the right. To reinforce these fragile points, situated at the most vulnerable areas of the support, namely the two bottom corners, the panel has two iron plates attached on the back. These plates, which date possibly to the seventeenth century, have fulfilled their protective function, and since they represent no element of danger to the panel, we decided to leave them.

Paint layer. Of the eight Raphael paintings in the possession of the Prado, the four which retain their original wooden supports are also the ones where the paint surface is best conserved.

These four paintings seem to have undergone fewer restorations or at least not to have been subjected to radical cleanings which might have caused irreparable harm to the paint surface. The rather respectful tactic of the former restorers was confined to covering the small losses of color with oil, and to varnishing the paintings in successive layers to freshen the colors. With the passing years, the oil retouchings have darkened, and the color has changed due to oxidization of the oil, and this is now visible, as in the case of the *Cardinal*, where several retouching strokes are noticeable on the garments. Also, the accumulated layers of oxidized varnishes on the paintings have caused them to darken and take on a brownish, amber-like color, which prevents appreciation of the true tonalities, and varied ranges and tints of the original color. Fortunately, cleaning off these varnishes and removing the retouchings have proved highly successful and these paintings, treasured and respected by former restorers, have remained admirably intact beneath their successive layers of aging varnishes.

Although the good condition of the original support was decisive in the conservation of Raphael's four paintings, the *Madonna of the Oak* presented specific conservation problems with regard to the paint layer that could be considered serious. The *Madonna of the Oak* underwent a restoration treatment for the progressive lifting of the paint layer and preparation, which had entailed the risk of further detachments with considerable losses of color.

The painting had for many years shown blisters, as is revealed in the earliest photographs in the Prado Museum, dating around 1930, but these had become increasingly dangerous in recent years. This painting, however, is the only one of the four on wooden supports to present this problem of blistering in the shape of vertical crests that follow the direction of the grain of the wood.

This problem may have been exacerbated by the fact that the painting had been kept for the past four centuries in exceedingly dry environments, thus increasing the exudation of oil, as well as the contraction of the wood. These two factors have caused blistering on the painting and also contraction. The process has accelerated in recent years in the gallery of the Prado where the painting was installed in 1957. It is an area exposed to great climatic fluctuations, which is aggravated by the massive increase of visitors in the recent period of the museum's life.

The appearance of the painting was truly alarming, as revealed in photographs made in raking light (pl. 323–324, 326) showing almost the entire surface to be covered with cracks and blisters, areas detached from the support and in grave danger of coming off.

The first operation we performed on the *Madonna of the Oak* was to fix the color on the support, using as an adhesive either glue or an animal derived gelatine.

The work was extremely delicate, and raised critical problems of judgment. The preliminary phase had to be geared mainly to fixing the paint surface without violating it in order that it remain completely level, taking into account the contraction of the

wood and striving to conserve the painting in its most integral state, without jeopardy to its future conservation. At a future date, after the panel has reacted to being placed in the new galleries of the museum, with their relatively constant temperature and humidity, it may be possible to achieve a consolidation of the color by trying to unify completely the paint surface.

With this in mind, the color fixing was done gradually and very slowly on extremely small areas so that the glue might penetrate, fixing the surface color, and at the same time softening the preparation sufficiently so that the blisters would be reduced as much as possible for, as previously mentioned, we were unable to level the surface of the painting completely due to the drastic contraction of the wood.

After four months of this labor, we felt confident that both the color, as well as the priming of the painting, had been reconnected to the wood support on which the picture had been painted. Thus assured, we could proceed with the second phase of restoration: cleaning the picture surface.

Cleaning. Before restoration of the *Madonna of the Oak* began, we detected, upon close scrutiny of the painting, a slightly darkened spot on the left cheek of the Virgin's face and that the entire surface covering the spot had a smoother texture, without any cracking. It was logical to assume that this was due to some former retouching in oil that had been applied on that area, and that over the years the tone had changed.

When the painting was examined under ultraviolet light, it was confirmed that the area of the Virgin's left cheek had been retouched and that this retouching extended horizontally over the adjacent area of the veil.

The ultraviolet light revealed other retouchings: the principal one situated on the Child's mouth and left shoulder, and on the sleeve of the Virgin's robe behind the Child.

Lastly, several retouchings in the area of the meadow in the foreground covered unnecessarily extensive areas of putty, attempting to conceal the unevenness of the wood resulting from the three cracks on the lower edge of the panel, and this overlapped wide areas of the original painting.

Once the painting had been examined, we embarked on the cleaning process. At the Prado studio we knew that the varnishes traditionally employed by the "restorer-painters" of the Royal Collection and afterwards by the Museum restorers, were natural varnishes, prepared generally on a mastic resin base dissolved in oil of turpentine (essence of turpentine). These varnishes have been accumulating for centuries on our paintings, yellowing and darkening their original colors, particularly the most valuable works in the collection, by Velazquez, Titian and the Venetians, and Raphael. Removing these varnishes is one of the normal tasks in the Prado's restoration studio.

We know through experience how soft and easily eliminated they prove to be with mixtures of alcohol and essence of turpentine, or alcohol, acetone, and water. These solvents provide the best results in removing oxidized varnishes, for they are sufficiently weak in their action to enable us to eliminate the varnishes with a virtually total guarantee of not touching the original glazes of the painting.

The *Madonna of the Oak* was cleaned in this manner, and the result was splendid, allowing its original coloring, which had been concealed for centuries, to emerge, and

even disclosing portions that had heretofore been invisible, such as the beautiful land-scape on the left side, painted with rear illumination and impossible previously to ap-preciate.

Once the varnishes and soil were removed, we proceeded with the cleaning, re-moving the retouchings in oil mechanically with the tip of a scalpel. When the retouch-ings were removed, we were able to verify, as is almost always the case with old re-touchings, that the bare patches were much smaller than the repainted areas.

Reintegration of paint losses (pictorial restoration). After the cleaning of the *Madonna of the Oak* was complete, we were able to assess the paint losses (pl. 322). The losses are few and insignificant as such, but there are two places which affect important parts of the painting and raised doubts therefore as to what criterion to follow in covering these damages.

1. The loss on the Virgin's left cheek (pl. 327): since, on the one hand, the head is the centerpoint and main focal point of the painting and, on the other, our intention was to respect totally the integrity of the painting, we were faced with the problem of how to cover that loss. There were various possibilities: one was to employ a flat neutral color, another to perform a visible reintegration by using lines or dots, or finally, to attempt a totally invisible restoration. We tried out the three methods and decided on the third. Since the area was so delicate in tone and line, any intrusion might diminish the expressiveness, meaning, and beauty of the painting and destroy its harmony. Be-sides, it was unnecessary to interpret or add anything to the painting, but simply to fill in at small intervals the subtle shadings of the original colors that model the cheek.

2. The Child's mouth (pl. 325): the problem here involved other difficulties, inas-much as the outline on the right side of the upper lip and on the left half of the lower lip were missing. But there was information available for reconstructing accurately the outline of the mouth. Also, portions of a former reconstruction remained, and though extremely darkened due to having been painted in oil, it reconstructed the mouth quite accurately, and coincided with the universally known form of this popular painting. In the latter instance, we left the base color of the former restoration, and over it adjusted the coloring by means of a very fine vertical stripe. The normal visitor to the museum would not notice it, though someone closely examining the painting might notice the existence of that small lacuna.

Restoration of these two losses, as well as others of lesser importance, was done with watercolors.

Varnish. The painting was varnished with a varnish prepared in the Prado's restora-tion studio, a mastic resin base dissolved in essence of turpentine. Before restoration of the bare areas began, a first coat of varnish was applied by brush. After restoration the painting was again varnished with a light varnish spray to bring out the nuances of the original, being careful that the painting not lose its quality and texture (pl. 160-163).[1]

[1] The reader is referred to the catalogue, *Rafael en España*, published by the Museo del Prado, May–Au- gust 1985, where a wealth of technical data is pre-sented.—ED.

16

La *Trasfigurazione* e la *Pala di Monteluce*: Considerazioni sulla loro tecnica esecutiva alla luce dei recenti restauri

FABRIZIO MANCINELLI

La *Trasfigurazione* (pl. 164) e l'*Incoronazione della Vergine* (pl. 173–174) del monastero di Monteluce sono tra le opere di maggiori dimensioni uscite dalla bottega di Raffaello. Esse misurano infatti rispettivamente cm 410 × 279 e cm 354 × 235, ed hanno quindi proporzioni superiori sia allo *Spasimo di Sicilia* (cm 318 × 229) che alla *Madonna di Foligno* (cm 320 × 194), le sole altre pale d'altare dell'Urbinate che superino i tre metri di altezza, fatta eccezione per la precoce pala di S. Nicola da Tolentino che presumibilmente superava i quattro metri. La *Trasfigurazione* e la *Pala di Monteluce* sono inoltre accomunate da una curiosa circostanza: esse sono infatti rimaste entrambe incompiute al momento della morte del maestro; a livello di dettagli la prima, in misura certamente maggiore, come vedremo, la seconda, anche se per una valutazione definitiva bisognerà attendere la fine del restauro attualmente in corso. Il restauro ha dato preziosissime informazioni sulla tecnica usata per realizzare le due pale d'altare ed in questa sede ognuna di esse verrà esaminata procedendo, per così dire, dal basso verso l'alto, cioè dal supporto verso il colore.[1]

Il supporto della *Trasfigurazione* è costituito da cinque tavole verticali di ciliegio,

[1] Il restauro della *Trasfigurazione* fu realizzato, nel Laboratorio di Restauro Pitture dei Musei Vaticani, tra il marzo 1972 ed il gennaio 1976 da Luigi Brandi coadiuvato da Enrico Guidi (pulitura e ritocco) e Marcello Mattarocci (risanamento del legno e parchettatura) sotto la direzione di chi scrive, con la supervisione del Direttore Generale dei Musei prof. Deoclecio Redig de Campos. Collaborarono Franco Dati (gassazione del supporto), Giorgio Barnia (radiografie), Giuseppe Morresi (calchi) e inoltre Augusto Troccoli, Claudio Cellante e Luigi Gandini (parchettatura). Le analisi, le sezioni di colore e le radiografie furono tutte eseguite nel Gabinetto di Ricerche Scientifiche dei Musei diretto dal dott. Nazzareno Gabrielli: alcune sezioni furono poi analizzate a Bologna dalla dott.ssa Raffaella Rossi Manaresi con strumenti più sofisticati di quelli allora in dotazione ai Musei. Consulenze esterne furono fornite dal dott. Elio Corona (legno) e dall'ing. Carlo Capasso (parchettatura e struttura di sostegno). Il restauro della *Pala di Monteluce* è invece iniziato nel febbraio 1983 ed è attualmente condotto da Enrico Guidi coadiuvato da Marcello Mattarocci (risana-

mento del legno e parchettatura) e Felice Bono (documentazione fotografica) sotto la direzione di chi scrive, con la supervisione del Direttore Generale dei Musei Vaticani prof. Carlo Pietrangeli e del prof. Pasquale Rotondi, Consulente per il Restauro. Le analisi, le sezioni di colore e le radiografie sono eseguite nel Gabinetto di Ricerche Scientifiche dei Musei, diretto dal dott. Nazzareno Gabrielli, da Luigi Gandini (sezioni e radiografie) e Giorgio Barnia (radiografie). Sul supporto ligneo ha fornito la sua consulenza il prof. Elio Corona, che sta preparando uno studio approfondito destinato ad essere pubblicato sul *Bollettino* dei Musei. Sul restauro della *Trasfigurazione* e su suoi risultati cfr. D. Redig de Campos, 'La *Trasfigurazione* di Raffaello. Cenni sulla sua storia e l'autografia del dipinto,' in *Strenna dei Romanisti*, (1977); F. Mancinelli, *Primo piano di un capolavoro. La Trasfigurazione di Raffaello*, Città del Vaticano s.d (1979); S. Freedberg, K. Oberhuber, F. Mancinelli, *A Masterpiece close up. The Transfiguration by Raphael*, Cambridge, Mass. (1981).

tutte ricavate, secondo il professor Elio Corona, da uno stesso albero (pl. 331). Le ta-
vole hanno uno spessore medio di mm 45 e, da sinistra a destra, misurano in larghezza
cm 53, cm 58.5, cm 58, cm 55, cm 53: quindi l'albero da cui esse furono ricavate
doveva avere un diametro superiore ai 60 centimetri. Sul retro il supporto di ciliegio è
rinforzato da tre traversoni orizzontali di castagno inseriti in incassi a coda di rondine.
La coesione tra tavola e tavola è inoltre assicurata da due serie di tenoni alloggiati in
incassi interni, visibili nelle radiografie e situati (pl. 332), ad altezze diverse, in modo
da creare una rete di punti di forza, negli spazi compresi tra i tre traversoni. Da un
punto di vista carpentieristico si tratta di un lavoro estremamente accurato sia per la
scelta e la qualità dei materiali impiegati, che per la realizzazione vera e propria. I mo-
tivi della scelta di questo particolare tipo di legno non sono del tutto chiari. Il ciliegio è
un legno pregiato, estremamente robusto e compatto, che fornisce notevoli garanzie di
resistenza e durata e può darsi che sulla scelta abbiano pesato le grandi dimensioni,
l'importanza della commissione, e la previsione del lungo viaggio a Narbonne. La ta-
vola non è camottata, tuttavia sulle linee di giunzione tra tavola e tavola sono applicate
lunghe strisce di tela che agli esami di laboratorio sono risultate di lino, certamente per
assicurare continuità di superficie tra tavola e tavola.

Le sezioni eseguite in occasione del restauro hanno poi consentito di individuare le
caratteristiche dell' imprimitura e della preparazione. L'imprimitura è costituita da uno
strato di gesso e colla sul quale è steso un ulteriore velo di colla pura. Lo strato di gesso
e colla risulta dato in più mani, probabilmente tre, in modo da favorire una stesura più
regolare ed è molto grasso, cioè molto ricco di colla. Il velo di colla finale ha la funzione
di impermeabilizzare la superficie così preparata e di favorire l'adesione della successiva
stesura del colore. La preparazione del colore è duplice. Una prima stesura è costituita
da uno strato uniforme di biacca, certamente destinato ad offrire una superficie perfet-
tamente chiara e brillante alla stesura del colore. Su questo strato si trova poi una pre-
parazione locale che varia da zona a zona, a seconda del colore finale: ad esempio il
cielo è preparato in verde, il manto lacca di garanza del S. Giovanni in azzurro e la veste
in verde chiaro, la veste lacca di garanza della donna inginocchiata in primo piano in
verde chiaro e il manto in azzurro, ecc. (pl. 169). Questi colori di preparazione non
sono piatti ma modellati: sono cioè più scuri nelle zone in ombra, più chiari nelle parti
in luce. La loro scelta è accuratamente studiata in modo da accentuare l'effetto finale
del quadro tutto giocato su una gamma raffinatissima di toni freddi.

Nella stesura del colore si riscontra una notevole differenza tra la parte alta e la
parte bassa del dipinto: differenza certamente dovuta al diverso tipo di illuminazione
delle due zone. Nella parte alta il colore è prevalentemente lavorato sulla tavolozza ed
è dato a velature molto sottili che lasciano trasparire la preparazione sottostante con
un effetto che col tempo si è accentuato più del dovuto, come nel S. Giovanni dove il
manto lascia intravedere l'anatomia sottostante, o nella testa di Elia dove i capelli, spu-
liture a parte, rivelano ormai distintamente la sagoma del cranio. Nella parte bassa
della pala la stesura è invece più compatta: il colore sfrutta sempre in trasparenza il
tono preparatorio sottostante ma ha più corpo, è meno lavorato sulla tavolozza, tal-
volta anzi è quasi puro, con un effetto conseguente di maggior plasticità dell'immagine.

La tipologia dei colori usati da Raffaello per la *Trasfigurazione*, secondo Luigi Brandi che con Enrico Guidi ha eseguito il restauro del dipinto, è la seguente.[2] Il bianco è bianco di piombo. I gialli, anche i più brillanti, sono tutti terre naturali, tra cui l'ocra gialla; i verdi sono quelli di rame, mentre tra i rossi si riconoscono il cinabro, l'ocra rossa, la lacca di garanza; l'azzurro è azzurrite, mentre tra i bruni risultano le terre naturali, gli ossidi di manganese, il sequiossido di ferro e il nero vegetale o nero vite. All'analisi eseguita purtroppo solo su pochissimi campioni risulta confermata la presenza di bianco di piombo, ocra gialla e malachite, mentre nelle sezioni l'azzurro del cielo appare composto in parte da azzurrite e in parte anche da oltremare (lapislazzuli). Il medium secondo Brandi è costituito da olio di lino e probabilmente anche da olio di noce, al quale sarebbe in parte imputabile l'eccessiva contrazione del colore in talune zone del dipinto. Non sono state trovate tracce della vernice originale, certamente rimossa nelle drastiche puliture del '700 e della prima metà dell'800.[3]

Indicazioni preziose sulle caratteristiche del primo abbozzo raffaellesco, e quindi sul cartone perduto, sono venute dalle radiografie che hanno rivelato tutta una serie di varianti rispetto alla versione finale (pl. 331). Un primo tipo di variante si riscontra nella parte alta della *Trasfigurazione* dove le quattro figure di Cristo, dei due profeti e del S. Giovanni sono abbozzate nude come nel disegno di Chatsworth, probabilmente per meglio controllarne e calibrarne la posizione nello spazio, come in effetti accade per l'immagine di Cristo, i cui piedi nella versione finale sono stati leggermente arretrati in modo da accentuare il movimento della figura in avanti. Significativo, a questo proposito, appare il fatto che il fenomeno interessi solo le quattro figure che si stagliano libere contro il cielo e che presentano le soluzioni dinamiche più complesse, mentre le figure prone di S. Pietro e S. Giacomo ed il gruppo dei due diaconi, compositivamente più semplici da definire e comunque coperti dal movimento della vetta della montagna e della vegetazione retrostante, sono stati abbozzati vestiti già in questa fase.

La seconda variante è costituita da una serie di pentimenti individuabili in più punti del quadro. Pentimenti che sono di due tipi: di semplice assestamento dell'immagine, spesso individuabili ad occhio nudo, senza l'ausilio delle radiografie come quelli dei piedi di Cristo e della donna inginocchiata in primo piano, come il libro ed il pollice della mano destra di S. Matteo, o come la mano destra ed il lembo inferiore del mantello del padre dell'ossesso: e pentimenti più sostanziali, di trasformazione radicale di alcuni elementi delle teste dei personaggi. Questi ultimi si riscontrano esclusivamente nella parte bassa del quadro e precisamente: sulle teste del S. Matteo, della donna inginocchiata in primo piano, dell'altra donna che indica l'ossesso, del padre di questi e del vecchio alla sua destra (pl. 332).

Il S. Matteo (pl. 333): nell'abbozzo la testa è identica a quella del "cartone ausiliario" del British Museum di Londra, quasi calva con una cerchia di capelli lisci che scendono a toccare le spalle dell'apostolo. La donna inginocchiata in primo piano (pl.

[2] Un articolo di Luigi Brandi dal titolo 'Considerazioni sulla tecnica tenuta da Raffaello per la pittura della *Trasfigurazione* desunte durante il suo restauro,' sarà pubblicato tra breve sul *Bollettino* dei Musei Vaticani.

[3] Sull'argomento cfr. Mancinelli, op. cit. in n. 1, pp. 19–21.

334): nell'abbozzo l'acconciatura è più semplice, con un nastro molto largo che scende a sostenere la crocchia di capelli sulla nuca; una lieve modifica si nota poi nel disegno della guancia e della labbra. L'altra donna che indica l'ossesso, forse la madre del ragazzo: nell'abbozzo il sopracciglio è aggrottato e le ombre segnano fortemente i lineamenti. Il padre dell'ossesso (pl. 335): nell'abbozzo la testa è molto stempiata con i capelli drammaticamente svolazzanti all'indietro come nel "modello" dell'Albertina; il viso è più di profilo con l'occhio destro meno visibile, mentre il sopracciglio sinistro, più basso e aggrottato dell'attuale, accentua l'espressione di scetticismo misto a sconforto del personaggio. Il vecchio alla destra del padre dell'ossesso: nell'abbozzo i capelli sembrano coperti dal mantello.

La presenza di queste varianti, la loro qualità ed il numero insolitamente alto, denunciano il lungo processo di elaborazione attraversato dal quadro prima di giungere alla sua redazione definitiva: un processo che evidentemente non si esaurì negli studi preparatori, ma che continuò a lungo anche dopo il trasferimento del cartone sulla tavola.

Un ultimo dato emerso dal restauro è quello dello stato non finito di numerosi dettagli del dipinto. In alcuni casi il fenomeno è particolarmente evidente perchè il dettaglio è chiaramente rimasto allo stato di abbozzo: in altri ci si trova in presenza di strane discontinuità nella stesura del colore, chiaramente percepibili ad una osservazione ravvicinata, e che non sono imputabili né ai danni provocati dalle spuliture del Sette, Ottocento—che spesso coesistono—né a differenze di mano, ma piuttosto ad un diverso stadio esecutivo della zona interessata.

Allo stato di abbozzo sono soprattutto tre particolari: la roccia in primo piano in basso a destra, la mano del personaggio che si trova alle spalle del gruppo degli accompagnatori dell'ossesso e che accenna verso il Cristo Trasfigurato, ed il piede destro di Elia. La roccia (pl. 172): dovrebbe essere molto più scura per fare da quinta e dare alla composizione una prima indicazione di profondità: è invece rimasta una sagoma marrone priva di modellato, con le erbe che la coprono qua e là preparate più in chiaro o più in scuro, secondo il gioco previsto delle luci, ma senza ulteriori rifiniture. La mano (pl. 171): è uno dei dettagli che recano più evidenti i segni di una spulitura, ma questo non può essere la sola causa del suo stato. È infatti completamente piatta e mal disegnata, e non si capisce bene se si tratti della destra o della sinistra, come è in realtà, ed inoltre il braccio in cui si innesta è modellato con un colore così simile a quello dello sfondo, da far pensare che Raffaello intendesse cancellarlo per dare maggiore risalto al gesto del personaggio antistante. La molteplicità di interpretazioni a cui si presta ha influito sulle copie dipinte o a stampa, per cui il movimento del personaggio è stato spesso frainteso e talvolta addirittura cancellato per evitare problemi. Infine il piede destro di Elia (pl. 170): è disegnato sommariamente, con un tratto rapido che ne segna il contorno della parte bassa e dell'alluce, senza entrare nel dettaglio delle altre dita, e, nella sagoma pressoché monocroma, la parte in ombra del calcagno è realizzata con una serie di pennellate più scure estremamente sommarie. Un confronto col piede sinistro, o ancor meglio con quelli di Mosè, non lascia dubbi sulla sua incompletezza. Ed incompiuta è anche la vegetazione dell'albero che fa da sfondo.

Ad uno stadio esecutivo più avanzato, ma pur sempre incompiute, sembrerebbero poi numerose figure del dipinto, eseguite con un colore estremamente magro e tirato, dato a pennellate sommarie, quasi da abbozzo, sotto le quali s'intravvede il disegno preparatorio. Tra esse sono soprattutto le immagini dei due diaconi sul Monte Tabor—si vedano in particolare la testa e le mani di quello con la dalmatica viola—ed il gruppo dell'ossesso e dei suoi familiari. Più chiaro tra tutti il caso dell'ossesso e del padre. Il fanciullo: è realizzato con un colore molto tirato e privo di velature di rifinitura, che lascia trasparire in più punti la preparazione sottostante (occhi, collo) e denuncia la presenza di un pentimento nel movimento del panneggio. Il padre: le mani sono appena abbozzate e la destra lascia vedere il pentimento della posizione delle dita che in origine erano più arretrate, mentre la testa denota una stesura vigorosa ma estremamente sommaria e priva di rifiniture. Le sopracciglia, i capelli, il nastro che li cinge e l'orecchio sono appena abbozzati e solo sulla barba il pennello dell'artista ha iniziato a creare quel sottile gioco di luci e trasparenze che si nota in altre figure, mentre pochi tocchi di biacca creano il gioco dei piani del volto e accennano al movimento delle rughe sulla fronte.

Per contrasto e per avere un'idea di quello che Raffaello intendeva forse raggiungere—per lo meno in alcuni casi—nella parte bassa del dipinto, può essere utile prendere in esame la figura dell'Apostolo col manto lacca di garanza che indica verso il Cristo sul Monte Tabor. In questo caso le pieghe del mantello, preventivamente modellate con una serie di velature sovrapposte, sono state ulteriormente rifinite con un fitto tratteggio incrociato, di sapore vagamente accademico, chiaramente teso a togliere durezza alla modellazione. Con ciò non si vuol dire che Raffaello volesse raggiungere dovunque questo grado di rifinitura, ma è evidente che su figure come quelle dell'ossesso e del padre il colore non ha il corpo che ha generalmente sul resto del dipinto; mancano per così dire le stesure finali pur rimanendo la qualità straordinariamente alta. E non sembra probabile che il fenomeno sia imputabile ad una semplice differenza di mano. La presenza di parti non finite e soprattutto quella dei dettagli rimasti al livello di abbozzo esclude comunque l'intervento della bottega dopo la morte di Raffaello se non per eseguire la verniciatura finale dell'opera.

Indicazioni di estremo interesse stanno emergendo anche dal restauro della *Pala di Monteluce* (pl. 173–174), attualmente condotto nel Laboratorio dei Musei Vaticani da Enrico Guidi.[4] Questa pala presenta la caratteristica, unica nel suo genere, di essere costituita da due pannelli, il cui limite è chiaramente segnato dalla linea curva verso il basso che corre al centro della nube su cui siedono le figure del Cristo e della Vergine Incoronata. Di fronte ad una struttura così insolita le ipotesi che si possono fare sono tre: che la pala sia stata volutamente eseguita su due pannelli separati, che la pala sia stata tagliata per qualche motivo, ed infine che la pala sia il risultato dell'unione di due pezzi ricavati da due diversi dipinti. Le principali opinioni in proposito sono state espresse dall'Orsini, dal Dollmayr e più recentemente, in un saggio del 1961 ripubblicato in italiano nel 1983, da John Shearman. Secondo l'Orsini all'origine vi sono motivi di

[4] Il restauro è stato finora eseguito sul supporto e solo sul pannello superiore: tasselli di pulitura sono stati aperti solo sul pannello superiore.

comodo "per commodità del trasporto che si dovette fare da Roma a Perugia."[5] Secondo il Dollmayr, invece, il contratto del 1505 prevedeva una *Assunzione*, mentre in quello del 1516 era stata concordata una *Incoronazione*, per cui la pala, iniziata dal Penni come un' *Assunzione*, dovette essere modificata sostituendo il pannello superiore con quello attuale.[6] Infine, secondo lo Shearman, "l'unica spiegazione . . . è che Giulio o il Penni, alla cui mentalità questo fatto sembra adattarsi, aggiunsero ingegnosamente la parte inferiore di un'altra pala d'altare in parte finita, che doveva rappresentare un'*Assunta*"—e che Shearman identifica con quella per la Cappella Chigi—"alla metà superiore dell'*Incoronazione* iniziata per Monteluce."[7]

Anche se per formulare un'ipotesi definitiva bisognerà attendere la fine dell'intervento in corso, elementi concreti sulla natura del dipinto e la sua genesi sono già emersi dagli esami preliminari al restauro e dai primi saggi di pulitura.

Con il distacco dalle pareti della Pinacoteca e la rimozione della cornice ottocentesca si sono potuti esaminare per la prima volta i bordi ed il retro della pala. La prima informazione emersa da questo esame è che il dipinto fu rifilato in passato su tutti e quattro i lati, in quanto il colore arriva fin sul bordo del supporto ligneo, dove appare chiaramente tagliato da uno strumento che, nel corso dell'operazione, provocó numerose cadute di colore: non vi sono invece elementi evidenti che permettano di stabilire la data e l'entità del taglio (pl. 175–177).

L'esame ha inoltre permesso di studiare la natura e le caratteristiche strutturali del supporto ligneo della pala ed il sistema di collegamento del pannello superiore a quello inferiore (pl. 336). Il pannello superiore ha un'altezza massima di cm 166, una larghezza di cm 235, ed è composto di nove tavole verticali di pioppo di larghezza estremamente variabile: da sinistra a destra, esse misurano infatti mediamente cm 15, cm 34, cm 20, cm 29.5, cm 48, cm 23, cm 20. Lo spessore varia tra i 36 ed i 39 mm. Sul retro il pannello è rinforzato da due traversoni orizzontali di castagno inseriti nei consueti incassi a coda di rondine. Nelle radiografie (pl. 337) non si nota, al contrario della *Trasfigurazione*, la presenza di tenoni alloggiati in incassi interni—forse perchè i traversoni orizzontali sono molto più vicini—mentre all'esterno, in corrispondenza dei punti di giunzione tra tavola e tavola, ma solo lungo il perimetro del pannello, sono visibili due serie di rinforzi a farfalla alloggiati in incassi a vista, la cui messa in opera potrebbe però essere successiva al montaggio del pannello stesso.

Le tavole sembrano provenire da più di un albero e non da uno solo come nella *Trasfigurazione*. Nonostante la qualità pregiata del legno esse presentano numerosi difetti. In particolare su alcune si notano degli avvallamenti che non si ripercuotono sulla superficie cromatica del dipinto. Ciò significa che il difetto era presente fin dall'origine e che il carpentiere vi pose rimedio nel montaggio, stuccando in qualche modo i dislivelli più evidenti sul retro e piallando la parte eccedente sul davanti. Su questo lato vi sono tracce di una camottatura parziale, con strisce di tela applicate solo in alcuni dei

[5] B. Orsini, *Guida al Forestiere per l'Augusta Città di Perugia*, Perugia (1784), p. 208.
[6] F. Dollmayr, 'Raffaels Werkstätte,' in *Jahrbuch der königlich Sammlungen des allerhöchsten Kaiserhauses*, xvi (1895), p. 254.
[7] J. Shearman, 'La Cappella Chigi in S. Maria del Popolo,' in *Funzione e Illusione. Raffaello, Pontormo, Correggio*, Milano (1983), p. 133.

punti di giunzione tra tavola e tavola, e non su tutti come invece accade nella *Trasfigurazione*.

Il pannello della parte bassa ha ovviamente la stessa larghezza di quello superiore, mentre l'altezza massima, al livello dei due apici laterali, è di cm 215 ca, al centro di cm 194. Le tavole impiegate per costruire questo pannello sono 8, meno quindi che nel pannello superiore. Le loro dimensioni sono relativamente meno variabili:da sinistra a destra la loro larghezza media è infatti di cm 20, cm 28, cm 34.5, cm 26, cm 37.5, cm 26.5, cm 26.5, cm 35.5. Lo spessore oscilla tra i 38 ed i 40 mm. Il legno è sempre il pioppo.

Sul retro la struttura è rinforzata da due traversoni orizzontali di castagno inseriti in incassi a coda di rondine. Come nel pannello superiore, nelle radiografie (pl. 338) non si nota la presenza di tenoni inseriti in incassi interni nonostante la distanza dei traversoni orizzontali, mentre esternamente, in alto e in basso, in prossimità dei bordi ed in corrispondenza dei punti di giunzione tra tavola e tavola, sono visibili due serie di rinforzi a farfalla inseriti in incassi a vista. Significativo è certamente il fatto che questi rinforzi non compaiono nella fascia compresa tra i due traversoni orizzontali, nonostante la distanza che li divide, ma solo in prossimità dei bordi. Un rinforzo a farfalla è stato poi usato per fermare una spaccatura del legno. Come nel pannello superiore, sul retro vi sono numerose stuccature chiaramente riconducibili al montaggio del pannello ed eseguite per ridurre i dislivelli fra una tavola e l'altra. Non vi è altresì traccia di camottatura anche solo parziale sul davanti.

Il sistema di aggancio dei due pannelli è molto semplice: quello superiore poggia su quello inferiore con un incastro a L che gli impedisce di slittare in avanti, mentre sul retro i due pannelli sono tenuti accostati inserendo tre travetti in altrettante coppie di "ponticelli-asola" fissati uno al pannello superiore e l'altro a quello inferiore. I travetti scorrono inoltre in incassi che impediscono loro qualsiasi spostamento laterale. Sia i ponticelli-asola che i travetti sono di castagno.

Il taglio curvilineo a cui sono stati sottoposti i lati combacianti dei due pannelli è chiaramente determinato dalla necessità di evitare eventuali spostamenti laterali di quello superiore: una soluzione molto simile fu adottata in seguito dal Salviati, sia pure con materiali differenti, per la pala della Cappella del Pallio nel Palazzo della Cancelleria a Roma.[8] L'unione dei due pannelli è resa stabile dalla presenza della cornice senza la quale il sistema fin qui descritto non sarebbe stato ovviamente sufficiente.

Le sezioni eseguite nella fase preliminare del restauro hanno poi fornito preziose indicazioni sulla natura dell'imprimitura, della preparazione e dei colori usati nei due settori del dipinto.[9] L'imprimitura del pannello superiore è costituita da uno strato di gesso e colla sul quale è steso un ulteriore velo impermeabilizzante di colla pura. Lo strato di gesso e colla risulta dato in più mani, almeno tre, chiaramente distinguibili sia in fluorescenza che a luce normale. La preparazione del colore è costituita da uno strato di biacca che nelle sezioni appare perfettamente bianca.

[8] F. Mancinelli, G. Colalucci, 'Francesco Salviati, La Natività,' in *Monumenti, Musei e Gallerie Pontificie. Bollettino*, iv, Città del Vaticano (1983).

[9] Le sezioni sono state tutte prelevate lungo i margini del dipinto.

L'imprimitura del pannello inferiore è invece costituita da uno strato di gesso e colla, visibilmente più ricco di colla di quello superiore e dato in una sola mano. Sopra questo strato si trova il consueto velo di colla impermeabilizzante. La preparazione del colore è costituita da uno strato di biacca che però, a differenza di quella del pannello superiore, appare chiaramente grigiastra.

I colori individuabili nei due settori del dipinto per mezzo delle sezioni sono i seguenti: nel pannello superiore compaiono il bianco di piombo, l'ocra gialla, l'azzurro smaltino e forse l'azzurrite, la lacca garanza e probabilmente sia il minio che il cinabro; nel pannello inferiore compaiono invece il bianco di piombo, l'azzurrite ma non l'azzurro smaltino, il minio, il cinabro, la lacca di garanza, l'ocra gialla e la malachite. La tecnica, anche se per il momento non sono ancora disponibili le analisi che possano confermare l'osservazione diretta, è chiaramente ad olio; tuttavia, secondo il restauratore Enrico Guidi, l'uso di questa tecnica è molto diverso nelle due zone della pala, e nel pannello superiore il dipinto, più che un olio vero e proprio, ricorda una tempera grassa. In altre parole, l'artista che operò in questa zona sembra avere una formazione tecnica di tipo ancora quattrocentesco che non si riscontra nella parte bassa. Vi sono poi altre differenze nell'uso del colore: nel pannello superiore esso appare quasi costantemente lavorato sulla tavolozza e steso prevalentemente a velature molto sottili che sfruttano in trasparenza il tono sottostante; nel pannello inferiore, invece, il colore è più puro e la stesura è a strati più compatti. Va comunque tenuto presente che su questi due modi di operare pesò certamente anche la diversa illuminazione delle due zone del dipinto.

Preziose informazioni sulla fase esecutiva dell'opera sono venute dalle radiografie e dalle riflettografie, eseguite preliminarmente al restauro, che hanno rivelato la presenza di numerose varianti sia nel pannello superiore che in quello inferiore. Nel pannello superiore le varianti più importanti interessano soprattutto le figure dei due grandi angeli laterali con le mani piene di fiori. L'angelo sinistro: in riflettografia (pl. 339) e non nelle radiografie il mazzo di fiori appare molto più folto e complesso dell'attuale, con una lunga spiga di grano e delle foglie di fragola che non compaiono nella versione definitiva; inoltre il fogliame nascondeva quasi completamente la mano, lasciando visibili solo due dita. L'angelo destro (pl. 340–342): a differenza dell'attuale aveva il torso completamente nudo; inoltre il braccio sinistro non era alzato ma rilasciato lungo il fianco, la mano semi piegata a trattenere qualcosa di cui non è possibile scorgere la natura, ma certamente non il mazzo di fiori attuale. Queste varianti sono visibili sia nelle radiografie che nelle riflettografie dove risultano anche più leggibili.

Le riflettografie hanno poi messo in risalto la presenza sullo sfondo di decine di teste di putti che riempivano completamente il cielo alle spalle del Cristo e della Vergine (pl. 339) e che in parte sono schizzate a carboncino, in parte disegnate a pennello in nero vite: in nero vite, poi, dato l'effetto riflettografico, deve essere stato abbozzato anche il mazzo di fiori con la spiga dell'angelo a sinistra.

Le sezioni di colore hanno rivelato che le teste dei putti furono disegnate direttamente sulla preparazione a bianco di piombo, e successivamente velate con un leggero strato di colore costituito da bianco di piombo misto ad ocra gialla. Questo strato non

era particolarmente coprente e col tempo è diventato quasi trasparente, rendendo leggibili ad occhio nudo sia le teste dei putti che l'abbozzo preliminare del mazzo di fiori dell'angelo sinistro. L'effetto di trasparenza era forse in parte previsto per le teste dei cherubini ma certamente non per il primo abbozzo del mazzo di fiori. La pulitura della zona relativa ha messo in luce che sia il mazzo di fiori che la mano che lo tiene sono stati eseguiti da un artista diverso da quello che ha dipinto l'avambraccio sottostante. Mentre infatti l'avambraccio è dipinto per "accrescimento," modellando a velature successive, la mano ed i fiori sono realizzati con una pittura estremamente rapida, d'effetto piuttosto rozza al confronto.[10] Della stessa mano sembrano essere poi anche le correzioni dell'angelo destro.

Nel pannello inferiore le varianti sono tutte sullo sfondo e sono visibili in parte nelle radiografie, in parte nelle riflettografie. A sinistra le radiografie hanno rivelato la presenza, nell'abbozzo preliminare, di una serie di colonne (pl. 338), mentre a destra nelle riflettografie, al posto delle pareti della grotta attuale, compare un muro coronato da una trabeazione estremamente elaborata. Con ogni evidenza, quindi, nella versione preliminare, al posto della grotta che inquadra il gruppo degli Apostoli riuniti intorno alla tomba della Vergine, doveva esserci uno sfondo architettonico.

Sulla base degli elementi emersi dal restauro si possono trarre alcune conclusioni. Si può innanzitutto escludere che il dipinto sia stato tagliato dopo il suo completamento dato il diverso numero di tavole che ne costituiscono il supporto ligneo, nove nel pannello superiore, otto in quello inferiore, e la loro diversa larghezza nei due settori della pala. Molto improbabile appare anche l'ipotesi che i due pannelli siano stati dipinti indipendentemente ma per una stessa pala. Innanzitutto è diversa l'imprimitura: tre strati nel pannello superiore, uno solo, molto ricco di colla, in quello inferiore. Inoltre è diversa la preparazione a biacca: perfettamente bianca nella parte alta, grigiastra in quella bassa. Si tratta di operazioni preliminari che, ammettendo l'ipotesi dell'identità di destinazione, dovrebbero essere state compiute contemporaneamente su tutti e due i pannelli. Con ogni probabilità lavori di questo tipo non venivano eseguiti personalmente dal maestro, ma erano lasciati a qualche garzone: tuttavia, anche pensando a due diversi esecutori, è difficile accettare l'idea che nell'ambito della stessa bottega la medesima operazione potesse essere realizzata contemporaneamente in modi così differenti. Comunque, se ciò può essere eventualmente possibile per l'imprimitura, lo è molto più difficilmente per la preparazione, in quanto ciò avrebbe comportato l'impiego di materiali diversi o di un diverso sistema di preparazione degli stessi, ferma restando l'identità del colore che è il bianco di piombo. E si badi che la differenza di tono è minima ad occhio nudo, per cui la scelta non può essere stata influenzata in alcun modo da considerazioni sulla differente illuminazione delle due parti del dipinto.

Resta l'ipotesi che i due pannelli siano stati ricavati da due pale diverse. A favore di quest'idea depongono tra l'altro due elementi. Innanzitutto la presenza delle farfalle di rinforzo, alloggiate in incassi a vista e non interni, e disposte in prossimità del bordo

[10] La differenza di mano si nota anche nel modo di disegnare le dita: l'artista che ha realizzato il primo abbozzo disegna delle dita lunghe ed affusolate—come nella mano sinistra dell'angelo, certamente sua—mentre quello che ha dipinto le varianti fa invece delle dita tozze, più cilindriche.

superiore e inferiore dei due pannelli e non nella fascia compresa fra i traversoni orizzontali. Da un punto di vista strutturale la loro presenza è completamente superflua: non lo è invece se si suppone che, dovendo segare i due pannelli da due pale certamente più grandi, il carpentiere abbia inserito questi rinforzi nei punti di congiunzione tra tavola e tavola ed in prossimità del taglio, per evitare che l'azione dell'attrezzo potesse ripercuotersi in modo dannoso sulla superficie cromatica, o eventualmente per prevenire eventuali movimenti delle singole tavole, una volta liberate. Il secondo elemento è costituito dalla presenza nella fase di abbozzo dello sfondo del pannello inferiore, di una serie di strutture architettoniche successivamente sostituite dalle pareti della grotta attuale. Questa trasformazione, così radicale e piuttosto insolita da un punto di vista iconografico, può essere meglio spiegata se si considera la notevole differenza di proporzioni esistente tra le figure della parte alta e quelle della parte bassa. La presenza di uno sfondo architettonico, infatti, avrebbe certamente accentuato la percezione di questa differenza, mentre la grotta ha, in qualche misura, un effetto mimetico.

Non è tra i compiti che questo studio si prefigge il riesaminare a fondo il problema dell'identità delle due pale da cui furono ricavati i pannelli che compongono il dipinto attuale, fermo restando che allo stato delle conoscenze l'ipotesi più probabile è che il pannello superiore sia stato ricavato dalla pala di Monteluce e quello inferiore dalla pala della Cappella Chigi.

Per ciò che riguarda il pannello superiore, il solo su cui al momento sia in corso la pulitura, si direbbe che l'artista o gli artisti che terminarono di dipingerlo—probabilmente sia Giulio che il Penni—abbiano lavorato su un dipinto in cui solo alcune figure o parti di figura—si veda il braccio alzato dell'angelo sinistro—avevano superato la fase dell'abbozzo preliminare.[11] Ciò significa, con ogni probabilità, che la parte bassa perduta della pala originale era, nella migliore delle ipotesi, solo abbozzata.[12]

Poichè sia l'abbozzo vero e proprio che le parti solo iniziate denotano una qualità superiore al resto del quadro, e tecnicamente sembrano eseguite da un artista dotato di una formazione ancora in parte quattrocentesca, viene spontaneo pensare al nome di Raffaello, al quale rimanda anche il confronto con parti non rifinite della *Trasfigurazione*, come la figura dell'ossesso.[13]

[11] Alla fase del primo abbozzo appartiene anche una testa di putto nettamente più grande di quelle disegnate in nero vite, rilevabile significativamente solo nelle radiografie e situata sopra il mazzo di fiori dell'angelo destro. Sempre solo nelle radiografie sembrerebbe possibile individuare una seconda testa di putto di analoghe dimensioni sopra il mazzo di fiori dell'angelo sinistro. Nella versione definitiva queste due teste furono evidentemente cancellate per essere sostituite da quelle disegnate in nero vite.

[12] Sulle dimensioni originali della pala e quindi sull'entità della parte mancante si possono fare solo delle congetture basate però sull'analisi dei due contratti pubblicati a suo tempo da Umberto Gnoli che sembrano fornire delle indicazioni molto precise (cfr. U. Gnoli, 'Raffaello e la "Incoronazione" di Monteluce,' in *Bollettino d'Arte*, xi [1917], pp. 133–54). Nel

contratto del 1505 Raffaello si impegna a 'facere construere et depingere una tavola sive cona sopra l'altare grande de la chiesa de fuore de dicta chiesa de quilla perfection, *proportione* qualita et conditione della tavola sive cona existente in nargne in la chiesa de san Girolamo del luoco menore.' Nel contratto del 1516 la questione delle dimensioni ha un particolare rilievo in quanto si ribadisce 'che dicta Tavola sia dell'altezza et grandezza che fu ragionata nel primo disegno dato dal prefato M. Raphaello.' Se ne deve concludere che la tavola commissionata doveva avere le stesse dimensioni, o quanto meno la stessa 'proportione,' di quella di Domenico Ghirlandaio a Narni, che misura cm 330 × 230.

[13] L'eventuale presenza iniziale di Raffaello nella fase esecutiva della *Pala di Monteluce* non contrasta con quanto è detto in un documento del 1525 nel quale

Un indizio sulla data *ante quem* in cui la pala di Monteluce passò dalla fase della progettazione, sulla quale peraltro sappiamo ben poco, a quella della realizzazione su tavola, potrebbe venire dall'esame degli schizzi scoperti in occasione del restauro sul retro del pannello superiore (pl. 179). Gli schizzi erano nascosti da uno spesso strato protettivo di cera, certamente applicato in occasione del soggiorno parigino del dipinto, in quanto la cera, tra l'altro, copriva il frammento di un giornale francese del tempo. Si tratta di disegni di vario genere, tutti a carboncino salvo uno, certamente cinquecenteschi, che coprono l'intera superficie compresa tra i due traversoni orizzontali. Da sinistra a destra si distinguono: una testa di putto; un gruppo di tre schizzi parzialmente sovrapposti, comprendenti una zampa equina, un cratere con due diverse soluzioni per le anse, la base di una colonna collocata su un parapetto, disegnata in pianta ed in alzato (questo è il solo disegno a sanguigna); il disegno in pianta di un sistema parasta-pilastro cruciforme, forse il dettaglio di una loggia; la pianta di un edificio con una scala a chiocciola angolare; il dettaglio della facciata di una costruzione civile, costituito da tre finestre a parapetto pieno—quella centrale timpanata, le due laterali con coronamento curvilineo—sormontate a breve distanza da un imponente cornicione; immediatamente al di sotto, ma probabilmente indipendente, è lo studio in pianta di due coppie di colonne o semicolonne incassate in una parete; segue l'alzato di due, forse tre, colonne doriche collegate da una trabeazione, ed uno schema proporzionale costituito dalla sequenza numerica 5/6/5/6/./5/6.

Gli schizzi furono chiaramente eseguiti in tempi diversi: talvolta, come nel caso della pianta dell'edificio con la scala a chiocciola angolare, cancellando un disegno precedente a sanguigna, o anche sovrapponendo il nuovo al già fatto, come accade per lo schizzo a sanguigna della base della colonna, che è eseguito sopra quelli della zampa equina e del cratere ansato.

Oltre ad essere stati eseguiti in tempi successivi, i disegni sembrano di mano diversa, ma dato che la superficie su cui furono realizzati condizionò certamente il segno in modo determinante, risulta difficile esprimere un giudizio qualitativo, fermo restando che il gruppo apparentemente più omogeneo e di qualità sembra essere quello dei disegni architettonici a carboncino. Costante resta comunque il carattere di appunto di lavoro e di strumento di discussione, per cui nel loro insieme i disegni forniscono una preziosa ed affascinante testimonianza sul tipo di problemi a cui si stava interessando la bottega che li produsse. E poichè il loro carattere è chiaramente cinquecentesco ed è difficilmente ipotizzabile che siano stati eseguiti dopo che la pala era stata messa in opera, si deve necessariamente pensare all'ambiente raffaellesco. Raffaellesco è del resto il metodo di lavoro: tipica a questo proposito l'idea di proporre due soluzioni alternative per lo stesso problema, come nel disegno del cratere ansato, tipico il fatto, soprattutto a questa data, di disegnare in pianta ed in alzato un dettaglio architettonico. E raffaellesco è anche lo stile disegnativo per ciò che riguarda gli schizzi architettonici a carboncino: è difficile dire, in verità, se si tratti della mano del maestro o di qualche

si parla dell'incarico a Berto di Giovanni dell' 'ornamento della nostra tavola facemmo a roma per mano de maestro rafaello e Io: francesco e giulio sui discipoli.' Cfr. Gnoli, op. cit. in n. 12, p. 153, doc. no. 25.

aiuto, ma, tenuto conto del tipo di superficie e del carattere di appunto di lavoro dei disegni, non vi è nulla che contrasti con quel poco che conosciamo della produzione di Raffaello come disegnatore di architetture, soprattutto nel caso dello studio della facciata di un edificio civile. Il problema è la data in cui questi disegni furono prodotti, se prima o dopo la morte dell'Urbinate. Va detto che, allo stato attuale delle conoscenze, non è chiaro se si tratti di studi relativi ad uno o a più edifici. Tuttavia, nel caso della facciata, è possibile che ci si trovi in presenza di uno studio per Palazzo Branconio dell'Aquila:[14] in questo senso si sono espressi verbalmente John Shearman, Howard Burns, Arnold Nesselrath e Pier Nicola Pagliara che anzi ritiene si tratti di una prima idea per la facciata del piano nobile del cortile: di diverso avviso è Luitpold Frommel che pensa piuttosto a Palazzo Salviati.[15]

Qualora l'ipotesi di Palazzo Branconio risultasse valida, i disegni avrebbero un *terminus post quem* nella data del 1518, perchè il 30–31 Agosto di quell'anno veniva dato in enfiteusi il terreno destinato alla costruzione del palazzo.[16] E ciò potrebbe indicare che a quell'epoca la *Pala di Monteluce* era già stata abbozzata e comunque che almeno il supporto era in opera nello studio di Raffaello.

[14] Su Palazzo Branconio cfr. C. L. Frommel, *Der römische Palastbau der Hochrenaissance*, Tübingen (1973), ii, pp. 355–65; S. Ray, *Raffaello architetto; linguaggio artistico e ideologia nel Rinascimento romano*, Roma (1974), pp. 190–200.

[15] Su Palazzo Salviati cfr. Frommel, op.cit., pp. 305–14.

[16] Questo dato è frutto delle ricerche di Pier Nicola Pagliara, che ne ha dato comunicazione in occasione del convegno raffaellesco organizzato dai Musei Vaticani e dalla Biblioteca Hertziana nel marzo 1983.

Appendice: Le sezioni di colore della
Pala di Monteluce

NAZZARENO GABRIELLI

LA particolare tipologia del dipinto la *Pala di Monteluce*, già ampiamente descritta nella relazione del dott. Fabrizio Mancinelli, ha posto, nella fase preliminare al restauro, tutta una serie di interrogativi ai quali abbiamo cercato di dare delle risposte significative ed esaurienti mediante accurate indagini di laboratorio: radiografie, riflettografie, analisi di pigmenti e allestimento di sezioni di colore.

Prescindendo dal dato stilistico si è cercato di individuare nelle materie costitutive dell'opera e, dato il periodo storico, comuni nelle due parti, eventuali differenze specificatamente pertinenti ad una diversa manipolazione e stesura delle stesse.

A tal uopo sono stati effettuati, nelle due parti del dipinto ed esclusivamente lungo il bordo, dei prelievi di sostanza da sottoporre, mediante sezioni di colore, ad una prima indagine microscopica. La stessa ha significativamente evidenziato delle differenze riguardanti la diversa stesura dell'imprimitura sulla tavola e la composizione della preparazione sull'imprimitura.

Infatti l'imprimitura di gesso e colla, substrato della parte riguardante *L'Incoronazione della Vergine*, è stessa in tre strati distinti e chiaramente visibili in fluorescenza perchè separati da una sottile scialbatura di colla. La preparazione bianca costituita, molto probabilmente, da carbonato basico di piombo (biacca) è sovrapposta all'imprimitura in strato omogeneo.

La parte inferiore del dipinto presenta una imprimitura stesa sulla tavola in un'unica mano più ricca di colla (chiaramente visibile in fluorescenza perchè più accesa) e con la preparazione (biacca) più grigia e meno uniforme nel suo spessore.[1]

Descritte queste poche note, che a mio avviso, differenziano sostanzialmente le due parti del dipinto per ciò che concerne la diversa manipolazione e forse composizione delle sostanze, passo ad elencare alcune sezioni di colore prelevate in punti diversi della tavola senza analizzare, per ora, quelle differenze che eventualmente possono dividere i pigmenti per la loro natura e per il loro medium.

Prelievi effettuati nella parte superiore della tavola

Plate 184. Giallo chiaro del cielo sopra la corona della Vergine

a - strato gesso e colla
b - sottile scialbatura di colla
c - piccolo strato costituito, molto probabilmente, da biacca (piombo-carbonato basico)
d - spesso strato giallo costituito da biacca e ocra gialla

d′ - piccolo strato di colore giallo di base, sovrapposto al precedente costituito da biacca, ocra gialla e piccoli cristallini, di difficile identificazione nella sezione, azzurri e verdi
e - sottile strato di vernice (visibile in fluorescenza)

[1] Senz'altro sussistono differenze nelle due biacche costituenti le preparazioni della parte inferiore e superiore della tavola. Questa indagine potrà essere eseguita successivamente col metodo dell'attivazione neutronica.

Plate 185. Verde azzurro del cielo sotto la manica dell'Angelo sinistro

a - strato di gesso e colla
b - sottile scialbatura di colla
c - piccolo strato di biacca
d - strato sovrapposto a (c) costituito da biacca

come colore base, con pigmenti essenzialmente azzurri di smalto e altri di ocra
e - sottile strato di vernice (visibile in fluorescenza)

Plate 186. Incarnato della gamba dell'Angioletto sinistro

a - strato di gesso e colla
b - sottile scialbatura di colla
c - piccolo strato di biacca come base con molti cristallini blu di smalto (particolarmente visibili in fluorescenza)

c^1 - spesso strato costituito da biacca di base con cristallini rossi di minio o cinabro(?) e altri di ocra gialla
d - strato di vernice (visibile in fluorescenza)

Plate 187. Lacca della manica dell'Angelo destro

a - strato di gesso e colla
b - sottile scialbatura di colla
c - piccolo strato di biacca
d - sottile strato con biacca e pigmenti blu di smalto
e - strato di colore arancione con pigmenti blu

f - spesso strato di lacca con pigmenti blu di smalto o azzurrite(?)
g - strato rosa con biacca, lacca e cristallini di cinabro(?)
h - strato di vernice

Plate 188. Lacca scura della veste dell'Angelo destro

a - strato di gesso e colla
b - sottile scialbatura di colla
c - piccolo strato di biacca
d - sottile strato con biacca e pigmenti blu di smalto

e - strato chiaro di lacca con pigmenti blu di smalto
f - spesso strato di lacca
g - piccolo strato di difficile identificazione particolarmente visibile in fluorescenza

Plate 189. Disegno delle teste dei Putti

a - strato di gesso e colla
b - sottile scialbatura di colla
c - strato bianco probabilmente biacca che nella sua

parte superiore è misto a ocra gialla
d - piccolo strato costituito da "nero vite."
e - sottile scialbatura di biacca e ocra gialla

Prelievi effettuati nella parte inferiore della tavola

Plate 190. Aureola dorata dell'Apostolo in secondo piano accanto al bordo destro

a - strato di gesso e colla
b - spesso strato di colore bianco di base con pigmenti gialli e marroni coerente alla preparazione sottostante senza alcun elemento di separazione
c - piccolo strato verde chiaro con cristalli di terra verde o malachite(?)

d - strato di lacca con pigmenti blu di azzurrite(?)
e - doratura
f - doppio(?) strato di vernice perchè separati da una sottile linea scura, probabilmente sporcizia

Plate 191. Lacca scura del manto dell'Apostolo inginocchiato in primo piano a destra

a - strato di gesso e colla
b - sottile scialbatura di colla
c - strato bianco, probabilmente biacca

d - strato di lacca con pigmenti blu di azzurrite(?)
e - spesso strato di vernice, visibile in fluorescenza

Plate 192. Giallo del manto dell'Apostolo calvo in secondo piano a sinistra

a - strato di gesso e colla
b - sottile scialbatura di colla
c - strato bianco, probabilmente biacca
d - sottile strato rosa arancio con pigmenti di minio
e - sovrapposto a (d) è uno strato rosato costituito forse da biacca e cinabro
f - strato di lacca

g - strato marrone scuro di ocra gialla e pigmenti rossi
h - strato giallo più chiaro del precedente
i - sottile linea scura: sporcizia(?) visibile in fluorescenza
l - vernice

Plate 193. Rosso del manto dell'Apostolo inginocchiato in secondo piano a sinistra

a - strato di gesso e colla
b - sottile scialbatura di colla
c - strato bianco, probabilmente biacca
d - spesso strato bianco di base con cristallini rossi e gialli
e - piccolo strato di lacca misto a bianco
f - spesso strato di lacca
g - piccolo strato rosa con bianco di base e pigmenti rossi di cinabro
h - linea scura: sporcizia(?)
i - vernice

Plate 194. Verde del vestito dell'Apostolo inginocchiato in secondo piano a sinistra

a - strato di gesso e colla
b - sottile scialbatura di colla
c - strato bianco, probabilmente biacca
d - strato giallo di base al quale è sovrapposto un altro strato meno giallo ricco di pigmenti verdi di malachite
e - strato verde scuro, su cui giacciono due strati di verde più chiaro
f - spesso strato di bianco di base con pigmenti verdi
g - piccolo strato verde

General Index

Raphael Index

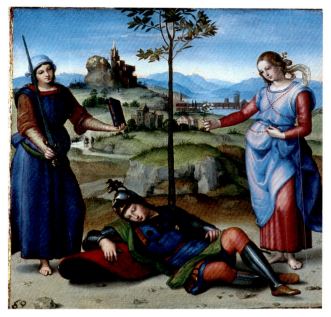

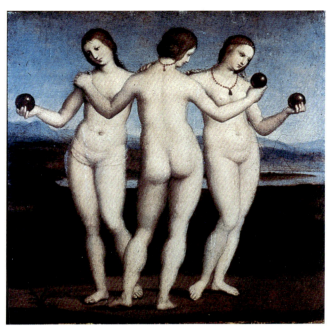

1. *Allegory* (*The Vision of a Knight*) (London, National Gallery), after cleaning

2. *The Three Graces* (Chantilly, Musée Condé)

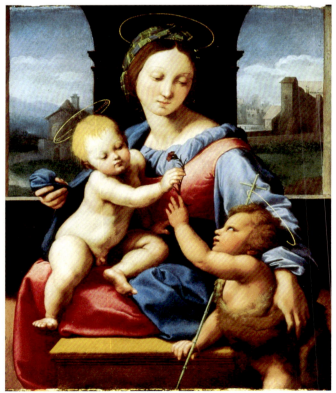

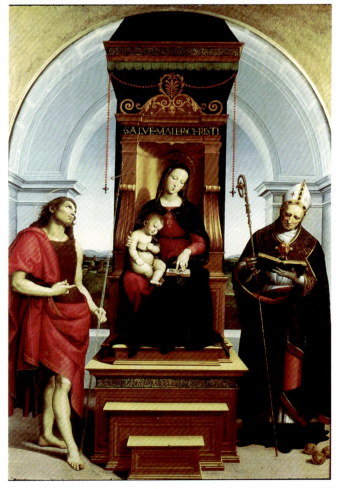

3. *Madonna and Child with the Infant Baptist* (*The Aldobrandini Madonna*) (London, National Gallery)

4. *Madonna and Child with Saint John the Baptist and Saint Nicholas of Bari* (*The Ansidei Madonna*) (London, National Gallery)

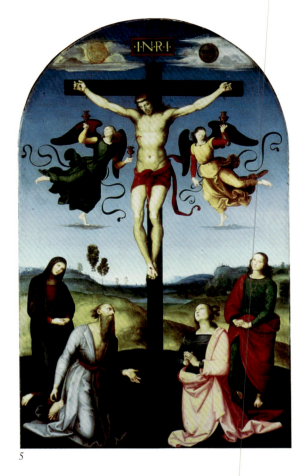

5

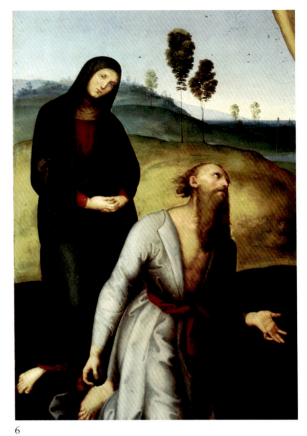

6

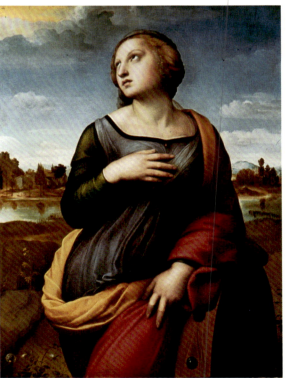

7

8

5–6. *The Crucified Christ with the Virgin Mary, Saints and Angels* (London, National Gallery)

7–8. *Saint Catherine of Alexandria* (London, National Gallery)

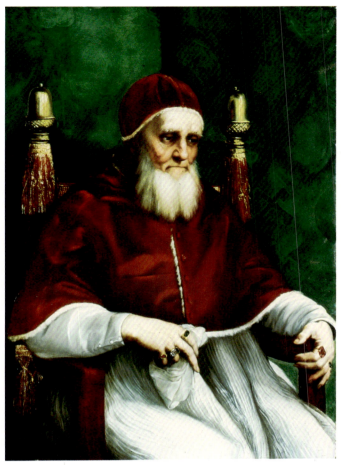

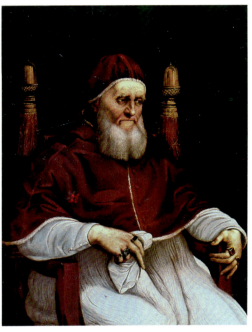

9. *Pope Julius II* (London, National Gallery), after cleaning, showing *pentimenti* in background

10. *Pope Julius II* (Florence, Uffizi)

11. Before cleaning

12. After cleaning, detail showing *pentimenti*

13. Showing painterly brushwork

11–13. *Pope Julius II* (London, National Gallery)

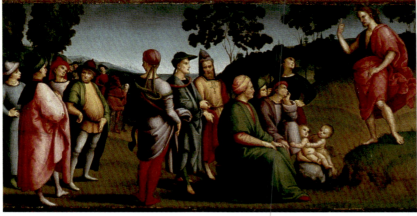

14

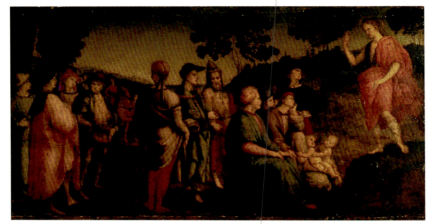

15

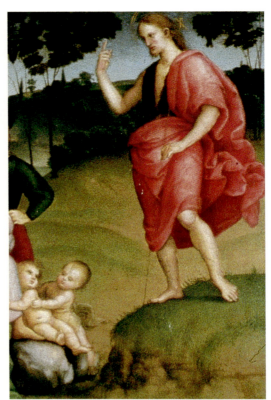

17

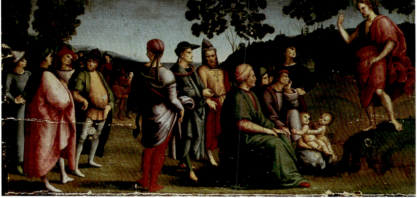

16

14–17. *Saint John the Baptist Preaching* (London, National Gallery):

14. After cleaning
15. Before cleaning
16. Before in-painting
17. Showing drawing with the brush on top of the forms

18. Cross-section, green background

19. Cross-section, green background showing blue layer beneath

20. Cross-section, of red mozetta

18–20. *Pope Julius II* (London, National Gallery)

21

23

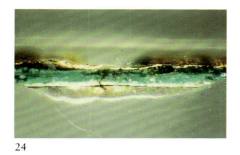

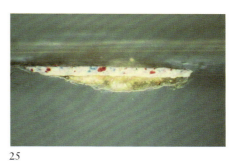

22

24

25

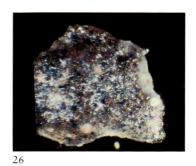

26

21–25. *The Crucified Christ*:

21. Inscription
22. Photomicrograph, reverse of brown fragment of paint showing silver
23. Hem of Saint John's robe
24. Cross-section of Saint John's robe
25. Cross-section of Saint Jerome's sleeve

26. *Aldobrandini Madonna*, photomicrograph, Virgin's blue sleeve

27a

27b

28

29

27–29. *Saint John the Baptist Preaching*:

27a. Photomicrograph, brown foliage
27b. Reverse of the same fragment
28. Cross-section of browned tree
29. Top surface of red lake glaze.

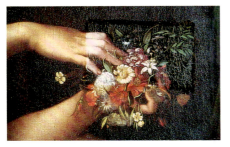

30. Angel's hands with flowers, partially cleaned

31. Madonna's sleeve, partially cleaned

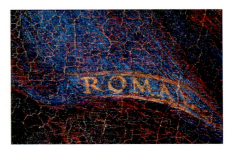

32. Inscription: Romae, Madonna's robe

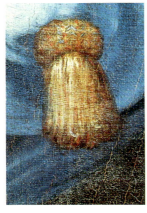

33. Tassel, showing lead-white layer over gesso

34. Compositional construction lines in red

35. Black underdrawing, Madonna's neckline

36. Incised line, *pentimento*, cradle

37. Red lake underpainting, Madonna's ultramarine robe

38. Pink underpainting, pale blue sky (ultramarine and lead-white)

39. Red-blue *cangiante* drapery, angel

40. Red lake underpainting under green, sleeve of Saint Elizabeth

41. Red lake underpainting glazed in blue, Madonna's belt

30–41. *Holy Family of Francis I* (Paris, Louvre)

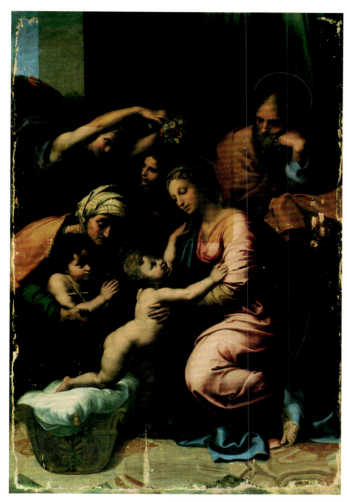

42. *Holy Family of Francis I*, in the course of cleaning

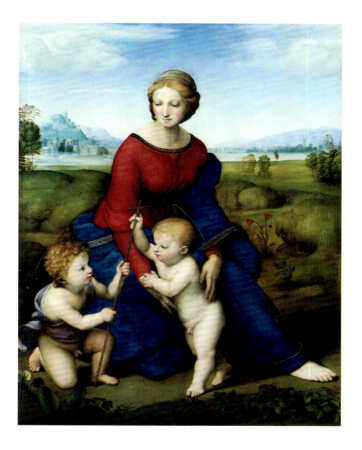

43. *Madonna in the Meadow* (Vienna, Kunsthistorisches Museum)

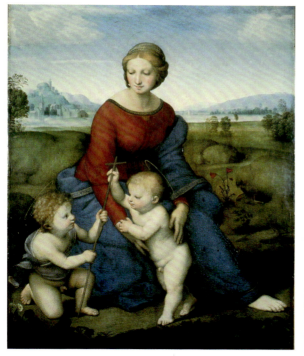

44. Before cleaning

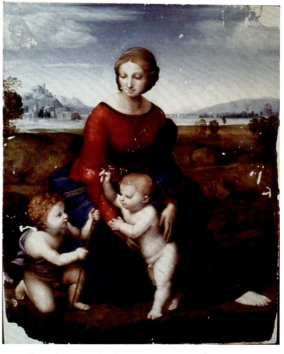

45. After cleaning, before in-painting, putty filled in

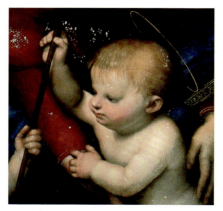

46. After cleaning, showing losses

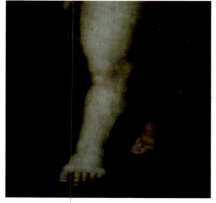

47. Christ Child's legs before cleaning

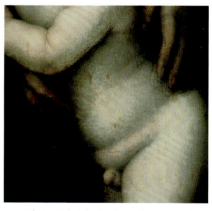

48. Christ Child's body before cleaning

49. Madonna's left hand after cleaning, putty filled in

50. After cleaning and in-painting

51. Christ Child's feet, after cleaning, before retouching

44–51. *Madonna in the Meadow*

52. Madonna's head before cleaning

53. During cleaning

54. After cleaning, before in-painting

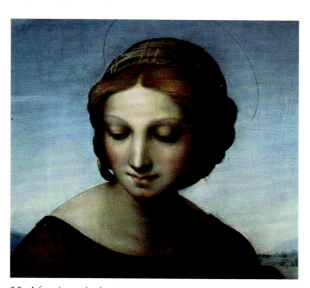

55. After in-painting

56. After cleaning, before in-painting

57. After cleaning and retouching

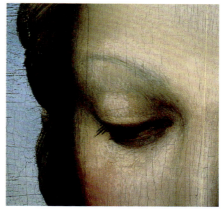

58. After cleaning

52–58. *Madonna in the Meadow*

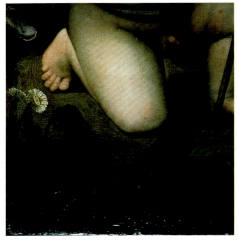

59. Lower left corner before cleaning

60. After cleaning, putty filled in

61. *Tratteggio* in-painting

62. After retouching

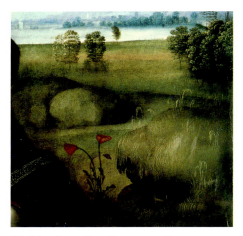

66. Meadow after cleaning and retouching

63. Sky, upper right corner, before cleaning

64. After cleaning, putty filled in

65. After retouching

59–66. *Madonna in the Meadow*

67–76. *Madonna in the Meadow*:

67. Cross-section, blue sky, right of Madonna's head

68. Cross-section, yellowish green meadow, middle-ground left

69. Cross-section, dark brownish green landscape behind John's shoulder

70. Cross-section, Madonna's red dress

71. Cross-section, Madonna's blue robe

72. Cross-section, John's shoulder

73. Madonna's bodice, showing date after cleaning, before in-painting

74. John's shoulder, knothole filled with putty, partially in-painted

75. Madonna's head and sky after cleaning

76. Madonna's neck, cleaning damages from previous cleaning

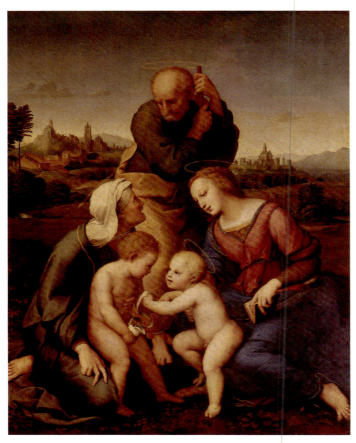

77. Before cleaning

77–78. *Canigiani Holy Family* (Munich, Alte Pinakothek)

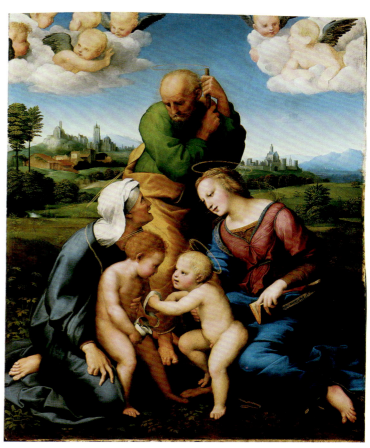

78. After cleaning

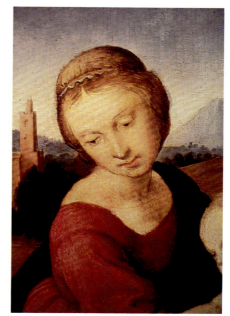

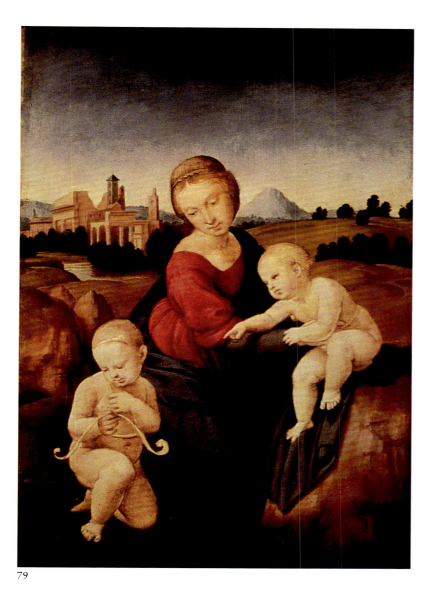

79

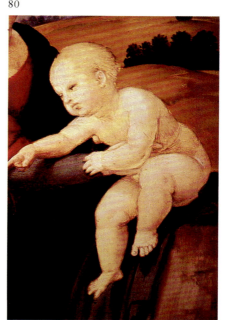

79–81. *Esterházy Madonna*, unfinished (Budapest, Museum of Fine Arts)

80

81

82

82. *Canigiani Holy Family*, putti, upper left, after cleaning
83. *Canigiani Holy Family*, putti, extreme upper left, after cleaning

83

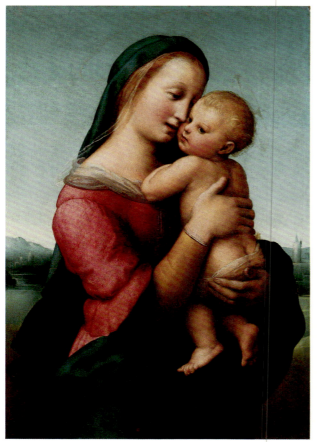

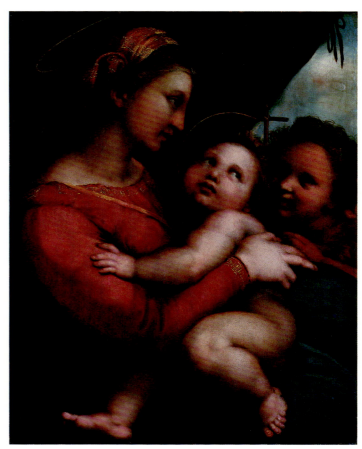

84a 84b

84. *Tempi Madonna* (a) and *Madonna della Tenda* (b) (Munich, Alte Pinakothek), after cleaning

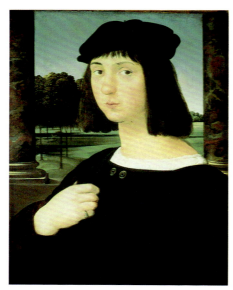

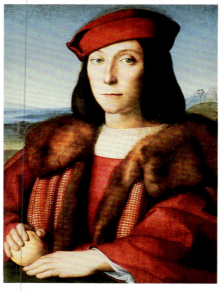

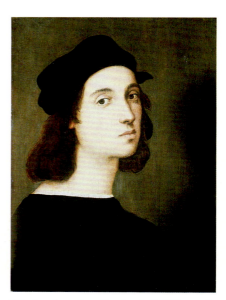

85. After Raphael: *Portrait of a Young Man* (Munich, Alte Pinakothek)

86. *Portrait of a Young Man with Apple* (Florence, Uffizi), also called *Francesco Maria della Rovere*

87. Attributed to Raphael: *Self-Portrait* (Florence, Uffizi)

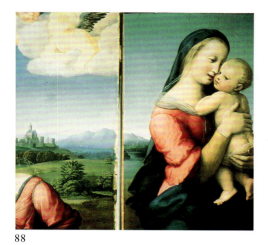

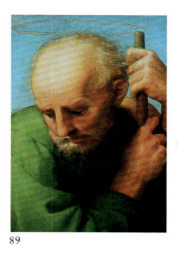

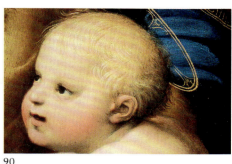

90

88. *Canigiani Holy Family* and *Tempi Madonna* : sky color compared
89. *Canigiani Holy Family*, Joseph's head
90. *Canigiani Holy Family*, Christ Child's head

88

89

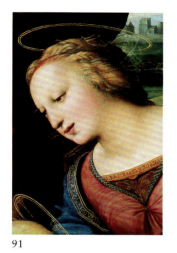

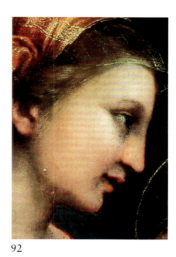

93

91. *Canigiani Holy Family*, Madonna's head
92. *Madonna della Tenda*, Madonna's head
93. *Canigiani Holy Family*, damaged putti, upper right

91

92

94

95

96

94. Perugino: *Madonna and Saints Adoring Child* (Munich, Alte Pinakothek), Saint Augustine's head
95. *Canigiani Holy Family*, Christ Child's ear
96. *Canigiani Holy Family*, two children
97. *Canigiani Holy Family*, landscape, right edge

97

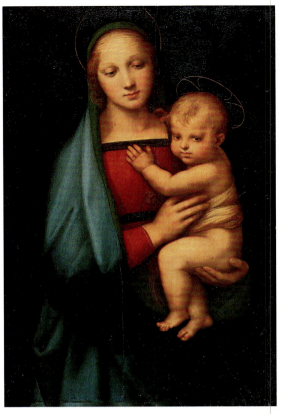

98. *Madonna del Granduca* (Florence, Palazzo Pitti), after cleaning

99. *Madonna del Baldacchino* (Florence, Palazzo Pitti)

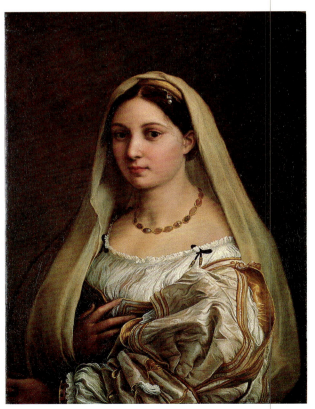

100. *Portrait of a Lady*, called *La Velata* (Florence, Palazzo Pitti), after cleaning

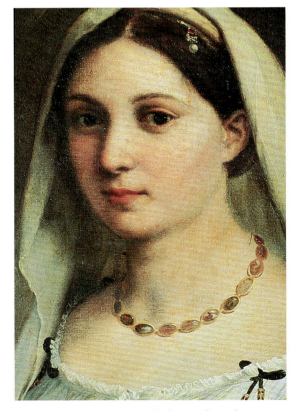

101. *Portrait of a Lady*, called *La Velata* after cleaning, detail

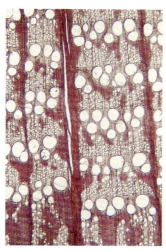

102. Poplar 103. Oak 104. Chestnut 105. Linden

102–105. Comparison of wood cross-sections

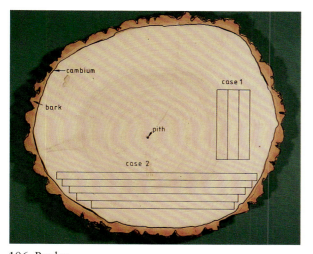

106. Poplar

106–107. Various modes for the formation of board out of trunk

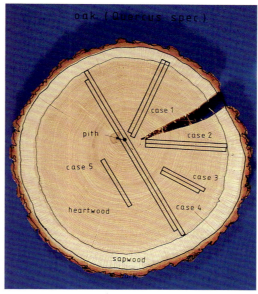

107. Oak

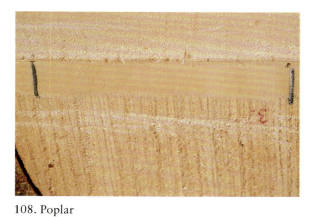

108. Poplar 109. Oak

108–109. Comparison of growth-ring patterns

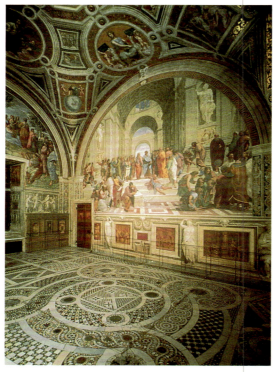

110. Stanza della Segnatura, floor, beginning of the sixteenth century

111. Raphael, Stufetta for Cardinal Bibbiena, floor, about 1516

112. Bernini, inlaid tomb lid, Chigi Chapel, about 1660–64

113. Chigi Chapel, decoration between the capitals

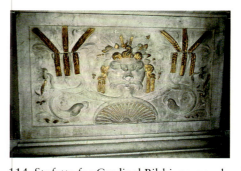

114. Stufetta for Cardinal Bibbiena, panels

115. Corinthian capital incised on its side like those in the Chigi Chapel

116. Chigi Chapel, frieze, one side in *Portasanta* marble, one side in *Rosso Antico* marble

117. Chigi Chapel, marbles of the niche

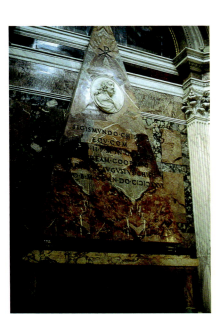

118. Chigi Chapel, Sigismodo tomb

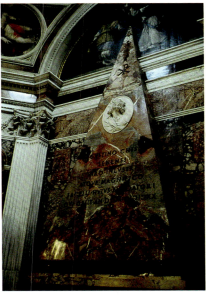

119. Chigi Chapel, Agostino tomb

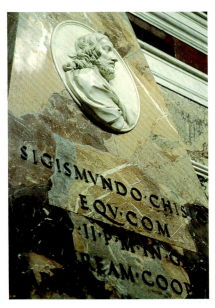

120. Chigi Chapel, *giocati* joints on the pyramids

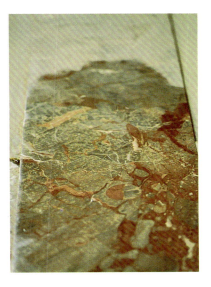

121–122. *Giocati* joints

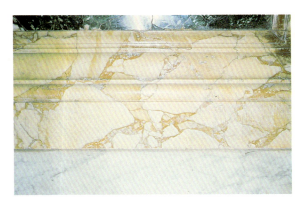

125. Chigi Chapel, balustrade at entrance

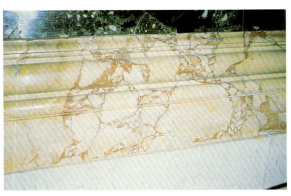

123–124. Chigi Chapel, mouldings of the two pedestals in a very similar *Giallo Antico* marble from Numidia

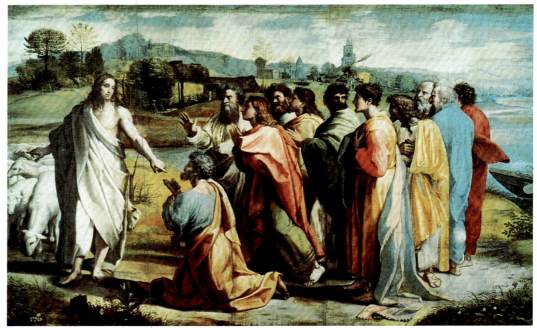

126

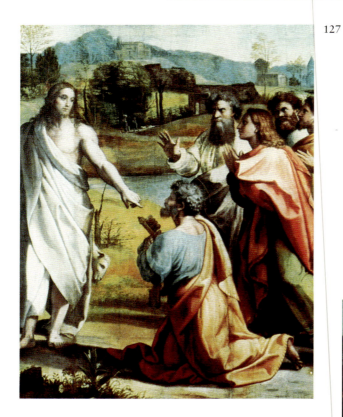

127

128

126–129. *Christ's Charge to Peter* (London, Royal
Collection on loan to Victoria and Albert Museum)

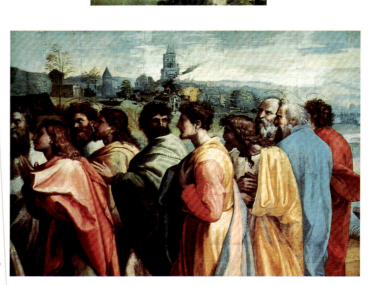

129

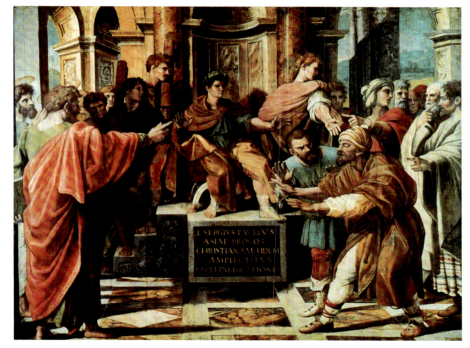

130

130–132. *The Blinding of Elymas* (London,
Royal Collection, on loan to Victoria and
Albert Museum)

131

132

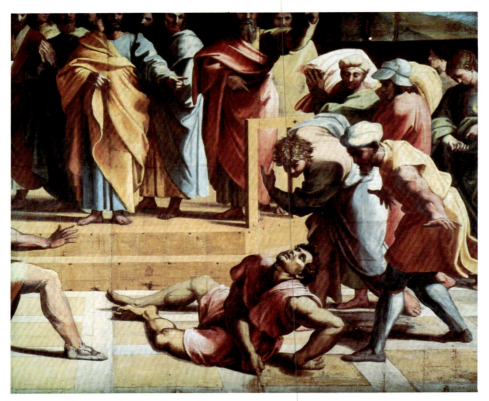

133. *The Death of Ananias* (London, Royal Collection on loan to Victoria and Albert Museum) detail

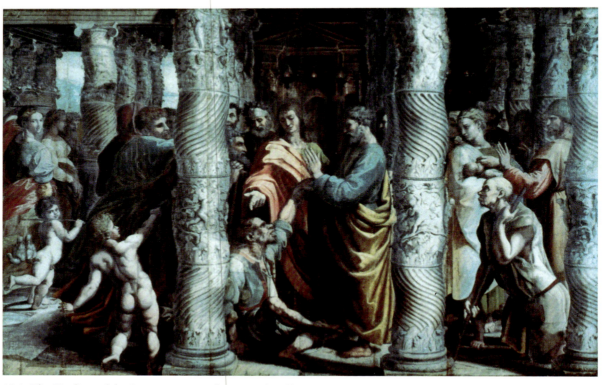

134. *The Healing of the Lame Man* (London, Royal Collection, on loan to Victoria and Albert Museum)

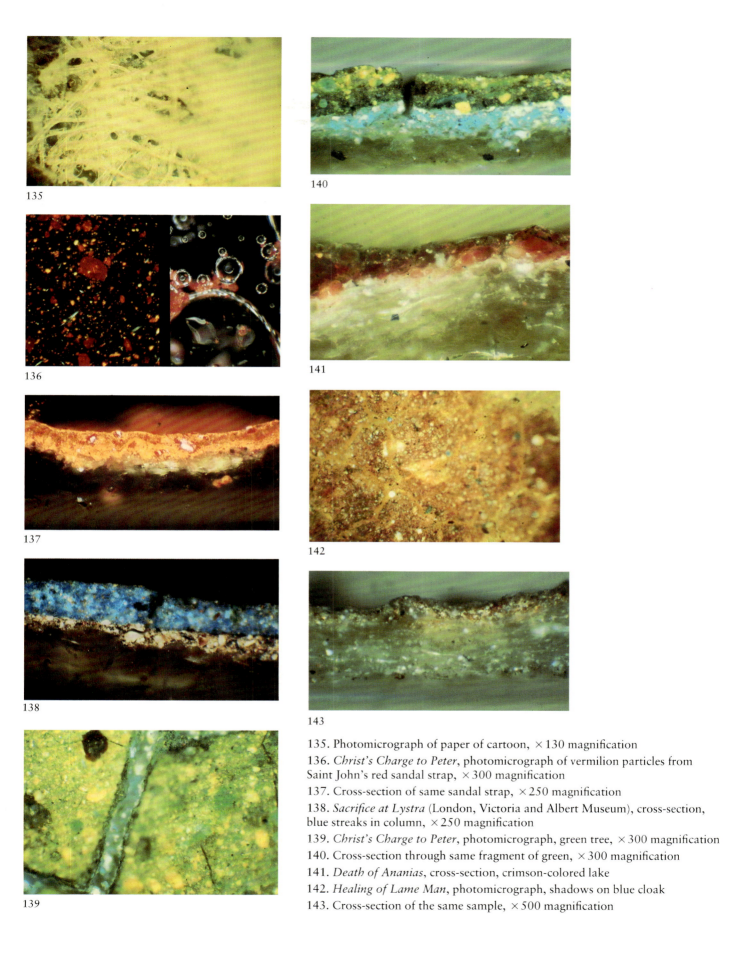

135. Photomicrograph of paper of cartoon, × 130 magnification

136. *Christ's Charge to Peter*, photomicrograph of vermilion particles from Saint John's red sandal strap, × 300 magnification

137. Cross-section of same sandal strap, × 250 magnification

138. *Sacrifice at Lystra* (London, Victoria and Albert Museum), cross-section, blue streaks in column, × 250 magnification

139. *Christ's Charge to Peter*, photomicrograph, green tree, × 300 magnification

140. Cross-section through same fragment of green, × 300 magnification

141. *Death of Ananias*, cross-section, crimson-colored lake

142. *Healing of Lame Man*, photomicrograph, shadows on blue cloak

143. Cross-section of the same sample, × 500 magnification

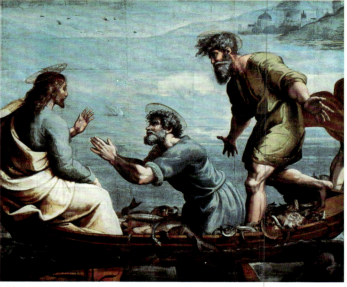

144

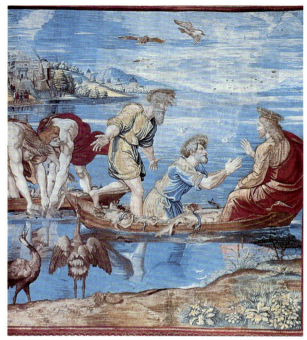

145

144. *The Miraculous Draught of Fishes* (London, Victoria and Albert Museum)

145. *The Miraculous Draught of Fishes*, tapestry (London, Victoria and Albert Museum)

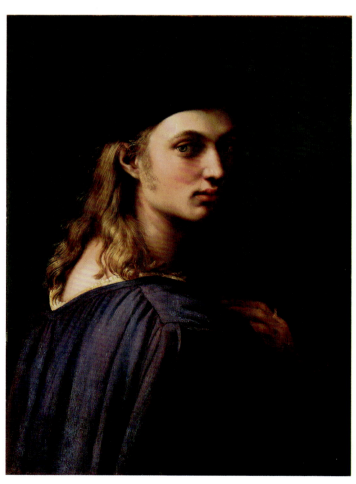

146. *Bindo Altoviti* (Washington, National Gallery of Art)

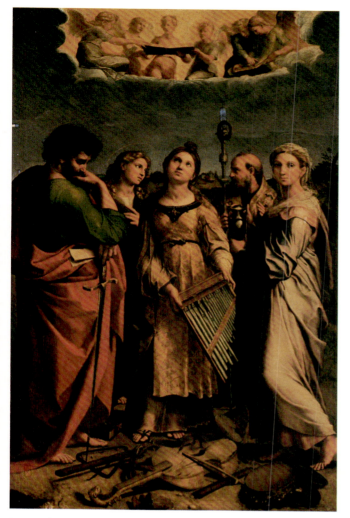

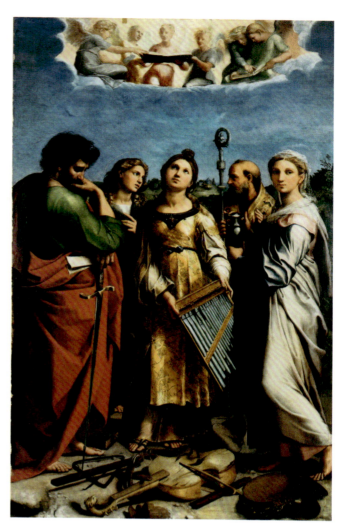

147. Before cleaning

148. After cleaning

147–148. *Santa Cecilia* (Bologna, Pinacoteca)

149–155. *Santa Cecilia*, cross-secions:

149. Blue sky to the left of Cecilia's head

150. Blue sky to the right of Magdalen's head

151. Red robe of Saint Paul, with no retouching

152. Red robe of Saint Paul, from retouched area

153. Same cross-section as 149, in fluorescent light

154. Same cross-section as 150, in fluorescent light

155. Same cross-section as 151, in fluorescent light

149

153

150

154

151

155

152

156–158. *Transfiguration* (Vatican, Pinacoteca):

156. Cross-section, blue sky

157. Cross-section, blue castle

158. Cross-section, red-brown shadow of a robe

159. *Madonna di Foligno* (Vatican, Pinacoteca), cross-section, blue sky

156

157

158

159

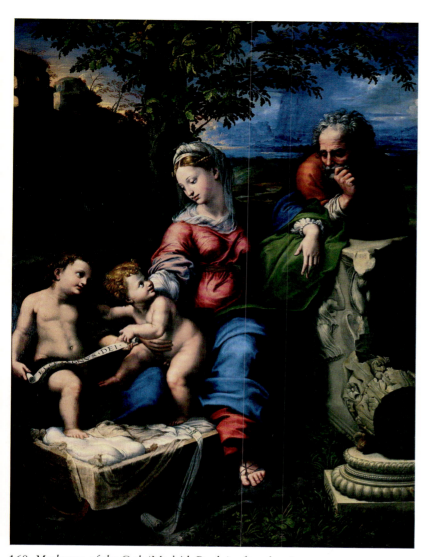

160. *Madonna of the Oak* (Madrid, Prado), after cleaning

162. Madonna

161. Top right

163. Christ Child and Infant John

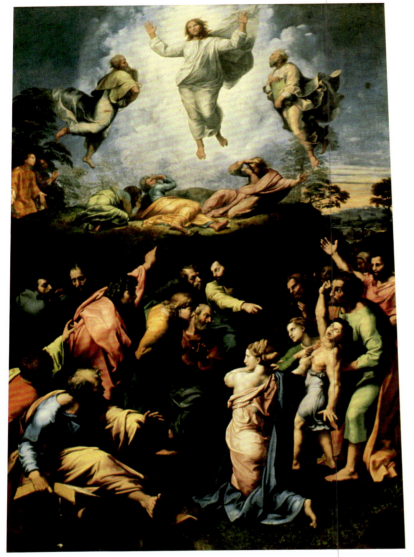

164. After cleaning

164–166. *The Transfiguration* (Vatican, Pinacoteca)

165. Elijah

166. Saint Matthew

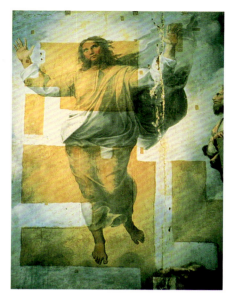

167. Christ, during cleaning

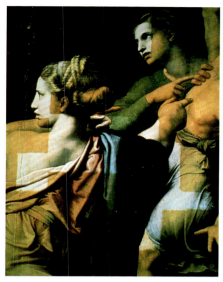

168. Lower zone, during cleaning

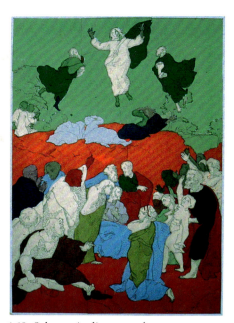

169. Schematic diagram of undermodeling

170. Unfinished foot of Elijah

171. Unfinished hand of man behind epileptic boy

172. Unfinished, rock in lower right corner

167–172. *The Transfiguration*

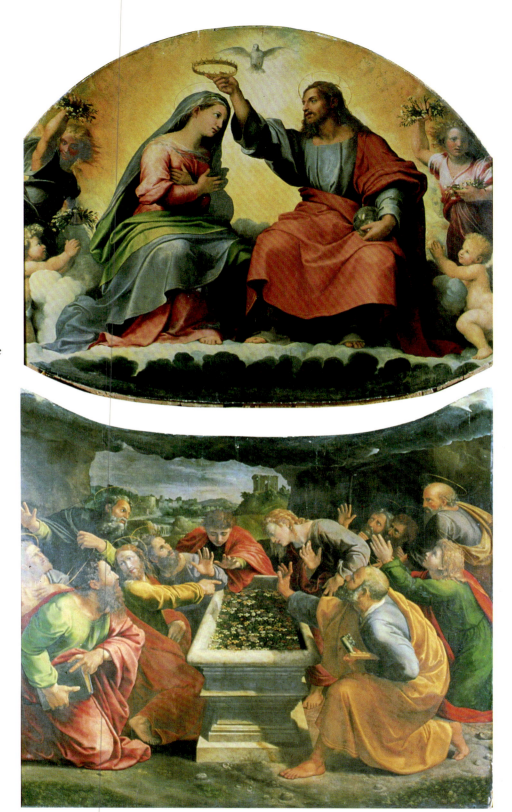

173. *Coronation of the Virgin* (*Pala di Monteluce*) (Vatican, Pinacoteca), upper zone

174. *Coronation of the Virgin*, lower zone

175. Angel, upper left, showing cut edge of panel

176. Christ and angel, showing cut edge

177. Angel, upper right, showing cut edge

178. Angel and putti, upper left

179. Sketches on back of panel

180. Bottom and right edge of upper panel

181. Saint Matthew, lower left

182. Saint Peter, lower right

183. Apostles, lower right

175–183. *Coronation of the Virgin*

184. Light yellow of sky above the Madonna's crown

185. Greenish blue of sky below sleeve of angel at the left

186. Flesh of leg of little angel at the left

187. Red lake of sleeve of angel at the right

188. Dark red lake of robe of angel at the right

189. Drawing of the putti's heads

190. Gold halo of the apostle in the second rank at the right edge

191. Dark red lake of the robe of kneeling apostle in the first row at the right

192. Yellow of the robe of bald apostle in the second rank, left

193. Red of the kneeling apostle's robe in the second rank, left

194. Green of the vestment of kneeling apostle in the second rank, left

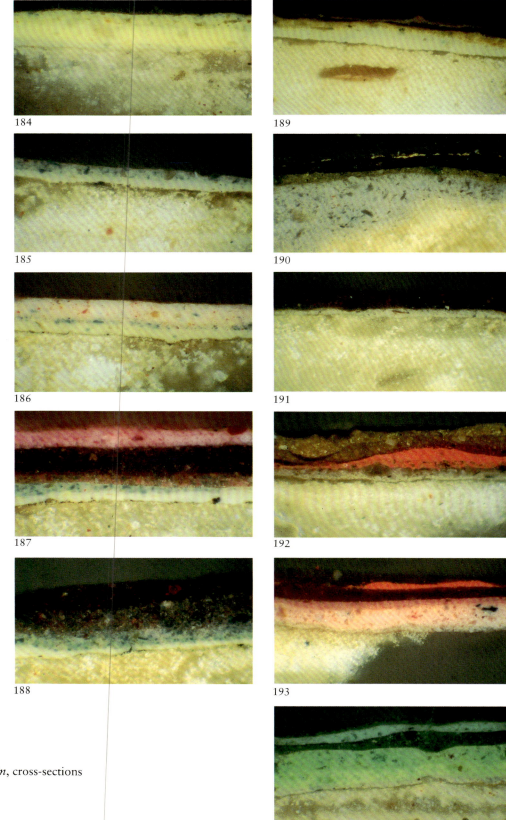

184–194. *Coronation of the Virgin,* cross-sections

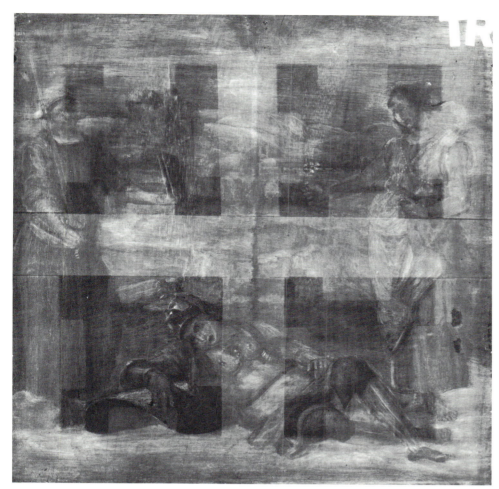

195. *Allegory* (*The Vision of a Knight*)
(London, National Gallery),
x-radiograph

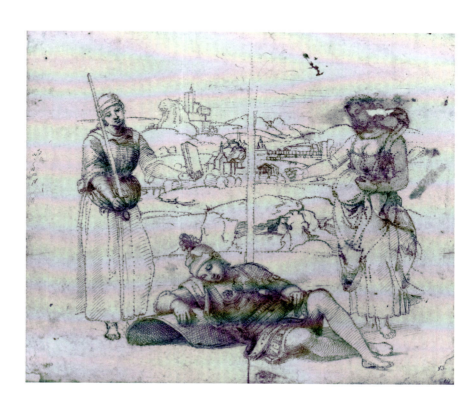

196. *The Vision of a Knight*, cartoon
(London, National Gallery)

197–199. *The Vision of a Knight*, reflectograms

197

198

199

200. *The Crucified Christ with the Virgin Mary, Saints and Angels* (London, National Gallery), panchromatic photograph

201. *Saint Catherine of Alexandria* (London, National Gallery), infrared photograph

202. *Saint Catherine of Alexandria*, x-radiograph

203. Perugino: *The Angel Raphael and Tobias* (London, National Gallery), x-radiograph

203

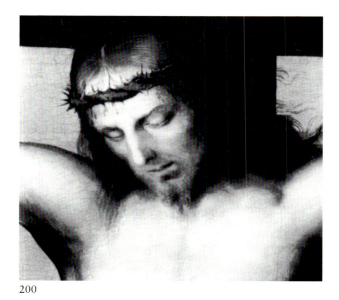

200

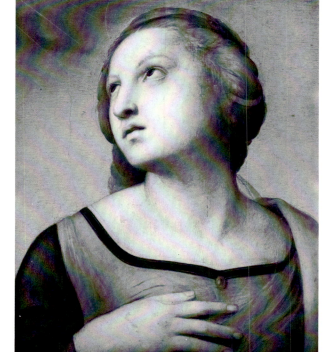

201

202

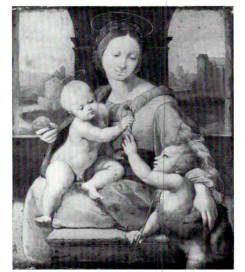

204

205

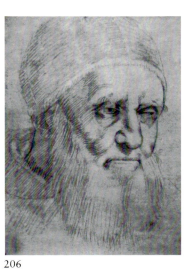

206

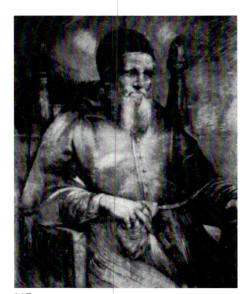

207

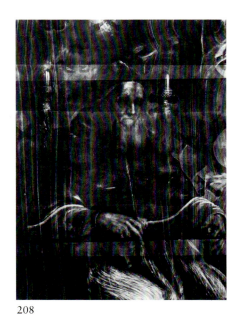

208

204–205. *Madonna and Child with the Infant Baptist* (*The Aldobrandini Madonna*) (London, National Gallery):

 204. Infrared photograph
 205. X-radiograph, detail of upper half

206. Preparatory sketch for head, *Pope Julius II* (Chatsworth, Devonshire Collection)

207–208. *Pope Julius II* (London, National Gallery):

 207. Cartoon copied after the painting (Florence, Corsini Gallery)
 208. X-radiograph

209. *Saint John the Baptist Preaching* (London, National Gallery), infrared photograph

209

210. *La Belle Jardinière* (Paris, Louvre)

211. *La Belle Jardinière*, date

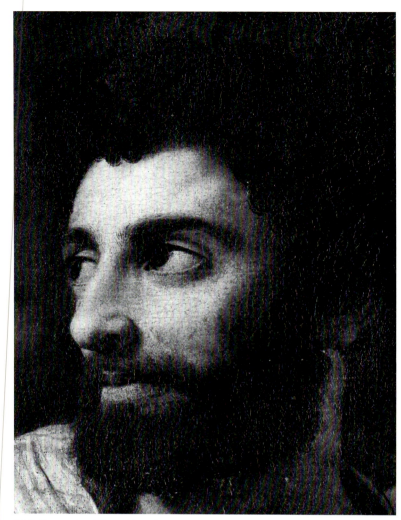

213. *Portrait of Two Men* (Paris, Louvre)

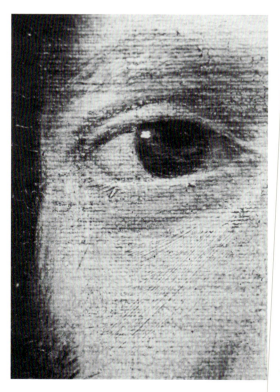

212. *Baldassare Castiglione* (Paris, Louvre), eye

214. X-radiograph

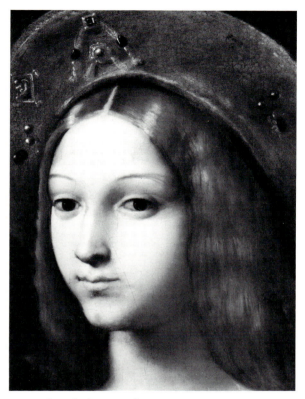

215. Infrared photograph

214–215. *Jeanne d'Aragon* (Paris, Louvre)

216–217. *Saint Michael* (Paris, Louvre)

217. Infrared photograph

216. Head

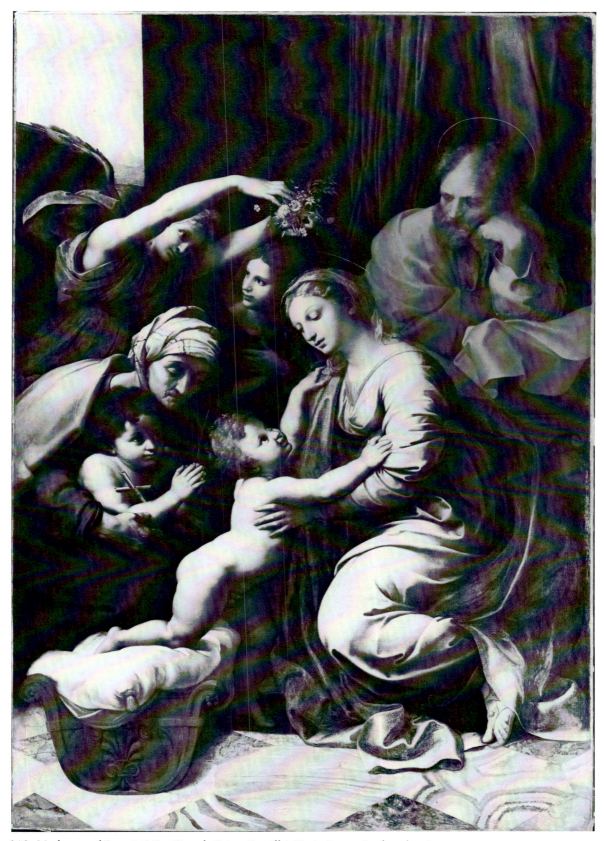

218. *Madonna of Francis I* (*La Grande Sainte Famille*) (Paris, Louvre), after cleaning

219. Fragment form *Saint Nicholas of Tolentino* (Paris, Louvre), angel, before in-painting

220. *Madonna of Francis I*, infrared photograph

221

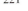

221–222. *Madonna of Francis I*, infrared photographs

222

223. Infrared photograph

223–224. Workshop of Raphael: *The Small Holy Family*
(Paris, Louvre)

224. Saint John's head

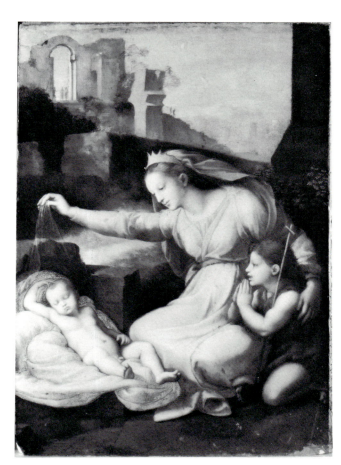

225. X-radiograph

226. Infrared photograph

225–226. Workshop of Raphael (Penni): *Madonna with Diadem* (*Madonna with the Veil*)
(Paris, Louvre)

227–228. *Madonna in the Meadow* (Vienna, Kunsthistorisches Museum), x-radiographs

227

228

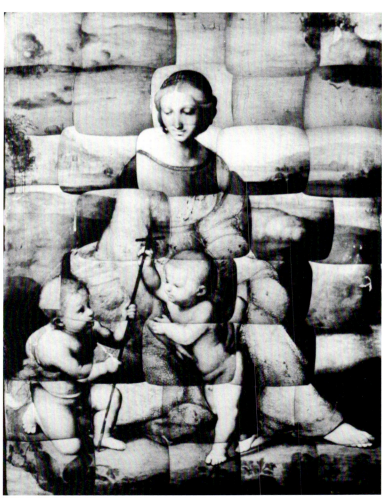

229

229–230. *Madonna in the Meadow*, reflectograms

230

231–236. *Madonna in the Meadow*:

231–235. Reflectograms

236. Ultraviolet photograph, Christ Child's foot

232

231

234

233

235

236

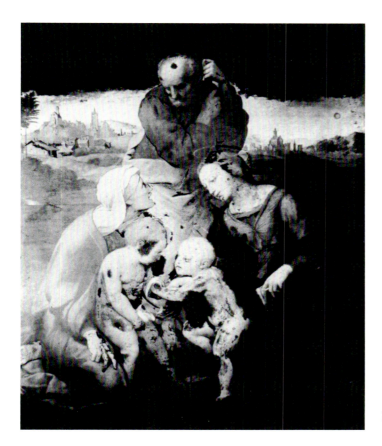

237–238. *Canigiani Holy Family* (Munich, Alte Pinakothek)

237. Ultraviolet photograph

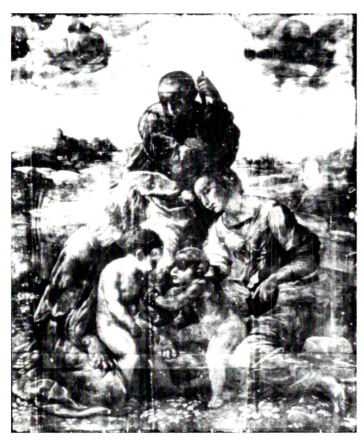

238. X-radiograph

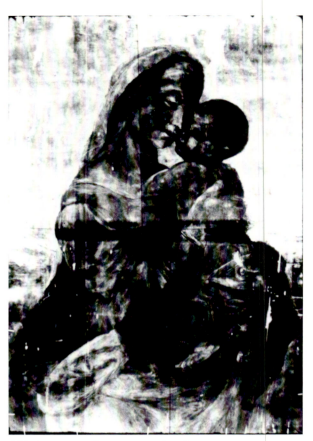

239. *Tempi Madonna* (Munich, Alte Pinakothek), x-radiograph

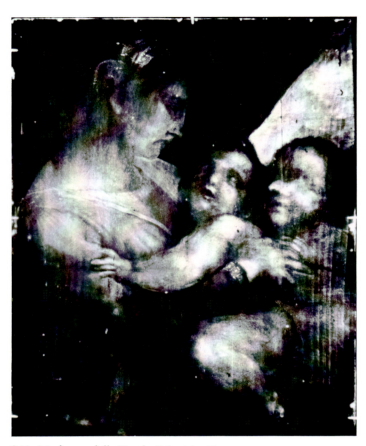

240. *Madonna della Tenda* (Munich, Alte Pinakothek), x-radiograph

241. Attributed to Raphael: *Portrait of a Young Man* (Munich, Alte Pinakothek), x-radiograph

242. *Canigiani Holy Family*, reflectogram

243. Perugino: *Madonna and Saints Adoring Child* (Munich, Alte Pinakothek), reflectogram

244. Infrared photograph, putti, upper left

245. Reflectogram, Joseph's foot

246. Reflectogram, architectural detail

247. Reflectogram, Christ Child's ear

244–248. *Canigiani Holy Family*

248. Back of panel, punch mark

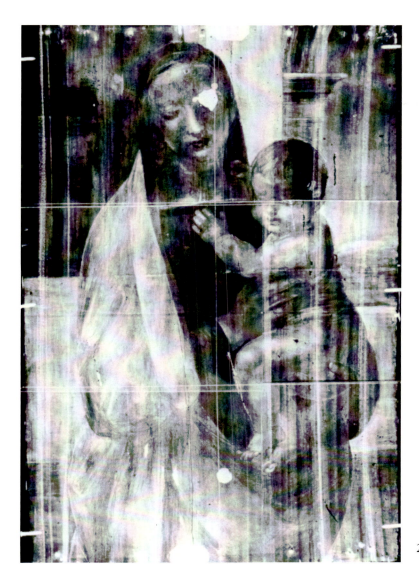

249–251. *Madonna del Granduca*
(Florence, Palazzo Pitti)

249. X-radiograph

250. Reflectogram

251. Reflectogram

252–261. *Madonna del Granduca*, reflectograms

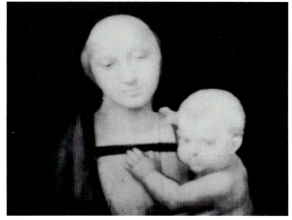

252

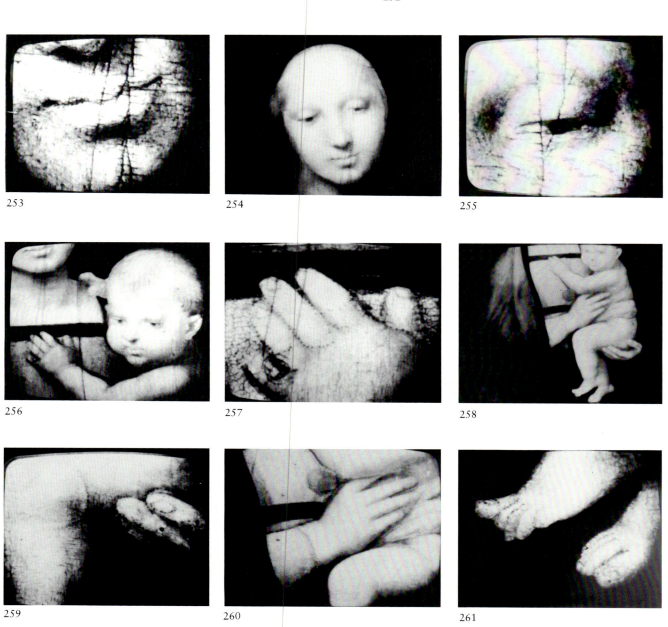

253

254

255

256

257

258

259

260

261

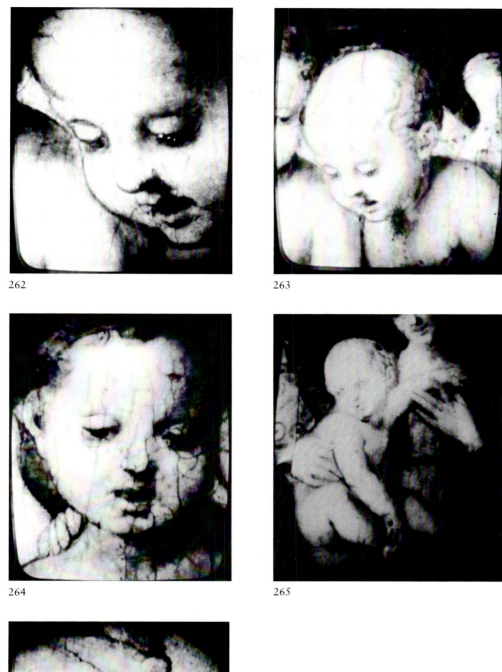

262

263

264

265

266

262–266. *Madonna del Baldacchino* (Florence, Palazzo Pitti), reflectograms

267

268

269

267–272. *Madonna del Baldacchino*:

 267. X-radiograph

 268. X-radiograph

 269. Reflectogram

 270. X-radiograph

 271. Reflectogram

 272. Reflectogram

270

271

272

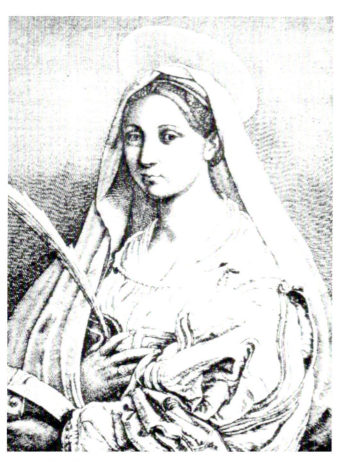

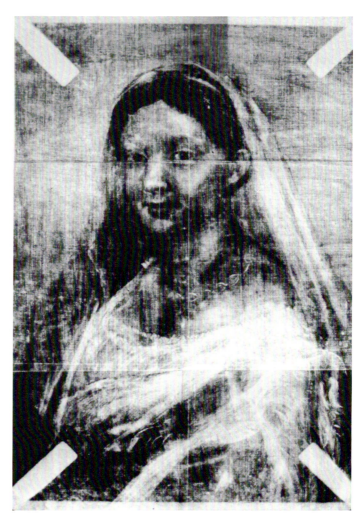

273. Etching by Wenzel Hollar after the *Donna Velata* with attributes of Saint Catherine

274. *Donna Velata* (Florence, Palazzo Pitti), x-radiograph

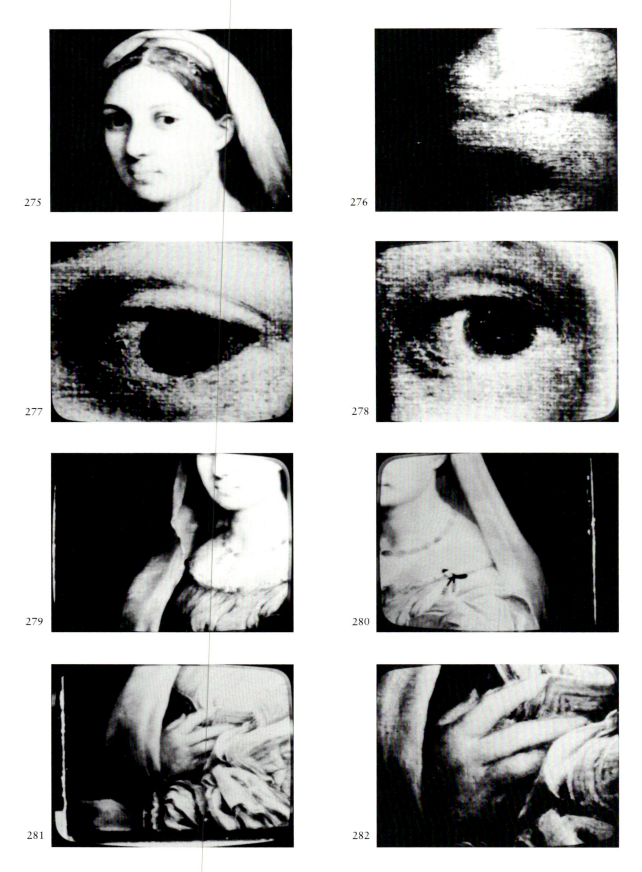

275–282. *Donna Velata*, reflectograms

283

284

283. *Diotalevi Madonna* (Berlin-Dahlem,
Gemäldegalerie)

284. *Solly Madonna* (Berlin-Dahlem, Gemäldegalerie)

285. *Diotalevi Madonna*, back of panel

285

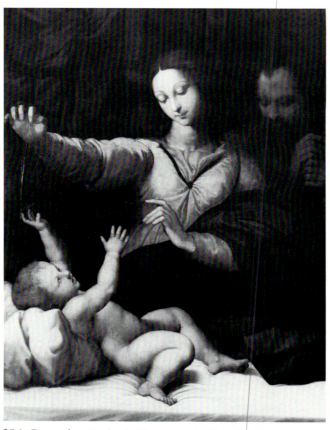

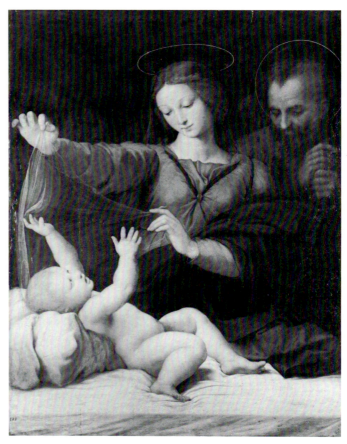

286. Copy after Raphael: *Madonna del Velo* (Malibu, J. Paul Getty Museum)

287. *Madonna del Velo* (*Madonna di Loreto*) (Chantilly, Musée Condé)

288. Madonna's head

290. *Madonna del Velo* (Getty version), Madonna's arm, infrared photograph

289. Madonna's arm and head

288–289. *Madonna del Velo* (Chantilly version), infrared photographs

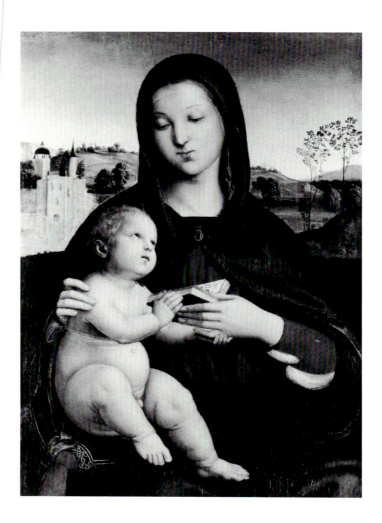

292. *Madonna and Child* (Pasadena, Norton
Simon Art Foundation)

291. *Madonna del Velo*
(Chantilly version), back of panel

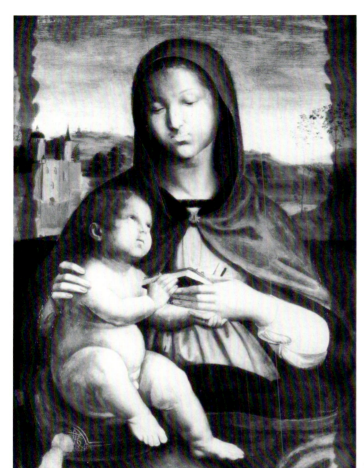

293

293–294. Simon *Madonna*, infrared photographs

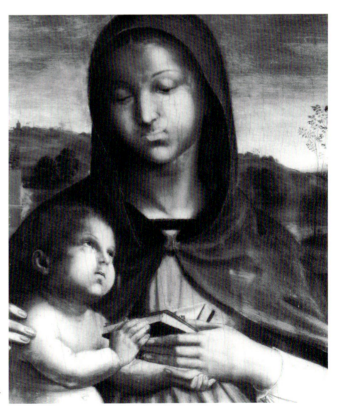

294

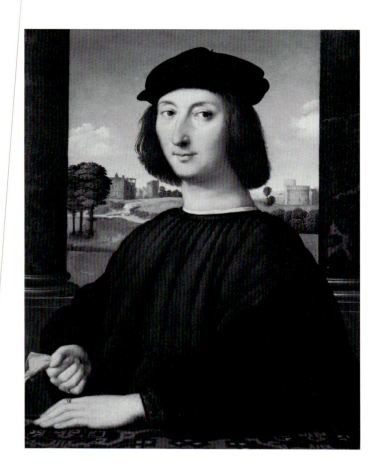

295. Attributed to Raphael: *Portrait of a Young Man* (Malibu, J. Paul Getty Museum)

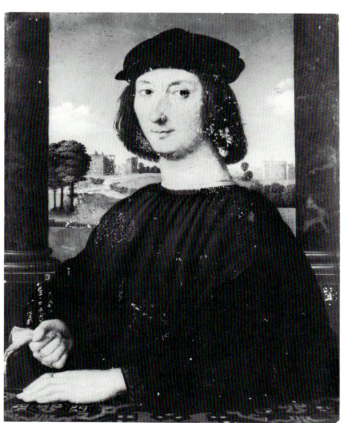

296. Getty *Portrait* in stripped condition

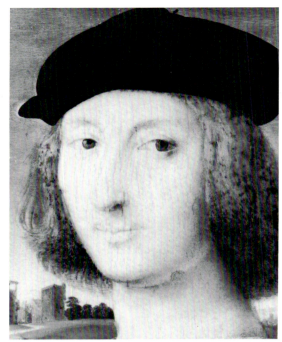

297

298

297–298. Getty *Portrait*, infrared photographs

299. *Portrait of a Young Man with Apple* (pl. 86)
(Florence, Uffizi), infrared photograph

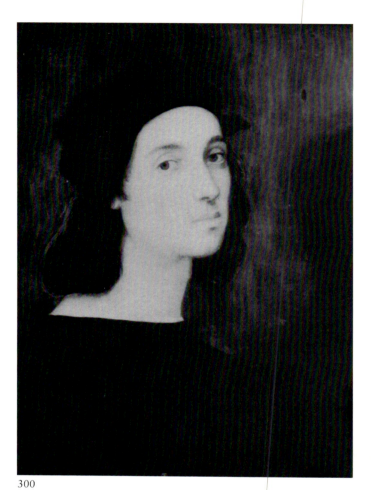

300

300–301. Attributed to Raphael: *Self-Portrait* (pl. 87) (Florence, Uffizi), infrared photographs

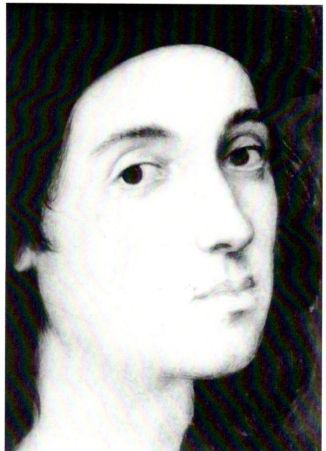

301

302. *The Death of Ananias* (London, Royal Collection, on loan to the Victoria and Albert Museum), Ananias's legs, showing drawing

303. *The Sacrifice at Lystra* (London, Royal Collection, on loan to the Victoria and Albert Museum), streaks in column

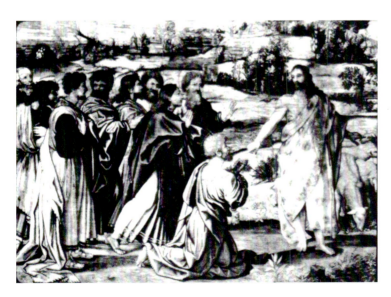

304. *Christ's Charge to Peter*, tapestry (Vatican, Pinacoteca)

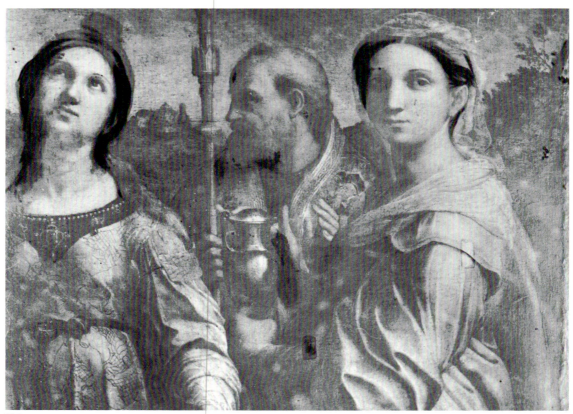

305

305–306. *Santa Cecilia* (Bologna, Pinacoteca):

 305. Fluorescence photograph, before cleaning
 306. Fluorescence photograph, same detail as pl. 307

307. *Santa Cecilia*, infrared photograph

306

307

308. Fluorescence photograph of sky, the bright rectangle is cleaned

309. Reflected ultraviolet photograph, same detail as pl. 308

308–309. *Santa Cecilia*, cleaning tests of sky

310

310–311. *Santa Cecilia*, infrared photographs
showing underdrawing

311

312. *Santa Cecilia*, infrared reflectogram showing underdrawing

313

313–315. *Santa Cecilia*, infrared reflectograms showing underdrawing and *pentimenti*

314

315

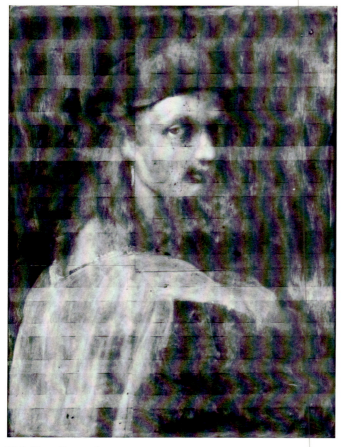

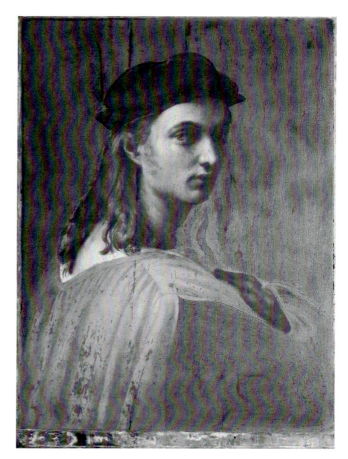

316. X-radiograph

317. Ultraviolet photograph

316–317. *Bindo Altoviti* (Washington, National Gallery of Art)

319

318

318–319. *Bindo Altoviti*:

 318. Back of panel before transfer
 319. Paint and ground seen from reverse during transfer

320. *Niccolini-Cowper Madonna* (Washington, National Gallery of Art), x-radiograph

321. *Small Cowper Madonna* (Washington, National Gallery of Art), reflectogram

322. Showing losses

322–325. *Madonna of the Oak* (Madrid, Prado)

323. Joseph seen in raking light before restoration

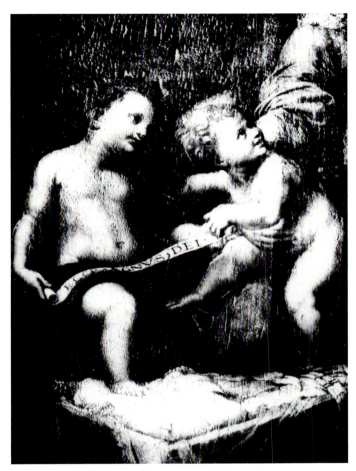

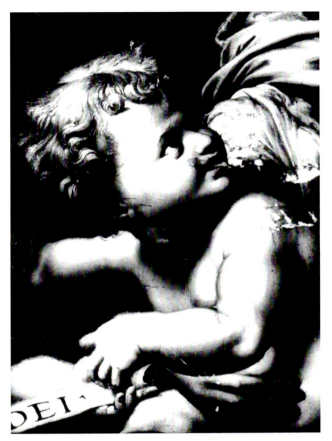

324. Christ Child and infant Saint John seen in raking light before restoration

325. Christ Child showing losses

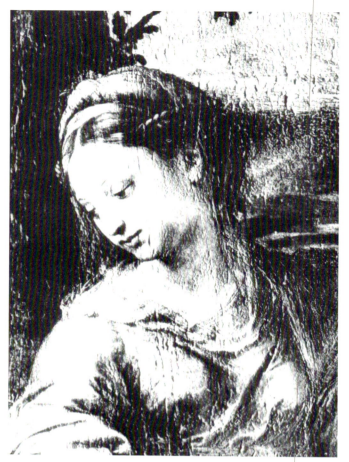 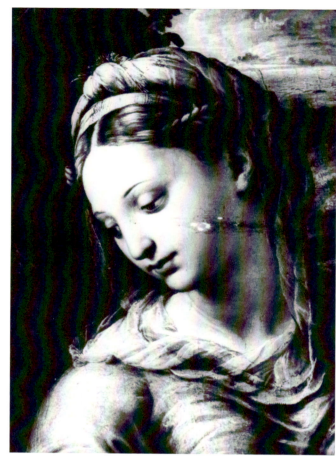

326. Madonna in raking light before restoration

327. Madonna showing losses

326–327. *Madonna of the Oak*

328. *Madonna of the Oak*

329. *Holy Family* (*La Perla*) (Madrid, Prado), back of panel

330. *The Cardinal* (Madrid, Prado), back of panel

331

331–335. *The Transfiguration* (Vatican, Pinacoteca), x-radiographs

332

333

334

335

336. Diagram of the support

336–338. *Coronation of the Virgin* (*Pala di Monteluci*)
(Vatican, Pinacoteca)

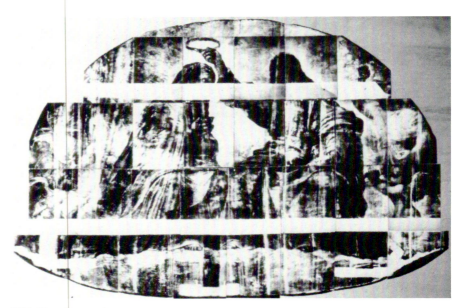

337. X-radiograph

338. X-radiograph

339

340

341

342

343

339–343. *Coronation of the Virgin*:

339–342. Reflectograms
343. Sketches on back of panel